ANTI-STORY:

an anthology of experimental fiction edited by PHILIP STEVICK

THE FREE PRESS
New York London Toronto Sydney Singapore

THE FREE PRESS
A Division of Simon & Schuster Inc.
1230 Avenue of the Americas
New York, NY 10020

Manufactured in the United States of America

20 19 18 17 16 15 14 13 12

Library of Congress Catalog Card Number: 78–131596

ISBN 0-02-931500-X

contents

v

introduction

NOT LONG AGO I attended an exhibit of modern sculpture. It contained work that one might expect in such a show, welded automobile junk, steel I-beams enameled in primary colors and bent in odd angles, plexiglass with flashing lights, and even though such forms have been done before, work of that kind always fascinates me because of what it does with surface and texture, solidity and proportion. The exhibit also included some kinds of work that I had never seen before and would not have been able to imagine, one of them, for example, an arrangement by means of which huge loops of spring steel were made to flip over and whip around so as to make not only a constantly changing visual object but also a noise, one of the eeriest noises I have ever heard. But there were two works in the exhibit that seemed to me then most striking and even now hang in my mind with a kind of haunting vividness which I associate with art of a very special kind of power. The first of these was a room, actually a maze of many small rooms, made of mirror glass, not only the walls but the floors and ceiling. A person was required to take off his shoes and walk through it in stocking feet. I went through it twice and would have gone through it again except that there was a small crowd of people waiting to go through and I was afraid I might look foolish. The other was a painted wood construction, six feet high, in the shape of a huge capital letter O. I have been conditioned not to touch sculpture, so as I approached the O I only looked, even though I wanted to push it, to see if it would rock. The guard, seeming to understand my wish, said, "Go ahead and push it. It's all right." So I pushed it, and it rocked, emitting noises from some primitive chime-like mechanism inside of its surface. Later I had moved into the next room and was looking at something else when I heard the O begin to rock again. I looked through the door to see who the next person was who had been caught by the impulse to push the thing and discovered that it was the guard himself, the only person in the room, who was smiling slightly and watching, as

the giant O wobbled slowly back and forth, saying "Baling, balong."

Neither I nor the guard had ever seen anything quite like that rocking O before, and that, clearly, was part of its fascination, its novelty; yet its novelty was built upon certain familiar perceptions; the O was close enough to things that we had seen before so that we knew it should rock and when it made its noise, that too was rather familiar, like the sound made by the toys that small children push and pull as they learn to walk. Both I and the guard had *done* something with the work; instead of looking, we pushed, and the work of art responded by rocking. I don't know about the guard, but I am slightly changed now. All sculpture looks different to me because I once pushed a sculpture, it rocked and made noises.

In describing my response to sculpture of a particularly audacious kind, I have been trying to suggest what occurs whenever we confront the new in art, not only in sculpture or painting but also in drama or film or fiction. And although I have chosen my examples from contemporary sculpture and mean them as an introduction to new fiction, that confrontation is hardly a twentieth-century phenomenon but is probably as old as art itself. It seems likely that if we had records enough to be sure of how the Roman readers of the poetry of Catullus felt about him in his own time, we would find that some were offended, some indignant, some contemptuous, and some were, as we often are with the art of our time, fascinated, puzzled, unsure when to laugh, and deeply troubled by their inability to say anything very intelligent about art so new. Re-reading sympathetically some of the early critics on Ibsen, for a more recent example, one can understand both their frustration and their excitement in being faced with a body of work showing great power and great theatrical truth, yet indescribable by any of the nineteenth-century critical formulae. Audiences for art have often been caught between the feeling, on the one hand, that old forms are inadequate to their own contemporary reality and that they must open themselves to the possibility of the new in art, and the feeling, on the other hand, that their own particular new art is per-

verse, bizarre, subversive, at the very least an extraordinarily diffi-
cult exercise in adaptation.

Such strains between artistic innovation and its anxious audi-
ence are scattered throughout history, but in the twentieth cen-
tury so much art has been so resolutely and powerfully innovative
that one might easily think of innovation as being the constant
motive of all artists in all times and places. Art need not, of
course, be so anti-traditional as it has often been in our century,
and much of the world's great art is technically conservative—the
music of Bach, the fiction of Thackeray. In our time, all the same,
we have perpetuated the idea of the *avant-garde,* kept the phrase
alive through recurrent waves of "advanced" art. (It is a military
metaphor which implies that certain of our artists are "ahead"
of the rest of us, and where they go the rest of us will follow,
like an army following its reconaissance scouts.) We have pos-
sessed, as no other period has, the means for popularizing new
movements in art with great speed. (Consider the progress of
"pop art," for example, from a bizarre and incomprehensible
phenomenon on the fringes of the New York art world, to an
international artistic style assimilated by the imaginations of
millions, all in a few years.) For a multitude of reasons, some of
them substantial, some specious, the arts in the twentieth century
have been more innovative than in any comparable period in the
past. And despite the perpetual problems of coming to terms with
the new in art, we are likely to feel that artistic innovation is a
kind of triumph, a tribute to the energy of art, that it should be
able, again and again, to show us what we haven't seen before,
by means of techniques that perpetually astonish us.

No one doubts the place of fiction of novel length in this tra-
dition of experiment. Late James and late Conrad, Proust, Mann,
Gide, Joyce, Beckett, Faulkner—it is a dazzling pantheon, re-
markable not only for the extent of its genius but for the extent
of its shared assumptions concerning the experimental, anti-tra-
ditional role of art. The place of short fiction, however, is quite
different. In the early years of the century, short fiction chal-
lenges the received notions of time and space, continuity and
coherence, artistic illusion and psychological process just as pow-

erfully and successfully as longer fiction does. It puzzles and troubles its readers with its artistic audacity. And it includes some of the most extraordinary art of our time, as passionate in its craftsmanship, as controlled in its structure, as penetrating in its vision as art of any kind. But then a kind of fatigue overtakes the form, changing short fiction into perhaps the most conservative art of mid-century, during the nineteen-fifties probably the single mode of artistic expression most self-imitative.

One can gauge the magnitude of the self-imitation by finding a good collection of short fiction, "art stories" of the most serious intent, compiled perhaps twenty years ago, containing the best English and American stories of the half century, with a representative group of European stories in translation, then reading straight through the collection without stopping. It is disturbing and ultimately tiresome to find so many patterned and rather obvious symbols. It is surprising and ultimately annoying to see how many of the stories concern children, or adults with child minds, who grasp, in a way that they do not fully understand, the nature of evil, always at the same relative point in the story, so that each story that presents such a character could be plotted on a graph, its action superimposed upon the graph of the other stories, showing that their shapes coincide. It is surprising how few distinct voices one finds. Of course there are highly distinctive voices, Hemingway's most obviously. Still, short fiction often tends to mute the distinctiveness of an author who works in both short and long forms. And thus, taking the voices of our exemplary collection together, there is so much water color realism, so much understated perceptiveness, so much good taste that the art seems finally not to come from our often ugly and brutal century at all but from another time and place. And so it is that a reader now, coming to the short fiction of the first half of the twentieth century, could discover what made the best of that fiction new and puzzling and audacious in its own time. But he would discover, also, how short fiction, in an age in which every other art continued to extend its own possibilities, became rather predictable and formulaic.

Short fiction, then, has its own history in the twentieth century and its history does not parallel the waves of innovation and

consolidation that take place in any other art. The accomplishment of the genre in the first half of the century was done within what now looks like quite a narrow range of formal possibilities. And it has not been until recently that a significant number of writers of fiction, some of the finest that we have, have used short fiction so as to extend its formal possibilities with daring and imagination and to make artistic objects which the masters of the story in the early years of the century could scarcely recognize.

Like the O sculpture of my museum experience, these new short fictions are startling and bizarre, always unpredictable, often, if we will let them work on us, quite funny. Like the O, the experimental fiction of the last twenty years seeks to seduce us into experiencing it in ways which our experience of traditional art has not prepared us for. Both the sculpture and the fiction break down the applicability of traditional categories both of judgment and description. Try out some of the traditional categories of judgment, for example, on the fiction that follows: perceptiveness, good taste, intelligence, the ability to create credible characters, the satisfactory resolution of themes. These don't help very much, any more than the traditional terms help us to judge and understand a plywood O. Both the sculpture and the fiction are aggressively anti-traditional in the way in which they play upon the very nature of their respective arts. The last thing we expect of a sculpture, Rodin's *The Kiss* let us say, is that, if we push it, it will rock. The traditional sculpture, by its very nature, stands still. The last thing we expect of a fiction, if we base our expectations upon traditional fiction, is that it will talk to us, mocking our banalities, or shift without preparation between a kind of lunatic fantasy and a precisely calibrated and perfectly credible realism, or stop after fifty words. It isn't the nature of fiction to do these things, which is why one finds them done in the fictions in this book.

It is by considering such contrariness that one can most easily specify what recent experimental fiction is doing. Boswell reports his having asked Johnson what poetry is. Johnson replied, " 'Why, Sir, it is much easier to say what it is not. We all *know* what light is; but it is not easy to *tell* what it is.' " To tell what recent

fiction is, we must tell what recent fiction is not. And the place to begin is with the word "epiphany." The word was first applied to literature by Joyce, who borrowed it from its religious usage in which it means the showing forth specifically of Christ's divinity; Joyce chose to apply the word to certain very brief recorded moments in an artistic journal, events, sensations, visual observations that Joyce thought exhibited a sort of luminous intensity. From that usage Joyce carried it over so as to apply it to the moment of insight at the structural heart of his shorter fiction, that image or event near the end of a story which makes possible for at least one of the characters, and for us as readers, an intuitive act of understanding. Since Joyce, the word has been widely used, its usage extended, and it has been made to apply to insights quite unJoycean and to writers who would have been horrified to find themselves in Joyce's company. The word was none too precise as Joyce used it; it has become less precise since. Still, for all of its imprecision, the word does signify a structural feature of hundreds of modern stories of the kind that now seems conservative. The whole significance of such stories, their whole justification for being, is invested in that moment of insight around which the rest of the story deploys itself. The epiphany, in the extended sense I have indicated, is the single feature of the modern classic story most repeated and consistently characteristic. Conversely, there is no feature of the classic twentieth-century story so carefully avoided by writers who wish to do something new with short fiction. Characters in the works that follow do not learn. There are no insights. Relationships are not grasped in an instant. Structurally, the stories are flat, or circular, or cyclic, or mosaic constructions, or finally indeterminate or incomprehensible in their shape—they are not climactic. What we start with is pretty much what we have at the end. No epiphanies.

I have called the collection that follows *Anti-Story* and arranged its contents as I have on the assumption that there is a considerable range of contrariness in recent experimental fiction, more than a reaction against what may now seem a certain blandness in earlier fiction, more than a reaction against formal predictability, more than a reaction against epiphany, with all

that it implies of structure and sensibility. The depth of the reaction is evident in the difficulty one encounters in trying to apply the word "story" itself. One hesitates to call most of the works in the collection that follows stories at all. They are "short prose works," "pieces," "fictions," "sketches," "fables," anything but "stories," since that word, the word that most easily and naturally names the classic genre of short fiction, inevitably carries connotations of narrative ease, facility, the arched shape, the climactic form, all of these being qualities generally avoided in new experimental fiction. The works that follow are, in a sense, a reaction against "story-ness," and I have tried, in my section headings, to give some indication of what those classic attributes of "story" are.

AGAINST MIMESIS. To be swept up in the story, carried along in the story, to identify with the hero, to experience the story as being real, these and a dozen other phrases come to anyone's mind as part of our equipment for describing the experience of those narrative works that move us and seem to us to have "imitated life," which is what "mimesis" means. There is, if we think about it, quite a wide latitude in the possible ways of imitating life: a newspaper cartoon of a public figure "imitates life," and so does a Rembrandt portrait. But in either case, whether the imitation is crude or intricate, stylized or plausibly proportioned, we are persuaded by its force as an illusion. If we know the object of the political cartoonist's art, we say that the cartoon "looks just like" its object; and, even though we cannot know what the model of Rembrandt looked like, we infer, from the kind of painting it is, that painting and model looked alike. No one would wish to speak condescendingly of mimetic theory: some of the most admirable thinkers about art have held that the function of art is to imitate nature. And no one would wish to speak condescendingly of mimetic art: it is certainly possible to see it as the central tradition of Western art, or at least of Western literature, as Erich Auerbach does in his great *Mimesis*. Still, it is possible to break the illusion that we are experiencing an imitation of life with some remarkable effects. In certain productions of the plays of Brecht, for example, the action takes place not simply on a bare stage but a stage in which all of the

various curtains and dividers have been removed so that we see
the back of the theater building, the ropes and wiring and graf-
fiti on the rear wall of the stage. Brecht will not let us believe
that we are seeing "life." We are compelled to believe that we
are seeing a play. Or in the early productions of the plays of
Brendan Behan, Behan himself would often appear in the audi-
ence, criticizing the actors, shouting instructions to the director,
complimenting himself aloud for an especially effective passage.
We are no longer surprised when this sort of thing takes place
in dramatic art, when, in a movie, we see the director and cam-
eraman in the act of making the movie that we are seeing. In
every other art, including the novel, the illusion that we are
caught up in life as we experience the work has been broken
and manipulated in various ways. Painters have long since dis-
covered that it is possible to make a painting whose subject is
paint. And Gide's *The Counterfeiters*, written over forty-five
years ago, is a novel about the writing of a novel. But only in
recent years has short fiction contained the same possibilities, the
rendering of a reality "out there" in the world of observed ex-
perience deliberately broken by a reflexive commentary on the
work itself, fiction about fiction.

AGAINST "REALITY." What does a fairy tale do for us when we
are children? Sometimes it refracts the "real" world, giving us
an especially sharp angle of perception as we view, after having
heard the fairy story, our own world of experience once again.
Alice in Wonderland is perhaps the most powerful and sustained
example of this effect upon experience of a fantasy world: after
reading *Alice*, at any age, nothing ever looks quite the same
again. Is it possible, though, to take the premises of fantasy that
I have suggested one step farther? Something else that a fairy
tale might do for us when we are children is to substitute an-
other world for the one we have, the other world of the story
having nothing to do with our world of experience. No experi-
ence is refracted, nobody's view of the "real" world is heightened
and made more perceptive, by a reading of Edward Lear's *The
Pobble Who Has No Toes*. It is its own world. Unlike the world
of *Alice*, it does not touch our world at any point. We read it,
when children, for fun. And we read it, when adults, when the

real world has become a bore. But can these motives engage not only writers and readers of children's literature but also writers of the very first rank and readers of a mature and discriminating taste? They can and have, in fact, throughout the history of narrative literature. From the romances of the ancient Greeks to our own time, there is a consistent tradition of works of the first rank which project a world which never was and is not likely to be, including implausible people doing incredible things. It simply happens that the short story developed during a time when "realism" was valued in prose fiction. The realistic conventions have not bound all writers of short fiction. A number of classic American writers from Hawthorne to Henry James wrote fantasies of story length. But the fact remains that our expectation, in beginning to read a short fiction, is that it will seem to be bound by the probabilities which we assume to operate in the experiential world that we all know. It has, on the contrary, become the purpose of some of the most extraordinary writers of short fiction now at work to cut loose from the conventions of realism, to recapture, on their own terms, the narrative wonder of earlier romance, to make their own preposterous and often quite scary worlds, and to devise new uses for fantasy.

AGAINST EVENT. In *really* old-fashioned stories, as we all know, something happens. Sherlock Holmes finds the criminal. The nice boy overcomes obstacles and marries the nice girl. That sort of thing. In the classic modern story, what happens tends to be subjective and inward, often the epiphany that I have described. Even if what happens is subjective, however, we expect to find a character who does things, goes places, meets people. In the lowest keyed, most intensely psychological story, we are still likely to have events. How can we see and respond to a character except by seeing him *in action?* There is another possibility and it is terribly obvious once we see it done: we can see and respond to a character by hearing him talk. He doesn't have to do anything at all, just talk to us. In a sense, it is not a new possibility. Most conspicuously, Browning's dramatic monologues brought to a very high artistic point the poetic projection of a character talking, a credible kind of talk yet a talk so rich and dense that everything worth knowing about the character is im-

plied in what he says. A great deal of modern poetry is dramatic monologue, in the tradition of Browning; it exists for the sake of the voice it projects. It is an indictment of the self-imposed limitations of writers of short fiction that the monologue, with its rich possibilities for the projection of loves and hates, convictions and self-deceptions, wit and texture and implication, has not been exploited more than it has. But the monologue has been so little used that it is, for the writers of short fiction, an experimental form in our time. The potentialities of the tape recorder have complicated the experimental and problematic nature of the form. Is a transcription of a living person talking into a tape recorder a fiction? Does it make any difference whether the speaker is "making up stories" or telling what he believes to be facts? If the tape is edited by a skilled writer, is the transcription more or less a fiction? Does it matter if the speaker *is somebody*? Hard questions, but necessary ones.

AGAINST SUBJECT. We tend to dislike talking about "subject" in works of literature and devise ways of substituting other words for "subject," "theme," for example, or "controlling idea" or "paraphrasable core." Whatever words we use, however, it is traditional that, when we begin to talk and organize our thoughts about a literary work, we begin by looking for what the work is "about." There is nothing wrong with such a determination. *Paradise Lost* is a large and complicated work, but it is "about" the fall of the angels and the fall of man, or, shifting one's perspective somewhat, it is "about" freedom of choice in a universe containing infinite possibilities for good and evil. Nearly any classic story can be said, with a kind of simple accuracy, to be "about" some abstraction: the discovery of love, the loss of innocence, reconciliation to the fact of death, the renunciation of self-interest, the recognition of evil. There is, however, no intrinsic reason why a short fiction, or any other literary work, should be so constructed as to provide us an answer to our preliminary question of what its subject is. When a fiction is so organized, it implies that the writer knew, before he began to write, what the subject of his fiction would be and that he carefully aimed every effect at that subject, whether we think of subject as an idea, a large controlling image, or an emotional evocation. Many

writers, critics, and readers would say that there is no other way of writing. Either the writer is in control of his subject or he is not; and if he is not, the work is without question a failure. But let us consider the opposite case. Is it possible to have a fiction which is coherent on its own terms but so tentative and exploratory that its writer seems never entirely clear what its center is, not even at its end? Can we ever assume that a writer knows what he is doing but does not know what his subject is? The only honest way to answer the question is to read some works that are frankly exploratory and see if we can grant the writers the latitude they implicitly ask for, the latitude to be as indeterminate and tentative as they wish to be.

AGAINST THE MIDDLE RANGE OF EXPERIENCE. Among full length fictions, romance customarily deals with the extraordinary, the novel with the ordinary. There are plenty of short fictions that are small romances and deal with magic spells and superheroes. But there are not very many of these which we are likely to regard as art of the highest order. It is the stories which are little novels that make up the main tradition of short fiction, and, generally speaking, the highest examples of the art which is possible in the form. As I have described it previously, most of the development of the short story takes place during a time when realism is the dominant fictional mode. Even those small romances practiced by classic American writers, the stories of Poe, the symbolic fantasies of Hawthorne, the ghostly tales of James, project rather ordinary kinds of people into bizarre and occult situations. Ordinarily, characters in both novels and "little novels" are often odd, eccentric, and neurotic; they are not likely to be wild and driven people. What they do is dramatic—they go through spiritual and emotional crises, they love and die; they do not contract rare diseases, or climb Mt. Everest, or write immortal symphonies. There are good reasons that they don't. We wouldn't believe in them if they did these things. But the trouble is that there *are* extremities in experience which a little novel is ill-equipped to contain. (Certain Southern writers, beginning with Faulkner, are an exception to every generalization.) A writer concerned with the horrors and idiocies of our time may give up the possibilities of realism altogether, if he wishes, mak-

ing fantasies instead, allowing them to exert the oblique and mythic power on our ordinary lives that old romances do, and some of the writers in the collection, as I have indicated, do just that. Something else such writers may do, however, is to bring together, in a way which would have been very difficult in the classic story, something of the mad, brutal, vulgar extremity of contemporary experience *along with* elements of the middle range of experience, the droning banalities of our "dailiness." To allow the middle range of experience to co-exist, in a single work, with the extremities of contemporary experience is to do strange things to that ordinariness, to deny it its solidity. The phrase "experimental fiction" is always in danger of suggesting cuteness, facility, shallowness, a set of mannerisms worked up in the cause of modernity, the put-on. No doubt some fictional experiments are just that. In any case, no fictions are more likely to persuade the skeptical reader of the seriousness of their writers, I think, than those in which the middle range of experience is invested with extreme terror, extreme stupidity, and extreme brutality.

AGAINST ANALYSIS. Where the "new novel" in recent French literature came from and what it amounts to are larger questions than can even be introduced here. What it does can be seen, in small, in the three selections that evoke a phenomenal world. The phrase "new novel" suggests a consolidated movement and such writers as Robbe-Grillet and Nathalie Sarraute are sometimes written about as if their methods and ideas were interchangeable. They are, on the contrary, strikingly different from each other, as the selections indicate. What all of the practitioners of the "new novel" share, however, despite great individual differences, and what the three selections in the anthology, being small-scale exploitations of the possibilities of the "new novel," also share, is a determination to render the experiencing mind, free of the encumbrances of traditional fiction. What are these encumbrances that have to go? Character for one thing. An experiencing mind is not a character. A character is a construct, imagined and projected by an author, seen, to some extent, from the outside. If, in a fiction, we stay within a particular perceiving mind, then we are not really seeing a character at all. Plot, too, has to go. A perceiving mind does not shape life into a

story. To be true to one's phenomenological angle of vision, one must make the fiction as shapeless as the mind that perceives it. Above all, analysis has to go. All of the judgments by means of which the traditional author helps us to understand his characters, all of the discussions of "ideas" that bear upon the characters, all of the breaking down of motive and remote cause, these are the rather arrogant intrusions of the author's own ego upon his proper subject—the experiencing mind. For a reader, staying within that phenomenal world for the duration of a novel can be a difficult experience, exasperating, claustrophobic, certainly confusing, quite possibly boring. No one can complain, however, about the demands made on his attention by the short pieces included here. And no one is likely to come away from the three pieces feeling, as some have of the program of the "new novelists" in general, that they are sterile exercises in philosophical rigorism. Doing away with many of the fictional conventions we have all grown used to, the "new novelists" leave us with a phenomenal world broader than we might have expected, virtuose in its execution, and extraordinarily vital.

AGAINST MEANING. Fiction, clearly, "makes sense" only insofar as the world of experience makes sense in the mind of the writer. If, to him, the universe is absurd, without cause, direction, or coherence, then the only possible story is a kind of total antistory, whatever form that might take, that expresses without blinking a vision of that absurdity. That ought to settle the matter, if it were so simple as it seems. We would learn to read absurdist stories if we cared to. Or leave them alone if we found their premises too uncongenial. What makes the matter complicated is that different writers, like different people generally, feel absurdity with vastly differing scopes, in different ways, and the focus of one's response to absurdity need not be metaphysical. A television commercial, by means of an irrelevant drama, persuades us of the efficacy of a worthless product. A public official makes a statement, couched in banalities which he could not possibly use with sincerity, proposing ideas which no sane man believes, all with the hope of getting elected. Our days and nights are filled with absurdity of that kind, which depends, for our perception of its absurdity, on no particular conclusions about

the nature of the universe. At the same time, it is certainly true
that some kind of world view in which a concept of the absurd
is central has been held by a substantial number of writers of
the first rank in our time. To make a work of fiction which
bodies forth the absurd, whatever the absurd may mean in any
given instance, may oblige the writer to make a form and a
stylistic vehicle which are tough and hard, stoic and grim; or it
may compel a writer to make comedy, and some of the funniest
fiction of our time grows out of the metaphysical conviction that
nothing makes sense. No one can say, before the fact, what an
absurdist fiction ought to look like. The only obligation one can
be sure of is the obligation of the writer to experiment, since
the one thing a writer who confronts the absurd cannot rely
upon is traditional artistic conventions.

AGAINST SCALE. How long can a fiction be before it ceases to
be a story and becomes a novella or short novel? After perhaps
thirty pages we are likely to feel that a story is rather long for
a story, that complications of a different kind are being revealed
than we expect in a story, and we begin to think of the work
as a short novel. How *short* can a story be? Those stories in
magazines one can buy in the supermarket which say "Complete
on this page" are likely to strike discriminating readers as gim-
micky, tricksy pieces of commercial fluff whose shortness is pos-
sible only because of the slickness of their construction. How
short can a *serious* fiction be? As short as one likes? That's too
easy an answer. A fiction must be long enough to display the art
and craft of its writer, his own vision, his voice, his power. The
minimal story, in fact, is an experiment no less audacious than
the others. And it raises the strange question of shortness in fic-
tion, a question which we probably did not think about before,
cannot answer, and cannot ignore.

I began by being personal. Certain recent fiction amazes
and delights me, I suggested, in the way that certain recent
sculpture does. There is no sense being impersonal when making
an anthology of works published within the last twenty years,
many within the last five. There are not many other judgments
to rely upon besides one's own. I end by being personal once
again. Every fiction in the collection that follows is the result

of audacity and calculated risk-taking so striking that I have watched each one, as if watching a circus high-wire act, compelled into the kind of admiration I give to people who are both very skillful and very nervy. Many of the fictions seem to me terribly funny. I'm not sure how many of them are great and enduring fiction. Neither is anyone else. But all of the fictions that follow, taken together, have persuaded me that no art is more vital at the present time than experimental fiction.

 P. S.

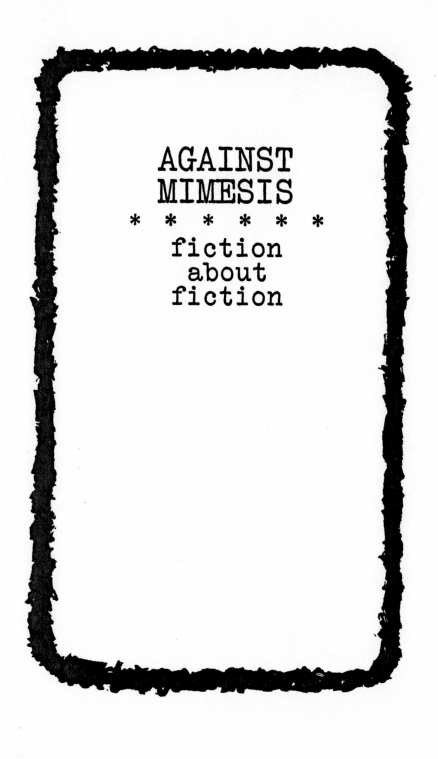

AGAINST MIMESIS

* * * * * *

fiction
about
fiction

life-story
John Barth

1

WITHOUT discarding what he'd already written he began his story afresh in a somewhat different manner. Whereas his earlier version had opened in a straight-forward documentary fashion and then degenerated or at least modulated intentionally into irrealism and dissonance he decided this time to tell his tale from start to finish in a conservative, "realistic," unself-conscious way. He being by vocation an author of novels and stories it was perhaps inevitable that one afternoon the possibility would occur to the writer of these lines that his own life might be a fiction, in which he was the leading or an accessory character. He happened at the time[1] to be in his study attempting to draft the opening pages of a new short story; its general idea had preoccupied him for some months along with other general ideas, but certain elements of the conceit, without which he could scarcely proceed, remained unclear. More specifically: narrative plots may be imagined as consisting of a "ground-situation" (Scheherazade desires not to die) focused and dramatized by a "vehicle-situation" (Scheherazade beguiles the King with endless stories), the several incidents of which have their final value in terms of their bearing upon the "ground-situation." In our author's case it was the "vehicle" that had vouchsafed itself, first as a germinal proposition in his commonplace book—D comes to suspect that the world is a novel, himself a fictional personage —subsequently as an articulated conceit explored over several pages of the workbook in which he elaborated more systematically his casual inspirations: since D is writing a fictional account of this conviction he has indisputably a fictional existence

From Lost in the Funhouse *by John Barth. Copyright © 1968 by John Barth. Reprinted by permission of Doubleday and Company, Inc.*
1. 9:00 A.M., Monday, June 20, 1966.

in his account, replicating what he suspects to be his own situation. Moreover E, hero of D's account, is said to be writing a similar account, and so the replication is in both ontological directions, et cetera. But the "ground-situation"—some state of affairs on D's part which would give dramatic resonance to his attempts to prove himself factual, assuming he made such attempts—obstinately withheld itself from his imagination. As is commonly the case the question reduced to one of stakes: what were to be the consequences of D's—and finally E's— disproving or verifying his suspicion, and why should a reader be interested?

What a dreary way to begin a story he said to himself upon reviewing his long introduction. Not only is there no "ground-situation," but the prose style is heavy and somewhat old-fashioned, like an English translation of Thomas Mann, and the so-called "vehicle" itself is at least questionable: self-conscious, vertiginously arch, fashionably solipsistic, unoriginal—in fact a convention of twentieth-century literature. Another story about a writer writing a story! Another regressus in infinitum! Who doesn't prefer art that at least overtly imitates something other than its own processes? That doesn't continually proclaim "Don't forget I'm an artifice!"? That takes for granted its mimetic nature instead of asserting it in order (not so slyly after all) to deny it, or vice-versa? Though his critics sympathetic and otherwise described his own work as avant-garde, in his heart of hearts he disliked literature of an experimental, self-despising, or overtly metaphysical character, like Samuel Beckett's, Marian Cutler's, Jorge Borges's. The logical fantasies of Lewis Carroll pleased him less than straight-forward tales of adventure, subtly sentimental romances, even densely circumstantial realisms like Tolstoy's. His favorite contemporary authors were John Updike, Georges Simenon, Nicole Riboud. He had no use for the theater of absurdity, for "black humor," for allegory in any form, for apocalyptic preachments meretriciously tricked out in dramatic garb.

Neither had his wife and adolescent daughters, who for that matter preferred life to literature and read fiction when at all for entertainment. Their kind of story (his too, finally) would

begin if not once upon a time at least with arresting circumstance, bold character, trenchant action. C flung away the whining manuscript and pushed impatiently through the french doors leading to the terrace from his oak-wainscoted study. Pausing at the stone balustrade to light his briar he remarked through a lavender cascade of wisteria that lithe-limbed Gloria, Gloria of timorous eye and militant breast, had once again chosen his boat-wharf as her basking-place.

By Jove he exclaimed to himself. It's particularly disquieting to suspect not only that one is a fictional character but that the fiction one's in—the fiction one is—is quite the sort one least prefers. His wife entered the study with coffee and an apple-pastry, set them at his elbow on his work table, returned to the living room. Ed' pelut' kondo nedode; nyoing nyang. One manifestation of schizophrenia as everyone knows is the movement from reality toward fantasy, a progress which not infrequently takes the form of distorted and fragmented representation, abstract formalism, an increasing preoccupation, even obsession, with pattern and design for their own sakes—especially patterns of a baroque, enormously detailed character—to the (virtual) exclusion of representative "content." There are other manifestations. Ironically, in the case of graphic and plastic artists for example the work produced in the advanced stages of their affliction may be more powerful and interesting than the realistic productions of their earlier "sanity." Whether the artists themselves are gratified by this possibility is not reported.

B called upon a literary acquaintance, B——, summering with Mrs. B and children on the Eastern Shore of Maryland. "You say you lack a ground-situation. Has it occurred to you that that circumstance may be your ground-situation? What occurs to me is that if it is it isn't. And conversely. The case being thus, what's really wanting after all is a well-articulated vehicle, a foreground or upstage situation to dramatize the narrator's or author's grundlage. His what. To write merely C comes to suspect that the world is a novel, himself a fictional personage is but to introduce the vehicle; the next step must be to initiate its uphill motion by establishing and complicating some conflict. I would advise in addition the eschewal of overt and self-conscious dis-

cussion of the narrative process. I would advise in addition the eschewal of overt and self-conscious discussion of the narrative process. The via negativa and its positive counterpart are it is to be remembered poles after all of the same cell. Returning to his study. If I'm going to be a fictional character G declared to himself I want to be in a rousing good yarn as they say, not some piece of avant-garde preciousness. I want passion and bravura action in my plot, heroes I can admire, heroines I can love, memorable speeches, colorful accessory characters, poetical language. It doesn't matter to me how naively linear the anecdote is; never mind modernity! How reactionary J appears to be. How will such nonsense sound thirty-six years from now?[2] As if. If he can only get K through his story I reflected grimly; if he can only retain his self-possession to the end of this sentence; not go mad; not destroy himself and/or others. Then what I wondered grimly. Another sentence fast, another story. Scheherazade my only love! All those nights you kept your secret from the King my rival, that after your defloration he was unnecessary, you'd have killed yourself in any case when your invention failed.

Why could he not begin his story afresh X wondered, for example with the words why could he not begin his story afresh et cetera? Y's wife came into the study as he was about to throw out the baby with the bathwater. "Not for an instant to throw out the baby while every instant discarding the bathwater is perhaps a chief task of civilized people at this hour of the world.[3] I used to tell B——— that without success. What makes you so sure it's not a film he's in or a theater-piece?

Because U responded while he certainly felt rather often that he was merely acting his own role or roles he had no idea who the actor was, whereas even the most Stanislavsky methodist would presumably if questioned closely recollect his offstage identity even onstage in mid-act. Moreover a great part of T's "drama," most of his life in fact, was non-visual, consisting entirely in introspection, which the visual dramatic media couldn't manage easily. He had for example mentioned to no one his

2. 10:00 A.M., Monday, June 20, 1966.
3. 11:00 A.M., Monday, June 20, 1966.

growing conviction that he was a fictional character, and since he was not given to audible soliloquizing a "spectator" would take him for a cheerful, conventional fellow, little suspecting that et cetera. It was of course imaginable that much goes on in the mind of King Oedipus in addition to his spoken sentiments; any number of interior dramas might be being played out in the actors' or characters' minds, dramas of which the audience is as unaware as are V's wife and friends of his growing conviction that he's a fictional character. But everything suggested that the medium of his life was prose fiction—moreover a fiction narrated from either the first-person or the third-person-omniscient point of view.

Why is it L wondered with mild disgust that both K and M for example choose to write such stuff when life is so sweet and painful and full of such a variety of people, places, situations, and activities other than self-conscious and after all rather blank introspection? Why is it N wondered et cetera that both M and O et cetera when the world is in such parlous explosive case? Why et cetera et cetera et cetera when the word, which was in the beginning, is now evidently nearing the end of its road? Am I being strung out in this ad libitum fashion I wondered merely to keep my author from the pistol? What sort of story is it whose drama lies always in the next frame out? If Sinbad sinks it's Scheherazade who drowns; whose neck one wonders is on her line?

2

Discarding what he'd already written as he could wish to discard the mumbling pages of his life he began his story afresh, resolved this time to eschew overt and self-conscious discussion of his narrative process and to recount instead in the straight-forwardest manner possible the several complications of his character's conviction that he was a character in a work of fiction, arranging them into dramatically ascending stages if he could for his readers' sake and leading them (the stages) to an exciting climax and dénouement if he could.

He rather suspected that the medium and genre in which he

worked—the only ones for which he felt any vocation—were moribund if not already dead. The idea pleased him. One of the successfullest men he knew was a blacksmith of the old school who et cetera. He meditated upon the grandest sailing-vessel ever built, the *France II*, constructed in Bordeaux in 1911 not only when but because the age of sail had passed. Other phenomena that consoled and inspired him were the great flying-boat *Hercules*, the zeppelin *Hindenburg*, the *Tsar Pushka* cannon, the then-record Dow-Jones industrial average of 381.17 attained on September 3, 1929.

He rather suspected that the society in which he persisted—the only one with which he felt any degree of identification—was moribund if not et cetera. He knew beyond any doubt that the body which he inhabited—the only one et cetera—was et cetera. The idea et cetera. He had for thirty-six years lacking a few hours been one of our dustmote's three billion tenants give or take five hundred million, and happening to be as well a white male citizen of the United States of America he had thirty-six years plus a few hours more to cope with one way or another unless the actuarial tables were mistaken, not bloody likely, or his term was unexpectedly reduced.

Had he written for his readers' sake? The phrase implied a thitherto-unappreciated metaphysical dimension. Suspense. If his life was a fictional narrative it consisted of three terms—teller, tale, told—each dependent on the other two but not in the same ways. His author could as well tell some other character's tale or some other tale of the same character as the one being told as he himself could in his own character as author; his "reader" could as easily read some other story, would be well advised to; but his own "life" depended absolutely on a particular author's original persistence, thereafter upon some reader's. From this consideration any number of things followed, some less tiresome than others. No use appealing to his author, of whom he'd come to dislike even to think. The idea of his playing with his characters' and his own self-consciousness! He himself tended in that direction and despised the tendency. The idea of his or her smiling smugly to himself as the "words" flowed from his "pen" in which his protagonist's unhappy inner life was exposed!

Ah he had mistaken the nature of his narrative; he had thought it very long, longer than Proust's, longer than any German's, longer than *The Thousand Nights and a Night* in ten quarto volumes. Moreover he'd thought it the most prolix and pedestrian *tranche-de-vie* realism, unredeemed by even the limited virtues of colorful squalor, solid specification, an engaging variety of scenes and characters—in a word a bore, of the sort he himself not only would not write but would not read either. Now he understood that his author might as probably resemble himself and the protagonist of his own story-in-progress. Like himself, like his character aforementioned, his author not impossibly deplored the obsolescence of humanism, the passing of *savoir-vivre*, et cetera; admired the outmoded values of fidelity, courage, tact, restraint, amiability, self-discipline, et cetera; preferred fictions in which were to be found stirring actions, characters to love as well as ditto to despise, speeches and deeds to affect us strongly, et cetera. He too might wish to make some final effort to put by his fictional character and achieve factuality or at least to figure in if not be hero of a more attractive fiction, but be caught like the writer of these lines in some more or less desperate tour de force. For him to attempt to come to an understanding with such an author were as futile as for one of his own creations to et cetera.

But the reader! Even if his author were his only reader as was he himself of his work-in-progress as of the sentence-in-progress and his protagonist of his, et cetera, his character as reader was not the same as his character as author, a fact which might be turned to account. What suspense.

As he prepared to explore this possibility one of his mistresses whereof he had none entered his brown study unannounced. "The passion of love," she announced, "which I regard as no less essential to a satisfying life than those values itemized above and which I infer from my presence here that you too esteem highly, does not in fact play in your life a role of sufficient importance to sustain my presence here. It plays in fact little role at all outside your imaginative and/or ary life. I tell you this not in a criticizing spirit, for I judge you to be as capable of the sentiment aforementioned as any other imagin[ative], deep-feeling man in

good physical health more or less precisely in the middle of the road of our life. What hampers, even cripples you in this regard is your final preference, which I refrain from analyzing, for the sedater, more responsible pleasures of monogamous fidelity and the serener affections of domesticity, notwithstanding the fact that your enjoyment of these is correspondingly inhibited though not altogether spoiled by an essentially romantical, unstable, irresponsible, death-wishing fancy. V. S. Pritchett, English critic and author, will put the matter succinctly in a soon-to-be-written essay on Flaubert, whose work he'll say depicts the course of ardent longings and violent desires that rise from the horrible, the sensual, and the sadistic. They turn into the virginal and mystical, only to become numb by satiety. At this point pathological boredom leads to a final desire for death and nothingness—the Romantic syndrome. If, not to be unfair, we qualify somewhat the terms horrible and sadistic and understand satiety to include a large measure of vicariousness, this description undeniably applies to one aspect of yourself and your work; and while your ditto has other, even contrary aspects, the net fact is that you have elected familial responsibilities and rewards—indeed, straight-laced middle-classness in general—over the higher expenses of spirit and wastes of shame attendant upon a less regular, more glamorous style of life. So to elect is surely admirable for the layman, even essential if the social fabric, without which there can be no culture, is to be preserved. For the artist, however, and in particular the writer, whose traditional material has been the passions of men and women, the choice is fatal. You having made it I bid you goodnight probably forever."

Even as she left he reached for the sleeping pills cached conveniently in his writing desk and was restrained from their administration only by his being in the process of completing a sentence, which he cravenly strung out at some sacrifice of rhetorical effect upon realizing that he was et cetera. Moreover he added hastily he had not described the intruder for his readers' vicarious satiety: a lovely woman she was, whom he did not after all describe for his readers' et cetera inasmuch as her appearance and character were inconstant. Her interruption of his work inspired a few sentences about the extent to which

his fiction inevitably made public his private life, though the trespasses in this particular were as nothing beside those of most of his profession. That is to say, while he did not draw his characters and situations directly from life nor permit his author-protagonist to do so, any moderately attentive reader of his oeuvre, his what, could infer for example that its author feared for example schizophrenia, impotence creative and sexual, suicide —in short living and dying. His fictions were preoccupied with these fears among their other, more serious preoccupations. Hot dog. As of the sentence-in-progress he was not in fact unmanageably schizophrenic, impotent in either respect, or dead by his own hand, but there was always the next sentence to worry about. But there was always the next sentence to worry about. In sum he concluded hastily such limited self-exposure did not constitute a misdemeanor, representing or mis as it did so small an aspect of his total self, negligible a portion of his total life— even which totalities were they made public would be found remarkable only for their being so unremarkable. Well shall he continue.

Bearing in mind that he had not developed what he'd mentioned earlier about turning to advantage his situation vis-à-vis his "reader" (in fact he deliberately now postponed his return to that subject, sensing that it might well constitute the climax of his story) he elaborated one or two ancillary questions, perfectly aware that he was trying, even exhausting, whatever patience might remain to whatever readers might remain to whoever elaborated yet another ancillary question. Was the novel of his life for example a *roman à clef.* ? Of that genre he was as contemptuous as of the others aforementioned; but while in the introductory adverbial clause it seemed obvious to him that he didn't "stand for" anyone else, any more than he was an actor playing the role of himself, by the time he reached the main clause he had to admit that the question was unanswerable, since the "real" man to whom he'd correspond in a *roman à clef* would not be also in the *roman à clef* and the characters in such works were not themselves aware of their irritating correspondences.

Similarly unanswerable were such questions as when "his" story (so he regarded it for convenience and consolement though

for all he knew he might be not the central character; it might
be his wife's story, one of his daughters's, his imaginary mistress's,
the man-who-once-cleaned-his-chimney's) began. Not impossibly
at his birth or even generations earlier: a *Bildungsroman*, an
Erziehungsroman, a *roman fleuve*. I More likely at the mo-
ment he became convinced of his fictional nature: that's where
he'd have begun it, as he'd begun the piece currently under his
pen. If so it followed that the years of his childhood and younger
manhood weren't "real," he'd suspected as much, in the first-order
sense, but a mere "background" consisting of a few well-placed
expository insinuations, perhaps misleading, or inferences, per-
haps unwarranted, from strategic hints in his present reflections.
God so to speak spare his readers from heavyfooted forced exposi-
tions of the sort that begin in the countryside near ____ in May
of the year ____ it occurred to the novelist ____ that his own
life might be a ____, in which he was the leading or an accessory
character. He happened at the time to be in the oak-wainscoted
study of the old family summer residence; through a lavender
cascade of hysteria he observed that his wife had once again
chosen to be the subject of this clause, itself the direct object of
his observation. A lovely woman she was, whom he did not de-
scribe in keeping with his policy against drawing characters from
life as who should draw a condemnee to the gallows. Begging his
pardon. Flinging his tiresome tale away he pushed impatiently
through the French windows leading from his study to a sheer
drop from the then-record high into a nearly fatal depression.

He clung onto his narrative depressed by the disproportion
of its ratiocination to its dramatization, reflection to action. One
had heard *Hamlet* criticized as a collection of soliloquies for
which the implausible plot was a mere excuse; witnessed Italian
operas whose dramatic portions were no more than interstitial re-
lief and arbitrary continuity between the arias. If it was true
that he didn't take his "real" life seriously enough even when it
had him by the throat, the fact didn't lead him to consider
whether the fact was a cause or a consequence of his tale's tedium
or both.

Concluding these reflections he concluded these reflections:
that there was at this advancèd page still apparently no ground-

situation suggested that his story was dramatically meaningless. If one regarded the absence of a ground-situation, more accurately the protagonist's anguish at that absence and his vain endeavors to supply the defect, as itself a sort of ground-situation, did his life-story thereby take on a kind of meaning? A "dramatic" sort he supposed, though of so sophistical a character as more likely to annoy than to engage.

<div align="center">3</div>

The reader! You, dogged, uninsultable, print-oriented bastard, it's you I'm addressing, who else, from inside this monstrous fiction. You've read me this far, then? Even this far? For what discreditable motive? How is it you don't go to a movie, watch TV, stare at a wall, play tennis with a friend, make amorous advances to the person who comes to your mind when I speak of amorous advances? Can nothing surfeit, saturate you, turn you off? Where's your shame?

Having let go this barrage of rhetorical or at least unanswered questions and observing himself nevertheless in midst of yet another sentence he concluded and caused the "hero" of his story to conclude that one or more of three things must be true: 1) his author was his sole and indefatigable reader; 2) he was in a sense his own author, telling his story to himself, in which case in which case; and/or 3) his reader was not only tireless and shameless but sadistic, masochistic if he was himself.

For why do you suppose—you! you!—he's gone on so, so relentlessly refusing to entertain you as he might have at a less desperate than this hour of the world[4] with felicitous language, exciting situation, unforgettable character and image? Why has he as it were ruthlessly set about not to win you over but to turn you away? Because your own author bless and damn you his life is in your hands! He writes and reads himself; don't you think he knows who gives his creatures their lives and deaths? Do they exist except as he or others read their words? Age except we turn their pages? And can he die until you have no

4. 11:00 P.M., Monday, June 20, 1966.

more of him? Time was obviously when his author could have turned the trick; his pen had once to left-to-right it through these words as does your kindless eye and might have ceased at any one. This. This. And did not as you see but went on like an Oriental torturemaster to the end.

But you needn't! He exclaimed to you. In vain. Had he petitioned you instead to read slowly in the happy parts, what happy parts, swiftly in the painful no doubt you'd have done the contrary or cut him off entirely. But as he longs to die and can't without your help you force him on, force him on. Will you deny you've read this sentence? This? To get away with murder doesn't appeal to you, is that it? As if your hands weren't inky with other dyings! As if he'd know you'd killed him! Come on. He dares you.

In vain. You haven't: the burden of his knowledge. That he continues means that he continues, a fortiori you too. Suicide's impossible: he can't kill himself without your help. Those petitions aforementioned, even his silly plea for death—don't you think he understands their sophistry, having authored their like for the wretches he's authored? Read him fast or slow, intermittently, continuously, repeatedly, backward, not at all, he won't know it; he only guesses someone's reading or composing his sentences, such as this one, because he's reading or composing sentences such as this one; the net effect is that there's a net effect, of continuity and an apparently consistent flow of time, though his pages do seem to pass more swiftly as they near his end.

To what conclusion will he come? He'd been about to append to his own tale inasmuch as the old analogy between Author and God, novel and world, can no longer be employed unless deliberately as a false analogy, certain things follow: 1) fiction must acknowledge its fictitiousness and metaphoric invalidity or 2) choose to ignore the question or deny its relevance or 3) establish some other, acceptable relation between itself, its author, its reader. Just as he finished doing so however his real wife and imaginary mistresses entered his study; "It's a little past midnight" she announced with a smile; "do you know what that means?"

Though she'd come into his story unannounced at a critical moment he did not describe her, for even as he recollected that he'd seen his first light just thirty-six years before the night incumbent he saw his last: that he could not after all be a character in a work of fiction inasmuch as such a fiction would be of an entirely different character from what he thought of as fiction. Fiction consisted of such monuments of the imagination as Cutler's *Morganfield*, Riboud's *Tales Within Tales*, his own creations; fact of such as for example read those fictions. More, he could demonstrate by syllogism that the story of his life was a work of fact: though assaults upon the boundary between life and art, reality and dream, were undeniably a staple of his own and his century's literature as they'd been of Shakespeare's and Cervantes's, yet it was a fact that in the corpus of fiction as far as he knew no fictional character had become convinced as had he that he was a character in a work of fiction. This being the case and he having in fact become thus convinced it followed that his conviction was false. "Happy birthday," said his wife et cetera, kissing him et cetera to obstruct his view of the end of the sentence he was nearing the end of, playfully refusing to be nay-said so that in fact he did at last as did his fictional character end his ending story endless by interruption cap his pen.

the seventh
trunk
Heinrich Böll

FOR THIRTY-TWO YEARS I have been trying to finish writing a story, the beginning of which I read in the *Bockelmunden*

From 18 Stories by Heinrich Böll. Translated from the German by Leila Vennewitz. Copyright © 1966 by Heinrich Böll. Used with permission of McGraw-Hill Book Company.

Parish News but the promised continuation of which I never got
to see, since, for unknown reasons (probably political—it was in
1933) this modest publication ceased to appear. The name of the
author of this story is engraved on my memory: he was called
Jacob Maria Hermes, and for thirty-two years I have tried in vain
to find other writings by him; no encyclopedia, no authors' society
index, not even the Bockelmunden parish register, still extant,
lists his name, and it looks as though I must finally accept the
fact that the name of Jacob Maria Hermes was a pseudonym.
The last editor of the *Bockelmunden Parish News* was Vice-Prin-
cipal Ferdinand Schmitz (retired), but by the time I had finally
tracked him down I was unduly delayed by prewar, wartime,
and postwar events, and when at last in 1947 I trod my native
soil again, I found that Ferdinand Schmitz had just died at the
age of eighty-eight.

I freely admit that I invited myself to his funeral, not only
to do final honor to a man under whose editorship at least half
of *the* most masterly short story I had ever read had been
published; and not only because I hoped to find out more about
Jacob Maria Hermes from his relatives—but also because in
1947 attendance at a country funeral meant the promise of a
decent meal. Bockelmunden is a pretty village: old trees, shady
slopes, half-timbered farmhouses. On this summer's day, tables
had been set up in the yard of one of the farms, there was home-
slaughtered meat from the Schmitz family storerooms, there was
beer, cabbage, fruit, later on cakes and coffee—all served by two
pretty waitresses from Nellessen's inn; the church choir sang the
hymn that is *de rigueur* on the occasion of schoolteachers' fu-
nerals, "With wisdom and honor hast thou mastered the school."
Trumpets sounded, club banners were unfurled (illegally, for
this was still prohibited at that time); when the jokes grew
broader, the atmosphere—as it is so nicely put—became more
relaxed, I sat down beside each person there and asked them all
in turn if they knew anything about the editorial estate of the
deceased. The answers were unanimous and shattering: in five,
six, or seven cartons (the information varied only as to quantity),
the entire archives, the entire correspondence of the *Bockelmun-*

den Parish News had been burned during the final days of the war "as a result of enemy action."

Having eaten my fill and drunk a little too much, yet without obtaining any precise information on Jacob Maria Hermes, I returned home with that sense of disappointment familiar to anyone who has ever tried to catch two butterflies with one net but has only managed to catch the vastly inferior butterfly while the other, the gorgeous shimmering one, flew away.

Nothing daunted, I tried for the next eighteen years to do what I had been trying to do for the previous fourteen years: finish writing the best short story I had ever read—and all attempts were in vain for the simple reason: I couldn't get the seventh trunk open!

I regret having to expatiate a little here; not thirty-two but thirty-five years ago I fished out of the bargain barrel in a secondhand bookstore in the Old Town of Cologne a pamphlet entitled "The Secret of the Seventh Trunk, or, How to Write Short Prose." This remarkable publication consisted of only a few pages; the author was called Heinrich Knecht and described himself as "temporarily conscripted into service with the Deutz Cuirassiers." The pamphlet had been published in 1913 by "Ulrich Nellessen, Publisher and Printer, corner of Teutoburg and Maternus Street." Underneath, in small print, was the remark: "The author may also be reached at this address in his (very limited) free time."

I could, of course, hardly suppose that in 1939 anyone would still be serving in the Cuirassiers as he had been in 1913, for, although I did not (and still do not) know what a Cuirassier is, I did know that that part of the Republic in which I was living had been spared the presence of the Army (not forever, unfortunately, as it turned out five years later for the first time, and twenty-five years later for the second)—but there was a slight chance that the printer and publisher were still to be found at this corner, and somehow I am quite touched at the thought of that thirteen-year-old boy immediately mounting his bicycle and racing from a westerly part of the city to that southerly one to discover that the two streets do not form a corner at all. To this

day I admire the persistence with which I rode from the northern
entrance of Römer Park, where at that time the built-up right-
hand side of Maternus Street came to an end, to the Teutoburg
Street, which had (and still has) the impudence to end shortly
before the western entrance to Römer Park—from there to the
office of the Tourist Association where with a pencil I furtively
extended the right side of Maternus Street and the left side of
Teutoburg Street on the city map hanging there, to discover that,
if these two streets formed a corner, they would do so in the
middle of the Rhine. So Heinrich Knecht, the old so-and-so, pro-
vided he was halfway honest, must have lived roughly fifty yards
north of Marker 686 in a caisson at the bottom of the Rhine and
have swum every morning a mile and a half down-river to report
for duty at his Cuirassier's barracks. *Today* I am no longer so
certain that he really did not live there, perhaps still does: a
deserter from the Cuirassiers, the color of the river, with a green
beard, consoled by naiads—little knowing that for deserters times
are still bad. *At the time* I was simply so shattered by all this
hocus-pocus that I bought the first three cigarettes in my life
with my last nickel; I enjoyed the first cigarette, and since then
I have been a fairly heavy smoker. Needless to say, there was no
trace either of the Nellessen printing shop. I did not even at-
tempt to find Knecht—perhaps I ought to have got hold of a
boat, dived in fifty yards north of Marker 686, and taken hold of
Heinrich Knecht by his green beard. The thought never occurred
to me at the time—*today* it is too late: I have smoked too many
cigarettes since then to risk a dive, and Knecht is to blame for
that.

I need hardly mention that I soon knew Knecht's treatise by
heart; I carried it with me, on my person, in war and peace;
during the war I lost it, it was in a haversack that also contained
(I beg forgiveness of all militant atheists!) a New Testament, a
volume of poems by Trakl, the half-story by Hermes, four blank
furlough certificates, two spare paybooks, a company stamp, some
bread, some *ersatz* spread, a package of fine-cut, and some
cigarette paper. Cause of loss: enemy action.

Today, enriched, saturated almost, by literary insight and
hindsight, and a little more perspicacious too, I have, of course,

no difficulty in realizing that Knecht and Hermes must have known about each other, that both names were perhaps pseudonyms for Ferdinand Schmitz—that the name Nellessen linking the two should have put me on the track. These are unpleasant, embarrassing assumptions, terrible consequences of an education that was forced upon me, betrayal of that earnest, flushed boy riding his bicycle right across Cologne that summer's day to find a street corner that did not exist. It was not until much later, actually only now that I am writing it down, that I realized that names, all names, are but sounding brass: Knecht, Hermes, Nellessen, Schmitz—and the only thing that matters is: someone actually wrote this half of a short story, actually wrote "The Seventh Trunk," so when I am asked to acknowledge who encouraged me to write, who influenced me, here are the names: Jacob Maria Hermes and Heinrich Knecht. Unfortunately I cannot reproduce the Hermes short story word for word, so I will merely relate what happened in it. The central character was a nine-year-old girl who, in a school playground surrounded by maple trees, was persuaded, duped, perhaps even forced, by a nun who in a nice way was not quite right in the head to join a brotherhood whose members undertook to attend Holy Mass on Sundays, "reverently," not once but twice. There was only one weak sentence in the story, and I can recall it—the weaknesses of one's fellow writers are always what one remembers best—word for word. The sentence goes: "Sister Adelheid suddenly became aware of her senselessness." First of all I am firmly convinced that there was a typographical error here, that instead of senselessness it should have been sensualness (in my own case it has happened three times that printers, typesetters, and proofreaders have made senselessness out of sensualness); secondly: an outright psychological statement of this kind was utterly out of keeping with Hermes' prose style, which was as dry as immortelles. In the preceding sentence a spot of cocoa on the little girl's blue blouse had been mentioned. He must have meant sensualness. I swear with even greater emphasis: a man of the stature of a Jacob Maria Hermes does not regard nuns as senseless, and nuns who become aware of their senselessness simply do not belong in his repertoire, especially as three para-

graphs further on, in a prose as arid as the steppes, he let the little girl become fourteen years old without having her suffer complexes, conflicts, or convulsions, although usually she went only once to church, on many Sundays not at all, and only on a single occasion twice. Nowadays one does not have to even get wind of ecclesiastical wrath, one has only to be an ardent TV-viewer, to know that both terms, senselessness and sensualness, as applied to a nun, will find their way directly into the Church Council chamber and out again. For some Council fathers would immediately attack the term senselessness as applied by a nun in an internal monologue to her own existence; others would defend it; and needless to say it would not be the attackers but the defenders who would cause an author considerable trouble, for he would have to point to a printer's error, send them a notarized copy of his manuscript, and still they would interpret his allusion to a typographical error as cowardice and maintain that he was "attacking progress from the rear."

It stands to reason that it was not Hermes' intention to attack anything or anyone from the rear, or to turn his back on anyone or anything. I am so indebted to him that, in his place, I bare my breast to reactionaries and avant-gardists alike, because I know very well: a short story which speaks of a brotherhood whose members undertake to attend Mass not once but twice on Sundays—prose of this kind is highly suspect to both parties.

For thirty-two years now I have been carrying the end of this story around with me, and what rejoices me as a contemporary but inhibits me as an author is the fact that I know (no: I sense) that this woman is still alive, and perhaps this is why the seventh trunk will not spring open.

This is precisely the place where I must finally explain about Knecht's seventh trunk. Before doing so I must quickly, in a few sentences, deal with the numerous works of which none ranks equally with Knecht's but of which many are worthy of considerable note. It seems to me there are so many handbooks on how to write a short story that I am often surprised that not more good ones are written. For instance: the directions given in every creative writing course, teaching every beginner, clearly and to the point, with a minimum of fuss, how to make a story

so attractive and so convenient that it poses not the slightest dif-
ficulty for the Sunday supplement copy editor—i.e., has a maxi-
mum length of one hundred column-length lines, in other words
roughly the size (comparatively speaking, of course) of the
smallest transistor in the world. And there are many more direc-
tions than those I have mentioned: one has only to read them
and then just simply (these four expansion words contain the
entire secret of short-story writing), and then just simply write
it down, except—except that Knecht's very last injunction states:
"And from the final trunk, the seventh one, the finished short
prose, lively as a mouse, must jump out the moment the trunk
springs open." This last sentence has always reminded me of a
superstition that one of my great-grandmothers—she must have
been called Nellessen, which would make her the third in the
conspiracy—used to tell us about. All one had to do, according
to my great-grandmother, was take a few stale crusts of bread,
and some rags, and tie them securely inside a cardboard or
wooden box, open the box after at most six weeks, and live mice
would come jumping out.

The moral of this would therefore be quite simple: one need
only know Heinrich Knecht, read *half* a story by Jacob Maria
Hermes, and have had a superstitious great-grandmother, and
all one would have to do would be *to just simply* write down
one's first short story. Of course one needs some *subject matter*,
only a little really: a nine-year-old girl with cocoa spots on her
blue blouse, a few nuns, who in a nice way are not quite right
in the head, a school playground, a few maple trees, and seven
trunks. Before any youthful readers bent on writing short stories
go dashing off to acquire some trunks, I must quickly explain
that the term "trunk" is of course variable: the seventh "trunk"
can be one of those exquisitely designed little cases in which one
keeps electric razors, it can be a carton for fifty cigarettes, an
empty make-up kit might do too; what is important is what
Knecht regards as indispensable: the "trunks" must get smaller
and smaller; the first one sometimes has to be enormous. Where,
for example, is an author in the first stage, the "preparation of
subject matter," as Knecht calls it, to put a railway station, or
a school, a bridge over the Rhine, or a whole block of tene-

ments? He has to rent an abandoned factory site until—and it may take years—he needs only the color of the bridge, only the smell of the school, and these he must put into the second trunk, although in this second trunk a horse, a truck, a barracks, and an abbey may be waiting, of which, as soon as it is the third trunk's turn, he will keep only a hair, a squeak, the echo of a command, and a response, while in the third trunk an old blanket, cigarette butts, empty bottles, and a few pawn tickets are waiting. Pawn tickets were evidently Knecht's favorite documents, for I recall a sentence of his: "Why, O Scribe, carry large objects around with you, when there are institutions which not only relieve you of having to store these objects but even give you money for them, money that you do not need to pay back if, after the due date, you are no longer interested in the object? Make use, therefore, of the institutions which help you to lighten your baggage." It does not take long to tell all the rest, for al' the rest consists of: and so on. Needless to say—I am most anxious to avoid any misunderstanding—needless to say, the fifth or sixth trunk can be some little container the size of a matchbox, and the seventh can be an old biscuit tin; all that matters is that the seventh trunk must be closed, if only by a plain rubber band, and it must spring open by itself. Only one question remains unresolved, and it will probably cause youthful readers some anxiety: what does one do with living people where they are needed for short prose? One can neither—and possibly for twenty years, for it can take a good short story that long to wait for its awakening in the seventh trunk—so, one cannot shut living people up for that long, nor can one leave them at the pawnbroker's; what is one to do with them? Answer: they are not needed: one can pull out a hair, secretly remove a shoelace from a shoe, or brush a lipstick across a piece of cigarette paper; that is enough, for—here I must earnestly remind readers of my great-grandmother Nellessen: the point is not to put life into the case or box, the point is that life has to be created in it and jump out of its own accord. And so on—*and then just simply write* the whole thing *down.*

how I contemplated the world from the Detroit House of Correction and began my life over again

Joyce Carol Oates

NOTES for an essay for an English class at Baldwin Country Day School; poking around in debris; disgust and curiosity; a revelation of the meaning of life; a happy ending. . . .

I. Events

1. The girl (myself) is walking through Branden's, that excellent store. Suburb of a large famous city that is a symbol for large famous American cities. The event sneaks up on the girl, who believes she is herding it along with a small fixed smile, a girl of fifteen, innocently experienced. She dawdles in a certain style by a counter of costume jewelry. Rings, earrings, necklaces. Prices from $5 to $50, all within reach. All ugly. She eases over to the glove counter, where everything is ugly too. In her close-fitted coat with its black fur collar she contemplates the luxury of Branden's, which she has known for many years: its many

mild pale lights, easy on the eye and the soul, its elaborate tinkly decorations, its women shoppers with their excellent shoes and coats and hairdos, all dawdling gracefully, in no hurry.

Who was ever in a hurry here?

2. The girl seated at home. A small library, paneled walls of oak. Someone is talking to me. An earnest husky female voice drives itself against my ears, nervous, frightened, groping around my heart, saying, "If you wanted gloves why didn't you say so? Why didn't you ask for them?" That store, Branden's, is owned by Raymond Forrest who lives on DuMaurier Drive. We live on Sioux Drive. Raymond Forrest. A handsome man? An ugly man? A man of fifty or sixty, with gray hair, or a man of forty with earnest courteous eyes, a good golf game, who is Raymond Forrest, this man who is my salvation? Father has been talking to him. Father is not his physician; Dr. Berg is his physician. Father and Dr. Berg refer patients to each other. There is a connection. Mother plays bridge with. . . . On Mondays and Wednesdays our maid Billie works at. . . . The strings draw together in a cat's cradle, making a net to save you when you fall. . . .

3. *Harriet Arnold's*. A small shop, better than Branden's. Mother in her black coat, I in my close-fitted blue coat. Shopping. Now look at this, isn't this cute, do you want this, why don't you want this, try this on, take this with you to the fitting room, take this also, what's wrong with you, what can I do for you, why are you so strange . . . ? "I wanted to steal but not to buy," I don't tell her. The girl droops along in her coat and gloves and leather boots, her eyes scan the horizon which is pastel pink and decorated like Branden's, tasteful walls and modern ceilings with graceful glimmering lights.

4. Weeks later, the girl at a bus-stop. Two o'clock in the afternoon, a Tuesday, obviously she has walked out of school.

5. The girl stepping down from a bus. Afternoon, weather changing to colder. Detroit. Pavement and closed-up stores;

grillwork over the windows of a pawnshop. What is a pawnshop, exactly?

II. Characters

1. The girl stands five feet five inches tall. An ordinary height. Baldwin Country Day School draws them up to that height. She dreams along the corridors and presses her face against the Thermoplex Glass. No frost or steam can ever form on that glass. A smudge of grease from her forehead . . . could she be boiled down to grease? She wears her hair loose and long and straight in suburban teenage style, 1968. Eyes smudged with pencil, dark brown. Brown hair. Vague green eyes. A pretty girl? An ugly girl? She sings to herself under her breath, idling in the corridor, thinking of her many secrets (the thirty dollars she once took from the purse of a friend's mother, just for fun, the basement window she smashed in her own house just for fun) and thinking of her brother who is at Susquehanna Boys' Academy, an excellent preparatory school in Maine, remembering him unclearly . . . he has long manic hair and a squeaking voice and he looks like one of the popular teenage singers of 1968, one of those in a group, *The Certain Forces, The Way Out, The Maniacs Responsible*. The girl in her turn looks like one of those fieldsful of girls who listen to the boys' singing, dreaming and mooning restlessly, breaking into high sullen laughter, innocently experienced.

2. The mother. A midwestern woman of Detroit and suburbs. Belongs to the Detroit Athletic Club. Also the Detroit Golf Club. Also the Bloomfield Hills Country Club. The Village Women's Club at which lectures are given each winter on Genet and Sartre and James Baldwin, by the Director of the Adult Education Program at Wayne State University. . . . The Bloomfield Art Association. Also the Founders Society of the Detroit Institute of Arts. Also. . . . Oh, she is in perpetual motion, this lady, hair like blown-up gold and finer than gold, hair and fingers and body of inestimable grace. Heavy weighs the gold on the back of her

hairbrush and hand mirror. Heavy heavy the candlesticks in the dining room. Very heavy is the big car, a Lincoln, long and black, that on one cool autumn day split a squirrel's body in two unequal parts.

3. The father. Dr. —————. He belongs to the same clubs as #2. A player of squash and golf; he has a golfer's umbrella of stripes. Candy stripes. In his mouth nothing turns to sugar, however, saliva works no miracles here. His doctoring is of the slightly sick. The sick are sent elsewhere (to Dr. Berg?), the deathly sick are sent back for more tests and their bills are sent to their homes, the unsick are sent to Dr. Coronet (Isabel, a lady), an excellent psychiatrist for unsick people who angrily believe they are sick and want to do something about it. If they demand a male psychiatrist, the unsick are sent by Dr. ————— ————— (my father) to Dr. Lowenstein, a male psychiatrist, excellent and expensive, with a limited practice.

4. Clarita. She is twenty, twenty-five, she is thirty or more? Pretty, ugly, what? She is a woman lounging by the side of a road, in jeans and a sweater, hitch-hiking, or she is slouched on a stool at a counter in some roadside diner. A hard line of jaw. Curious eyes. Amused eyes. Behind her eyes processions move, funeral pageants, cartoons. She says, "I never can figure out why girls like you bum around down here. What are you looking for anyway?" An odor of tobacco about her. Unwashed underclothes, or no underclothes, unwashed skin, gritty toes, hair long and falling into strands, not recently washed.

5. Simon. In this city the weather changes abruptly, so Simon's weather changes abruptly. He sleeps through the afternoon. He sleeps through the morning. Rising he gropes around for something to get him going, for a cigarette or a pill to drive him out to the street, where the temperature is hovering around 35°. Why doesn't it drop? Why, why doesn't the cold clean air come down from Canada, will he have to go up into Canada to get it, will he have to leave the Country of his Birth and sink into Canada's frosty fields . . .? Will the F.B.I. (which he

dreams about constantly) chase him over the Canadian border
on foot, hounded out in a blizzard of broken glass and horns
. . .?

"Once I was Huckleberry Finn," Simon says, "but now I am
Roderick Usher." Beset by frenzies and fears, this man who
makes my spine go cold, he takes green pills, yellow pills, pills
of white and capsules of dark blue and green . . . he takes other
things I may not mention, for what if Simon seeks me out and
climbs into my girl's bedroom here in Bloomfield Hills and stran-
gles me, what then . . .? (As I write this I begin to shiver. Why
do I shiver? I am now sixteen and sixteen is not an age for
shivering.) It comes from Simon, who is always cold.

III. World Events

Nothing.

IV. People & Circumstances Contributing
to this Delinquency

Nothing.

V. Sioux Drive

George, Clyde G. 240 Sioux. A manufacturer's representative;
children, a dog; a wife. Georgian with the usual columns. You
think of the White House, then of Thomas Jefferson, then your
mind goes blank on the white pillars and you think of nothing.
Norris, Ralph W. 246 Sioux. Public relations. Colonial. Bay win-
dow, brick, stone, concrete, wood, green shutters, sidewalk, lan-
tern, grass, trees, black-top drive, two children, one of them my
classmate Esther (Esther Norris) at Baldwin. Wife, cars. Ramsey,
Michael D. 250 Sioux. Colonial. Big living room, thirty by twenty-
five, fireplaces in living room library recreation room, paneled
walls wet bar five bathrooms five bedrooms two lavatories central
air conditioning automatic sprinkler automatic garage door three
children one wife two cars a breakfast room a patio a large

fenced lot fourteen trees a front door with a brass knocker never knocked. Next is our house. Classic contemporary. Traditional modern. Attached garage, attached Florida room, attached patio, attached pool and cabana, attached roof. A front door mailslot through which pour *Time Magazine, Fortune, Life, Business Week, The Wall Street Journal, The New York Times, The New Yorker, The Saturday Review, M.D., Modern Medicine, Disease of the Month* . . . and also. . . . And in addition to all this a quiet sealed letter from Baldwin saying: *Your daughter is not doing work compatible with her performance on the Stanford-Binet.* . . . And your son is not doing well, not well at all, very sad. Where is your son anyway? Once he stole trick-and-treat candy from some six-year-old kids, he himself being a robust ten. The beginning. Now your daughter steals. In the Village Pharmacy she made off with, yes she did, don't deny it, she made off with a copy of *Pageant Magazine* for no reason, she swiped a roll of lifesavers in a green wrapper and was in no need of saving her life or even in need of sucking candy, when she was no more than eight years old she stole, don't blush, she stole a package of *Tums* only because it was out on the counter and available, and the nice lady behind the counter (now dead) said nothing. . . . Sioux Drive. Maples, oaks, elms. Diseased elms cut down. Sioux Drive runs into Roosevelt Drive. Slow turning lanes, not streets, all drives and lanes and ways and passes. A private police force. Quiet private police, in unmarked cars. Cruising on Saturday evenings with paternal smiles for the residents who are streaming in and out of houses, going to and from parties, a thousand parties, slightly staggering, the women in their furs alighting from automobiles bought of Ford and General Motors and Chrysler, very heavy automobiles. No foreign cars. Detroit. In 275 Sioux, down the block, in that magnificent French Normandy mansion, lives ————— ————— himself, who has the C————— account itself, imagine that! Look at where he lives and look at the enormous trees and chimneys, imagine his many fireplaces, imagine his wife and children, imagine his wife's hair, imagine her fingernails, imagine her bathtub of smooth clean glowing pink, imagine their embraces, his trouser pockets filled with odd coins and keys and dust and peanuts, imagine their

ecstasy on Sioux Drive, imagine their income tax returns, imagine their little boy's pride in his experimental car, a scaled-down C——————, as he roars around the neighborhood on the sidewalks frightening dogs and Negro maids, oh imagine all these things, imagine everything, let your mind roar out all over Sioux Drive and DuMaurier Drive and Roosevelt Drive and Ticonderoga Pass and Burning Bush Way and Lincolnshire Pass and Lois Lane.

When spring comes its winds blow nothing to Sioux Drive, no odors of hollyhocks or forsythia, nothing Sioux Drive doesn't already possess, everything is planted and performing. The weather vanes, had they weather vanes, don't have to turn with the wind, don't have to contend with the weather. There is no weather.

VI. Detroit

There is always weather in Detroit. Detroit's temperature is always 32°. Fast falling temperatures. Slow rising temperatures. Wind from the north northeast four to forty miles an hour, small craft warnings, partly cloudy today and Wednesday changing to partly sunny through Thursday . . . small warnings of frost, soot warnings, traffic warnings, hazardous lake conditions for small craft and swimmers, restless Negro gangs, restless cloud formations, restless temperatures aching to fall out the very bottom of the thermometer or shoot up over the top and boil everything over in red mercury.

Detroit's temperature is 32°. Fast falling temperatures. Slow rising temperatures. Wind from the north northeast four to forty miles an hour. . . .

VII. Events

1. The girl's heart is pounding. In her pocket is a pair of gloves! In a plastic bag! Airproof breathproof plastic bag, gloves selling for twenty-five dollars on Branden's counter! In her pocket! Shoplifted! . . . In her purse is a blue comb, not very clean. In her purse is a leather billfold (a birthday present from

her grandmother in Philadelphia) with snapshots of the family
in clean plastic windows, in the billfold are bills, she doesn't
know how many bills. . . . In her purse is an ominous note from
her friend Tykie *What's this about Joe H. and the kids hanging
around at Louise's Sat. night? You heard anything?* . . . passed
in French class. In her purse is a lot of dirty yellow Kleenex, her
mother's heart would break to see such very dirty Kleenex, and
at the bottom of her purse are brown hairpins and safety pins
and a broken pencil and a ballpoint pen (blue) stolen from
somewhere forgotten and a purse-size compact of Cover Girl
Make-Up, Ivory Rose. . . . Her lipstick is Broken Heart, a cor-
rupt pink; her fingers are trembling like crazy; her teeth are be-
ginning to chatter; her insides are alive; her eyes glow in her
head; she is saying to her mother's astonished face *I want to
steal but not to buy.*

2. At Clarita's. Day or night? What room is this? A bed, a
regular bed, and a mattress on the floor nearby. Wallpaper hang-
ing in strips. Clarita says she tore it like that with her teeth. She
was fighting a barbaric tribe that night, high from some pills she
was battling for her life with men wearing helmets of heavy iron
and their faces no more than Christian crosses to breathe
through, every one of those bastards looking like her lover Simon,
who seems to breathe with great difficulty through the slits of
mouth and nostrils in his face. Clarita has never heard of Sioux
Drive. Raymond Forrest cuts no ice with her, nor does the
C——————— account and its millions; Harvard Business School
could be at the corner of Vernor and 12th Street for all she cares,
and Vietnam might have sunk by now into the Dead Sea under
its tons of debris, for all the amazement she could show . . . her
face is overworked, overwrought, at the age of twenty (thirty?)
it is already exhausted but fanciful and ready for a laugh. Clar-
ita says mournfully to me *Honey somebody is going to turn you
out let me give you warning.* In a movie shown on late television
Clarita is not a mess like this but a nurse, with short neat hair
and a dedicated look, in love with her doctor and her doctor's
patients and their diseases, enamored of needles and sponges and
rubbing alcohol. . . . Or no: she is a private secretary. Robert

Cummings is her boss. She helps him with fantastic plots, the canned audience laughs, no, the audience doesn't laugh because nothing is funny, instead her boss is Robert Taylor and they are not boss and secretary but husband and wife, she is threatened by a young starlet, she is grim, handsome, wifely, a good companion for a good man. . . . She is Claudette Colbert. Her sister too is Claudette Colbert. They are twins, identical. Her husband Charles Boyer is a very rich handsome man and her sister, Claudette Colbert, is plotting her death in order to take her place as the rich man's wife, no one will know because they are *twins*. . . . All these marvelous lives Clarita might have lived, but she fell out the bottom at the age of thirteen. At the age when I was packing my overnight case for a slumber party at Toni Deshield's she was tearing filthy sheets off a bed and scratching up a rash on her arms. . . . Thirteen is uncommonly young for a white girl in Detroit, Miss Brook of the Detroit House of Correction said in a sad newspaper interview for the *Detroit News;* fifteen and sixteen are more likely. Eleven, twelve, thirteen are not surprising in colored . . . they are more precocious. What can we do? Taxes are rising and the tax base is falling. The temperature rises slowly but falls rapidly. Everything is falling out the bottom, Woodward Avenue is filthy, Livernois Avenue is filthy! Scraps of paper flutter in the air like pigeons, dirt flies up and hits you right in the eye, oh Detroit is breaking up into dangerous bits of newspaper and dirt, watch out. . . .

Clarita's apartment is over a restaurant. Simon her lover emerges from the cracks at dark. Mrs. Olesko, a neighbor of Clarita's, an aged white wisp of a woman, doesn't complain but sniffs with contentment at Clarita's noisy life and doesn't tell the cops, hating cops, when the cops arrive. I should give more fake names, more blanks, instead of telling all these secrets. I myself am a secret; I am a minor.

3. My father reads a paper at a medical convention in Los Angeles. There he is, on the edge of the North American continent, when the unmarked detective put his hand so gently on my arm in the aisle of Branden's and said, "Miss, would you like to step over here for a minute?"

And where was he when Clarita put her hand on my arm, that wintry dark sulphurous aching day in Detroit, in the company of closed-down barber shops, closed-down diners, closed-down movie houses, homes, windows, basements, faces . . . she put her hand on my arm and said, "Honey, are you looking for somebody down here?"

And was he home worrying about me, gone for two weeks solid, when they carried me off . . .? It took three of them to get me in the police cruiser, so they said, and they put more than their hands on my arm.

4. I work on this lesson. My English teacher is Mr. Forest, who is from Michigan State. Not handsome, Mr. Forest, and his name is plain unlike Raymond Forrest's, but he is sweet and rodent-like, he has conferred with the principal and my parents, and everything is fixed . . . treat her as if nothing has happened, a new start, begin again, only sixteen years old, what a shame, how did it happen?—nothing happened, nothing could have happened, a slight physiological modification known only to a gynecologist or to Dr. Coronet. I work on my lesson. I sit in my pink room. I look around the room with my sad pink eyes. I sigh, I dawdle, I pause, I eat up time, I am limp and happy to be home, I am sixteen years old suddenly, my head hangs heavy as a pumpkin on my shoulders, and my hair has just been cut by Mr. Faye at the Crystal Salon and is said to be very becoming.

(Simon too put his hand on my arm and said, "Honey, you have got to come with me," and in his six-by-six room we got to know each other. Would I go back to Simon again? Would I lie down with him in all that filth and craziness? Over and over again

a Clarita is being betrayed as in front of a Cunningham Drug Store she is nervously eyeing a colored man who may or may not have money, or a nervous white boy of twenty with sideburns and an Appalachian look,

who may or may not have a knife hidden in his jacket pocket, or a husky red-faced man of friendly countenance who may or may not be a member of the Vice Squad out for an early twilight walk.)

I work on my lesson for Mr. Forest. I have filled up eleven pages. Words pour out of me and won't stop. I want to tell everything . . . what was the song Simon was always humming, and who was Simon's friend in a very new trench coat with an old high school graduation ring on his finger . . .? Simon's bearded friend? When I was down too low for him Simon kicked me out and gave me to him for three days, I think, on Fourteenth Street in Detroit, an airy room of cold cruel drafts with newspapers on the floor. . . . Do I really remember that or am I piecing it together from what they told me? Did they tell the truth? Did they know much of the truth?

VIII. Characters

1. Wednesdays after school, at four; Saturday mornings at ten. Mother drives me to Dr. Coronet. Ferns in the office, plastic or real, they look the same. Dr. Coronet is queenly, an elegant nicotine-stained lady who would have studied with Freud had circumstances not prevented it, a bit of a Catholic, ready to offer you some mystery if your teeth will ache too much without it. Highly recommended by Father! Forty dollars an hour, Father's forty dollars! Progress! Looking up! Looking better! That new haircut is so becoming, says Dr. Coronet herself, showing how normal she is for a woman with an I.Q. of 180 and many advanced degrees.

2. Mother. A lady in a brown suede coat. Boots of shiny black material, black gloves, a black fur hat. She would be humiliated could she know that of all the people in the world it is my ex-lover Simon who walks most like her . . . self-conscious and unreal, listening to distant music, a little bowlegged with craftiness. . . .

3. Father. Tying a necktie. In a hurry. On my first evening home he put his hand on my arm and said, "Honey, we're going to forget all about this."

4. Simon. Outside a plane is crossing the sky, in here we're in a hurry. Morning. It must be morning. The girl is half out of her mind, whimpering and vague, Simon her dear friend is wretched this morning . . . he is wretched with morning itself . . . he forces her to give him an injection, with that needle she knows is filthy, she has a dread of needles and surgical instruments and the odor of things that are to be sent into the blood, thinking somehow of her father. . . . This is a bad morning, Simon says that his mind is being twisted out of shape, and so he submits to the needle which he usually scorns and bites his lip with his yellowish teeth, his face going very pale. *Ah baby!* he says in his soft mocking voice, which with all women is a mockery of love, *do it like this—Slowly—*And the girl, terrified, almost drops the precious needle but manages to turn it up to the light from the window . . . it is an extension of herself, then? She can give him this gift, then? *I wish you wouldn't do this to me,* she says, wise in her terror, because it seems to her that Simon's danger—in a few minutes he might be dead—is a way of pressing her against him that is more powerful than any other embrace. She has to work over his arm, the knotted corded veins of his arm, her forehead wet with perspiration as she pushes and releases the needle, staring at that mixture of liquid now stained with Simon's bright blood. . . . When the drug hits him she can feel it herself, she feels that magic that is more than any woman can give him, striking the back of his head and making his face stretch as if with the impact of a terrible sun. . . . She tries to embrace him but he pushes her aside and stumbles to his feet. *Jesus Christ,* he says. . . .

5. Princess, a Negro girl of eighteen. What is her charge? She is close-mouthed about it, shrewd and silent, you know that no one had to wrestle her to the sidewalk to get her in here; she came with dignity. In the recreation room she sits reading *Nancy*

Drew and the Jewel Box Mystery, which inspires in her face tiny wrinkles of alarm and interest: what a face! Light brown skin, heavy shaded eyes, heavy eyelashes, a serious sinister dark brow, graceful fingers, graceful wristbones, graceful legs, lips, tongue, a sugarsweet voice, a leggy stride more masculine than Simon's and my mother's, decked out in a dirty white blouse and dirty white slacks; vaguely nautical is Princess's style. . . . At breakfast she is in charge of clearing the table and leans over me, saying, *Honey you sure you ate enough?*

6. The girl lies sleepless, wondering. Why here, why not there? Why Bloomfield Hills and not jail? Why jail and not her pink room? Why downtown Detroit and not Sioux Drive? What is the difference? Is Simon all the difference? The girl's head is a parade of wonders. She is nearly sixteen, her breath is marvelous with wonders, not long ago she was coloring with crayons and now she is smearing the landscape with paints that won't come off and won't come off her fingers either. She says to the matron *I am not talking about anything,* not because everyone has warned her not to talk but because, because she will not talk, because she won't say anything about Simon who is her secret. And she says to the matron *I won't go home* up until that night in the lavatory when everything was changed. . . . "No, I won't go home I want to stay here," she says, listening to her own words with amazement, thinking that weeds might climb everywhere over that marvelous $86,000 house and dinosaurs might return to muddy the beige carpeting, but never never will she reconcile four o'clock in the morning in Detroit with eight o'clock breakfasts in Bloomfield Hills . . . oh, she aches still for Simon's hands and his caressing breath, though he gave her little pleasure, he took everything from her (five-dollar bills, ten-dollar bills, passed into her numb hands by men and taken out of her hands by Simon) until she herself was passed into the hands of other men, police, when Simon evidently got tired of her and her hysteria. . . . *No, I won't go home, I don't want to be bailed out,* the girl thinks as a *Stubborn and Wayward Child* (one of several charges lodged against her) and the matron un-

derstands her crazy white-rimmed eyes that are seeking out some new violence that will keep her in jail, should someone threaten to let her out. Such children try to strangle the matrons, the attendants, or one another . . . they want the locks locked forever, the doors nailed shut . . . and this girl is no different up until that night her mind is changed for her. . . .

IX. That Night

Princess and Dolly, a little white girl of maybe fifteen, hardy however as a sergeant and in the House of Correction for armed robbery, corner her in the lavatory at the farthest sink and the other girls look away and file out to bed, leaving her. God how she is beaten up! Why is she beaten up? Why do they pound her, why such hatred? Princess vents all the hatred of a thousand silent Detroit winters on her body, this girl whose body belongs to me, fiercely she rides across the midwestern plains on this girl's tender bruised body . . . revenge on the oppressed minorities of America! revenge on the slaughtered Indians! revenge on the female sex, on the male sex, revenge on Bloomfield Hills, revenge revenge. . . .

X. Detroit

In Detroit weather weighs heavily upon everyone. The sky looms large. The horizon shimmers in smoke. Downtown the buildings are imprecise in the haze. Perpetual haze. Perpetual motion inside the haze. Across the choppy river is the city of Windsor, in Canada. Part of the continent has bunched up here and is bulging outward, at the tip of Detroit, a cold hard rain is forever falling on the expressways . . . shoppers shop grimly, their cars are not parked in safe places, their windshields may be smashed and graceful ebony hands may drag them out through their shatterproof smashed windshields crying *Revenge for the Indians!* Ah, they all fear leaving Hudson's and being dragged to the very tip of the city and thrown off the parking roof of Cobo Hall, that expensive tomb, into the river. . . .

XI. Characters We Are Forever Entwined With

1. Simon drew me into his tender rotting arms and breathed gravity into me. Then I came to earth, weighted down. He said *You are such a little girl,* and he weighed me down with his delight. In the palms of his hands were teeth marks from his previous life experiences. He was thirty-five, they said. Imagine Simon in this room, in my pink room: he is about six feet tall and stoops slightly, in a feline cautious way, always thinking, always on guard, with his scuffed light suede shoes and his clothes which are anyone's clothes, slightly rumpled ordinary clothes that ordinary men might wear to not-bad jobs. Simon has fair, long hair, curly hair, spent languid curls that are like . . . exactly like the curls of wood shavings to the touch, I am trying to be exact . . . and he smells of unheated mornings and coffee and too many pills coating his tongue with a faint green-white scum. . . . Dear Simon, who would be panicked in this room and in this house (right now Billie is vacuuming next door in my parents' room: a vacuum cleaner's roar is a sign of all good things), Simon who is said to have come from a home not much different from this, years ago, fleeing all the carpeting and the polished banisters . . . Simon has a deathly face, only desperate people fall in love with it. His face is bony and cautious, the bones of his cheeks prominent as if with the rigidity of his ceaseless thinking, plotting, for he has to make money out of girls to whom money means nothing, they're so far gone they can hardly count it, and in a sense money means nothing to him either except as a way of keeping on with his life. *Each Day's Proud Struggle,* the title of a novel we could read at jail. . . . Each day he needs a certain amount of money. He devours it. It wasn't love he uncoiled in me with his hollowed-out eyes and his courteous smile, that remnant of a prosperous past, but a dark terror that needed to press itself flat against him, or against another man . . . but he was the first, he came over to me and took my arm, a claim. We struggled on the stairs and I said, "Let me loose, you're hurting my neck, my face," it was such a surprise that my skin hurt where he rubbed it, and afterward we lay face

to face and he breathed everything into me. In the end I think
he turned me in.

2. Raymond Forrest. I just read this morning that Raymond
Forrest's father, the chairman of the board at ————————, died
of a heart attack on a plane bound for London. I would like to
write Raymond Forrest a note of sympathy. I would like to thank
him for not pressing charges against me one hundred years ago,
saving me, being so generous . . . well, men like Raymond For-
rest are generous men, not like Simon. I would like to write him
a letter telling of my love, or of some other emotion that is posi-
tive and healthy. Not like Simon and his poetry, which he
scrawled down when he was high and never changed a word
. . . but when I try to think of something to say it is Simon's
language that comes back to me, caught in my head like a bad
song, it is always Simon's language:

> There is no reality only dreams
> Your neck may get snapped when you wake
> My love is drawn to some violent end
> She keeps wanting to get away
> My love is heading downward
> And I am heading upward
> She is going to crash on the sidewalk
> And I am going to dissolve into the clouds

XII. Events

1. Out of the hospital, bruised and saddened and converted,
with Princess's grunts still tangled in my hair . . . and Father in
his overcoat looking like a Prince himself, come to carry me off.
Up the expressway and out north to home. Jesus Christ but the
air is thinner and cleaner here. Monumental houses. Heartbreak-
ing sidewalks, so clean.

2. Weeping in the living room. The ceiling is two storeys high
and two chandeliers hang from it. Weeping, weeping, though Bil-

lie the maid is *probably listening.* I will never leave home again.
Never. Never leave home. Never leave this home again, never.

3. Sugar doughnuts for breakfast. The toaster is very shiny
and my face is distorted in it. Is that my face?

4. The car is turning in the driveway. Father brings me home.
Mother embraces me. Sunlight breaks in movieland patches on
the roof of our traditional contemporary home, which was de-
signed for the famous automotive stylist whose identity, if I told
you the name of the famous car he designed, you would all
know, so I can't tell you because my teeth chatter at the thought
of being sued . . . or having someone climb into my bedroom
window with a rope to strangle me. . . . The car turns up the
black-top drive. The house opens to me like a doll's house, so
lovely in the sunlight, the big living room beckons to me with
its walls falling away in a delirium of joy at my return, Billie the
maid is *no doubt* listening from the kitchen as I burst into tears
and the hysteria Simon got so sick of. Convulsed in Father's arms
I say I will never leave again, never, why did I leave, where did
I go, what happened, my mind is gone wrong, my body is one
big bruise, my backbone was sucked dry, it wasn't the men who
hurt me and Simon never hurt me but only those girls . . . my
God how they hurt me . . . I will never leave home again. . . .
The car is perpetually turning up the drive and I am perpetually
breaking down in the living room and we are perpetually taking
the right exit from the expressway (Lahser Road) and the wall
of the restroom is perpetually banging against my head and per-
petually are Simon's hands moving across my body and adding
everything up and so too are Father's hands on my shaking
bruised back, far from the surface of my skin on the surface of
my good blue cashmere coat (drycleaned for my release). . . . I
weep for all the money here, for God in gold and beige carpet-
ing, for the beauty of chandeliers and the miracle of a clean
polished gleaming toaster and faucets that run both hot and cold
water, and I tell them *I will never leave home, this is my home,
I love everything here, I am in love with everything here.* . . .

the coal
shoveller
Keith Fort

"THE CLOCK is ticking."

That's a poor beginning for my short story. The trouble with
"clock" is that it symbolizes time, and I don't want to introduce
any big ideas into my story. Besides, I actually have an electric
clock which whirrs.

It is a snowy day in midwinter. Out of my second-story win-
dow I see the street. The snow is so deep that all traffic has
stopped. The last vehicle to come by was a truck which dumped
five or six tons of coal on the sidewalk beside the red brick Vic-
torian building across the street. It was once a fine mansion, or
so my mother told me during her visit. She had lived in Wash-
ington in the early 1900's when her father was a senator. She
said that a school for young ladies was there, and the "best peo-
ple" sent their daughters to it. Now the building is divided into
small, cheap apartments for government workers. When I walk
by, I sometimes see rats in the yard. The land is quite valuable,
and in time the grey cupolas, the bay windows, and the portico
will come down to be replaced by a new glass and steel office
building in the style of the Holiday Inn which is just behind it.
On top of the inn is a lattice fence which, I assume, shields some
kind of sun porch. At night they turn pink floodlights on the
lattice.

A Negro man is shovelling the coal into the basement. I am
separated from him by Massachusetts Avenue. The task I have
set myself is not a very difficult one. The scene is visually appeal-
ing to me. I would like to write a simple short story describing
the scene and, perhaps, giving some idea of the rather interesting
neighborhood in which I live. I have no theme to draw out of
the scene. The thing itself is enough. So it seems that the best

First published in The Sewanee Review, LXXVII, 4 (Autumn, 1969).
Copyright © 1969 by The University of the South, and with permission of
the author.

style for me would be something on the order of the new novels.

The northeast wind blows the snow almost horizontally down Seventeenth Street. It slaps against the coal shoveller's face, sticks to him briefly, melts and falls. He is wearing a faded green army jacket. A black strip over his left breast has the words "U. S. Army" printed on it in gold letters. The Negro's face is partially muffled by a grey hat with ear flaps and a red scarf wrapped high around his neck. His eyes are turned onto the coal pile in front of him. The lumps are of various sizes, the smaller pieces on the bottom. The head of the coal scoop runs along the snow and enters the coal. The handle is brown with a faded red stripe where it meets the scoop. The shovel comes out. He swings around to the south. The blue flag on the Australian embassy. The white house next to it. The tops of parked cars. The whiteness of Seventeenth Street. The elaborate concrete curves of the B'nai Brith building. The blue fence around the Holiday Inn swimming pool. The red brick building. The black hole into the cellar. The coal clatters down into the chute. Black dust flecks the snow. He continues his movement, turning north into the wind. The apartment building across Massachusetts Avenue. The window on the second floor. Up Seventeenth Street. The flashing red sign "The Bacchus." The coal pile. The shovel goes in. The wood is brown, surrounded by a red stripe where the handle meets the black scoop. A grey glove with a hole in it. The skin beneath the hole is black.

I can't go on like that. Words have a powerful integrity of their own which no amount of authorial intention can eliminate. I could write a hundred essays on how objective I am going to be, but the connotations of "white," "snow," and "black" would still be there. All that I wanted was to describe the scene, but who could fail to see in my story a comment on the white noose that is strangling our black inner-city?

You might argue that my objections to continuing my story as I started it are based solely on the assumption of a faulty reader reaction, and that I should be skillful enough to remake the consciousness of my audience as I write. Can someone like Robbe-Grillet actually believe that he is reshaping the mind of man as

he writes? I don't have the arrogance to deny reality in the name of an idea of reality.

Nor am I convinced that fiction *should* try to approximate painting (or the films). Prose has been headed in this direction for some time, but like most movements in art this one was begun on ill-defined premises and succeeding writers merely spun out a potential. We have come to a point now where the weaknesses inherent in the original assumptions prevent us from going further. To ask words to make fiction into photographic realism is to demand a performance which they are totally incapable of giving.

Since I cannot escape words and since words are necessarily symbols, I might as well write a more traditional story in which I admit that every time I use a word I am interpreting reality. The only ideas I can draw out of the scene are my own because they are obviously the only ones I know. I have no concept of the way in which the coal shoveller sees the world.

Amelia, who was six, had exhausted every possibility for entertainment she could find in the house. She had played with her dolls, colored the book she had been given at the school Christmas party the day before, and had made two entirely different houses out of the sofa pillows. An unusual inclination to help her mother had resulted in her being ushered out of the kitchen when she had spilled a cup of milk that was to be used for the Christmas cookies. On most holidays she would have gone to visit one of her friends, but the private school she went to was in the suburbs where most of the pupils lived, and her mother wasn't willing to risk driving through the snow. If she were at someone else's house they could at least watch television, but her father allowed only two programs a week and she had squandered her time for two solid hours on Sunday. Amelia had finally settled by the window where she watched the snow and the old colored man across the street who was shovelling the coal. She wanted to go outside and play, but it wasn't allowed because of the traffic.

In desperation she went back to the kitchen and asked her mother to take her out, but "There is too much to be done, darling," was all she got.

"There's not any cars in the street."

"It's still dangerous. Maybe your father will take you out when he's through working."

Amelia went back into the living room and tried to color another picture, but the tiger she was working on didn't interest her. She closed the book and looked at the door which led into her father's study. The rule that "Daddy is not to be bothered when he's working" was, she knew, an absolute one.

Under most circumstances this suited her well enough because she was actually frightened by the room. The study had been built on the side of the house the summer before when her father had published a book and had been given a big raise. To help him in his work the room had no windows and a special control which kept the room at the same temperature all the time. The darkness and the quietness bothered her, but she had reached her limit.

She walked to the door as quietly as she could, turned the knob, and had started in when her mother heard her.

"Don't bother daddy."

Her mother came running from the kitchen and pulled her away. The door was open a crack. She saw her father in the dark room with the bright light over his typewriter making his face look all black and white.

"I'm sorry, Michael," her mother said as she closed the door. "It's snowing and she wanted to go out."

"That's all right," Michael said through the closed door. "I'll take her out in a few minutes. My train of thought is broken now anyway." He had been married for ten years and the way his wife said "snowin'" still bothered him. It was embarrassing for a sociologist, active in the Civil Rights movement, to have a Southern wife.

Michael turned back to his desk. Actually he was pleased with the interruption. He was almost through with the article he had been working on about the problems of urban Negroes in Washington. He had attacked the question from various angles, poking at it first with the intellect then with the emotions. The piece now had about the right amount of feeling and thought to make it acceptable to one of the slick magazines. It would be good to let the manuscript sit overnight. One more polishing tomorrow, and

it would be finished. He took the last page out of the typewriter, laid it neatly with the others, leaned back in his chair, and surveyed with satisfaction the day's production.

The bright lights in the living room hurt his eyes. His wife was making more than the usual amount of noise in the kitchen. Out of the window he saw the curtain of snow that was falling over the street. In the distance the old Negro man was shovelling coal.

"Let's go, daddy," Amelia said. "There's lots of snow."

She was dressed in a bright red snow suit.

"Where are your galoshes?" he asked.

"Margaret," he called into the kitchen, "are you trying to make the child sick by letting her go out without her galoshes?"

His wife came out of the kitchen. "Amelia. I told you to put them on."

"I don't want to go out," Amelia said sullenly.

"Now that I've stopped work," her father said, "we are going out into the snow."

Amelia went to the closet, and with her mother's help laboriously pulled on the galoshes. Michael got on his own overshoes and coat.

"I wish I could go with you," his wife said. "The snow is beautiful."

"When I was a boy in Wisconsin, we wouldn't have called this anything but a flurry," he said with a smile.

"I've never seen so much," Amelia said.

From there on the story writes itself. Michael goes into the snow. He gradually discovers the reality of his wife's life and that he has never understood the Negroes at all. Finally, he arrives at some understanding of the emotional sterility of his own life, which is sentimentally compared to his childhood back in Wisconsin.

Sound familiar? Joyce's "The Dead." I didn't deliberately set out to imitate the story, but it was there waiting for me like a trap. I couldn't avoid imitation.

In addition to my feeling that this has been done already better than I could do it, there are other reasons why I don't like

my story. The focus is on the main character's movement towards self-understanding. It posits that intellectual and emotional development is all that counts. The reality of the Negro coal shoveller, even the realness of the snow and the house, is not considered important beside the ideas which I have extracted (or perhaps created) from them. My story would end by suggesting the subordination of thing to idea. I am inclined to agree with those who say that literature (no matter how negative the themes) which reinforces the habit of extracting ideas from reality panders to the self-interest of the middle class. You can be sure that both you and I would prefer a few hours of anguish trying to understand the validity of various attitudes that one could take toward the Negro shovelling coal to five minutes of real or fictional exposure to the reality of that man's life and his work.

Not only am I blocked philosophically from writing a Joycean story—I am also incompatible with its style. I lack the necessary innocence. When the symbolic technique was devised, writers must have been able to allow their symbols to emerge "naturally." I have studied fiction too long. Take the "study" in my story. Is that too heavy-handed? How subtle should a symbol be? I honestly don't know. I rather imagine that a good symbol is one that takes an English teacher about two minutes to decipher and one of his students ten. Talk of "organic symbols" that grow out of reality is absolute garbage at this point in the evolution of fictional techniques.

If I use symbols I also depend heavily on my readers' being willing to accept my symbolism for what I intend. For example, I said in my story that Michael laid the last page "neatly" on the others. "Neatly" is a symbol for certain aspects of his character. But what is actually wrong with being neat? If there weren't a general, if ill-defined, prejudice of modern readers in favor of emotional spontaneity, that word might be honorific. If you say that *in the context* the symbol is made meaningful, I reply that my story is nothing but a pastiche of such symbols.

Underlying all of them is a series of romantic values epitomized by the noble Negro coal shoveller, the goodness of nature (represented by the snow), and the joys of childhood. When I draw these values out of my story, as I am doing now, they are

subject to attack. But one of the advantages that comes to the fictionalist is that he doesn't have to defend his assumptions. The critics tell us that he doesn't have to defend his assumptions. The critics tell us that we should examine literature from within. This idea has been forced on them by the "creative" writers. Who can blame an author like Henry James for wanting his value assumptions considered "out of bounds"?

Then there is the rather obvious point that I have completely distorted reality in my story. I live in a small apartment. A house on Massachusetts Avenue would cost a fortune. I am the one from the South, not my wife.

Since I am aware of the ideas behind my symbols, why not write an essay instead of a short story? I reject that at once. My first inclination is to explain this rejection by saying something about the "mystery of art." Many writers talk of this mystery, and it seems to me that they do so primarily to convince themselves that they are somehow "special" and belong to a cult of super souls who have powers (and, more importantly, privileges) that ordinary mortals can't understand. The real reason that I prefer fiction is that it gives me a feeling of righteousness which is denied to me in essays. In fiction I redefine reality by style. When I survey the new world I have created in my story I can say, "Yes, by God, since the world is like that I am completely justified in feeling what I feel." I am quick to admit that I need this kind of self-justification and that I want to use the devices of fiction to make others second my righteousness.

In the fragment of my story on Michael, I disguised, under the illusion of objectivity, my own need to use fiction to justify myself and gain approval of readers. But now that I admit this need, I might as well try an autobiographical story in which I reveal myself more directly and, consequently, make a more overt appeal for approval. I will use the time (mentioned earlier) when my mother came to visit me here.

The woman stands in the small, cramped apartment. She looks down on the oblivious snow in the avenue—not knowing that she or he existed. The woman in front of him—a mother, but not a mother because mothers are associated with home, and here is

not home. She, vaguely ashamed to be here—not of him because
it is not his fault that he lives here with a Yankee wife, but of
herself, of her dead husband, and her dead father and the long
line of failures that have reduced the family to the point of living
in a small apartment.

He puts her bag on the floor and waits awkwardly for her to
do something. She asks for a glass of sherry. It is almost twilight.
The snow is falling harder outside—the blanket is making all men
equal in cold and misery and accentuating the memory of warm
Southern summers with the smell of purple wisteria twisting
through honeysuckle when the bright colors differentiated people:
blacks from whites and whites from poor whites. And it is all over
for her now because there is no more home to live in and no
more wooded yards lined with flowers, and she and the son and
the Negro servants have all fled north to Washington, where they
are equal under the snow but hating that equality—the Negro
because the equalness is not real, the son because he is poor, and
the Mother because she knows that she is better. She sips sherry
in the twilight and the son straight whiskey—waiting.

He has put out on the table a book of family history because
it will please her to know that he cares. She looks at it, and the
book, like a trigger, explodes the blocks against history, and be-
tween sips of sherry there pours out the talk that he has heard so
often, but that still can make him desire again to be a child in a
world where he could maintain the illusion of a baronial grandeur
bequeathed to him by the past—but for him so long away that
the memory he had received is like the deformed last of the litter.
A tiny final effort from the exhausted womb of the old South. Too
twisted and confused to do more than make him wish he had
been closer to the source of the myth.

"Do you see that house?" she says as she walks to the window.
"Yes."

"I went to school there when your grandfather was a senator.
He was a great man. I drove up every morning to that building
in a carriage. All the great people sent their children there. At
least I think that's the building. So much has changed."

As she talks, he thinks:

He was a child. It was summer at his grandmother's. The

large rambling house with its rows of bedrooms and the porch
that ran all around the house high up in the foothills of the
Georgia Blue Ridge. "On a clear day," his grandmother said, "you
can see to the sea." But even then he knew that was not true. It
had been a summer place, but now a few of the downstairs rooms
had been insulated so that she could live there—not in isolation
but still fighting with the ferocious anger that her mother before
her had used to hold the family together after the War, but which
had not been able to cope with Yankee businessmen, boll weevils,
and resentful Negro workers in South Georgia. Now she lived on
the hill surrounded by thick underbrush which kept from her the
knowledge of the encroaching townspeople whose squat, white
houses lapped at the hill. All that was left outside of the under-
brush of what had once been a great estate was the Episcopal
church at the foot of the hill which his great-grandfather had
built just after the War for the use of the family and the other
summer people.

Then the summer when he was seven he came and his grand-
mother told him that he could no longer play in the church be-
cause it had been sold. She said "sold" with an icy pride which
made him afraid. On the first Sunday when he was there his
grandmother was sitting on the porch reading Sir Walter Scott
to him—he not understanding, but made peaceful by the words
which flowed in and out of the mimosa trees and the humming of
bees. She stopped. "Did you understand that?"

"What, ma'am?"

"What I read to you."

"Not exactly."

"Listen. 'My foot is on my native heath, and my name is Mac-
Gregor!' Does that mean anything to you?"

"Yes, ma'am," he lied. But it did. A thousand times since he
had said it. When he came home from college and the heath was
a quarter-acre yard with an old Ford in it. And even now when
he walked into the little apartment on Massachusetts Avenue he
said it with bitterness.

Before she started reading again, the church bell sounded
from outside of the underbrush. He heard singing coming out of

a loudspeaker—cracked twangy accents of country people. He felt his grandmother stiffen.

"Angela," she said.

"Yes'm." The fat old Negro woman came out onto the porch drying her hands on her apron. The enormous kindness of the woman became a natural part of the warm summer morning.

"What is that noise?"

"There's more folks want to go to the church than it'll hold. They put up speakers for those who's outside."

"Thank you, Angela."

Angela went back to fix Sunday dinner.

"I want you to remember," his grandmother said to him, "that Sunday morning is God's gift of Peace. For one as old as I, Peace is sacred."

"Yes, ma'am," he said.

That night as he lay in his bed and watched the moon lie on the state of Georgia he saw a frail woman carrying a big can move like a black shadow away from the house and into the underbrush. He was afraid, too afraid to think, and he waited until the orange light had taken away the silver moonlight, and he slept.

When the vacation was over and he was home he asked his mother and father why it had happened. They pretended not to understand but answered anyway. "Your grandmother is a fine, strong woman," his father said with pride. But he could not understand this because when his father's boss would call on Sunday morning his father would grumble but go to work. "We have to eat," he would say. And his father worked for a Baptist although the boss became an Episcopalian like him later on.

And he could not understand how Sunday mornings could both be sacred and not sacred and he saw that his father loved the strength of his grandmother but also wanted to get a raise from the Baptist. Being a child he could not stand uncertainty and found a third way which he believed could eventually fuse the opposition into oneness—intelligence, which he now knew was the weakest weapon he could have chosen because it compounded, not resolved, the opposition. The more clearly his mind

failed to understand why Sundays were sacred the more he
longed to share in his grandmother's pride. But unlike his father
for whom the beliefs were closer and more real and who lost his
life trying to work for the Baptist and live by his grandmother's
sureness, the dream of the peace of Sunday mornings was so far
removed from him that he was almost denied the pleasure of hav-
ing it as a dream; and yet at times like this, when his mother was
talking, he could almost reach out to the voice of his grandmother
("MY foot is on my native heath") that created in him, for how-
ever short a time, the innocence of dreaming, when he could free
himself of knowing the inconsistencies, the injustices, the contra-
dictions that were housed in his grandmother's impoverished
Eden. Perhaps, he thought, if there is another generation the
dream will be taken away and we can function in the Baptists'
world (although he did not understand the legitimacy of the
Baptist as symbol any more) and the sins of the fathers will be
gone. But in the small apartment with its books and its type-
writer the disease was all the peace and beauty which he had
ever known and the cure seemed worse than the illness. And he
watched the coal shoveller—a man without hope, for whom jail
and the welfare line are the legacies of a belief in the sanctity of
Sunday morning, and the mother's voice, now crumbled into
mumbling quests after the ability of words to rebuild a belief in
the present reality of the dream, is also the legacy. And he knows
that the dream has produced evil, but knowing is, as it always
had been for him, a false god.

His mother says: "That old colored man—I suppose you say
'Negro' now—reminds me of old Dick the footman who used to
open the carriage door for us when we came to school. Your
grandfather sent him money every year. . . ."

I wish that I could honestly see the fall of the Old South as
tragic in the way that Faulkner did. Only occasionally do I even
care about the fact that I don't care. The story gives a completely
false impression of what I actually feel on the subject. I blame
the misrepresentation on the style which was so intoxicating that
it carried me where I didn't want to go.

And where was I going? Deeper and deeper into my mind or
at least into the pseudo-mind which the words were creating as

they went along. By the time thinking has become words it has
ceased to be self.

Style dominates the piece and focuses the reader's attention
on my way of seeing the world. Like most middle-class writers
I have a decided anti-middle-class bias, and I don't believe the
"I" is worth a sustained story. (Someday I would like to study
the strong streak of masochism which runs through or even domi-
nates modern fiction. Middle-class writers take great pleasure in
writing about the "emotional bankruptcy" of middle-class writers.
And certainly there is no better way to be popular with the gen-
eral public than to tell them how horrible they are. The way in
which this masochism works is obvious in my own story of
Michael the sociologist. I have some of my hero's characteristics,
and in the story I objectified my own sins and controlled things in
such a way that Michael is punished. Having paid for my errors
by sticking pins in my image, I can continue to muddle along as
usual without feeling the need to take any real action.) I am also
interested in the extent to which certain kinds of beliefs control
ideas. Does my Faulknerian story depend on my putting myself
into a frame of mind where I can believe in the reality of the
myth of the Old South? And did the symbolic technique in my
first story depend on the romantic values which formed the
assumptions on which the story was based? I think the answer to
both questions is yes.

At this point I accuse myself of not being able to finish any
of these stories because I am a nihilist. But I immediately recog-
nize that nothing is further from the truth. I believe in a great
many things—so many in fact that the beliefs tend to cancel each
other out. Good writers are successful because they can eliminate
(at least in a given work) all but one possible way of seeing the
world. They develop styles and structures because they are fol-
lowing through with this single vision. Robbe-Grillet's novels, for
example, are the product of one particular way of looking at the
world. As he was writing, he was able to block from his mind the
knowledge that during most of his life he sees the world in many
different ways. If he looked at reality in his daily life as he does
in his novels, he would never be able to do a single practical
thing like catching a train or showing up for a speaking engage-

ment on time. Is arrogant, spiritual narrowmindedness the essence of the writer?

The scene is still there. The janitor is still shovelling coal. Because the street is quiet, I can hear the shovel as it scrapes into the coal. Do you believe that? You might. But it is cold and the window is closed. Massachusetts Avenue is a big street. I hear nothing. Why did I add the sound to my description? Writers are supposed to "render" and not "report." Writing classes do more harm than good.

That's neither here nor there. Since I am beginning to understand the extent to which masochism is a dominant motivation in all of my stories, perhaps I should try to be more honest and objectify my "anti-self" into an active romantic. I must have bottled up in myself an enormous amount of anti-intellectual, anti-establishment hostility. As I have said before, I know nothing of what the coal shoveller actually thinks, but I can easily make him into whatever I want. I'll make him the rogue hero that I might like to be.

My anti-hero's name is to be Reginald Cowpersmith. He is twenty-eight, married, and unemployed. He finds himself on this particular snowy day walking by the pile of coal, where he sees an angry building superintendent starting to shovel the coal. Reginald, who is broke, asks for the job.

"The boy who is supposed to look after this sort of thing didn't show up," the superintendent said. He was winded from the one or two shovelfuls he had tossed down the chute.

"It's hard to know who to trust these days," Reginald said.

"That's very true. I'm lucky you happened to be passing by."

"I could certainly use the work," Reginald said in his most serious tone.

"I'm surprised a nice-looking young man like yourself has to go around looking for odd jobs."

"I'm at the University, sir," Reginald said. "It's very expensive. I also have a family to support. I try to supplement my income in whatever way I can."

"I wish other people in this city had your ambition."

"*They* need our sympathy, sir."

"Quite right. I know I can trust you. Here's five dollars. Shovel

the coal into the cellar. I want to get home while I can." The superintendent shuffled toward Rhode Island Avenue and the bus home.

"Cheerio," Reginald called after him as he waved good-by. "And," he added, when he saw the superintendent was out of earshot, "do me the pleasure of applying thy rosy lips to the gentle curvature of my buttocks."

Reginald imagined the superintendent at home in some place like Hyattsville sitting in front of a fire telling his wife, children, and sad-eyed cocker spaniel how lucky he was to find "this white boy" to shovel his coal instead of "that no-good nigger."

"Cowpersmith," Reginald asked himself, "what would you like for Christmas out of this five dollars?"

"Perhaps, a gift for a needy family," Reginald replied.

"Not likely."

"A bottle of whiskey?"

"It's on the list," Cowpersmith said.

"A fuck in a neighborhood brothel?"

"Agreed."

Reginald stuck the shovel into the pile of coal and retired into the apartment house to contemplate the laws of economics which prevented a five-dollar bill from buying both presents.

He lit a cigarette and leaned against the radiator. Beside him was a row of old mailboxes. He reached into the nearest one and came up with a handful of letters. A hand-addressed one from Des Moines. The writing suggested aged parents. A circular from Catholic Charities, Inc. A request for funds from CORE. An announcement of the January offerings of the Apollo film club and a letter from the Civil Service Commission advertising "New Benefits for Government Employees."

"The poor creature must be lonely," Reginald said.

"It's hard to be away from home at Christmas time," Cowpersmith agreed.

"We might as well give ourselves one of our presents free."

"In what apartment does the lonely young lady live?" Cowpersmith asked.

"In No. three. After you, Mr. Cowpersmith."

"Thank you, Reggie."

Reginald walked up the stairs.

The hall smelled of rotten gentility. Reginald pictured the time when liveried Uncle Toms served great ladies in these halls. He had a fleeting image of himself as a Southern Senator walking down these stairs before the big rooms had been divided up into apartments. "Good evening, Senator Cowpersmith, the ladies are waiting in the drawing room."

He knocked on apartment number three.

The girl who opened the door had four immediately observable characteristics. Two large tits and two wide, frightened eyes.

"Excuse me, ma'am," he said. "I'm the substitute janitor and the superintendent asked me to look at your radiator."

"I didn't know anything was wrong with it."

"It'll only take a second."

"All right."

He went in. The apartment was warm and homey. The living room-bedroom was neat. The convertible couch in the corner, for which he had future plans, seemed adequate to support the two of them, and he was sure that the sheets would be clean, a detail which he had come to insist on since he had been married and had come to appreciate some of the refinements that go with domestic bliss. On the desk in one corner were three pictures. Two were of "mom" and "dad." A third tinted photograph showed an insipid-looking young man in a uniform.

As he fiddled with the radiator he talked to her. "It is certainly a cold day. But then Christmas without snow is like a day without wine, as the French say."

She nodded suspiciously. The use of "French" and "wine" had been a mistake.

"Christmas brings out the best in us," he said, taking a new approach. "Love, charity, the simple virtues that seem so far removed from city life."

"You're an educated man," she said. "It's funny but I've lived in Washington now for almost a year and I haven't really talked to anybody during that time."

"I guess the city isn't what you expected," he said. "It must be very lonely for you."

"Yes."

Any "yes" is a good sign, Reginald thought. Affirm one idea and you will tend to affirm everything.

"How does it happen that you are working as a janitor?" she asked.

"I'm a writer."

"Really?"

"Yes. I have a novel I'm working on. I need the money from odd jobs, but I also want to find out the kind of life the poor people live here, particularly the Negroes."

"I've thought of the same thing," she said excitedly.

"They have a hard time." He stopped fiddling with the radiator and stood up.

"I'll bet you do too," she said.

"Adversity is the trifling burden which man must bear if he is to fulfill the kingdom of God on earth. I do what I can." He was a little anxious about the last statement. It might have been too extreme, but he recognized as he watched her that by adopting the "writer" tag he had adequately prepared her for exaggerated language.

"Would you like some coffee?"

"Thank you, but I have to get back outside to finish shovelling the coal. I think your radiator will be all right now."

"You have time for just a cup."

"I guess so."

She went into the tiny kitchen. Her ass, a fifth characteristic which he had not previously had the opportunity to observe, waved in a friendly way. He followed her. As she put the pot on the stove he moved in on her . . .

God, but I hate bastards who write stories like that. They think that cruelty is cute and justified in the name of their own super souls. Kerouac, Donleavy, Miller, the whole lot of them. Dividing up the world into two parts—themselves and the squares. They condemn with a thoughtless pride grounded in a morality of immorality which is more rigid than the Calvinist code which they profess to hate. Being "right," they are justified in doing anything to the enemy. How many people could Reginald Cowpersmith hurt in the course of one short story? Four or

five probably. Maybe two dozen in a novel. When I read *The
Catcher in the Rye* my sympathies are with Mr. and Mrs. Caul-
field and "old Spencer." I care more about Miss Frost in *The
Gingerman* than about the Gingerman.

Does that sound too moral? I would personally be happy with
a situation where writers had no effect at all on the immediate
existence of readers. But fictionalists have for so long thought of
themselves as prophets that they have talked a gullible, freedom-
escaping world into believing that they are. Given the function of.
art in our time, I agree with Bellows when he says that we must
have writers who think.

What would happen if the neo-romantics did think? They
would find among other things that they are paranoid. They write
fiction in which Society tries to destroy them, a theme which
serves no other purpose than to inflate their egos. Actually Society
cares very little about them. The rôle of the rebel is a self-serving
one.

And, furthermore, the rebellion of these anti-heroes is usually
much tamer than it seems on the surface because they don't chal-
lenge the basic value systems of society. I also feel that my own
story (like most of those in the genre) would have ended senti-
mentally with Reginald showing that at heart he was a swell fel-
low and that my readers should love him. Behind every romantic
hero is a maudlin child.

What is left to me? I seem to lack the necessary emotional
commitment to follow through with any of the styles I have tried.
Of all writers, the satirist is the closest to being beyond inno-
cence. He accepts, as a given, the futility of self-assertion. Ulti-
mately, of course, no one who bothers to write can be completely
un-innocent, but by writing satire I can approach this condition.

I have a perfect scene for my story. There is a little bar
around the corner called "The Bacchus." I go there occasionally.
It is *the* place for Washington hipsters, so I can ridicule my
romantic enemies who hang out there. These habitués are also
vaguely associated with the arts, and there is nothing more de-
lightful to one in my position than to attack those who still are
committed to the muses.

I need a norm by which the objects of my satire are to be

measured. The coal shoveller will do. He is a man who has a job to do and a family to support—a practical, realistic person.

The man was sitting alone in a booth near the bar, drinking beer and watching the scene in front of him. The young hipsters and their older gurus milled around. The door opened. The man turned around. An old Negro was shuffling through the room toward the bar. He wore a "surplus" green jacket. Over his left pocket was a black strip with "U.S. Army" stitched on it in gold. The man in the booth felt suddenly excited. He tried to call to the coal shoveller, but he had already taken a seat at the bar. The man watched and listened.

The coal shoveller spoke to the bartender. "I'll have a beer," he said. The bartender gave him a large draft. "I been shovelling coal so long," the coal shoveller said. "I was mighty cold. The boss gone home."

"A cold day," the bartender agreed.

"I wasn't sure about coming in here. Some places still don't like the colored customers."

"It's okay in here," the bartender laughed.

"I knew it'd be okay. I seen that sign over the door. About Bacchus and all. He's the place kicker for the Cardinals ain't he? Man he sure is a fat fellow. Can you think of gettin' all the money he does without having to stay in shape."

The bartender, who was waiting on another customer, nodded automatically.

"I knew it was okay to come in a place where football fans come. I know a good bit about football. I seen Bacchus kick four field goals on TV against the Browns just last Sunday."

He drank some of his beer. "Lots of Redskin fans in here. But you can carry that football business too far. Letting your hair grow long just for a football team."

The bartender wasn't listening to him, so he spoke to the man beside him.

"I think Jerry Smith's a good tight end."

"*Really?*" said the man. "I don't know him, but I'd like to."

A pretty white girl sat down on the other side of him. "Do you use consciousness expansion drugs?" she asked.

"No, ma'am. I'm a janitor."

"You're cute," she said.

The coal shoveller was embarrassed. Several others were now standing around him. "Do you play an instrument?" one of them asked.

He pulled a harmonica out of his pocket.

"Give us a tune," they said. A crowd had gathered. He began to play "Ole Black Joe."

The man in the booth looked on with disgust at the hipsters. God, but I hate bastards like that, the man thought. In their arrogant moral sureness. Dividing the world up into two parts— themselves and the squares—and condemning with a thoughtless pride grounded in a morality of immorality which is more rigid than the Calvinist code which they profess to hate. They know nothing of the coal shoveller and they don't care. Poor bastard caught in that stupid conversation.

The coal shoveller had finished his tune.

The crowd standing around him joined in a chorus of praise.

—It's *it*.

—The real thing.

—No Joan Baez crap here.

—Authentic.

—Close to Leadbelly.

—Real Delta Blues.

"Thank you," the shoveller said.

"You must come and give us a concert," the blonde girl said.

"I'll try to," the coal shoveller said. "Right now, I've got to get back to my shovelling."

He got up from the bar stool and shuffled toward the door.

The man in the booth impulsively grabbed his arm as he passed. "Have a beer with me," he said.

"Thank you," the coal shoveller replied, "but I got to get back to my shovelling."

"Please."

The urgency of the request startled the coal shoveller. He sat down. The man ordered two beers. "Those people are all phony," he said. "They don't understand you. They are using you as a symbol."

"I was glad to have a chance to play my harmonica," the coal shoveller said. "My wife don't let me play at home."

"I've been watching you shovel the coal. I live on the second floor of the building across the street."

"Is that a fact."

"I don't come in here often."

"What kind of business you in?"

"I'm a writer," the man said, "but I try to avoid attributing an essence to myself in view of the cultist associations with *the Artist* in our time. I prefer to say, 'I write.'"

"What you write? I like stories on sports."

"That's why it's so important that I talk to you. Right now I'm trying to write a story about you shovelling coal."

"Is that a fact?" the coal shoveller said. He smiled broadly. "Where can I read it?"

"I don't know who'll take it. It's an experimental story."

"Oh." He looked disappointed. "What you experimenting about?"

"With the problems of language," the man said, growing excited. "I am trying to show that literary language is a shifting kaleidoscope of lights and shadows, full at once of absences and replenishments. A word is a door that opens onto the hypocritical and inexact world of idea. The very fact that I must attempt such a story shows that Western tradition has run its course. Art has been dehumanized so that no man can honestly write on anything but the problem of writing. The word as means has become the word as end. But I say to myself, so what? Let's not avoid the reality of this problem, but face it as I am in my story. We can reduce the long history of ideological and bourgeois domination of the arts in which reality has been subordinated by idea . . ." He punctuated his last statement with a violent wave of his arm. He knocked over the bowl of pretzels on the table. The coal shoveller began carefully to replace them.

"You see," the man continued, looking urgently at the shoveller, "words are symbols. Perceiving is not done with words. So when I try to describe you shovelling coal, my story takes on connotations and implications which I don't want and which in-

evitably reflect my own mind. But if I can help to make both readers and writers question the assumptions on which they work, we will begin to level Western society. The hunger for the word, the nutritive value of idea will be burned out of the literate middle class. And from the courage to criticize the assumptions which have thus far guided our civilization we will reach the zero degree of culture. Of course, I am no fool. I know that the absolute is an abstraction which will never be reached, because you cannot use language to destroy language. . ."

"You're right," the shoveller interrupted. "Zero is a little low. I was listening to WOOK a while back and they said it'd be about 15 tonight. Could I have a cigarette?"

"Sure," the man said. He gave a cigarette to the coal shoveller and took one for himself. "Got a light?"

The coal shoveller lit the cigarettes.

"Nor do I think," the man continued, "that destruction of this cultural edifice we have raised would be any great loss. Art has become only another profession. Words are used by people to get ahead in their jobs, to gain prestige. It is not like it must have been with the grand amateurism of my grandfather. But all of these minds working on art with the tools of science eventually will see the emptiness at the center of art. Now literature is a worthless commodity in the market place where it is bartered for money. . ."

"Having money troubles?" the coal shoveller asked sympathetically. "Christmas is a hard time."

"It's not a question of money," the man said irritably. "You see in my business it's publish or . . ." He checked himself. "After all my short story has enormous social overtones as well. You and the other poor people of the world have been hoodwinked by ideas for so long. You will be the ones ultimately benefited by writers' willingness to examine their assumptions."

The man clapped the coal shoveller on the back with such force that he bumped against the table and spilled the pretzels again. "It is for you that I am writing this story."

"I certainly appreciate that," the coal shoveller said as he started replacing the pretzels. "Not many white people think about us colored people. Have a pretzel."

But, good Lord, what has any of this got to do with the original aim of my short story?

Little has changed. It is darker now. The snow is still falling heavily. The streets are still empty. The streetlights are on. The coal shoveller is slowly and steadily shovelling. I don't want to turn on the light because it would prevent me from seeing clearly out the window, but it is too dark for me to continue writing.

AGAINST
"REALITY"
* * * * * *
the uses
of fantasy

Pierre Menard, author of Don Quixote

Jorge Luis Borges

TO SILVINA OCAMPO

THE *visible* works left by this novelist are easily and briefly enumerated. It is therefore impossible to forgive the omissions and additions perpetrated by Madame Henri Bachelier in a fallacious catalogue that a certain newspaper, whose Protestant tendencies are no secret, was inconsiderate enough to inflict on its wretched readers—even though they are few and Calvinist, if not Masonic and circumcised. Menard's true friends regarded this catalogue with alarm, and even with a certain sadness. It is as if yesterday we were gathered together before the final marble and the fateful cypresses, and already Error is trying to tarnish his Memory.... Decidedly, a brief rectification is inevitable.

I am certain that it would be very easy to challenge my meager authority. I hope, nevertheless, that I will not be prevented from mentioning two important testimonials. The Baroness de Bacourt (at whose unforgettable *vendredis* I had the honor of becoming acquainted with the late lamented poet) has seen fit to approve these lines. The Countess de Bagnoregio, one of the most refined minds in the Principality of Monaco (and now of Pittsburgh, Pennsylvania, since her recent marriage to the international philanthropist Simon Kautsch who, alas, has been so slandered by the victims of his disinterested handiwork) has sacrificed to "truth and death" (those are her words) that majestic reserve which distinguishes her, and in an open letter pub-

Reprinted by permission of Grove Press, Inc. Copyright © 1962 by Grove Press, Inc. Translated from the Spanish © 1956 by Emece Editores, S.A., Buenos Aires.

65

lished in the magazine *Luxe* also grants me her consent. These authorizations, I believe, are not insufficient.

I have said that Menard's *visible* lifework is easily enumerated. Having carefully examined his private archives, I have been able to verify that it consists of the following:

a) A symbolist sonnet which appeared twice (with variations) in the magazine *La Conque* (the March and October issues of 1899).

b) A monograph on the possibility of constructing a poetic vocabulary of concepts that would not be synonyms or periphrases of those which make up ordinary language, "but ideal objects created by means of common agreement and destined essentially to fill poetic needs" (Nîmes, 1901).

c) A monograph on "certain connections or affinities" among the ideas of Descartes, Leibnitz and John Wilkins (Nîmes, 1903).

d) A monograph on the *Characteristica Universalis* of Leibnitz (Nîmes, 1904).

e) A technical article on the possibility of enriching the game of chess by means of eliminating one of the rooks' pawns. Menard proposes, recommends, disputes, and ends by rejecting this innovation.

f) A monograph on the *Ars Magna Generalis* of Ramón Lull (Nîmes, 1906).

g) A translation with prologue and notes of the *Libro de la invención y arte del juego del axedrez* by Ruy López de Segura (Paris, 1907).

h) The rough draft of a monograph on the symbolic logic of George Boole.

i) An examination of the metric laws essential to French prose, illustrated with examples from Saint-Simon (*Revue des langues romanes*, Montpellier, October, 1909).

j) An answer to Luc Durtain (who had denied the existence of such laws) illustrated with examples from Luc Durtain (*Revue des langues romanes*, Montpellier, December, 1909).

k) A manuscript translation of the *Aguja de navegar cultos* of Quevedo, entitled *La boussole des précieux*.

l) A preface to the catalogue of the exposition of lithographs by Carolus Hourcade (Nîmes, 1914).

m) His work, *Les problèmes d'un problème* (Paris, 1917)

which takes up in chronological order the various solutions of the famous problem of Achilles and the tortoise. Two editions of this book have appeared so far; the second has as an epigraph Leibnitz' advice "Ne craignez point, monsieur, la tortue," and contains revisions of the chapters dedicated to Russell and Descartes.

n) An obstinate analysis of the "syntactic habits" of Toulet (*N.R.F.*, March, 1921). I remember that Menard used to declare that censuring and praising were sentimental operations which had nothing to do with criticism.

o) A transposition into Alexandrines of *Le Cimetière marin* of Paul Valéry (*N.R.F.*, January, 1928).

p) An invective against Paul Valéry in the *Journal for the Suppression of Reality* of Jacques Reboul. (This invective, it should be stated parenthetically, is the exact reverse of his true opinion of Valéry. The latter understood it as such, and the old friendship between the two was never endangered.)

q) A "definition" of the Countess of Bagnoregio in the "victorious volume"—the phrase is that of another collaborator, Gabriele d'Annunzio—which this lady publishes yearly to rectify the inevitable falsifications of journalism and to present "to the world and to Italy" an authentic effigy of her person, which is so exposed (by reason of her beauty and her activities) to erroneous or hasty interpretations.

r) A cycle of admirable sonnets for the Baroness de Bacourt (1934).

s) A manuscript list of verses which owe their effectiveness to punctuation.[1]

Up to this point (with no other omission than that of some vague, circumstantial sonnets for the hospitable, or greedy, album of Madame Henri Bachelier) we have the *visible* part of Menard's works in chronological order. Now I will pass over to that other part, which is subterranean, interminably heroic, and unequalled, and which is also—oh, the possibilities inherent in the man!—inconclusive. This work, possibly the most significant of our time,

1. Madame Henri Bachelier also lists a literal translation of a literal translation done by Quevedo of the *Introduction á la vie dévote* of Saint Francis of Sales. In Pierre Menard's library there are no traces of such a work. She must have misunderstood a remark of his which he had intended as a joke.

consists of the ninth and thirty-eighth chapters of Part One of
Don Quixote and a fragment of the twenty-second chapter. I
realize that such an affirmation seems absurd; but the justification
of this "absurdity" is the primary object of this note.[2]

Two texts of unequal value inspired the undertaking. One was
that philological fragment of Novalis—No. 2005 of the Dresden
edition—which outlines the theme of *total* identification with a
specific author. The other was one of those parasitic books which
places Christ on a boulevard, Hamlet on the Cannebière and Don
Quixote on Wall Street. Like any man of good taste, Menard de-
tested these useless carnivals, only suitable—he used to say—for
evoking plebeian delight in anachronism, or (what is worse)
charming us with the primary idea that all epochs are the same,
or that they are different. He considered more interesting, even
though it had been carried out in a contradictory and superficial
way, Daudet's famous plan: to unite in *one* figure, Tartarin, the
Ingenious Gentleman and his squire. . . . Any insinuation that
Menard dedicated his life to the writing of a contemporary *Don
Quixote* is a calumny of his illustrious memory.

He did not want to compose another *Don Quixote*—which
would be easy—but *the Don Quixote*. It is unnecessary to add
that his aim was never to produce a mechanical transcription of
the original; he did not propose to copy it. His admirable ambi-
tion was to produce pages which would coincide—word for word
and line for line—with those of Miguel de Cervantes.

"My intent is merely astonishing," he wrote me from Bayonne
on December 30th, 1934. "The ultimate goal of a theological or
metaphysical demonstration—the external world, God, chance,
universal forms—are no less anterior or common than this novel
which I am now developing. The only difference is that philoso-
phers publish in pleasant volumes the intermediary stages of their
work and that I have decided to lose them." And, in fact, not one
page of a rough draft remains to bear witness to this work of
years.

The initial method he conceived was relatively simple: to

2. I also had another, secondary intent—that of sketching a portrait of
Pierre Menard. But how would I dare to compete with the golden pages the
Baroness de Bacourt tells me she is preparing, or with the delicate and pre-
cise pencil of Carolus Hourcade?

know Spanish well, to re-embrace the Catholic faith, to fight against Moors and Turks, to forget European history between 1602 and 1918, and to *be* Miguel de Cervantes. Pierre Menard studied this procedure (I know that he arrived at a rather faithful handling of seventeenth-century Spanish) but rejected it as too easy. Rather because it was impossible, the reader will say! I agree, but the undertaking was impossible from the start, and of all the possible means of carrying it out, this one was the least interesting. To be, in the twentieth century, a popular novelist of the seventeenth seemed to him a diminution. To be, in some way, Cervantes and to arrive at *Don Quixote* seemed to him less arduous—and consequently less interesting—than to continue being Pierre Menard and to arrive at *Don Quixote* through the experiences of Pierre Menard. (This conviction, let it be said in passing, forced him to exclude the autobiographical prologue of the second part of *Don Quixote.* To include this prologue would have meant creating another personage—Cervantes—but it would also have meant presenting *Don Quixote* as the work of this personage and not of Menard. He naturally denied himself such an easy solution.) "My undertaking is not essentially difficult," I read in another part of the same letter. "I would only have to be immortal in order to carry it out." Shall I confess that I often imagine that he finished it and that I am reading *Don Quixote*— the entire work—as if Menard had conceived it? Several nights ago, while leafing through Chapter XXVI—which he had never attempted—I recognized our friend's style and, as it were, his voice in this exceptional phrase: *the nymphs of the rivers, mournful and humid Echo.* This effective combination of two adjectives, one moral and the other physical, reminded me of a line from Shakespeare which we discussed one afternoon:

> *Where a malignant and turbaned Turk* . . .

Why precisely *Don Quixote*, our reader will ask. Such a preference would not have been inexplicable in a Spaniard; but it undoubtedly was in a symbolist from Nîmes, essentially devoted to Poe, who engendered Baudelaire, who engendered Mallarmé, who engendered Valéry, who engendered Edmond Teste. The letter quoted above clarifies this point. "*Don Quixote*," Menard explains, "interests me profoundly, but it does not seem to me to

have been—how shall I say it—inevitable. I cannot imagine the universe without the interjection of Edgar Allan Poe

Ah, bear in mind this garden was enchanted!

or without the *Bateau ivre* or the *Ancient Mariner*, but I know that I am capable of imagining it without *Don Quixote*. (I speak, naturally, of my personal capacity, not of the historical repercussions of these works.) *Don Quixote* is an accidental book, *Don Quixote* is unnecessary. I can premeditate writing, I can write it, without incurring a tautology. When I was twelve or thirteen years old I read it, perhaps in its entirety. Since them I have re-read several chapters attentively, but not the ones I am going to undertake. I have likewise studied the *entremeses*, the comedies, the *Galatea*, the exemplary novels, and the undoubtedly laborious efforts of *Pérsiles y Sigismunda* and the *Viaje al Parnaso*. . . . My general memory of *Don Quixote*, simplified by forgetfulness and indifference, is much the same as the imprecise, anterior image of a book not yet written. Once this image (which no one can deny me in good faith) has been postulated, my problems are undeniably considerably more difficult than those which Cervantes faced. My affable precursor did not refuse the collaboration of fate; he went along composing his immortal work a little *à la diable*, swept along by inertias of language and invention. I have contracted the mysterious duty of constructing literally his spontaneous work. My solitary game is governed by two polar laws. The first permits me to attempt variants of a formal and psychological nature; the second obliges me to sacrifice them to the 'original' text and irrefutably to rationalize this annihilation. . . . To these artificial obstacles one must add another congenital one. To compose *Don Quixote* at the beginning of the seventeenth century was a reasonable, necessary and perhaps inevitable undertaking; at the beginning of the twentieth century it is almost impossible. It is not in vain that three hundred years have passed, charged with the most complex happenings—among them, to mention only one, that same *Don Quixote*."

In spite of these three obstacles, the fragmentary *Don Quixote* of Menard is more subtle than that of Cervantes. The latter indulges in a rather coarse opposition between tales of knighthood

and the meager, provincial reality of his country; Menard chooses
as "reality" the land of Carmen during the century of Lepanto
and Lope. What Hispanophile would not have advised Maurice
Barrès or Dr. Rodríguez Larreta to make such a choice! Menard,
as if it were the most natural thing in the world, eludes them. In
his work there are neither bands of gypsies, conquistadors, mys-
tics, Philip the Seconds, nor autos-da-fé. He disregards or pro-
scribes local color. This disdain indicates a new approach to the
historical novel. This disdain condemns *Salammbô* without
appeal.

It is no less astonishing to consider isolated chapters. Let us
examine, for instance, Chapter XXXVIII of Part One "which
treats of the curious discourse that Don Quixote delivered on the
subject of arms and letters." As is known, Don Quixote (like
Quevedo in a later, analogous passage of *La hora de todos*)
passes judgment against letters and in favor of arms. Cervantes
was an old soldier, which explains such a judgment. But that the
Don Quixote of Pierre Menard—a contemporary of *La trahison
des clercs* and Bertrand Russell—should relapse into these
nebulous sophistries! Madame Bachelier has seen in them an
admirable and typical subordination of the author to the psychol-
ogy of the hero; others (by no means perspicaciously) a *tran-
scription* of *Don Quixote;* the Baroness de Bacourt, the influence
of Nietzsche. To this third interpretation (which seems to me
irrefutable) I do not know if I would dare to add a fourth, which
coincides very well with the divine modesty of Pierre Menard: his
resigned or ironic habit of propounding ideas which were the
strict reverse of those he preferred. (One will remember his
diatribe against Paul Valéry in the ephemeral journal of the
superrealist Jacques Reboul.) The text of Cervantes and that of
Menard are verbally identical, but the second is almost infinitely
richer. (More ambiguous, his detractors will say; but ambiguity
is a richness.) It is a revelation to compare the *Don Quixote* of
Menard with that of Cervantes. The latter, for instance, wrote
(*Don Quixote,* Part One, Chapter Nine):

. . . *la verdad, cuya madre es la historia, émula del tiempo, depósito
de las acciones, testigo de lo pasado, ejemplo y aviso de lo presente,
advertencia de lo por venir.*

[. . . truth, whose mother is history, who is the rival of time, depository of deeds, witness of the past, example and lesson to the present, and warning to the future.]

Written in the seventeenth century, written by the "ingenious layman" Cervantes, this enumeration is a mere rhetorical eulogy of history. Menard, on the other hand, writes:

. . . *la verdad, cuya madre es la historia, émula del tiempo, depósito de las acciones, testigo de lo pasado, ejemplo y aviso de lo presente, advertencia de lo por venir.*

[. . . truth, whose mother is history, who is the rival of time, depository of deeds, witness of the past, example and lesson to the present, and warning to the future.]

History, *mother* of truth; the idea is astounding. Menard, a contemporary of William James, does not define history as an investigation of reality, but as its origin. Historical truth, for him, is not what took place; it is what we think took place. The final clauses—*example and lesson to the present, and warning to the future*—are shamelessly pragmatic.

Equally vivid is the contrast in styles. The archaic style of Menard—in the last analysis, a foreigner—suffers from a certain affectation. Not so that of his precursor, who handles easily the ordinary Spanish of his time.

There is no intellectual exercise which is not ultimately useless. A philosophical doctrine is in the beginning a seemingly true description of the universe; as the years pass it becomes a mere chapter—if not a paragraph or a noun—in the history of philosophy. In literature, this ultimate decay is even more notorious. "*Don Quixote*," Menard once told me, "was above all an agreeable book; now it is an occasion for patriotic toasts, grammatical arrogance and obscene deluxe editions. Glory is an incomprehension, and perhaps the worst."

These nihilist arguments contain nothing new; what is unusual is the decision Pierre Menard derived from them. He resolved to outstrip that vanity which awaits all the woes of mankind; he undertook a task that was complex in the extreme and futile from the outset. He dedicated his conscience and

nightly studies to the repetition of a pre-existing book in a foreign tongue. The number of rough drafts kept on increasing; he tenaciously made corrections and tore up thousands of manuscript pages.[3] He did not permit them to be examined, and he took great care that they would not survive him. It is in vain that I have tried to reconstruct them.

I have thought that it is legitimate to consider the "final" *Don Quixote* as a kind of palimpsest, in which should appear traces—tenuous but not undecipherable—of the "previous" handwriting of our friend. Unfortunately, only a second Pierre Menard, inverting the work of the former, could exhume and resuscitate these Troys. . . .

"To think, analyze and invent," he also wrote me, "are not anomalous acts, but the normal respiration of the intelligence. To glorify the occasional fulfillment of this function, to treasure ancient thoughts of others, to remember with incredulous amazement that the *doctor universalis* thought, is to confess our languor or barbarism. Every man should be capable of all ideas, and I believe that in the future he will be."

Menard (perhaps without wishing to) has enriched, by means of a new technique, the hesitant and rudimentary art of reading: the technique is one of deliberate anachronism and erroneous attributions. This technique, with its infinite applications, urges us to run through the *Odyssey* as if it were written after the *Aeneid*, and to read *Le jardin du Centaure* by Madame Henri Bachelier as if it were by Madame Henri Bachelier. This technique would fill the dullest books with adventure. Would not the attributing of *The Imitation of Christ* to Louis Ferdinand Céline or James Joyce be a sufficient renovation of its tenuous spiritual counsels?

Nîmes
1939

—TRANSLATED BY ANTHONY BONNER

3. I remember his square-ruled notebooks, the black streaks where he had crossed out words, his peculiar typographical symbols and his insect-like handwriting. In the late afternoon he liked to go for walks on the outskirts of Nîmes; he would take a notebook with him and make a gay bonfire.

Gogol's wife

Tommaso Landolfi

AT THIS point, confronted with the whole complicated affair of
Nikolai Vassilevitch's wife, I am overcome by hesitation. Have
I any right to disclose something which is unknown to the whole
world, which my unforgettable friend himself kept hidden from
the world (and he had his reasons), and which I am sure will
give rise to all sorts of malicious and stupid misunderstandings?
Something, moreover, which will very probably offend the sensi-
bilities of all sorts of base, hypocritical people, and possibly of
some honest people too, if there are any left? And finally, have
I any right to disclose something before which my own spirit
recoils, and even tends toward a more or less open disapproval?

But the fact remains that, as a biographer, I have certain
firm obligations. Believing as I do that every bit of information
about so lofty a genius will turn out to be of value to us and to
future generations, I cannot conceal something which in any
case has no hope of being judged fairly and wisely until the end
of time. Moreover, what right have we to condemn? Is it given
to us to know, not only what intimate needs, but even what
higher and wider ends may have been served by those very deeds
of a lofty genius which perchance may appear to us vile? No
indeed, for we understand so little of these privileged natures.
"It is true," a great man once said, "that I also have to pee, but
for quite different reasons."

But without more ado I will come to what I know beyond
doubt, and can prove beyond question, about this controversial
matter, which will now—I dare to hope—no longer be so. I will
not trouble to recapitulate what is already known of it, since I

do not think this should be necessary at the present stage of development of Gogol studies.

Let me say it at once: Nikolai Vassilevitch's wife was not a woman. Nor was she any sort of human being, nor any sort of living creature at all, whether animal or vegetable (although something of the sort has sometimes been hinted). She was quite simply a balloon. Yes, a balloon; and this will explain the perplexity, or even indignation, of certain biographers who were also the personal friends of the Master, and who complained that, although they often went to his house, they never saw her and "never even heard her voice." From this they deduced all sorts of dark and disgraceful complications—yes, and criminal ones too. No, gentlemen, everything is always simpler than it appears. You did not hear her voice simply because she could not speak, or to be more exact, she could only speak in certain conditions, as we shall see. And it was always, except once, in tête-à-tête with Nikolai Vassilevitch. So let us not waste time with any cheap or empty refutations but come at once to as exact and complete a description as possible of the being or object in question.

Gogol's so-called wife was an ordinary dummy made of thick rubber, naked at all seasons, buff in tint, or as is more commonly said, flesh-colored. But since women's skins are not all of the same color, I should specify that hers was a light-colored, polished skin, like that of certain brunettes. It, or she, was, it is hardly necessary to add, of feminine sex. Perhaps I should say at once that she was capable of very wide alterations of her attributes without, of course, being able to alter her sex itself. She could sometimes appear to be thin, with hardly any breasts and with narrow hips more like a young lad than a woman, and at other times to be excessively well-endowed or—let us not mince matters—fat. And she often changed the color of her hair, both on her head and elsewhere on her body, though not necessarily at the same time. She could also seem to change in all sorts of other tiny particulars, such as the position of moles, the vitality of the mucous membranes and so forth. She could even to a certain extent change the very color of her skin. One is faced with the necessity of asking oneself who she really was, or whether

it would be proper to speak of a single "person"—and in fact we shall see that it would be imprudent to press this point.

The cause of these changes, as my readers will already have understood, was nothing else but the will of Nikolai Vassilevitch himself. He would inflate her to a greater or lesser degree, would change her wig and her other tufts of hair, would grease her with ointments and touch her up in various ways so as to obtain more or less the type of woman which suited him at that moment. Following the natural inclinations of his fancy, he even amused himself sometimes by producing grotesque or monstrous forms; as will be readily understood, she became deformed when inflated beyond a certain point or if she remained below a certain pressure.

But Gogol soon tired of these experiments, which he held to be "after all, not very respectful" to his wife, whom he loved in his own way—however inscrutable it may remain to us. He loved her, but which of these incarnations, we may ask ourselves, did he love? Alas, I have already indicated that the end of the present account will furnish some sort of an answer. And how can I have stated above that it was Nikolai Vassilevitch's will which ruled that woman? In a certain sense, yes, it is true; but it is equally certain that she soon became no longer his slave but his tyrant. And here yawns the abyss, or if you prefer it, the Jaws of Tartarus. But let us not anticipate.

I have said that Gogol obtained with his manipulations *more or less* the type of woman which he needed from time to time. I should add that when, in rare cases, the form he obtained perfectly incarnated his desire, Nikolai Vassilevitch fell in love with it "exclusively," as he said in his own words, and that this was enough to render "her" stable for a certain time—until he fell out of love with "her." I counted no more than three or four of these violent passions—or, as I suppose they would be called today, infatuations—in the life (dare I say in the conjugal life?) of the great writer. It will be convenient to add here that a few years after what one may call his marriage, Gogol had even given a name to his wife. It was Caracas, which is, unless I am mistaken, the capital of Venezuela. I have never been able to discover the reason for this choice: great minds are so capricious!

Speaking only of her normal appearance, Caracas was what is called a fine woman—well built and proportioned in every part. She had every smallest attribute of her sex properly disposed in the proper location. Particularly worthy of attention were her genital organs (if the adjective is permissible in such a context). They were formed by means of ingenious folds in the rubber. Nothing was forgotten, and their operation was rendered easy by various devices, as well as by the internal pressure of the air.

Caracas also had a skeleton, even though a rudimentary one. Perhaps it was made of whalebone. Special care had been devoted to the construction of the thoracic cage, of the pelvic basin and of the cranium. The first two systems were more or less visible in accordance with the thickness of the fatty layer, if I may so describe it, which covered them. It is a great pity that Gogol never let me know the name of the creator of such a fine piece of work. There was an obstinacy in his refusal which was never quite clear to me.

Nikolai Vassilevitch blew his wife up through the anal sphincter with a pump of his own invention, rather like those which you hold down with your two feet and which are used today in all sorts of mechanical workshops. Situated in the anus was a little one-way valve, or whatever the correct technical description would be, like the mitral valve of the heart, which, once the body was inflated, allowed more air to come in but none to go out. To deflate, one unscrewed a stopper in the mouth, at the back of the throat.

And that, I think, exhausts the description of the most noteworthy peculiarities of this being. Unless perhaps I should mention the splendid rows of white teeth which adorned her mouth and the dark eyes which, in spite of their immobility, perfectly simulated life. Did I say simulate? Good heavens, simulate is not the word! Nothing seems to be the word, when one is speaking of Caracas! Even these eyes could undergo a change of color, by means of a special process to which, since it was long and tiresome, Gogol seldom had recourse. Finally, I should speak of her voice, which it was only once given to me to hear. But I cannot do that without going more fully into the relationship

between husband and wife, and in this I shall no longer be able to answer to the truth of everything with absolute certitude. On my conscience I could not—so confused, both in itself and in my memory, is that which I now have to tell.

Here, then, as they occur to me, are some of my memories.

The first and, as I said, the last time I ever heard Caracas speak to Nikolai Vassilevitch was one evening when we were absolutely alone. We were in the room where the woman, if I may be allowed the expression, lived. Entrance to this room was strictly forbidden to everybody. It was furnished more or less in the Oriental manner, had no windows and was situated in the most inaccessible part of the house. I did know that she could talk, but Gogol had never explained to me the circumstances under which this happened. There were only the two of us, or three, in there. Nikolai Vassilevitch and I were drinking vodka and discussing Butkov's novel. I remember that we left this topic, and he was maintaining the necessity for radical reforms in the laws of inheritance. We had almost forgotten her. It was then that, with a husky and submissive voice, like Venus on the nuptial couch, she said point-blank: "I want to go poo poo."

I jumped, thinking I had misheard, and looked across at her. She was sitting on a pile of cushions against the wall; that evening she was a soft, blonde beauty, rather well-covered. Her expression seemed commingled of shrewdness and slyness, childishness and irresponsibility. As for Gogol, he blushed violently and, leaping on her, stuck two fingers down her throat. She immediately began to shrink and to turn pale; she took on once again that lost and astonished air which was especially hers, and was in the end reduced to no more than a flabby skin on a perfunctory bony armature. Since, for practical reasons which will readily be divined, she had an extraordinarily flexible backbone, she folded up almost in two, and for the rest of the evening she looked up at us from where she had slithered to the floor, in utter abjection.

All Gogol said was: "She only does it for a joke, or to annoy me, because as a matter of fact she does not have such needs." In the presence of other people, that is to say of me, he generally made a point of treating her with a certain disdain.

We went on drinking and talking, but Nikolai Vassilevitch seemed very much disturbed and absent in spirit. Once he suddenly interrupted what he was saying, seized my hand in his and burst into tears. "What can I do now?" he exclaimed. "You understand, Foma Paskalovitch, that I loved her?"

It is necessary to point out that it was impossible, except by a miracle, ever to repeat any of Caracas' forms. She was a fresh creation every time, and it would have been wasted effort to seek to find again the exact proportions, the exact pressure, and so forth, of a former Caracas. Therefore the plumpish blonde of that evening was lost to Gogol from that time forth forever; this was in fact the tragic end of one of those few loves of Nikolai Vassilevitch, which I described above. He gave me no explanation; he sadly rejected my proffered comfort, and that evening we parted early. But his heart had been laid bare to me in that outburst. He was no longer so reticent with me, and soon had hardly any secrets left. And this, I may say in parenthesis, caused me very great pride.

It seems that things had gone well for the "couple" at the beginning of their life together. Nikolai Vassilevitch had been content with Caracas and slept regularly with her in the same bed. He continued to observe this custom till the end, saying with a timid smile that no companion could be quieter or less importunate than she. But I soon began to doubt this, especially judging by the state he was sometimes in when he woke up. Then, after several years, their relationship began strangely to deteriorate.

All this, let it be said once and for all, is no more than a schematic attempt at an explanation. About that time the woman actually began to show signs of independence or, as one might say, of autonomy. Nikolai Vassilevitch had the extraordinary impression that she was acquiring a personality of her own, indecipherable perhaps, but still distinct from his, and one which slipped through his fingers. It is certain that some sort of continuity was established between each of her appearances—between all those brunettes, those blondes, those redheads and auburn-headed girls, between those plump, those slim, those dusky or snowy or golden beauties, there was a certain something in com-

mon. At the beginning of this chapter I cast some doubt on the propriety of considering Caracas as a unitary personality; nevertheless I myself could not quite, whenever I saw her, free myself of the impression that, however unheard of it may seem, this was fundamentally the same woman. And it may be that this was why Gogol felt he had to give her a name.

An attempt to establish in what precisely subsisted the common attributes of the different forms would be quite another thing. Perhaps it was no more and no less than the creative afflatus of Nikolai Vassilevitch himself. But no, it would have been too singular and strange if he had been so much divided off from himself, so much averse to himself. Because whoever she was, Caracas was a disturbing presence and even—it is better to be quite clear—a hostile one. Yet neither Gogol nor I ever succeeded in formulating a remotely tenable hypothesis as to her true nature; when I say formulate, I mean in terms which would be at once rational and accessible to all. But I cannot pass over an extraordinary event which took place at this time.

Caracas fell ill of a shameful disease—or rather Gogol did—though he was not then having, nor had he ever had, any contact with other women. I will not even try to describe how this happened, or where the filthy complaint came from; all I know is that it happened. And that my great, unhappy friend would say to me: "So, Foma Paskalovitch, you see what lay at the heart of Caracas; it was the spirit of syphilis."

Sometimes he would even blame himself in a quite absurd manner; he was always prone to self-accusation. This incident was a real catastrophe as far as the already obscure relationship between husband and wife, and the hostile feelings of Nikolai Vassilevitch himself, were concerned. He was compelled to undergo long-drawn-out and painful treatment—the treatment of those days—and the situation was aggravated by the fact that the disease in the woman did not seem to be easily curable. Gogol deluded himself for some time that, by blowing his wife up and down and furnishing her with the most widely divergent aspects, he could obtain a woman immune from the contagion, but he was forced to desist when no results were forthcoming.

I shall be brief, seeking not to tire my readers, and also be-

cause what I remember seems to become more and more con-
fused. I shall therefore hasten to the tragic conclusion. As to this
last, however, let there be no mistake. I must once again make
it clear that I am very sure of my ground. I was an eyewitness.
Would that I had not been!

The years went by. Nikolai Vassilevitch's distaste for his wife
became stronger, though his love for her did not show any signs
of diminishing. Toward the end, aversion and attachment strug-
gled so fiercely with each other in his heart that he became quite
stricken, almost broken up. His restless eyes, which habitually
assumed so many different expressions and sometimes spoke so
sweetly to the heart of his interlocutor, now almost always shone
with a fevered light, as if he were under the effect of a drug. The
strangest impulses arose in him, accompanied by the most sense-
less fears. He spoke to me of Caracas more and more often, accus-
ing her of unthinkable and amazing things. In these regions I
could not follow him, since I had but a sketchy acquaintance with
his wife, and hardly any intimacy—and above all since my sensi-
bility was so limited compared with his. I shall accordingly re-
strict myself to reporting some of his accusations, without refer-
ence to my personal impressions.

"Believe it or not, Foma Paskalovitch," he would, for example,
often say to me: "Believe it or not, *she's aging!*" Then, unspeak-
ably moved, he would, as was his way, take my hands in his. He
also accused Caracas of giving herself up to solitary pleasures,
which he had expressly forbidden. He even went so far as to
charge her with betraying him, but the things he said became so
extremely obscure that I must excuse myself from any further
account of them.

One thing that appears certain is that toward the end Caracas,
whether aged or not, had turned into a bitter creature, querulous,
hypocritical and subject to religious excess. I do not exclude the
possibility that she may have had an influence on Gogol's moral
position during the last period of his life, a position which is suffi-
ciently well known. The tragic climax came one night quite un-
expectedly when Nikolai Vassilevitch and I were celebrating his
silver wedding—one of the last evenings we were to spend to-
gether. I neither can nor should attempt to set down what it was

that led to his decision, at a time when to all appearances he was resigned to tolerating his consort. I know not what new events had taken place that day. I shall confine myself to the facts; my readers must make what they can of them.

That evening Nikolai Vassilevitch was unusually agitated. His distaste for Caracas seemed to have reached an unprecedented intensity. The famous "pyre of vanities"—the burning of his manuscripts—had already taken place; I should not like to say whether or not at the instigation of his wife. His state of mind had been further inflamed by other causes. As to his physical condition, this was ever more pitiful, and strengthened my impression that he took drugs. All the same, he began to talk in a more or less normal way about Belinsky, who was giving him some trouble with his attacks on the *Selected Correspondence*. Then suddenly, tears rising to his eyes, he interrupted himself and cried out: "No. No. It's too much, too much. I can't go on any longer," as well as other obscure and disconnected phrases which he would not clarify. He seemed to be talking to himself. He wrung his hands, shook his head, got up and sat down again after having taken four or five anxious steps round the room. When Caracas appeared, or rather when we went in to her later in the evening in her Oriental chamber, he controlled himself no longer and began to behave like an old man, if I may so express myself, in his second childhood, quite giving way to his absurd impulses. For instance, he kept nudging me and winking and senselessly repeating: "There she is, Foma Paskalovitch; there she is!" Meanwhile she seemed to look up at us with a disdainful attention. But behind these "mannerisms" one could feel in him a real repugnance, a repugnance which had, I suppose, now reached the limits of the endurable. Indeed . . .

After a certain time Nikolai Vassilevitch seemed to pluck up courage. He burst into tears, but somehow they were more manly tears. He wrung his hands again, seized mine in his, and walked up and down, muttering: "That's enough! We can't have any more of this. This is an unheard of thing. How can such a thing be happening to me? How can a man be expected to put up with *this?*"

He then leapt furiously upon the pump, the existence of

which he seemed just to have remembered, and, with it in his hand, dashed like a whirlwind to Caracas. He inserted the tube in her anus and began to inflate her. . . . Weeping the while, he shouted like one possessed: "Oh, how I love her, how I love her, my poor, poor darling! . . . But she's going to burst! Unhappy Caracas, most pitiable of God's creatures! But die she must!"

Caracas was swelling up. Nikolai Vassilevitch sweated, wept and pumped. I wished to stop him but, I know not why, I had not the courage. She began to become deformed and shortly assumed the most monstrous aspect; and yet she had not given any signs of alarm—she was used to these jokes. But when she began to feel unbearably full, or perhaps when Nikolai Vassilevitch's intentions became plain to her, she took on an expression of bestial amazement, even a little beseeching, but still without losing that disdainful look. She was afraid, she was even committing herself to his mercy, but still she could not believe in the immediate approach of her fate; she could not believe in the frightful audacity of her husband. He could not see her face because he was behind her. But I looked at her with fascination, and did not move a finger.

At last the internal pressure came through the fragile bones at the base of her skull, and printed on her face an indescribable rictus. Her belly, her thighs, her lips, her breasts and what I could see of her buttocks had swollen to incredible proportions. All of a sudden she belched, and gave a long hissing groan; both these phenomena one could explain by the increase in pressure, which had suddenly forced a way out through the valve in her throat. Then her eyes bulged frantically, threatening to jump out of their sockets. Her ribs flared wide apart and were no longer attached to the sternum, and she resembled a python digesting a donkey. A donkey, did I say? An ox! An elephant! At this point I believed her already dead, but Nikolai Vassilevitch, sweating, weeping and repeating: "My dearest! My beloved! My best!" continued to pump.

She went off unexpectedly and, as it were, all of a piece. It was not one part of her skin which gave way and the rest which followed, but her whole surface at the same instant. She scattered in the air. The pieces fell more or less slowly, according to their

size, which was in no case above a very restricted one. I distinctly remember a piece of her cheek, with some lip attached, hanging on the corner of the mantelpiece. Nikolai Vassilevitch stared at me like a madman. Then he pulled himself together and, once more with furious determination, he began carefully to collect those poor rags which once had been the shining skin of Caracas, and all of her.

"Good-by, Caracas," I thought I heard him murmur, "Good-by! You were too pitiable!" And then suddenly and quite audibly: "The fire! The fire! She too must end up in the fire." He crossed himself—with his left hand, of course. Then, when he had picked up all those shriveled rags, even climbing on the furniture so as not to miss any, he threw them straight on the fire in the hearth, where they began to burn slowly and with an excessively unpleasant smell. Nikolai Vassilevitch, like all Russians, had a passion for throwing important things in the fire.

Red in the face, with an inexpressible look of despair, and yet of sinister triumph too, he gazed on the pyre of those miserable remains. He had seized my arm and was squeezing it convulsively. But those traces of what had once been a being were hardly well alight when he seemed yet again to pull himself together, as if he were suddenly remembering something or taking a painful decision. In one bound he was out of the room.

A few seconds later I heard him speaking to me through the door in a broken, plaintive voice: "Foma Paskalovitch, I want you to promise not to look. *Golubchik*, promise not to look at me when I come in."

I don't know what I answered, or whether I tried to reassure him in any way. But he insisted, and I had to promise him, as if he were a child, to hide my face against the wall and only turn round when he said I might. The door then opened violently and Nikolai Vassilevitch burst into the room and ran to the fireplace.

And here I must confess my weakness, though I consider it justified by the extraordinary circumstances. I looked round before Nikolai Vassilevitch told me I could; it was stronger than me. I was just in time to see him carrying something in his arms, something which he threw on the fire with all the rest, so that it suddenly flared up. At that, since the desire to *see* had entirely

mastered every other thought in me, I dashed to the fireplace. But Nikolai Vassilevitch placed himself between me and it and pushed me back with a strength of which I had not believed him capable. Meanwhile the object was burning and giving off clouds of smoke. And before he showed any sign of calming down there was nothing left but a heap of silent ashes.

The true reason why I wished to see was because I had already glimpsed. But it was only a glimpse, and perhaps I should not allow myself to introduce even the slightest element of uncertainty into this true story. And yet, an eyewitness account is not complete without a mention of that which the witness knows with less than complete certainty. To cut a long story short, that something was a baby. Not a flesh and blood baby, of course, but more something in the line of a rubber doll or a model. Something, which, to judge by its appearance, could have been called *Caracas' son*.

Was I mad too? That I do not know, but I do know that this was what I saw, not clearly, but with my own eyes. And I wonder why it was that when I was writing this just now I didn't mention that when Nikolai Vassilevitch came back into the room he was muttering between his clenched teeth: "Him too! Him too!"

And that is the sum of my knowledge of Nikolai Vassilevitch's wife. In the next chapter I shall tell what happened to him afterwards, and that will be the last chapter of his life. But to give an interpretation of his feelings for his wife, or indeed for anything, is quite another and more difficult matter, though I have attempted it elsewhere in this volume, and refer the reader to that modest effort. I hope I have thrown sufficient light on a most controversial question and that I have unveiled the mystery, if not of Gogol, then at least of his wife. In the course of this I have implicitly given the lie to the insensate accusation that he ill-treated or even beat his wife, as well as other like absurdities. And what else can be the goal of a humble biographer such as the present writer but to serve the memory of that lofty genius who is the object of this study?

TRANSLATED BY WAYLAND YOUNG

rhinoceros

Eugène Ionesco

In Memory of André Frédérique

WE were sitting outside the café, my friend Jean and I, peacefully talking about one thing and another, when we caught sight of it on the opposite pavement, huge and powerful, panting noisily, charging straight ahead and brushing against market stalls—a rhinoceros. People in the street stepped hurriedly aside to let it pass. A housewife uttered a cry of terror, her basket dropped from her hands, the wine from a broken bottle spread over the pavement, and some pedestrians, one of them an elderly man, rushed into the shops. It was all over like a flash of lightning. People emerged from their hiding-places and gathered in groups which watched the rhinoceros disappear into the distance, made some comments on the incident and then dispersed.

My own reactions are slowish. I absent-mindedly took in the image of the rushing beast, without ascribing any very great importance to it. That morning, moreover, I was feeling tired and my mouth was sour, as a result of the previous night's excesses; we had been celebrating a friend's birthday. Jean had not been at the party; and when the first moment of surprise was over, he exclaimed:

"A rhinoceros at large in town! doesn't that surprise you? It ought not to be allowed."

"True," I said, "I hadn't thought of that. It's dangerous."

"We ought to protest to the Town Council."

"Perhaps it's escaped from the Zoo," I said.

"You're dreaming," he replied. "There hasn't been a Zoo in our town since the animals were decimated by the plague in the seventeenth century."

"Perhaps it belongs to the circus?"

"What circus? The Council has forbidden itinerant entertainers to stop on municipal territory. None have come here since we were children."

"Perhaps it has lived here ever since, hidden in the marshy woods round about," I answered with a yawn.

"You're completely lost in a dense alcoholic haze. . . ."

"Which rises from the stomach. . . ."

"Yes. And has pervaded your brain. What marshy woods can you think of round about here? Our province is so arid they call it Little Castile."

"Perhaps it sheltered under a pebble? Perhaps it made its nest on a dry branch?"

"How tiresome you are with your paradoxes. You're quite incapable of talking seriously."

"Today, particularly."

"Today and every other day."

"Don't lose your temper, my dear Jean. We're not going to quarrel about that creature. . . ."

We changed the subject of our conversation and began to talk about the weather again, about the rain which fell so rarely in our region, about the need to provide our sky with artificial clouds, and other banal and insoluble questions.

We parted. It was Sunday. I went to bed and slept all day: another wasted Sunday. On Monday morning I went to the office, making a solemn promise to myself never to get drunk again, and particularly not on Saturdays, so as not to spoil the following Sundays. For I had one single free day a week and three weeks' holiday in the summer. Instead of drinking and making myself ill, wouldn't it be better to keep fit and healthy, to spend my precious moments of freedom in a more intelligent fashion: visiting museums, reading literary magazines and listening to lectures? And instead of spending all my available money on drink, wouldn't it be preferable to buy tickets for interesting plays? I was still unfamiliar with the avant-garde theatre, of which I had heard so much talk, I had never seen a play by Ionesco. Now or never was the time to bring myself up to date.

The following Sunday I met Jean once again at the same café.

"I've kept my promise," I said, shaking hands with him.

"What promise have you kept?" he asked.

"My promise to myself. I've vowed to give up drinking. Instead of drinking I've decided to cultivate my mind. Today I am clear-headed. This afternoon I'm going to the Municipal Museum and this evening I've a ticket for the theatre. Won't you come with me?"

"Let's hope your good intentions will last," replied Jean. "But I can't go with you. I'm meeting some friends at the brasserie."

"Oh, my dear fellow, now it's you who are setting a bad example. You'll get drunk!"

"Once in a way doesn't imply a habit," replied Jean irritably. "Whereas you. . . ."

The discussion was about to take a disagreeable turn, when we heard a mighty trumpeting, the hurried clatter of some perissodactyl's hoofs, cries, a cat's mewing; almost simultaneously we saw a rhinoceros appear, then disappear, on the opposite pavement, panting noisily and charging straight ahead.

Immediately afterwards a woman appeared holding in her arms a shapeless, bloodstained little object:

"It's run over my cat," she wailed, "it's run over my cat!"

The poor dishevelled woman, who seemed the very embodiment of grief, was soon surrounded by people offering sympathy.

Jean and I got up. We rushed across the street to the side of the unfortunate woman.

"All cats are mortal," I said stupidly, not knowing how to console her.

"It came past my shop last week!" the grocer recalled.

"It wasn't the same one," Jean declared. "It wasn't the same one: last week's had two horns on its nose, it was an Asian rhinoceros; this one had only one, it's an African rhinoceros."

"You're talking nonsense," I said irritably. "How could you distinguish its horns? The animal rushed past so fast that we could hardly see it; you hadn't time to count them. . . ."

"I don't live in a haze," Jean retorted sharply. "I'm clear-headed, I'm quick at figures."

"He was charging with his head down."

"That made it all the easier to see."

"You're a pretentious fellow, Jean. You're a pedant, who isn't

even sure of his own knowledge. For in the first place it's the Asian rhinoceros that has one horn on its nose, and the African rhinoceros that has two!"

"You're quite wrong, it's the other way about."

"Would you like to bet on it?"

"I won't bet against you. You're the one who has two horns," he cried, red with fury, "you Asiatic you!" (He stuck to his guns.) "I haven't any horns. I shall never wear them. And I'm not an Asiatic either. In any case, Asiatics are just like other people."

"They're yellow!" he shouted, beside himself with rage.

Jean turned his back on me and strode off, cursing.

I felt a fool. I ought to have been more conciliatory, and not contradicted him: for I knew he could not bear it. The slightest objection made him foam at the mouth. This was his only fault, for he had a heart of gold and had done me countless good turns. The few people who were there and who had been listening to us had, as a result, quite forgotten about the poor woman's squashed cat. They crowded round me, arguing: some maintained that the Asian rhinoceros was indeed one-horned, and that I was right; others maintained that on the contrary the African rhinoceros was one-horned, and that therefore the previous speaker had been right.

"That is not the question," interposed a gentleman (straw boater, small moustache, eyeglass, a typical logician's head) who had hitherto stood silent. "The discussion turned on a problem from which you have wandered. You began by asking yourselves whether today's rhinoceros is the same as last Sunday's or whether it is a different one. That is what must be decided. You may have seen one and the same one-horned rhinoceros on two occasions, or you may have seen one and the same two-horned rhinoceros on two occasions. Or again, you may have seen first one one-horned rhinoceros and then a second one-horned rhinoceros. Or else, first one two-horned rhinoceros and then a second two-horned rhinoceros. If on the first occasion you had seen a two-horned rhinoceros, and on the second a one-horned rhinoceros, that would not be conclusive either. It might be that since last week the rhinoceros had lost one of his horns, and that the one you saw today was the same. Or it might be that two two-

horned rhinoceroses had each lost one of their horns. If you could prove that on the first occasion you had seen a one-horned rhinoceros, whether it was Asian or African, and today a two-horned rhinoceros, whether it was African or Asian—that doesn't matter —then we might conclude that two different rhinoceroses were involved, for it is most unlikely that a second horn could grow in a few days, to any visible extent, on a rhinoceros's nose; this would mean that an Asian, or African, rhinoceros had become an African, or Asian, rhinoceros, which is logically impossible, since the same creature cannot be born in two places at once or even successively."

"That seems clear to me," I said. "But it doesn't settle the question."

"Of course," retorted the gentleman, smiling with a knowledgeable air, "only the problem has now been stated correctly."

"That's not the problem either," interrupted the grocer, who being no doubt of an emotional nature cared little about logic. "Can we allow our cats to be run over under our eyes by two-horned or one-horned rhinoceroses, be they Asian or African?"

"He's right, he's right," everybody exclaimed. "We can't allow our cats to be run over, by rhinoceroses or anything else!"

The grocer pointed with a theatrical gesture to the poor weeping woman, who still held and rocked in her arms the shapeless, bleeding remains of what had once been her cat.

Next day, in the paper, under the heading Road Casualties among Cats, there were two lines describing the death of the poor creature, "crushed underfoot by a pachyderm," it was said, without further details.

On Sunday afternoon I hadn't visited a museum; in the evening I hadn't gone to the theatre. I had moped at home by myself, overwhelmed by remorse at having quarrelled with Jean.

"He's so susceptible, I ought to have spared his feelings," I told myself. "It's absurd to lose one's temper about something like that . . . about the horns of a rhinoceros that one had never seen before . . . a native of Africa or of India, such faraway countries, what could it matter to me? Whereas Jean had always been my

friend, a friend who . . . to whom I owed so much . . . and who. . . ."

In short, while promising myself to go and see Jean as soon as possible and to make it up with him, I had drunk an entire bottle of brandy without noticing. But I did indeed notice it the next day: a sore head, a foul mouth, an uneasy conscience; I was really most uncomfortable. But duty before everything: I got to the office on time, or almost. I was able to sign the register just before it was taken away.

"Well, so you've seen rhinoceroses too?" asked the chief clerk, who, to my great surprise, was already there.

"Sure I've seen him," I said, taking off my town jacket and putting on my old jacket with the frayed sleeves, good enough for work.

"Oh, now you see, I'm not crazy!" exclaimed the typist Daisy excitedly. (How pretty she was, with her pink cheeks and fair hair! I found her terribly attractive. If I could fall in love with anybody, it would be with her. . . .) "A one-horned rhinoceros!"

"Two-horned!" corected my colleague Emile Dudard, Bachelor of Law, eminent jurist, who looked forward to a brilliant future with the firm and, possibly, in Daisy's affections.

"*I've* not seen it! And I don't believe in it!" declared Botard, an ex-schoolmaster who acted as archivist. "And nobody's ever seen one in this part of the world, except in the illustrations to school text-books. These rhinoceroses have blossomed only in the imagination of ignorant women. The thing's a myth, like flying saucers."

I was about to point out to Botard that the expression "blossomed" applied to a rhinoceros, or to a number of them, seemed to me inappropriate, when the jurist exclaimed:

"All the same, a cat was crushed, and before witnesses!"

"Collective psychosis," retorted Botard, who was a freethinker, "just like religion, the opium of the people!"

"I believe in flying saucers myself," remarked Daisy.

The chief clerk cut short our argument:

"That'll do! Enough chatter! Rhinoceros or no rhinoceros, flying saucers or no flying saucers, work's got to be done."

The typist started typing. I sat down at my desk and became engrossed in my documents. Emile Dudard began correcting the proofs of a commentary on the Law for the Repression of Alcoholism, while the chief clerk, slamming the door, retired into his study.

"It's a hoax!" Botard grumbled once more, aiming his remarks at Dudard. "It's your propaganda that spreads these rumours!"

"It's not propaganda," I interposed.

"I saw it myself . . ." Daisy confirmed simultaneously.

"You make me laugh," said Dudard to Botard. "Propaganda? For what?"

"You know that better than I do! Don't act the simpleton!"

"In any case, *I'm* not paid by the Pontenegrins!"

"That's an insult!" cried Botard, thumping the table with his fist. The door of the chief clerk's room opened suddenly and his head appeared.

"Monsieur Boeuf hasn't come in today."

"Quite true, he's not here," I said.

"Just when I needed him. Did he tell anyone he was ill? If this goes on I shall give him the sack. . . ."

It was not the first time that the chief clerk had threatened our colleague in this way.

"Has one of you got the key to his desk?" he went on.

Just then Madame Boeuf made her appearance. She seemed terrified.

"I must ask you to excuse my husband. He went to spend the weekend with relations. He's had a slight attack of 'flu. Look, that's what he says in his telegram. He hopes to be back on Wednesday. Give me a glass of water . . . and a chair!" she gasped, collapsing on to the chair we offered her.

"It's very tiresome! But it's no reason to get so alarmed!" remarked the chief clerk.

"I was pursued by a rhinoceros all the way from home," she stammered.

"With one horn or two?" I asked.

"You make me laugh!" exclaimed Botard.

"Why don't you let her speak!" protested Dudard.

Madame Boeuf had to make a great effort to be explicit:

"It's downstairs, in the doorway. It seems to be trying to come upstairs."

At that very moment a tremendous noise was heard: the stairs were undoubtedly giving way under a considerable weight. We rushed out on to the landing. And there, in fact, amidst the debris, was a rhinoceros, its head lowered, trumpeting in an agonized and agonizing voice and turning vainly round and round. I was able to make out two horns.

"It's an African rhinoceros . . ." I said, "or rather an Asian one."

My mind was so confused that I was no longer sure whether two horns were characteristic of the Asian or of the African rhinoceros, whether a single horn was characteristic of the African or of the Asian rhinoceros, or whether on the contrary two horns . . . In short, I was floundering mentally, while Botard glared furiously at Dudard.

"It's an infamous plot!" and, with an orator's gesture, he pointed at the jurist: "It's your fault!"

"It's yours!" the other retorted.

"Keep calm, this is no time to quarrel!" declared Daisy, trying in vain to pacify them.

"For years now I've been asking the Board to let us have concrete steps instead of that rickety old staircase," said the chief clerk. "Something like this was bound to happen. It was predictable. I was quite right!"

"As usual," Daisy added ironically. "But how shall we get down?"

"I'll carry you in my arms," the chief clerk joked flirtatiously, stroking the typist's cheek, "and we'll jump together!"

"Don't put your horny hand on my face, you pachydermous creature!"

The chief clerk had not time to react. Madame Boeuf, who had got up and come to join us, and who had for some minutes been staring attentively at the rhinoceros which was turning round and and round below us, suddenly uttered a terrible cry:

"It's my husband! Boeuf, my poor dear Boeuf, what has happened to you?"

The rhinoceros, or rather Boeuf, responded with ʋiolent and

yet tender trumpeting, while Madame Boeuf fainted into my arms and Botard, raising his to heaven, stormed: "It's sheer lunacy! What a society!"

When we had recovered from our initial astonishment, we telephoned to the Fire Brigade, who drove up with their ladders and fetched us down. Madame Boeuf, although we advised her against it, rode off on her spouse's back towards their home. She had ample grounds for divorce (but who was the guilty party?) yet she chose rather not to desert her husband in his present state.

At the little bistro where we all went for lunch (all except the Boeufs, of course) we learnt that several rhinoceroses had been seen in various parts of the town: some people said seven, others seventeen, others again said thirty-two. In face of this accumulated evidence Botard could no longer deny the rhinoceric facts. But he knew, he declared, what to think about it. He would explain it to us some day. He knew the "why" of things, the "underside" of the story, the names of those responsible, the aim and significance of the outrage. Going back to the office that afternoon, business or no business, was out of the question. We had to wait for the staircase to be repaired.

I took advantage of this to pay a call on Jean, with the intention of making it up with him. He was in bed.

"I don't feel very well!" he said.

"You know, Jean, we were both right. There are two-horned rhinoceroses in the town as well as one-horned ones. It really doesn't matter where either sort comes from. The only significant thing, in my opinion, is the existence of the rhinoceros in itself."

"I don't feel very well," my friend kept on saying without listening to me, "I don't feel very well!"

"What's the matter with you? I'm so sorry!"

"I'm rather feverish, and my head aches."

More precisely, it was his forehead which was aching. He must have had a knock, he said. And in fact a lump was swelling up there, just above his nose. He had gone a greenish colour, and his voice was hoarse.

"Have you got a sore throat? It may be tonsillitis."

I took his pulse. It was beating quite regularly.

"It can't be very serious. A few days' rest and you'll be all right. Have you sent for the doctor?"

As I was about to let go of his wrist I noticed that his veins were swollen and bulging out. Looking closely I observed that not only were the veins enlarged but that the skin all round them was visibly changing colour and growing hard.

"It may be more serious than I imagined," I thought. "We must send for the doctor," I said aloud.

"I felt uncomfortable in my clothes, and now my pyjamas are too tight," he said in a hoarse voice.

"What's the matter with your skin? It's like leather. . . ." Then, staring at him: "Do you know what happened to Boeuf? He's turned into a rhinoceros."

"Well, what about it? That's not such a bad thing! After all, rhinoceroses are creatures like ourselves, with just as much right to live. . . ."

"Provided they don't imperil our own lives. Aren't you aware of the difference in mentality?"

"Do you think ours is preferable?"

"All the same, we have our own moral code, which I consider incompatible with that of these animals. We have our philosophy, our irreplaceable system of values. . . ."

"Humanism is out of date! You're a ridiculous old sentimentalist. You're talking nonsense."

"I'm surprised to hear you say that, my dear Jean! Have you taken leave of your senses?"

It really looked like it. Blind fury had disfigured his face, and altered his voice to such an extent that I could scarcely understand the words that issued from his lips.

"Such assertions, coming from you. . . ." I tried to resume.

He did not give me a chance to do so. He flung back his blankets, tore off his pyjamas, and stood up in bed, entirely naked (he who was usually the most modest of men!) green with rage from head to foot.

The lump on his forehead had grown longer; he was staring fixedly at me, apparently without seeing me. Or, rather, he must

have seen me quite clearly, for he charged at me with his head lowered. I barely had time to leap to one side; if I hadn't he would have pinned me to the wall.

"You are a rhinoceros!" I cried.

"I'll trample on you! I'll trample on you!" I made out these words as I dashed towards the door.

I went downstairs four steps at a time, while the walls shook as he butted them with his horn, and I heard him utter fearful angry trumpetings.

"Call the police! Call the police! You've got a rhinoceros in the house!" I called out to the tenants who, in great surprise, looked out of their flats as I passed each landing.

On the ground floor I had great difficulty in dodging the rhinoceros which emerged from the concierge's lodge and tried to charge me. At last I found myself out in the street, sweating, my legs limp, at the end of my tether.

Fortunately there was a bench by the edge of the pavement, and I sat down on it. Scarcely had I more or less got back my breath when I saw a herd of rhinoceroses hurrying down the avenue and nearing, at full speed, the place where I was. If only they had been content to stay in the middle of the street! But they were so many that there was not room for them all there, and they overflowed on to the pavement. I leapt off my bench and flattened myself against the wall: snorting, trumpeting, with a smell of leather and of wild animals in heat, they brushed past me and covered me with a cloud of dust. When they had disappeared, I could not go back to sit on the bench; the animals had demolished it and it lay in fragments on the pavement.

I did not find it easy to recover from such emotions. I had to stay at home for several days. Daisy came to see me and kept me informed as to the changes that were taking place.

The chief clerk had been the first to turn into a rhinoceros, to the great disgust of Botard who, nevertheless, became one himself twenty-four hours later.

"One must keep up with one's times!" were his last words as a man.

The case of Botard did not surprise me, in spite of his apparent strength of mind. I found it less easy to understand the chief

clerk's transformation. Of course it might have been involuntary, but one would have expected him to put up more resistance.

Daisy recalled that she had commented on the roughness of his palms the very day that Boeuf had appeared in rhinoceros shape. This must have made a deep impression on him; he had not shown it, but he had certainly been cut to the quick.

"If I hadn't been so outspoken, if I had pointed it out to him more tactfully, perhaps this would never have happened."

"I blame myself, too, for not having been gentler with Jean. I ought to have been friendlier, shown more understanding," I said in my turn.

Daisy informed me that Dudard, too, had been transformed, as had also a cousin of hers whom I did not know. And there were others, mutual friends, strangers.

"There are a great many of them," she said, "about a quarter of the inhabitants of our town."

"They're still in the minority, however."

"The way things are going, that won't last long!" she sighed.

"Alas! And they're so much more efficient."

Herds of rhinoceroses rushing at top speed through the streets became a sight that no longer surprised anybody. People would stand aside to let them pass and then resume their stroll, or attend to their business, as if nothing had happened.

"How can anybody be a rhinoceros! It's unthinkable!" I protested in vain.

More of them kept emerging from courtyards and houses, even from windows, and went to join the rest.

There came a point when the authorities proposed to enclose them in huge parks. For humanitarian reasons, the Society for the Protection of Animals opposed this. Besides, everyone had some close relative or friend among the rhinoceroses, which, for obvious reasons, made the project well-nigh impracticable. It was abandoned.

The situation grew worse, which was only to be expected. One day a whole regiment of rhinoceroses, having knocked down the walls of the barracks, came out with drums at their head and poured on to the boulevards.

At the Ministry of Statistics, statisticians produced their sta-

tistics: census of animals, approximate reckoning of their daily increase, percentage of those with one horn, percentage of those with two. . . . What an opportunity for learned controversies! Soon there were defections among the statisticians themselves. The few who remained were paid fantastic sums.

One day, from my balcony, I caught sight of a rhinoceros charging forward with loud trumpetings, presumably to join his fellows; he wore a straw boater impaled on his horn.

"The logician!" I cried. "He's one too? is it possible?" Just at that moment Daisy opened the door.

"The logician is a rhinoceros!" I told her.

She knew. She had just seen him in the street. She was bringing me a basket of provisions.

"Shall we have lunch together?" she suggested. "You know, it was difficult to find anything to eat. The shops have been ransacked; they devour everything. A number of shops are closed 'on account of transformations,' the notices say."

"I love you, Daisy, please never leave me."

"Close the window, darling. They make too much noise. And the dust comes in."

"So long as we're together, I'm afraid of nothing, I don't mind about anything." Then, when I had closed the window: "I thought I should never be able to fall in love with a woman again."

I clasped her tightly in my arms. She responded to my embrace.

"How I'd like to make you happy! Could you be happy with me?"

"Why not? You declare you're afraid of nothing and yet you're scared of everything! What can happen to us?"

"My love, my joy!" I stammered, kissing her lips with a passion such as I had forgotten, intense and agonizing.

The ringing of the telephone interrupted us.

She broke from my arms, went to pick up the receiver, then uttered a cry: "Listen. . . ."

I put the receiver to my ear. I heard ferocious trumpetings.

"They're playing tricks on us now!"

"Whatever can be happening?" she inquired in alarm.

We turned on the radio to hear the news; we heard more trumpetings. She was shaking with fear.

"Keep calm," I said, "keep calm!"

She cried out in terror: "They've taken over the broadcasting station!"

"Keep calm, keep calm!" I repeated, increasingly agitated myself.

Next day in the street they were running about in all directions. You could watch for hours without catching sight of a single human being. Our house was shaking under the weight of our perissodactylic neighbours' hoofs.

"What must be must be," said Daisy. "What can we do about it?"

"They've all gone mad. The world is sick."

"It's not you and I who'll cure it."

"We shan't be able to communicate with anybody. Can you understand them?"

"We ought to try to interpret their psychology, to learn their language."

"They have no language."

"What do you know about it?"

"Listen to me, Daisy, we shall have children, and then they will have children, it'll take time, but between us we can regenerate humanity. With a little courage. . . ."

"I don't want to have children."

"How do you hope to save the world, then?"

"Perhaps after all it's we who need saving. Perhaps we are the abnormal ones. Do you see anyone else like us?"

"Daisy, I can't have you talking like that!"

I looked at her in despair.

"It's we who are in the right, Daisy, I assure you."

"What arrogance! There's no absolute right. It's the whole world that is right—not you or me."

"Yes, Daisy, I *am* right. The proof is that you understand me and that I love you as much as a man can love a woman."

"I'm rather ashamed of what you call love, that morbid thing. . . . It cannot compare with the extraordinary energy displayed by all these beings we see around us."

"Energy? Here's energy for you!" I cried, my powers of argument exhausted, giving her a slap.

Then, as she burst into tears: "I won't give in, no, I won't give in."

She rose, weeping, and flung her sweet-smelling arms round my neck.

"I'll stand fast, with you, to the end."

She was unable to keep her word. She grew melancholy, and visibly pined away. One morning when I woke up I saw that her place in the bed was empty. She had gone away without leaving any message.

The situation became literally unbearable for me. It was my fault if Daisy had gone. Who knows what had become of her? Another burden on my conscience. There was nobody who could help me to find her again. I imagined the worst, and felt myself responsible.

And on every side there were trumpetings and frenzied chargings, and clouds of dust. In vain did I shut myself up in my own room, putting cotton wool in my ears: at night I saw them in my dreams.

"The only way out is to convince them." But of what? Were these mutations reversible? And in order to convince them one would have to talk to them. In order for them to re-learn my language (which moreover I was beginning to forget) I should first have to learn theirs. I could not distinguish one trumpeting from another, one rhinoceros from another rhinoceros.

One day, looking at myself in the glass, I took a dislike to my long face: I needed a horn, or even two, to give dignity to my flabby features.

And what if, as Daisy had said, it was they who were in the right? I was out of date, I had missed the boat, that was clear.

I discovered that their trumpetings had after all a certain charm, if a somewhat harsh one. I should have noticed that while there was still time. I tried to trumpet: how feeble the sound was, how lacking in vigour! When I made greater efforts I only succeeded in howling. Howlings are not trumpetings.

It is obvious that one must not always drift blindly behind events and that it's a good thing to maintain one's individuality.

However, one must also make allowances for things; asserting one's own difference, to be sure, but yet . . . remaining akin to one's fellows. I no longer bore any likeness to anyone or to anything, except to ancient, old-fashioned photographs which had no connection with living beings.

Each morning I looked at my hands hoping that the palms. would have hardened during my sleep. The skin remained flabby. I gazed at my too-white body, my hairy legs: oh for a hard skin and that magnificent green colour, a decent, hairless nudity, like theirs!

My conscience was increasingly uneasy, unhappy. I felt I was a monster. Alas, I would never become a rhinoceros. I could never change.

I dared no longer look at myself. I was ashamed. And yet I couldn't, no, I couldn't.

a world ends
Wolfgang Hildesheimer

THE MARCHESA MONTETRISTO's last evening party has impressed itself indelibly on my memory. This is partly due, of course, to its extraordinary conclusion but in other ways as well the evening was unforgettable.

My acquaintance with the Marchesa—a Waterman by birth, of Little Gidding, Ohio—came about by a coincidence. I had sold her, through the intermediary of my friend, Herr von Perlhuhn (I mean of course the Abraham-a-Santa Clara expert, not the neo-mystic), the bathtub in which Marat was murdered. It is

Reprinted by permission of Suhrkamp Verlag. Copyright © 1962 Suhrkamp Verlag, Frankfurt/Main. Translated by Christopher Holme.

perhaps not generally known that it had been until then in my possession. Gambling debts obliged me to offer it for sale. So it was that I came to the Marchesa who had long wanted this appliance for her collection of eighteenth-century washing utensils. This was the occasion of my getting to know her. From the bathtub our conversation soon passed to more general esthetic topics. I noticed that the possession of this collector's piece had given me a certain prestige in her eyes. And I was not surprised when one day I was invited to one of her famous parties in her palazzo on the artificial island of San Amerigo. The Marchesa had had the island thrown up a few miles southeast of Murano on a sudden whim, for she detested the mainland—she said it was hurtful to her spiritual equilibrium, and she could find nothing to suit her in the existing stock of islands. So here she resided, devoting her life to the cult of the antique and forgotten, or, as she liked to put it, of the "true and eternal."

The invitation card gave the time of the party as eight o'clock, which meant that the guests were expected at ten. So custom ordered it. Further it ordered that the guests should come in gondolas. In this fashion, it is true, the crossing lasted nearly two hours and was moreover uncomfortable when the sea was rough, but these were unwritten rules of behavior at which no one but a barbarian would cavil—and barbarians were not invited. Besides, many of the younger guests, not yet fully sensible of the dignity of the occasion, would hire a *vaporetto* to take them within a hundred yards of the island whence they were ferried over one by one in a gondola which had been brought in tow.

The splendor of the building needs no description from me. For outside it was an exact replica of the Palazzo Vendramin, and inside every period, from the Gothic onward, was represented. But of course they were not intermingled. Each one had its own room. The Marchesa could really not be accused of breaches of style. Nor need the opulence of the catering be referred to her. Anyone who has ever attended a state banquet in a monarchy— and it is to such that I principally addressed myself—knows what it was like. Moreover it would hardly be true to the spirit of the Marchesa and her circle to mention the pleasures of the table, especially here, where I have to describe the last hours on earth

of some of the most eminent figures of the age, which I as sole survivor had the privilege to witness.

After exchanging a few civilities with my hostess and stroking the long-haired Pekinese which never stirred from her side, I was introduced to the Dombrowska, a woman doubly famous, first for her contributions to the rhythmic-expressionist dance, a vanishing art form, and secondly as the author of the book *Back to Youth*, which, as the title indicates, argued in favor of a return to youthfulness of style and which, I need hardly remind the reader, has won adherents far and wide. While we were chatting together, an elderly gentleman of upright bearing came up to us. It was Golch. The Golch. (Unnecessary to give further particulars of a man whose share in the enrichment of our intellectual life is so widely known.) The Dombrowska introduced me: "Herr Sebald, the late owner of Marat's bathtub." My fame had spread.

"Aha," said Golch. I inferred, from the inflection he gave to these syllables, that he was weighing my potentialities as a candidate for the cultural élite. I asked him how he had liked the exhibition of contemporary painting in Luxemburg. For one might, indeed one must, assume that those here assembled had seen, read, and heard everything of any real importance. That was why they were here. Golch raised his eyes as if looking for a word in space and said, "Passé." (He used the English accentuation of the word which was then in fashion. The words "cliché" and "pastiche" too were pronounced *à l'anglaise*. I don't know what the current usage is. I am now too much taken up with everyday affairs to concern myself with such matters.) I noticed in any case that I had blundered in thus mentioning the contemporary. I had gone down a step, but I had learnt my lesson.

A move was made to the buffet. Here I encountered Signora Sgambati, the astrologer, who had recently made a considerable stir by her theory that not only the fate of individuals but whole trends in the history of ideas could be read in the stars. She was no ordinary phenomenon, this Sgambati, as was at once clear from her appearance. Yet I find it incomprehensible in the circumstances that she did not see in the constellation of the heavens the imminent engulfment of so many substantial members of the intellectual world. She was deep in conversation with

Professor Kuntz-Sartori, the politician and royalist, who had been trying for decades to introduce a monarchy in Switzerland. Another notable figure.

After taking some refreshment the company moved to the Silver Room for what was to be the climax of the evening's entertainment, a performance of a special kind—the world première of two flute sonatas by Antonio Giambattista Bloch, a contemporary and friend of Rameau, who had been discovered by the musicologist Weltli. He too of course was there. They were played by the flautist Beranger (yes, a descendant) and accompanied by the Marchesa herself, on the self-same harpischord on which Celestine Rameau had initiated her son into the fundamental principles of counter-point, and which had been sent for from Paris. The flute too had a history, but I have forgotten it. The two performers had put on rococo costume for the occasion, and the little ensemble looked—they had purposely so arranged themselves—like a picture by Watteau. The performance of course took place by the dimmest of candlelight. There was not a person there who would have found electric light for such an occasion anything but intolerable. By a further sensitive whim of the Marchesa the guests were required after the first sonata (D major) to move over from the Silver Room (Baroque) to the Golden Room (early Rococo), there to enjoy the second sonata. For the Silver Room had a major resonance, the Golden, it could not be disputed, a minor.

At this point I must remark that the tedious elegance which clings to the flute sonatas of second-rank, and more particularly of newly discovered, masters of this period, was in the present case to be explained by the fact that no such person as Giambattista Bloch had ever lived. The works here performed had in reality been composed by the musicologist Weltli. Although this circumstance did not become known till later, I cannot, in retrospect, help feeling it a humiliation for the Marchesa that she should have employed her last moments in the interpretation, however masterly, of a forgery.

During the second movement of the F minor sonata I saw a rat creeping along the wall. I was astonished. At first I thought it might have been lured from its hole by the sound of the flute

—such things do happen, they say—but it was creeping in the opposite direction. It was followed by another rat. I looked at the guests. They had not noticed anything, and indeed most of them were keeping their eyes closed in order to be able to abandon themselves to the harmonies of Weltli's forgery. I now heard a dull reverberation, like very distant thunder. The floor began to vibrate. Again I looked at the guests. If they had heard anything—and something they must be hearing—it was at any rate not discernible from their hunched-up postures. I however was made uneasy by these strange symptoms.

A manservant entered. This is barely the place to remark that in the unusual costume worn by the Marchesa's domestic staff he looked like a character out of *Tosca*. He went up to the performers and whispered something in the Marchesa's ear. I saw her turn pale. How well it suited her in the dim candlelight! But she controlled herself and without interruption played the *andante* calmly to the end. Then she nodded to the flautist, stood up, and addressed the company.

"Ladies and gentlemen," she said, "I have just learnt that the foundations of the island and those of the palace with them are breaking up. The Office of Submarine Works has been informed. The right thing, I think we shall all agree, is to go on with the music."

She sat down again, gave the sign to Monsieur Beranger, and they played the *allegro con brio*, the last movement, which did seem to me at the time, though I had yet no inkling that it was a forgery, little suited to the uniqueness of the situation.

On the polished floor small puddles were forming. The reverberation had grown louder and sounded nearer. Most of the guests were now sitting upright, their faces ashen in the candlelight, and looking as if they were long dead already. I stood up and said, "I'm going," not so loud as to give offense to the musicians, but loud enough to intimate to the other guests that I had the courage to admit my fear. The floor was now almost evenly covered with water. Although I walked on tiptoe, I could not help splashing an evening dress or two as I passed. But, in view of what was soon to come, the damage I did must be reckoned inconsiderable. Few of the guests thought me worthy

of a glance, but I did not care. As I opened the door to the passage a wave of water poured into the room and caused Lady Fitzjones (the preserver of Celtic customs) to draw her fur wrap more closely about her—no doubt a reflex movement, for it could not be of any use. Before shutting the door behind me I saw Herr von Perlhuln (the neo-mystic, not the Abraham-a-Santa Clara expert) casting a half-contemptuous, half-melancholy glance in my direction. He too was now sitting in water almost to his knees. So was the Marchesa, who could no longer use the pedals. I do not as a matter of fact know how essential they are on the harpsichord. I remember thinking that if the piece had been a cello sonata, they would perforce have had to break it off here since the instrument would not sound in water. Strange what irrelevant thoughts occur to one in such moments.

In the entrance hall it was suddenly as quiet as in a grotto, only in the distance a sound of rushing water was to be heard. I divested myself of my tail coat and was soon swimming through the sinking palace toward the portals. My splashes echoed mysteriously from the walls and columns. Not a soul was to be seen. Evidently the servants had all fled. And why should they not? They had no obligation to the true and eternal culture, and those assembled here had no further need of their services.

Outside the moon shone as if nothing were amiss, and yet a world, no less, was here sinking beneath the ocean. As if at a great distance I could still hear the high notes of Monsieur Beranger's flute. He had a wonderful *embouchure*, that one must allow him.

I unhitched the last gondola which the escaping servants had left behind and pushed out to sea. Through the windows past which I paddled the water was now flooding into the palace. I saw that the guests had risen from their seats. The sonata must be at an end, for they were clapping, their hands held high over their heads, since the water was now up to their chins. With dignity the Marchesa and Monsieur Beranger were acknowledging the applause, though in the circumstances they could not bow.

The water had now reached the candles. Slowly they were extinguished, and as the darkness grew, it became quiet; the

applause was silenced. Suddenly I heard the crash and roar of a building in collapse. The Palazzo was falling. I steered the gondola seaward so as not to be hit by plaster fragments.

After paddling some hundreds of yards across the lagoon in the direction of the island of San Giorgio, I turned round once more. The sea lay dead calm in the moonlight as if no island had ever stood there. A pity about the bathtub, I thought, for that was a loss which could never be made good. The thought was perhaps rather heartless but experience teaches us that we need a certain distance from such events in order to appreciate their full scope.

AGAINST
EVENT
* * * * * *
the primacy
of voice

last class

Theodore Roethke

NOTE: In some American progressive colleges for women, it is
the custom to tell all, to shoot the works, in the last class. The
institution here is, let us say, Hysteria College; the course, The
Writing of Verse.

My sins are not important. Whatever I said was too good for
you. I tried. I said and I did. I survived. I have endured you,
O modern girl, sweetheart of papa and billboards; footpad and
assassin. Lord, I'm plumb tuckered out lugging these hunks of
pork up the lower slopes of Parnassus, knowing all the time that
as soon as I turn around, back they'll slip to blurbanity, inanity,
and the dearest, dullest people in the world. I'm tired of being
a day-laborer on this canary-farm, a ladies' maid in a seminary
of small beasts, a mid-wife sweating to effect a most particular
parturition: bringing forth little maimed ends of life, poems with
all the charm (if they didn't lay eggs) of aborted salamanders.

I'm tired of tippy-toe tasting; peripheral twittering; sniffing
for epiphanies; whistling after Wystan; Tate- and text-creeping;
dithering over irrevelant details; orphic posturing; adjective-
casting, nuancing; mincing before mirrors; speaking the condition
of somebody else's mouth; crooning in private over garbled quo-
tations; sucking toes already too tired; attitudinizing all those
dreary glazed varnished effusions from the boudoirs of frou-frou;
all the lower-case freud and joyce (Anna Livia Dribblenose); all
those moldy little sublimations emitting nothing more than a
faint sad smell; those cats and trees and silvery moons; those
bleak black ugsome birds—why not a whole series on the grave,
darling? I'm tried of the I-love-me bitches always trying to keep
somebody off balance; Park Avenue cuties who, denied dogs,

"Last Class" by Theodore Roethke. Reprinted with the permission of the
National Council of Teachers of English from the May 1957 issue of College
English.

keep wolfcubs named Errol Flynn, or bats and toads with names like Hoagy; all the cutesy, tricksy trivia and paraphernalia with which the stupid and sterile rich try to convince themselves they aren't really dead.

A young girl, said Montherlant, what a dreary subject for a writer. And don't I know it now, me up to the armpits in quivering adolescent entrails, still trying to find something I can save. Take it from me that's been hit over the head, still slug-nutty from those long years in the technique mines. I'm beginning to feel the mould creep over the noble lineaments of the soul. O the lies I've told my own energies trying to convince myself I was teaching you *something!* Twenty times a day I asked myself: Are you really worth it? And the more I asked, the more I lathered, vomiting before Thursday classes, chasing after examples like a greasy stackrat, learning passages by heart only to forget them when I got there, beating my off-stage beat to death, schmalzing all day long—a high-speed pitch artist, a sixteen-cylinder Mr. Chips, wide-open Willie (Just look sad and he'll change the assignment)—I ask you, is that the way for a grown man, and me past thirty-five, to make a living?

I shudder to think of the bromides I've bellowed; the horrendous affirmations; the immense and mindless sense of surprise with which I've belabored the obvious: all that passionate readjusting of platitudes we call progressive education. And by what garments of praise (trimmed with self-pity) haven't I lived and had my being: "Cecily-Ann says you're simply *divine* on Hopkins. I do so want to take you sometime!" Or papa, beaming with beatific bestiality that comes with a hundred grand a year after taxes: "Why, we spent a fortune on psychiatrists, but you really seem to have fixed her up." Buster, I fixed her better than you think: it just may be, in spite of everything, you have a human being on your hands who'll do something more than shake those greasy curls in the cribs of Greenwich village.

And now, small-fry sadists that you are, you still insist on extracting the ultimate hot-flash, the last tired gasp from this semester-end throe of exasperation. In other words, I simply must say what I think of my colleagues—as if you didn't already know

us better than the backs of your hands; as if you haven't been
playing us off, one against the other, watching those ever-so-
slight facial flickers for some hint of a rift, some revelation to
relay in Commons: "Oh, I know he *loathes* Secondary Source!
He practically told me so today in conference. And as for Stinky
Retriever!—"

The Faculty! Those privileged participants in this great edu-
cational experiment, those members of a community that so
honors the creative it just sucks it right up bones, blood and all.
That menagerie of fly-blown lesbians, tired refugees, grass-roots
Americans with classic tastes, Bonwit Teller tough guys, drama
boys, saxophone players, ex-bartenders, fugitives from the loony-
bin; creeps, vipers, toads, critics; finks, louts, lechers, fly-fisher-
men, sociologists; baby-prodders, pianists; dopes, mopes, co-ed
trolls, nine-day wonders; sibyls, second-cousins, toads, hacks,
trimmers; pikes, dikes, perch and bull-heads; drearies, queeries,
vealy-faced fairies; strange little women full of ticks and ethics;
existentialists with wet hands; sad-eyed determinists; a professor;
stoolies, droolies, ninnies, bibble-babbling informers; poops and
prophets.

But give them credit: most of them—coonie and wide, obtuse,
or just plain nutty—at least aren't dull. Fond of flourishing them-
selves before the devil, verbal about everything except what they
really know, given to thin pipings or furious bull-roarings about
the secrets of life—their desperations, their exaltations are most
lavish. They can't play bridge. What they know they know to
beat hell: and they care enough to give out—by some means;
twists, grunts, blasts, pokes, shrugs; off-the-cuff; on-the-snatch;
down-the-hatch; or with-the-club-dinner. They are teachers.

But there are a few sour specific instances, and we *do evolve*,
with rather horrifying speed and in spite of all the trumpeting
and snorting and parading of the ego, on and off the podium,
into certain well-defined, easily discernible types. For instance,
there is:

The Creep. A critic. Of the Waltz-me-around-again-Heinie,
I-hear-you-calling-Cleanth school. Surprised at an early age, by
polysyllables. Mad for myths and schemata. Couldn't tell a poem
if it came up and bit him in the behind. A small talent for

arranging ideas; an ear like a meat-grinder. There are always these coarse-faced detractors, these busy little men who bite the creative because it is human, debase the genuine truths, and emasculate the language. They pad through the halls, these insults to mediocrity, their eyes coming to alight only when salary increases are mentioned. They have ideas very publicly, these dreary bores with their clatter-language. And how they keep track of each other!

The Quince. Should have been a pimp or a cardinal's secretary. Stream-lined for Jesus, he. Ambition: to compose a great prayer. This, God, of course, busy as He is, will never permit. A walk-softly who some day will understate himself into spiritual anemia: he'll prolong the moment of contemplation until it reaches a perfect psychic vacuum. His boot-licking is a marvel to behold: the least possible waste motion.

Bullo, the Barber-Shop Mystic. A lingo-bingo boy, uphigh and happy. A great roaring sensibility on the loose: all ear and no forehead. Writes prose. Loves the Heartland. In winter lives on silage. Listen when he takes off.

Bufflehead. A pale, limp worm of a man, kind to his mother, considerate of his students, beastly to himself. He doesn't *know* and he doesn't know he doesn't—that's his tragedy. Poor dear, he's going to be shunted from place to place, always preceded by marvelous letters which a year later his colleagues will re-read with astonishment. At last he'll come to rest in some backwoods academy, where except for a few embittered cynics and lazy nature boys, everybody else will be stupider than he is. Then, if he marries, he'll become an administrator.

The Udder. All gush and goodwill and guts (girth) a yard wide. A suburban Sappho. The vice in the old village choir. A mind composed largely of fuzz. If she knew what she was, there would be no harm in her, but monkey she must with every amorphous psyche that comes her way. "You can't do your assignment? Try, just try, to imagine yourself a *Tree.*" But surely you classic cases in progressive pedagogy, weaned on Freud and Kraft-ebbing, aren't taken in by such shoddy sex-transfers. What she wants, really, is to keep you entranced forever in the soft silly gloze of adolescence, to have you perpetually saying farewell

to the warm womb but never once peeking out for just one look at reality. She loves you best bewildered. Let her be somebody else's mother.

The Allusionist. Do I hear "the furtive yelp of the masked and writhing poeticule"? Is this "the startling hysteria of weakness over-exerting itself"? I ask only answers. From him you can learn the pleasure of tangential authority and how never to come to the point. Even his sighs have another source. Echoes, said Hopkins, are an evil; this man is a veritable cave. And what he won't do, lack-love that he is, to keep his odious skin intact. But somehow he always survives. What's he doing, anyway, in this company of intellectual princes?

Brain Girl. The blue hair and zinc curls give you the clue, don't they? The unhappy extrovert, a female hill-billy who learned to count. So much common sense! And what crimes she commits in its name, always making the wrong decisions for the right reasons, professing a great love for ideas but actually afraid of them. A blameless public and private life; a terrible random energy. As an administrator, has done more human damage than a battalion of angels can undo. This she knows and she'll end in a fast car wound around a tree or bend double from cyanide. She can't pray: her soul has disappeared into those hand-painted jars and bottles on her dressing table.

The Raccoon. A lovely man and you know it. His prose would kill you, but face to face, he speaks straight to the spirit. A real source of life.

But do I hear a faint well-bred sigh, a shifting of thighs that means, "Why not talk about *us* for a change? After all, we're the customers." And so you are, dear darling provocatives.

Most exhausting, for me, are you milky sweet ones, still dimpled from mama's rosy interior, braces on teeth, straight from Miss Twitchett's or the stables of Stirrup-and-Halter Hall. Nicknames like Muffsie, Mopsy, Butter-Ball and Whim-Wham. Some of you are Irish. I can't will such willowy bones into women. I'm not a wet nurse. What nips and bites you have, little insects for juxtaposition, delicate baby spiders already weaving webs of self-delusion. Look at you close, and invariably you'll skitter away,

afraid of yourselves. Ah sweetlings, asleep in your fat, if you don't once in a while, at least look outside, the angels will be forever angry.

Then there are the self-loathers, fond of sitting on thistles; wearers of handmade peasant jewelry in the shape of chicken foetuses. These I have paid the compliment of thinking about in the abstract.

As for you, *Eulalea Mae*—please rise when I name you individually and when I'm done sit down on the *end* of your spine. It's still growing, remember. From your mother, lovely blob, you inherited the serenity of a cistern. Find some suntanned idiot boy about to get an Army commission. Let him marry your belly and you'll both be happy. In the meantime avoid all language.

Pretty-for-Nice. That block you're always talking about—are you sure it doesn't fill your entire head? You don't *like* paint and are afraid of it? Try drawing with chalk in your navel. I mean: be true to your own constrictions. Get down where your obsessions are. Live with the desperate and you'll survive.

Hell-for-Stuff. From me you seem to want the soft gaze of the brown bull. Alas, my dear, I'm not even a tired St. Bernard. Try a hot bath or the higher sublimations. Keep a stiff upper slip. But the caterwaul doesn't become you. That's the tom-cat's function.

Patricia Jane. In those raids on yourself you have won a few minor outposts. Now pay me the honor of writing like somebody else. I refuse to be best man at your spiritual marriage. An intense desire for experience but a horror of paying the price. To watch from a tent of mink—that is your wish. But how well you modulate the shape of a sentence and the assonantal sounds!

Ah, true indignation! how rare you are, how dangerous to court deliberately. Have I taught out of the whole wrath? I hope I have. I know you, little unwashed beasts. I love you for what you might be: I hate you for what you are. Yes! I fried you in the right embrace: the close kiss of why not. I taught you as I should; not what I know but what I do not know. I cut you down, and left you singing in your best bones. Did I say I? Indeed that would be a monstrous untruth, for I was never more

than an instrument. But if only once or twice, some sly generous hint from the unconscious slipped from the side of my mouth, if any of you have looked for the last time into that cracked mirror of absolute self-love, then we have not failed, you and I. We both may escape the blubs of nice, the leagues of swank and swink, all the petty malice and provincial nastiness that wants to smother, to suffocate anything human and alive.

But before I'm reduced to an absolute pulp by my own ambivalence, I must say goodbye. The old lion perisheth. Nymphs, I wish you the swoops of many fish. May your search for the abiding be forever furious. Oracular nutty's taking it on the lam. There's not enough here to please a needle. I won't say another word. I've hissed my last cliché. It's luck I wish you Wake the happy words.

you can't cover up the sky with your hand

Oscar Lewis

I AM AS FRANK as I am ugly and I don't try to hide what I am because you can't cover up the sky with your hand. There is nothing good about me. I have a bad temper, why should I deny it? At times I become so angry no one dares come near me, so angry I cry, and in my rage I want to kill.

When I get into these rages, it makes no difference to me

From La Vida, *by Oscar Lewis. Copyright © 1965, 1966 by Oscar Lewis. Reprinted by permission of Random House, Inc.*

whether I kill or get killed. I never feel sorry or anything. I'm
the kind of a woman that nobody can say anything to when
she's drunk, because any little thing and I'm ready for a fight. If
I have a husband and I'm drinking and he starts pestering me
or being jealous without cause, or quarreling about any little
thing my children do, I'd just as soon cut him with a razor, slash
him with a bottle—anything. It makes no difference to me, see?

I often carry a razor because if someone tries to hit you, you
have to defend yourself. When I was in the life, I kept a *Gem*
blade in my mouth all the time. I could eat with it there, drink,
talk and fight without anybody noticing it. I'd break off one
corner of the blade to form a little handle and then I'd slip it
between my lower gum and my cheek, with the cutting edge up.
That way the edge doesn't touch your mouth, it's in the air, see?
You can also hide a blade in your hair or you can slip it into
the top of your stocking. The one place you should never carry
a *Gem* is in your purse, because if you're arrested the cops will
find it. When I know I'm going to get into a fight I have the
Gem ready in my hand, hidden between my fingers. Then, when
I get the chance, I quickly cut the cheek or lip.

I'm not afraid of anyone but God, and I'll never accept mis-
treatment from a man. I wasn't born for that. When I live with
a man I'm faithful to the last, but if I find out he's cheating on
me, I swear I'll do the same to him. You can count on it, I'll
put the horns on him. Revenge! Because my *mamá* told me never
to let men dominate me. "If they do it to you, do it to them.
Never give in. Don't bow down." And I have the heart to do it.

I would rather be a man than a woman. If God had made me
a man I would have been the worst son of a great whore ever
born. Not a woman would have escaped me. *Ave María!* I'd have
a woman everywhere, and if they didn't give me what I wanted
I'd kick my way in. That's why God made me a woman, a real
bitch of one. I'm forty now and I've had six husbands, and if
I want I can have six more. I wipe my ass with men.

I may be Negro and I may be getting old and, if we face
facts, I was a whore. All this I cannot deny, but no one can
come to me and say, "Fernanda, you took my man away from
me." I can sing out with the greatest pride that I have never,

never taken away another woman's husband. I have always preferred men who are free. I may kid around with married men but it's all in the open. I'm no home breaker because I'd never do to another woman what I wouldn't want her to do to me. That's why I feel that I am worth more than most women here in La Esmeralda.

The truth is, I am really soft-hearted. I have lots of friends. The fights I have are only with my husbands. If someone lives with me, he won't die of hunger or need or anything. If I have money I will give it to anyone near me who needs it, because I can't see them suffer. That's the kind of a heart I have. I feel compassion.

I've done favors for lots of people. Why, I've taken to the streets to get a few pesos for someone in need. I've made lots of money and I've spent it all. What would I want to keep it for? We're not made of stone and we all must die, right? Suppose I save money in the bank and then I die. Who is going to enjoy that money? The government! No, I'd rather eat up my money myself before they come and take care of it for me.

I was born in Río Grande, a little country town about fifty miles from San Juan. When I was only a few months old my parents separated, and my *mamá* went off to work as a maid in San Juan and left me behind with my father's mother. People tell me that my grandmother treated me badly and beat me, but I don't remember that. By the time I was three I was sickly and as skinny as a noodle. I had that illness that makes the belly stick out and the ass cave in; rickets, they call it. Then one day someone went to see my *mamá* at work and said to her, "If you don't get that child out of her grandmother's house, she'll die." So my *mamá* went there and took me with her to San Juan.

After that I never lacked food as a child because *mamá* always worked and took care of me. The doctor she worked for prescribed extract of hemoglobin and told her to give me good, nourishing food, like pigeon broth. I got fat on that. I was so fat I could hardly get clothes to fit me! When I was a little older I had asthma but my *mamá* cured it with a brew of manatee fish bones, ground to a powder and boiled in water. Then, while I

was still a little girl, I had pains in my ovaries, and my *mamá* took me to the doctor often because of that.

My mother kept on supporting me even after she got herself a new husband. I was seven when she got together with Jorge. He was a charcoal vendor, but at that time he and my *mamá* were servants for the Cordero family. Jorge brought me up. He was very good to me. The first house we lived in was in an alley at Stop 26.[1] Afterward we lived in a slum in Santurce in a house that was very poor. It had a charcoal stove and two beds. There were no luxuries, no electricity, no radio, no television, no refrigerator. Nobody had anything like that in those days. Later, when I became a *señorita*, my *mamá* said that now that I was growing up it was time for me to get used to having luxuries and to learn what they were for and how to take care of them. So she bought a three-piece set of wicker furniture. After that, I began to take an interest in fixing up the house and making it look pretty.

My mother was a wonderful woman but she certainly had a temper! You can't imagine how those old people of the past were. When she was angry no one dared speak to her. I'd just disappear because she would hit me as hard as if I were a boy. She whipped me with a piece of rope, really deadly beatings. Afterward I didn't dare look her in the face for a week. Once she threw a lighted gas lamp at me. Another time she asked me to prepare some starch for her. I didn't know how and I put coffee in it. That made her so angry she threw the pot of boiling starch at me. It didn't hit me because I ran away and escaped. So long as I could get away I never had any problems in my childhood.

My mother had a sad life because she was often sick and in pain. She told me she had had a miscarriage and that the gut had come out before the baby. So the doctor said she needed an operation. They opened her and took out all her insides and she couldn't ever have her period again. After that, because she was all hollow inside, she'd get into a rage every month. She'd stop speaking to me for a week or two, but later she would make up

1. The use of the word *Parada* for Stop is peculiar to San Juan. At the beginning of the century a trolley line went from Old San Juan to Rio Piedras, and soon the Stop numbers came to designate not only the Stop itself but the area around it.

with me or I would make up with her. When I started to caress her she always said, "Go away, I won't have anything to do with you." But I answered, "Don't be like that, you know I'm your darling," until she stopped being angry.

My mother never taught me to do any kind of work, not even to cook a pot of rice. So I spent my childhood, until I was about eleven, playing all the time and never doing any work. I played with boys and fought with them. I knew how to use my fists. My mother never had any peace because someone was always going to her to complain, "*Doña* Luisa, your daughter's out here fighting with the boys. She's like a fighting cock and nobody can stop her." Then my mother had to drop whatever she was doing and rush off to catch me and beat me. I was really mischievous. I flew kites, spun tops, played marbles and I played with other girls' dolls because I never had one of my own. I got gifts on the Day of the Three Kings,[2] but everybody gave me clothing because my mother asked them not to give me dolls or toys. She always said that toys are broken in a day or two but clothes last a long time.

When I went to school for the first time, my mother took me. I started out at one of those private schools which charged twenty-five cents a week. They don't have that kind any more. I started when I was very small and kept going until I was seven. I was about eight when my mother enrolled me in a public school. In those days teachers really took an interest in the children. If a child did anything wrong, the teacher would give him a little slap on his bottom so that he would behave well and learn his lessons.

The teacher hit me only once. I didn't know how to write an *A* nicely, and she hit my hand hard with a ruler. When *mamá* saw my swollen hand and asked about it, I said I had hurt it playing during recess. I didn't tell her because I didn't want her to go to school and quarrel with my teacher. I never told my *mamá* when I was scolded or anything else that happened there. In school there are always fights among children and I fought often. They kept me back in the first grade because of my fighting.

2. Epiphany, January 6.

My *mamá* sent me to her mother in Río Grande to see if I would change my ways there and be promoted to the second grade. So after that I lived with my grandmother Clotilde and my half sister Migdalia. Migdalia is three years younger than I am. She is my only sister but she's not my father's daughter. I found out how it all happened when I was grown up. After leaving my father, my mother became pregnant by Migdalia's father, but I never knew the man. Migdalia was born in the Municipal Hospital in Santurce, and from the time she was forty days old my grandmother Clotilde took care of her and brought her up.

Clotilde was black with very white hair. She was so crazy that if a visitor stayed a long time she'd come right out and say, "Get out of here!" Then, if they stayed away two or three days, she sent for them and said, "You bastard, what's the matter with you? Why don't you ever come to my house any more?" When they said, "Why, *doña* Clotilde, you always kick out the people who go to visit you," she'd answer, "That's a lie and you know it." She had visitors every day; she'd quarrel with them, throw them out, send for them, and they always came back.

Her house was a wooden shack facing the street. It had three rooms and a smaller shack in the back. My grandmother kept all those rooms in case any of her relatives wanted to stay with her. She would often cry when she thought of my mother far away from her in Santurce. She cried because the days went by and my mother didn't come to see her and because she was always afraid that something might happen to her daughter. That's the way she was.

My grandmother wouldn't let my sister and me play with other children and she made us go to bed at five in the evening. If we didn't obey her, she would beat us with a rope or a black-jack. She said we would learn bad habits from other children. My sister and I played by ourselves in the back yard. On Saturdays she would buy food for us to prepare. We had our own kettles and charcoal stoves with three stones to hold the kettle over the fire. She gave us everything we needed so we wouldn't go looking elsewhere.

When she was drunk she would be very mean to us. She said we were shameless bitches, that we made her suffer and didn't

love her. Then she'd beat us with sticks and chase us out into the street. Later she'd go get us and bring us back. Sometimes she tied us to a pole, feet up and head down, and beat us like that. Or else she sent us to the cemetery to get tamarind twigs and she whipped us with those. She sometimes scorched the soles of our feet with burning paper so that we wouldn't be able to run outside. She would also punish us by making us kneel with outstretched arms, holding a large stone in each hand.

While I was living with Clotilde, I visited my mother every fifteen days at the home of the Cordero family. A *público*[3] would take me there and my mother paid him when we arrived. One day I returned to Río Grande from my *mamá's* house, and as soon as I got back Clotilde began to curse me. I don't know whether she was drunk or what. She locked me out that night and left me to sleep in the street. Dead she is, but she knows I speak the truth. I told my *mamá* about it later and she said to me, "Just try to bear it until the school year is over and you get promoted, then you can come live with me."

The trouble with my grandmother was that she had been crazy once and afterward she was always nervous. I don't know much about her madness because I was living with my *mamá* when it happpned, but I've heard that she went crazy when she gave birth to twins, and one of them died. It seems she did something that made her ill, and as we say, "the purge went to her head." That means that her menstrual blood rose instead of coming down as it should. Because of her madness, she lost some farms she had inherited. Her relatives took advantage of her condition and grabbed the land for themselves. All she had left was her house in Río Grande.

My grandmother never told us much about her life. She had two men that I know of, my grandfather, whom I never knew, and her second husband, Jaime, who still lives in Río Grande. He was a breeder of fighting cocks and spent a lot of time at cockfights. He also worked in the cane fields.

Jaime sold rum but didn't want to give any to Clotilde. He'd hide it from her, but she'd find it and drink it. Or she would go

3. Public taxis which provide fast and inexpensive transportation around the island.

buy it somewhere else. I think she's the one that taught us to drink, because whenever we got a little cold she dosed us with *cañita*[4] and burned sugar. When Clotilde got a bit high she chewed basil or mint, or paper and onions, to take away the smell of rum. It worked too; when she ate that stuff nobody could tell she had been drinking.

As long as she lived, Grandmother hardly loved me at all. She treated my sister better than me. Migdalia was her darling. My sister would ask for this or that, and every time she said, "Clotilde, give me—" my grandmother would drop whatever she was doing and go get what Migdalia wanted. But when I asked for something she'd say, "Go get it yourself." When my sister played some trick on me and we started to fight, my grandmother would beat me and say that I'd end up as a whore.

My mother's brother, Uncle Aurelio, lived near by. He had a good social standing in Río Grande. He had money and two stores, one of them a grocery. They were the best stores, always filled with customers, but he was a wicked man. One day there was nothing to eat at my grandmother's house, so at recess I went over to his store and asked him for a banana—you know how children are. He told me to get it at *mamá*'s house because she was hustling in Santurce and he didn't have to give me anything. I went back to school empty-handed, weeping and ashamed.

About fifteen days later I went to visit my *mamá* and I told her about it. She said, "Don't worry, sooner or later God will bring down a terrible punishment on him for telling such a terrible lie about me." And not much later, Uncle did show up at our house, crying. He'd had an attack of madness and everything he owned had to be sold; he went bankrupt. When my *mamá* saw him, she didn't say a word about what had happened. She gave him food and took him to see a number of spiritists. Because, you see, his trouble was due to a spell a woman had cast on him to make him go mad. Why, he even shaved his head. Crazy! And she made his testicles useless so that he couldn't take another woman. And he had been a ladies' man!

4. Raw bootleg rum.

My *mamá* did everything she could until she finally cured him of the curse. Then he knelt before her, weeping, and said, "Forgive me all the harm I have done you and your daughter."

"You know it is all forgiven," *mamá* answered. My *mamá* never bore a grudge.

One day when I was visiting my *mamá* in Santurce, she said, "I'll go back to Río Grande with you this time so you can meet your father. Maybe he'll help you, now that you are living there."

My father never took another woman after he and my *mamá* broke up. He lived with his mother all the rest of his life. The two of them were inseparable. My grandmother had several sons and daughters, but my father was her favorite. She was a strange woman. She'd be happy and then she'd get upset all of a sudden and everything bothered her. She was just like a little child. It was her fault that my parents broke up, because she didn't get on with my *mamá*.

My grandmother was named Fernanda like me. It was my *papá* who wanted to name me Fernanda but my *mamá* was against it. They had a big quarrel over that. When my *mamá* went to inscribe my name in the Registry, she found that my *papá* had already registered me. He had the right to do it because they were married, see?

About my *papá* I can truthfully say that I never knew a father's love. I don't know what it is to wear even a pair of *panties* bought by him. He refused to support me and it was all his mother's fault. That old woman was bad. She and my *papá* had comforts and they never shared any of them with me. Every time my *mamá* and I went there to ask my *papá* for money for my support, my grandmother would say, "Your father can't give you anything, he's not working now."

To get even, I played tricks on her. I would steal the eggs her chickens laid and I'd sell them. When I couldn't do that, I smashed them all. My grandmother never found out who did it.

My *papá* never gave me a thing but he was affectionate to me, in a way. He would take me on his lap and talk to me and caress me. Then he would kiss me and go off to drink rum.

Once he told me, "Nanda, wait for me at such and such a

place. I'm going to take you to buy some shoes and *panties*." I waited a long time until I saw a man go by and asked him, "Have you seen my father around here?"

The man asked, "Who's your father?"

"Rogelio."

"Oh, you're Rogelio's daughter. Yes, go to such and such a bar. He's there drinking."

And there he was, flat broke, and drunk. I went in and snatched the glass of rum from his hand and broke the bottle he was holding. It made me angry to see him like that. I told him, "Aren't you ashamed to drink like that, an old man like you? And you deceive me as if I were a baby, promising to buy me something and getting drunk instead."

Then I said to the lady at the bar, "Don't sell him any more rum because he never spends a cent on me. He just takes his money and buys rum." Well, all my father did that time was pick me up and carry me home. He loved me a lot, but what's the use of loving if he didn't give anything?

When he was drunk he always went to his house and lay down to sleep. He didn't get up again until he was sober. Drunk or sober, he never swore or hurt anybody's feelings. He didn't like swearing and one couldn't even say a little word like *coño* in his hearing. My father was always solemn, but everyone was very fond of him anyway. He was a man who never knew what it was to go to court. He never fought and always behaved with propriety. That's the way he treated me too; he never once beat or slapped me. But, God forgive me, my father was never a father to me and I loved my mother more than anyone else in the world. Dear God, forgive me!

motherlogue

Ann Quin

OH HELLO darling how lovely to hear you thank you for calling
on this day yes I know I know one shouldn't but still we
share this don't we dear his death of course it's really his birth-
day Well how are things anything happening it's been cold
here are you warm enough in that flat I told you how cold it
would get the snow's coming through my kitchen window
 no no it's all right now I've stuffed newspaper in it
mmmmmm is it well I haven't been out today are you using the
electric blanket I gave you because if not you could bring it
back next time you come down all it needs is a longer lead I'm
sure Richard can fix that has he done it yet I see well if you
aren't using it I may as well have it back By the way I've
got a new lodger Mr. Mole his name yes really Mole funny isn't
it and he's just like one too well he hasn't changed a thing in the
room left the furniture exactly as I had arranged it not like
some people the only trouble is he will use the lavatory late at
night wakes me up and you know the plug being pulled sounds
like a deluge coming down and then guess what yesterday he
came knocking at my door all white faced said a pigeon had
fallen down his chimney and would I see to it he was in a terrible
state he'd already moved his bed out and put it in that small
kitchen where he went off to while I was left to deal with the
pigeon well I called the chimney sweep what a todo and he
hasn't moved back in there no dear the lodger the pigeon was
taken out and there he is sleeps in that windowless room with
the electric light burning all the time of course I'll have to speak
to him I mean the electricity bill is large enough without
yes dear well he's a computer you know works with machines
 no he doesn't seem to have a girl friend
 no I don't think he's one of those what what I can't hear

you oh dear this line's terrible can you hear me oh did you
dear well what had your father got to say for himself then
yes he seems a little better walks more quickly seems more co-
herent doesn't he but he's now got this trouble in his ear like a
little heart beating away in there he said and you know what
he thinks some insect might have got in there yes dear an
insect in his ear it was certainly on his mind the whole day he
came down here he couldn't talk about anything else and you
know something every time he visits me he nestles down in the
armchair and says oh it's so good to be home again I have the
feeling if given half the chance he'd hang his hat up here and
oh dear you know how soft I can be and then he tries to kiss
me when he leaves but I always turn my cheek the other way
 what was that oh really well I don't know dear I was
thinking of flying to Edinburgh for Christmas there's a hotel ad-
vertised all in and you and Richard won't want me around you'll
want to be together won't you dear and I do have a week off
 yes yes well I thought it might be fun go off on my own
well your father told me when he asked what you might be doing
for Christmas you said you didn't really know by the way
he asked me when you might get married do you really think
 hello hello are you there who who who's she oh Rich-
ard's wife yes of course well I suppose he must miss the children
and that is a problem isn't it dear do you really think she'll
divorce him I mean
 and oh by the way you might tell him to get that magazine
readdressed it keeps coming here you know with his wife's name
on it I don't know what the postman must think and sometimes
it goes upstairs by mistake and there's a huge parcel for him
too he owes me some postage on it I don't know sometimes I
feel its like a post office here no no dear it doesn't matter it's
only a few bob but you know it's unlucky for stamps not to be
paid for anyway if he's expecting anything from New York he
might not get it the main post office there was burnt down and
all the mail for Europe well at least for Britain was completely
destroyed How's Ronnie have you seen him lately do give
him my love lovely boy so gentle and understanding oh you
had him round then what did you cook ah you must tell me

the secret of doing that no no darling I was only kidding of course Richard likes his food doesn't he takes a lot to feed a man like that of course he needs it all that energy does he still like his babyfood milk dear I mean and he's always eating isn't he still they say it's good to eat often and little does he still eat with his knife well dear that time he used the knife with the cheese I mean it was such a sharp knife he'll cut his tongue one of these days Well how are you feeling you sound a bit down oh yes the weather has been awful did you see in the paper that poor old woman found frozen to death and oh my goodness you remember Peggy I forgot to tell you I saw Lilly at the theatre the other night and she told me she was earth bound what dear no no not Lilly you know Peggy who was found dead after a whole week the landlady discovered her only because of the smell coming out onto the landing there she was a whole week rotting away well apparently she's earth bound they've had several new lodgers in and each one hasn't stayed long terrible things happening in the night bedclothes taken off furniture thrown about and one girl even had her nighty torn off yes yes dear they've seen her of course it was all Peggy's furniture I bet she's mad being left there like that for a whole week cheerful soul really wasn't she so full of life terrible thing to happen you never know do you Oh by the way dear I thought perhaps you'd like to come down this weekend there's a good play on and I could book tickets oh I see well enjoy yourselves Oh I forgot to tell you I've ordered a nice leather bag for you to match your coat after all that one you've got looks so tatty

How's the smoking dear I can hear you coughing away you ought to try those small cigars I told you about are you taking those vitamin pills I'm sure Richard is he knows how to take good care of himself did you read all that about the birth pills of course it might be those that spoil your complexion used to be so nice and clear well it does look kind of dry these days and you look so grey when you do come down I don't think cities really agree with you still God knows where you'll be this time next year the other end of the world I suppose What are you doing for New Year's Eve oh I see no no I haven't arranged anything and I'm certainly not going to the Scottish

do so cliquish besides they'd only put me next to a terrible old
blind man like last time no one else would and they think ah
there's old muggins we'll put her next to him as she hasn't got
anyone and he's not half as blind as he's supposed to be there
he is eyeing all the girls no I'm not putting up with that rather
spend it on my own the only problem is I haven't got a first
footer you know dear a dark man to come into the flat after
midnight no no the lodger won't do he's blonde at least I
think he is he hasn't got that much hair but I know he's not
dark ah well How's the money side of things have you worked
it out between you I mean you can spend a lot of money on
food alone feeding a big man like Richard it's a shame he can't
get a job no no not so much the money dear even a voluntary
job would get him out of the flat for a while I mean he's really
so restless isn't he all that excess energy and besides no woman
can stand having a man around all day

I see well it is difficult to make ends meet for me but then
something always turns up even when I'm down to my last
penny something turns up my guardian angel looks after me
just as well I suppose no one else will I thought I might take
up typing lessons can't afford a typewriter though well next
year as you know dear I retire of course everyone is amazed that
I've nearly reached retirement age what what do you mean
dear 1/3d for the cinema oh old age pensioners yes I know
it's silly really but when I see these old women drawing their
pensions out I think oh dear next year I'll be one of those
yes I know dear still at my age what man will look at me they
go after all these young girls not that I really need a man around
you know I couldn't bear the idea of sharing the same bed be-
sides I snore no what I want is a nice cultured man just for a
companion go to the theatre with occasionally someone who likes
classical music and good books but men of my age they're so
dull and the ones who do look at me aren't worth a second look

yes well I did go out once with that one but he had such
a terrible speaking voice I couldn't bear it besides I think he
thought I was a rich widow oh I soon tell them I have a job
and the car's not mine but belongs to the firm you soon know

then what they're after By the way dear I forgot to mention you
know that awful man who came up behind you on the beach
and exposed himself well the police have caught a man who's
assaulted three women along that stretch of the underwalk I bet
it's the same man terrible isn't it you can't go anywhere nowa-
days rape murder robbery only the other day a poor old woman
was coshed to death by hooligans in the grocery just round the
corner fancy doing that to a poor defenceless woman And oh
did I tell you about the car gave me a nasty turn the other day
this car in front of me a woman driver too which is unusual
turned off to the right suddenly no signals nothing good job I
had my wits about me and there was a lorry right behind me
he had to go up on the pavement don't know what would have
happened if he what dear oh sorry I always do get a bit
shouty when I'm hysterical well it did shake me up no no
the car's all right Oh I forgot to tell you such an awful dream
I had the other night no dear not the lavatory one wasn't
that a strange one there you were hanging half way out of the
cistern with all those people looking on and you said you wanted
to do it alone that you had to prove something and I thought
why demonstrate it in such a difficult way no this dream was
really awful I even woke up crying I was searching for you in
large buildings then in a huge forest and I couldn't find you
anywhere I woke up in a terrible state and it still haunts me
funny how some dreams have that effect on one isn't it that one
you had of me burning myself like a Buddhist nun no no I
never really try to interpret my dreams just as well probably
those nightmare ones amaze me because they always seem to be
some kind of prophesy it might take a few months but as sure
as fate something linked to the dream happens very weird isn't
it well dear I better ring off this must be costing you some-
thing you'll be down on the Sunday I suppose oh but darling
you can't possibly come down on Christmas Day there aren't
any trains running no no nothing that day had you forgotten
this is England not America everything closes down here
yes yes I'm absolutely sure anyway I expected you to be down
on Christmas Eve I'd like to see something of o.k. dear and

there's only about one train on Boxing Day so you'll have to go back the following day what's Ronnie doing by the way for Christmas

oh I see well it would have been nice to have had him with us liven things up a bit lovely boy do give him my love when you see him next Well dear it's been lovely hearing from you and I'll get a nice turkey I've got a lot of booze in yes I know dear he still drinks beer doesn't he most men drink beer well be seeing you darling lovely to hear yes yes goodbye oh what time train will you be getting I see well I'll wait until I hear from you on the phone yes yes goodbye darling take care of yourself and my love to

in the
heart of
the heart
of the
country
William Gass

A Place

SO I HAVE sailed the seas and come . . .

to B . . .

a small town fastened to a field in Indiana. Twice there have been twelve hundred people here to answer to the census. The

town is outstandingly neat and shady, and always puts its best side to the highway. On one lawn there's even a wood or plastic iron deer.

You can reach us by crossing a creek. In the spring the lawns are green, the forsythia is singing, and even the railroad that guts the town has straight bright rails which hum when the train is coming, and the train itself has a welcome horning sound.

Down the back streets the asphalt crumbles into gravel. There's Westbrook's, with the geraniums, Horsefall's, Mott's. The sidewalk shatters. Gravel dust rises like breath behind the wagons. And I am in retirement from love.

Weather

In the Midwest, around the lower Lakes, the sky in the winter is heavy and close, and it is a rare day, a day to remark on, when the sky lifts and allows the heart up. I am keeping count, and as I write this page, it is eleven days since I have seen the sun.

My House

There's a row of headless maples behind my house, cut to free the passage of electric wires. High stumps, ten feet tall, remain, and I climb these like a boy to watch the country sail away from me. They are ordinary fields, a little more uneven than they should be, since in the spring they puddle. The topsoil's thin, but only moderately stony. Corn is grown one year, soybeans another. At dusk starlings darken the single tree—a larch—which stands in the middle. When the sky moves, fields move under it. I feel, on my perch, that I've lost my years. It's as though I were living at last in my eyes, as I have always dreamed of doing, and I think then I know why I've come here. to see, and so to go out against new things—oh god how easily —like air in a breeze. It's true there are moments—foolish moments, ecstasy on a tree stump—when I'm all but gone, scattered

I like to think like seed, for I'm the sort now in the fool's position of having love left over which I'd like to lose; what good is it now to me, candy ungiven after Halloween?

A Person

There are vacant lots on either side of Billy Holsclaw's house. As the weather improves, they fill with hollyhocks. From spring through fall, Billy collects coal and wood and puts the lumps and pieces in piles near his door, for keeping warm is his one work. I see him most often on mild days sitting on his doorsill in the sun. I notice he's squinting a little, which is perhaps the reason he doesn't cackle as I pass. His house is the size of a single garage, and very old. It shed its paint with its youth, and its boards are a warped and weathered gray. So is Billy. He wears a short lumpy faded black coat when it's cold, otherwise he always goes about in the same loose, grease-spotted shirt and trousers. I suspect his galluses were yellow once, when they were new.

Wires

These wires offend me. Three trees were maimed on their account, and now these wires deface the sky. They cross like a fence in front of me, enclosing the crows with the clouds. I can't reach in, but like a stick, I throw my feelings over. What is it that offends me? I am on my stump, I've built a platform there and the wires prevent my going out. The cut trees, the black wires, all the beyond birds therefore anger me. When I've wormed through a fence to reach a meadow, do I ever feel the same about the field?

The Church

The church has a steeple like the hat of a witch, and five birds, all doves, perch in its gutters.

My House

Leaves move in the windows. I cannot tell you yet how beautiful it is, what it means. But they do move. They move in the glass.

Politics

. . . for all those not in love.

I've heard Batista described as a Mason. A farmer who'd seen him in Miami made this claim. He's as nice a fellow as you'd ever want to meet. Of Castro, of course, no one speaks.

For all those not in love there's law: to rule . . . to regulate . . . to rectify. I cannot write the poetry of such proposals, the poetry of politics, though sometimes—often—always now—I am in that uneasy peace of equal powers which makes a State; then I communicate by passing papers, proclamations, orders, through my bowels. Yet I was not a State with you, nor were we both together any Indiana. A squad of Pershing Rifles at the moment, I make myself Right Face! Legislation packs the screw of my intestines. Well, king of the classroom's king of the hill. You used to waddle when you walked because my sperm between your legs was draining to a towel. Teacher, poet, folded lover— like the politician, like those drunkards, ill, or those who faucet- off while pissing heartily to preach upon the force and fullness of that stream, or pause from vomiting to praise the purity and passion of their puke—I chant, I beg, I orate, I command, I sing—

Come back to Indiana—not too late!
　(Or will you be a ranger to the end?)
Good-bye . . . Good-bye . . . oh, I shall always wait
　You, Larry, traveler—
　　　　　　stranger,
　　　　　　　son,
　　　　　　　　—my friend—
my little girl, my poem by heart, my self, my childhood.

But I've heard Batista described as a Mason. That dries up my pity, melts my hate. Back from the garage where I have overheard it, I slap the mended fender of my car to laugh, and listen to the metal stinging tartly in my hand.

People

Their hair in curlers and their heads wrapped in loud scarves, young mothers, fattish in trousers, lounge about in the speed-wash, smoking cigarettes, eating candy, drinking pop, thumbing magazines, and screaming at their children above the whir and rumble of the machines.

At the bank a young man freshly pressed is letting himself in with a key. Along the street, delicately teetering, many grand-fathers move in a dream. During the murderous heat of sum-mer, they perch on window ledges, their feet dangling just inside the narrow shelf of shade the store has made, staring steadily into the street. Where their consciousness has gone I can't say. It's not in the eyes. Perhaps it's diffuse, all temperature and skin, like an infant's, though more mild. Near the corner there are several large overalled men employed in standing. A truck turns to be weighed on the scales at the Feed and Grain. Images drift on the drugstore window. The wind has blown the smell of cattle into town. Our eyes have been driven in like the eyes of the old men. And there's no one to have mercy on us.

Vital Data

There are two restaurants here and a tearoom. two bars. one bank, three barbers, one with a green shade with which he blinds his window. two groceries. a dealer in Fords. one drug, one hardware, and one appliance store. several that sell feed, grain, and farm equipment. an antique shop. a poolroom. a laundromat. three doctors. a dentist. a plumber. a vet. a fu-neral home in elegant repair the color of a buttercup. numerous beauty parlors which open and shut like night-blooming plants. a tiny dime and department store of no width but several floors.

a hutch, homemade, where you can order, after lying down or squirming in, furniture that's been fashioned from bent lengths of stainless tubing, glowing plastic, metallic thread, and clear shellac. an American Legion Post and a root beer stand. little agencies for this and that: cosmetics, brushes, insurance, greeting cards and garden produce—anything—sample shoes—which do their business out of hats and satchels, over coffee cups and dissolving sugar. a factory for making paper sacks and pasteboard boxes that's lodged in an old brick building bearing the legend OPERA HOUSE, still faintly golden, on its roof. a library given by Carnegie. a post office. a school. a railroad station. fire station. lumberyard. telephone company. welding shop. garage . . . and spotted through the town from one end to the other in a line along the highway, gas stations to the number five.

Education

In 1833, Colin Goodykoontz, an itinerant preacher with a name from a fairytale, summed up the situation in one Indiana town this way:
Ignorance and her squalid brood. A universal dearth of intellect. Total abstinence from literature is very generally practiced. . . . There is not a scholar in grammar or geography, or a *teacher capable of instructing* in them, to my knowledge. . . . Others are supplied a few months of the year with the most antiquated & unreasonable forms of teaching reading, writing & cyphering. . . . Need I stop to remind you of the host of loathsome reptiles such a stagnant pool is fitted to breed! Croaking jealousy; bloated bigotry; coiling suspicion; wormish blindness; crocodile malice!

Things have changed since then, but in none of the respects mentioned.

Business

One side section of street is blocked off with sawhorses. Hard, thin, bitter men in blue jeans, cowboy boots and hats,

untruck a dinky carnival. The merchants are promoting them-
selves. There will be free rides, raucous music, parades and
coneys, pop, popcorn, candy, cones, awards and drawings, with
all you can endure of pinch, push, bawl, shove, shout, scream,
shriek, and bellow. Children pedal past on decorated bicycles,
their wheels a blur of color, streaming crinkled paper and excited
dogs. A little later there's a pet show for a prize—dogs, cats,
birds, sheep, ponies, goats—none of which wins. The whirlabouts
whirl about. The Ferris wheel climbs dizzily into the sky as far
as a tall man on tiptoe might be persuaded to reach, and the
irritated operators measure the height and weight of every child
with sour eyes to see if they are safe for the machines. An elec-
trical megaphone repeatedly trumpets the names of the generous
sponsors. The following day they do not allow the refuse to
remain long in the street.

My House, This Place and Body

I have met with some mischance, wings withering, as Plato
says obscurely, and across the breadth of Ohio, like heaven on
a table, I've fallen as far as the poet, to the sixth sort of body,
this house in B, in Indiana, with its blue and gray bewitching
windows, holy magical insides. Great thick evergreens protect
its entry. And I live *in*.

Lost in the corn rows, I remember feeling just another stalk,
and thus this country takes me over in the way I occupy myself
when I am well . . . completely—to the edge of both my house
and body. No one notices, when they walk by, that I am brim-
ming in the doorways. My house, this place and body, I've come
in mourning to be born in. To anybody else it's pretty silly:
love. Why should I feel a loss? How am I bereft? She was never
mine; she was a fiction, always a golden tomgirl, barefoot, with
an adolescent's slouch and a boy's taste for sports and fishing, a
figure out of Twain, or worse, in Riley. Age cannot be kind.

There's little hand-in-hand here . . . not in B. No one touches
except in rage. Occasionally girls will twine their arms about
each other and lurch along, school out, toward home and play.

I dreamed my lips would drift down your back like a skiff on a river. I'd follow a vein with the point of my finger, hold your bare feet in my naked hands.

The Same Person

Billy Holsclaw lives alone—how alone it is impossible to fathom. In the post office he talks greedily to me about the weather. His head bobs on a wild flood of words, and I take this violence to be a measure of his eagerness for speech. He badly needs a shave, coal dust has layered his face, he spits when he speaks, and his fingers pick at his tatters. He wobbles out in the wind when I leave him, a paper sack mashed in the fold of his arm, the leaves blowing past him, and our encounter drives me sadly home to poetry—where there's no answer. Billy closes his door and carries coal or wood to his fire and closes his eyes, and there's simply no way of knowing how lonely and empty he is or whether he's as vacant and barren and loveless as the rest of us are—here in the heart of the country.

Weather

For we're always out of luck here. That's just how it is—for instance in the winter. The sides of the buildings, the roofs, the limbs of the trees are gray. Streets, sidewalks, faces, feelings—they are gray. Speech is gray, and the grass where it shows. Every flank and front, each top is gray. Everything is gray: hair, eyes, window glass, the hawkers' bills and touters' posters, lips, teeth, poles and metal signs—they're gray, quite gray. Cars are gray. Boots, shoes, suits, hats, gloves are gray. Horses, sheep, and cows, cats killed in the road, squirrels in the same way, sparrows, doves, and pigeons, all are gray, everything is gray, and everyone is out of luck who lives here.

A similar haze turns the summer sky milky, and the air muffles your head and shoulders like a sweater you've got caught in. In the summer light, too, the sky darkens a moment when you open your eyes. The heat is pure distraction. Steeped in our fluids,

miserable in the folds of our bodies, we can scarcely think of anything but our sticky parts. Hot cyclonic winds and storms of dust crisscross the country. In many places, given an indifferent push, the wind will still coast for miles, gathering resource and edge as it goes, cunning and force. According to the season, paper, leaves, field litter, seeds, snow, fill up the fences. Sometimes I think the land is flat because the winds have leveled it, they blow so constantly. In any case, a gale can grow in a field of corn that's as hot as a draft from hell, and to receive it is one of the most dismaying experiences of this life, though the smart of the same wind in winter is more humiliating, and in that sense even worse. But in the spring it rains as well, and the trees fill with ice.

Place

Many small Midwestern towns are nothing more than rural slums, and this community could easily become one. Principally during the first decade of the century, though there were many earlier instances, well-to-do farmers moved to town and built fine homes to contain them in their retirement. Others desired a more social life, and so lived in, driving to their fields like storekeepers to their businesses. These houses are now dying like the bereaved who inhabit them; they are slowly losing their senses—deafness, blindness, forgetfulness, mumbling, an insecure gait, an uncontrollable trembling has overcome them. Some kind of Northern Snopes will occupy them next: large-familied, Catholic, Democratic, scrambling, vigorous, poor; and since the parents will work in larger, nearby towns, the children will be loosed upon themselves and upon the hapless neighbors much as the fabulous Khan loosed his legendary horde. These Snopes will undertake makeshift repairs with materials that other people have thrown away; paint halfway round their house, then quit; almost certainly maintain an ugly loud cantankerous dog and underfeed a pair of cats to keep the rodents down. They will collect piles of possibly useful junk in the back yard, park their cars in the front, live largely leaning over engines, give not a hoot for the land, the old com-

munity, the hallowed ways, the established clans. Weakening widow ladies have already begun to hire large rude youths from families such as these to rake and mow and tidy the grounds they will inherit.

People

In the cinders at the station boys sit smoking steadily in darkened cars, their arms bent out the windows, white shirts glowing behind the glass. Nine o'clock is the best time. They sit in a line facing the highway—two or three or four of them— idling their engines. As you walk by a machine may growl at you or a pair of headlights flare up briefly. In a moment one will pull out, spinning cinders behind it, to stalk impatiently up and down the dark streets or roar half a mile into the country before return- ing to its place in line and pulling up.

My House, my Cat, my Company

I must organize myself. I must, as they say, pull myself to- gether, dump this cat from my lap, stir—yes, resolve, move, do. But do what? My will is like the rosy dustlike light in this room: soft, diffuse, and gently comforting. It lets me do . . . anything . . . nothing. My ears hear what they happen to; I eat what's put before me; my eyes see what blunders into them; my thoughts are not thoughts, they are dreams. I'm empty or I'm full . . . depend- ing; and I cannot choose. I sink my claws in Tick's fur and scratch the bones of his back until his rear rises amorously. Mr. Tick, I murmur, I must organize myself. I must pull myself to- gether. And Mr. Tick rolls over on his belly, all ooze.

I spill Mr. Tick when I've rubbed his stomach. Shoo. He steps away slowly, his long tail rhyming with his paws. How beauti- fully he moves, I think; how beautifully, like you, he commands his loving, how beautifully he accepts. So I rise and wander from room to room, up and down, gazing through most of my forty-one windows. How well this house receives its loving too. Let out like Mr. Tick, my eyes sink in the shrubbery. I am not here; I've

passed the glass, passed second-story spaces, flown by branches, brilliant berries, to the ground, grass high in seed and leafage every season; and it is the same as when I passed above you in my aged, ardent body; it's, in short, a kind of love; and I am learning to restore myself, my house, my body, by paying court to gardens, cats, and running water, and with neighbors keeping company.

Mrs. Desmond is my right-hand friend; she's eighty-five. A thin white mist of hair, fine and tangled, manifests the climate of her mind. She is habitually suspicious, fretful, nervous. Burglars break in at noon. Children trespass. Even now they are shaking the pear tree, stealing rhubarb, denting lawn. Flies caught in the screens and numbed by frost awake in the heat to buzz and scrape the metal cloth and frighten her, though she is deaf to me, and consequently cannot hear them. Boards creak, the wind whistles across the chimney mouth, drafts cruise like fish through the hollow rooms. It is herself she hears, her own flesh failing, for only death will preserve her from those daily chores she climbs like stairs, and all that anxious waiting. Is it now, she wonders. No? Then: is it now?

We do not converse. She visits me to talk. My task to murmur. She talks about her grandsons, her daughter who lives in Delphi, her sister or her husband—both gone—obscure friends—dead—obscurer aunts and uncles—lost—ancient neighbors, members of her church or of her clubs—passed or passing on; and in this way she brings the ends of her life together with a terrifying rush: she is a girl, a wife, a mother, widow, all at once. All at once—appalling—but I believe it; I wince in expectation of the clap. Her talk's a fence—a shade drawn, window fastened, door that's locked—for no one dies taking tea in a kitchen; and as her years compress and begin to jumble, I really believe in the brevity of life; I sweat in my wonder; death is the dog down the street, the angry gander, bedroom spider, goblin who's come to get her; and it occurs to me that in my listening posture I'm the boy who suffered the winds of my grandfather with an exactly similar politeness, that I am, right now, all my ages, out in elbows, as angular as badly stacked cards. Thus was I, when I loved you, every man I could be, youth and child—far from enough—and

you, so strangely ambiguous a being, met me, heart for spade, play after play, the whole run of our suits.

Mr. Tick, you do me honor. You not only lie in my lap, but you remain alive there, coiled like a fetus. Through your deep nap, I feel you hum. You are, and are not, a machine. You are alive, alive exactly, and it means nothing to you—much to me. You are a cat—you cannot understand—you are a cat so easily. Your nature is not something you must rise to. You, not I, live in: in house, in skin, in shrubbery. Yes. I think I shall hat my head with a steeple; turn church; devour people. Mr. Tick, though, has a tail he can twitch, he need not fly his Fancy. Claws, not metrical schema, poetry his paws; while smoothing . . . smoothing . . . smoothing roughly, his tongue laps its neatness. O Mr. Tick, I know you; you are an electrical penis. Go on now, shoo. Mrs. Desmond doesn't like you. She thinks you will tangle yourself in her legs and she will fall. You murder her birds, she knows, and walk upon her roof with death in your jaws. I must gather myself together for a bound. What age is it I'm at right now, I wonder. The heart, don't they always say, keeps the true time. Mrs. Desmond is knocking. Faintly, you'd think, but she pounds. She's brought me a cucumber. I believe she believes I'm a woman. Come in, Mrs. Desmond, thank you, be my company, it looks lovely, and have tea. I'll slice it, crisp, with cream, for luncheon, each slice as thin as me.

Politics

O all ye isolate and separate powers, Sing! Sing, and sing in such a way that from a distance it will seem a harmony, a Strindberg play, a friendship ring . . . so happy—happy, happy, happy —as here we go hand in handling, up and down. Our union was a singing, though we were silent in the songs we sang like single notes are silent in a symphony. In no sense sober, we barbershopped together and never heard the discords in our music or saw ourselves as dirty, cheap, or silly. Yet cats have worn out better shoes than those thrown through our love songs at us. Hush. Be patient—prudent—politic. Still, Cleveland killed you,

Mr. Crane. Were you not politic enough and fond of being beaten? Like a piece of sewage, the city shat you from its stern three hundred miles from history—beyond the loving reach of sailors. Well, I'm not a poet who puts Paris to his temple in his youth to blow himself from Idaho, or—fancy that—Missouri. My god, I said, this is my country, but must my country go so far as Terre Haute or Whiting, go so far as Gary?

When the Russians first announced the launching of their satellite, many people naturally refused to believe them. Later others were outraged that they had sent a dog around the earth. I wouldn't want to take that mutt from out that metal flying thing if he's still living when he lands, our own dog catcher said; anybody knows you shut a dog up by himself to toss around the first thing he'll be setting on to do you let him out is bite somebody.

This Midwest. A dissonance of parts and people, we are a consonance of Towns. Like a man grown fat in everything but heart, we overlabor; our outlook never really urban, never rural either, we enlarge and linger at the same time, as Alice both changed and remained in her story. You are blond. I put my hand upon your belly; feel it tremble from my trembling. We always drive large cars in my section of the country. How could you be a comfort to me now?

More Vital Data

The town is exactly fifty houses, trailers, stores, and miscellaneous buildings long, but in places no streets deep. It takes on width as you drive south, always adding to the east. Most of the dwellings are fairly spacious farm houses in the customary white, with wide wraparound porches and tall narrow windows, though there are many of tne grander kind—fretted, scalloped, turreted, and decorated with clapboards set at angles or on end, with stained-glass windows at the stair landings and lots of wrought iron full of fancy curls—and a few of these look like castles in their rarer brick. Old stables serve as garages now, and the lots are large to contain them and the vegetable and flower gardens which, ultimately, widows plant and weed and then entirely dis-

appear in. The shade is ample, the grass is good, the sky a glorious fall violet; the apple trees are heavy and red, the roads are calm and empty; corn has sifted from the chains of tractored wagons to speckle the streets with gold and with the russet fragments of the cob, and a man would be a fool who wanted, blessed with this, to live anywhere else in the world.

Education

Buses like great orange animals move through the early light to school. There the children will be taught to read and warned against Communism. By Miss Janet Jakes. That's not her name. Her name is Helen something—Scott or James. A teacher twenty years. She's now worn fine and smooth, and has a face, Wilfred says, like a mail-order ax. Her voice is hoarse, and she has a cough. For she screams abuse. The children stare, their faces blank. This is the thirteenth week. They are used to it. You will all, she shouts, you will all draw pictures of me. No. She is a Mrs.—someone's missus. And in silence they set to work while Miss Jakes jabs hairpins in her hair. Wilfred says an ax, but she has those rimless tinted glasses, graying hair, an almost dimpled chin. I must concentrate. I must stop making up things. I must give myself to life; let it mold me: that's what they say in *Wisdom's Monthly Digest* every day. Enough, enough—you've been at it long enough; and the children rise formally a row at a time to present their work to her desk. No, she wears rims; it's her chin that's dimpleless. Well, it will take more than a tablespoon of features to sweeten that face. So she grimly shuffles their sheets, examines her reflection crayoned on them. I would not dare . . . allow a child . . . to put a line around me. Though now and then she smiles like a nick in the blade, in the end these drawings depress her. I could not bear it—how can she ask?—that anyone . . . draw me. Her anger's lit. That's why she does it: flame. There go her eyes; the pink in her glasses brightens, dims. She is a pumpkin, and her rage is breathing like the candle in. No, she shouts, no—the cartoon trembling—no, John Mauck, John Stewart Mauck, this will not do. The picture flutters from her fingers. You've made me too muscular.

I work on my poetry. I remember my friends, associates, my students, by their names. Their names are Maypop, Dormouse, Upsydaisy. Their names are Gladiolus, Callow Bladder, Prince and Princess Oleo, Hieronymus, Cardinal Mummum, Mr. Fitchew, The Silken Howdah, Spot. Sometimes you're Tom Sawyer, Huckleberry Finn; it is perpetually summer; your buttocks are my pillow; we are adrift on a raft; your back is our river. Sometimes you are Major Barbara, sometimes a goddess who kills men in battle, sometimes you are soft like a shower of water; you are bread in my mouth.

I do not work on my poetry. I forget my friends, associates, my students, and their names: Gramophone, Blowgun, Pickle, Serenade . . . Marge the Barge, Arena, Uberhaupt . . . Doctor Dildoe, The Fog Machine. For I am now in B, in Indiana: out of job and out of patience, out of love and time and money, out of bread and out of body, in a temper, Mrs. Desmond, out of tea. So shut your fist up, bitch, you bag of death; go bang another door; go die, my dearie. Die, life-deaf old lady. Spill your breath. Fall over like a frozen board. Gray hair grows from the nose of your mind. You are a skull already—*memento mori*—the foreskin retracts from your teeth. Will your plastic gums last longer than your bones, and color their grinning? And is your twot still hazel-hairy, or are you bald as ditch? . . . bitch bitch bitch. I wanted to be famous, but you bring me age—my emptiness. Was it *that* which I thought would balloon me above the rest? Love? where are you? . . . love me. I want to rise so high, I said, that when I shit I won't miss anybody.

Business

For most people, business is poor. Nearby cities have siphoned off all but a neighborhood trade. Except for feed and grain and farm supplies, you stand a chance to sell only what one runs out to buy. Chevrolet has quit, and Frigidaire. A locker plant has left its afterimage. The lumberyard has been, so far, six months about its going. Gas stations change hands clumsily, a restaurant becomes available, a grocery closes. One day they came and

knocked the cornices from the watch repair and pasted campaign posters on the windows. Torn across, by now, by boys, they urge you still to vote for half an orange beblazoned man who as a whole one failed two years ago to win at his election. Everywhere, in this manner, the past speaks, and it mostly speaks of failure. The empty stores, the old signs and dusty fixtures, the debris in alleys, the flaking paint and rusty gutters, the heavy locks and sagging boards: they say the same disagreeable things. What do the sightless windows see, I wonder, when the sun throws a passerby against them? Here a stair unfolds toward the street—dark, rickety, and treacherous—and I always feel, as I pass it, that if I just went carefully up and turned the corner at the landing, I would find myself out of the world. But I've never had the courage.

That Same Person

The weeds catch up with Billy. In pursuit of the hollyhocks, they rise in coarse clumps all around the front of his house. Billy has to stamp down a circle by his door like a dog or cat does turning round to nest up, they're so thick. What particularly troubles me is that winter will find the weeds still standing stiff and tindery to take the sparks which Billy's little mortarless chimney spouts. It's true that fires are fun here. The town whistle, which otherwise only blows for noon (and there's no noon on Sunday), signals the direction of the fire by the length and number of its blasts, the volunteer firemen rush past in their cars and trucks, houses empty their owners along the street every time like an illustration in a children's book. There are many bikes, too, and barking dogs, and sometimes—halleluiah—the fire's right here in town—a vacant lot of weeds and stubble flaming up. But I'd rather it weren't Billy or Billy's lot or house. Quite selfishly I want him to remain the way he is—counting his sticks and logs, sitting on his sill in the soft early sun—though I'm not sure what his presence means to me . . . or to anyone. Nevertheless, I keep wondering whether, given time, I might not someday find a figure in our language which would serve him faithfully, and furnish his poverty and loneliness richly out.

Wires

Where sparrows sit like fists. Doves fly the steeple. In mist the wires change perspective, rise and twist. If they led to you, I would know what they were. Thoughts passing often, like the starlings who flock these fields at evening to sleep in the trees beyond, would form a family of paths like this; they'd foot down the natural height of air to just about a bird's perch. But they do not lead to you.

> Of whose beauty it was sung
> She shall make the old man young.

They fasten me.

If I walked straight on, in my present mood, I would reach the Wabash. It's not a mood in which I'd choose to conjure you. Similes dangle like baubles from me. This time of year the river is slow and shallow, the clay banks crack in the sun, weeds surprise the sandbars. The air is moist and I am sweating. It's impossible to rhyme in this dust. Everything—sky, the cornfield, stump, wild daisies, my old clothes and pressless feelings—seem fabricated for installment purchase. Yes. Christ. I am suffering a summer Christmas; and I cannot walk under the wires. The sparrows scatter like handfuls of gravel. Really, wires are voices in thin strips. They are words wound in cables. Bars of connection.

Weather

I would rather it were the weather that was to blame for what I am and what my friends and neighbors are—we who live here in the heart of the country. Better the weather, the wind, the pale dying snow . . . the snow—why not the snow? There's never much really, not around the lower Lakes anyway, not enough to boast about, not enough to be useful. My father tells how the snow in the Dakotas would sweep to the roofs of the barns in the old days, and he and his friends could sled on the crust that would form because the snow was so fiercely driven. In Bemidji trees have

been known to explode. That would be something—if the trees in Davenport or Francisville or Carbondale or Niles were to go blam some winter—blam! blam! blam! all the way down the gray, cindery, snow-sick streets.

A cold fall rain is blackening the trees or the air is like lilac and full of parachuting seeds. Who cares to live in any season but his own? Still I suspect the secret's in this snow, the secret of our sickness, if we could only diagnose it, for we are all dying like the elms in Urbana. This snow—like our skin it covers the country. Later dust will do it. Right now—snow. Mud presently. But it is snow without any laughter in it, a pale gray pudding thinly spread on stiff toast, and if that seems a strange description, it's accurate all the same. Of course soot blackens everything, but apart from that, we are never sufficiently cold here. The flakes as they come, alive and burning, we cannot retain, for if our temperatures fall, they rise promptly again, just as, in the summer, they bob about in the same feckless way. Suppose though . . . suppose they were to rise some August, climb and rise, and then hang in the hundreds like a hawk through December, what a desert we could make of ourselves—from Chicago to Cairo, from Hammond to Columbus—what beautiful Death Valleys.

Place

I would rather it were the weather. It drives us in upon ourselves—an unlucky fate. Of course there is enough to stir our wonder anywhere; there's enough to love, anywhere, if one is strong enough, if one is diligent enough, if one is perceptive, patient, kind enough—whatever it takes; and surely it's better to live in the country, to live on a prairie by a drawing of rivers, in Iowa or Illinois or Indiana, say, than in any city, in any stinking fog of human beings, in any blooming orchard of machines. It ought to be. The cities are swollen and poisonous with people. It ought to be better. Man has never been a fit environment for man—for rats, maybe, rats do nicely, or for dogs or cats and the household beetle.

And how long the street is, nowadays. These endless walls are

fallen to keep back the tides of earth. Brick could be beautiful but we have covered it gradually with gray industrial vomits. Age does not make concrete genial, and asphalt is always—like America—twenty-one, until it breaks up in crumbs like stale cake. The brick, the asphalt, the concrete, the dancing signs and garish posters, the feed and excrement of the automobile, the litter of its inhabitants: they compose, they decorate, they line our streets, and there is nowhere, nowadays, our streets can't reach.

A man in the city has no natural thing by which to measure himself. His parks are potted plants. Nothing can live and remain free where he resides but the pigeon, starling, sparrow, spider, cockroach, mouse, moth, fly and weed, and he laments the existence of even these and makes his plans to poison them. The zoo? There *is* the zoo. Through its bars the city man stares at the great cats and dully sucks his ice. Living, alas, among men and their marvels, the city man supposes that his happiness depends on establishing, somehow, a special kind of harmonious accord with others. The novelists of the city, of slums and crowds, they call it love—and break their pens.

Wordsworth feared the accumulation of men in cities. He foresaw their "degrading thirst after outrageous stimulation," and some of their hunger for love. Living in a city, among so many, dwelling in the heat and tumult of incessant movement, a man's affairs are touch and go—that's all. It's not surprising that the novelists of the slums, the cities, and the crowds, should find that sex is but a scratch to ease a tickle, that we're most human when we're sitting on the john, and that the justest image of our life is in full passage through the plumbing.

> That man, immur'd in cities, still retains
> His inborn inextinguishable thirst
> Of rural scenes, compensating his loss
> By supplemental shifts, the best he may.

Come into the country, then. The air nimbly and sweetly recommends itself unto our gentle senses. Here, growling tractors tear the earth. Dust roils up behind them. Drivers sit jouncing under bright umbrellas. They wear refrigerated hats and steer by looking at the tracks they've cut behind them, their transistors

blaring. Close to the land, are they? good companions to the soil? Tell me: do they live in harmony with the alternating seasons?

It's a lie of old poetry. The modern husbandman uses chemicals from cylinders and sacks, spike-ball-and-claw machines, metal sheds, and cost accounting. Nature in the old sense does not matter. It does not exist. Our farmer's only mystical attachment is to parity. And if he does not realize that cows and corn are simply different kinds of chemical engine, he cannot expect to make a go of it.

It isn't necessary to suppose our cows have feelings; our neighbor hasn't as many as he used to have either; but think of it this way a moment, you can correct for the human imputations later: how would it feel to nurse those strange tentacled calves with their rubber, glass, and metal lips, their stainless eyes?

People

Aunt Pet's still able to drive her car—a high square Ford—even though she walks with difficulty and a stout stick. She has a watery gaze, a smooth plump face despite her age, and jet black hair in a bun. She has the slowest smile of anyone I ever saw, but she hates dogs, and not very long ago cracked the back of one she cornered in her garden. To prove her vigor she will tell you this, her smile breaking gently while she raises the knob of her stick to the level of your eyes.

House, my Breath and Window

My window is a grave, and all that lies within it's dead. No snow is falling. There's no haze. It is not still, not silent. Its images are not an animal that waits, for movement is no demonstration. I have seen the sea slack, life bubble through a body without a trace, its spheres impervious as soda's. Downwound, the whore at wagtag clicks and clacks. Leaves wiggle. Grass sways. A bird chirps, pecks the ground. An auto wheel in penning circles keeps its rigid spokes. These images are stones; they are memorials. Beneath this sea lies sea: god rest it . . . rest the

world beyond my window, me in front of my reflection, above this page, my shade. Death is not so still, so silent, since silence implies a falling quiet, stillness a stopping, containing, holding in; for death is time in a clock, like Mr. Tick, electric . . . like wind through a windup poet. And my blear floats out to visible against the glass, befog its country and bespill myself. The mist lifts slowly from the fields in the morning. No one now would say: the Earth throws back its covers; it is rising from sleep. Why is the feeling foolish? The image is too Greek. I used to gaze at you so wantonly your body blushed. Imagine: wonder: that my eyes could cause such flowering. Ah, my friend, your face is pale, the weather cloudy; a street has been felled through your chin, bare trees do nothing, houses take root in their rectangles, a steeple stands up in your head. You speak of loving; then give me a kiss. The pane is cold. On icy mornings the fog rises to greet me (as you always did); the barns and other buildings, rather than ghostly, seem all the more substantial for looming, as if they grew in themselves while watched (as you always did). Oh my approach, I suppose, was like breath in a rubber monkey. Nevertheless, on the road along the Wabash in the morning, though the trees are sometimes obscured by fog, their reflection floats serenely on the river, reasoning the banks, the sycamores in French rows. Magically, the world tips. I'm led to think that only those who grow down live (which will scarcely win me twenty-five from *Wisdom's Monthly Digest*), but I find I write that only those who live down grow; and what I write, I hold, whatever I really know. My every word's inverted, or reversed—or I am. I held you, too, that way. You were so utterly provisional, subject to my change. I could inflate your bosom with a kiss, disperse your skin with gentleness, enter your vagina from within, and make my love emerge like a fresh sex. The pane is cold. Honesty is cold, my inside lover. The sun looks, through the mist, like a plum on the tree of heaven, or a bruise on the slope of your belly. Which? The grass crawls with frost. We meet on this window, the world and I, inelegantly, swimmers of the glass; and swung wrong way round to one another, the world seems in. The world —how grand, how monumental, grave and deadly, that word is: the world, my house and poetry. All poets have their inside lovers.

Wee penis does not belong to me, or any of this foggery. It is *his* property which he's thrust through what's womanly of me to set down this. These wooden houses in their squares, gray streets and fallen sidewalks, standing trees, your name I've written sentimentally across my breath into the whitening air, pale birds: they exist in me now because of him. I gazed with what intensity . . . A bush in the excitement of its roses could not have bloomed so beautifully as you did then. It was a look I'd like to give this page. For that is poetry: to bring within about, to change.

Politics

Sports, politics, and religion are the three passions of the badly educated. They are the Midwest's open sores. Ugly to see, a source of constant discontent, they sap the body's strength. Appalling quantities of money, time, and energy are wasted on them. The rural mind is narrow, passionate, and reckless on these matters. Greed, however shortsighted and direct, will not alone account for it. I have known men, for instance, who for years have voted squarely against their interests. Nor have I ever noticed that their surly Christian views prevented them from urging forward the smithereening, say, of Russia, China, Cuba, or Korea. And they tend to back their country like they back their local team: they have a fanatical desire to win; yelling is their forte; and if things go badly, they are inclined to sack the coach. All in all, then, Birch is a good name. It stands for the bigot's stick, the wild-child-tamer's cane.

Forgetfulness—is that their object?

Oh, I was new, I thought. A fresh start: new cunt, new climate, and new country—there you were, and I was pioneer, and had no history. That language hurts me, too, my dear. You'll never hear it.

Final Vital Data

The Modern Homemakers' Demonstration Club. The Prairie Home Demonstration Club. The Night-outers' Home Demonstra-

tion Club. The IOOF, FFF, VFW, WCTU, WSCS, 4-H, 40 and 8, Psi Iota Chi, and PTA. The Boy and Girl Scouts, Rainbows, Masons, Indians and Rebekah Lodge. Also the Past Noble Grand Club of the Rebekah Lodge. As well·as the Moose and the Ladies of the Moose. The Elks, the Eagles, the Jaynettes and the Eastern Star. The Women's Literary Club, the Hobby Club, the Art Club, the Sunshine Society, the Dorcas Society, the Pythian Sisters, the Pilgrim Youth Fellowship, the American Legion, the American Legion Auxiliary, the American Legion Junior Auxiliary, the Gardez Club, the Bridge for Fun Club, the What-can-you-do? Club, the Get Together Club, the Coterie Club, the Worthwhile Club, the Let's Help Our Town Club, the No Name Club, the Forget-me-not Club, the Merry-go-round Club . . .

Education

Has a quarter disappeared from Paula Frosty's pocket book? Imagine the landscape of that face: no crayon could engender it; soft wax is wrong; thin wire in trifling snips might do the trick. Paula Frosty and Christopher Roger accuse the pale and splotchy Cheryl Pipes. But Miss Jakes, I *saw* her. Miss Jakes is so extremely vexed she snaps her pencil. What else is missing? I appoint you a detective, John: search her desk. Gum, candy, paper, pencils, marble, round eraser—whose? A thief. I can't watch her all the time, I'm here to teach. Poor pale fosseted Cheryl, it's determined, can't return the money because she took it home and spent it. Cindy, Janice, John, and Pete—you four who sit around her—you will be detectives this whole term to watch her. A thief. In all my time. Miss Jakes turns, unfists, and turns again. I'll handle you, she cries. To think. A thief. In all my years. Then she writes on the blackboard the name of Cheryl Pipes and beneath that the figure twenty-five with a large sign for cents. Now Cheryl, she says, this won't be taken off until you bring that money out of home, out of home straight up to here, Miss Jakes says, tapping her desk.

Which is three days.

Another Person

I was raking leaves when Uncle Halley introduced himself to me. He said his name came from the comet, and that his mother had borne him prematurely in her fright of it. I thought of Hobbes, whom fear of the Spanish Armada had hurried into birth, and so I believed Uncle Halley to honor the philosopher, though Uncle Halley is a liar, and neither the one hundred twenty-nine nor the fifty-three he ought to be. That fall the leaves had burned themselves out on the trees, the leaf lobes had curled, and now they flocked noisily down the street and were broken in the wires of my rake. Uncle Halley was himself (like Mrs. Desmond and history generally) both deaf and implacable, and he shooed me down his basement stairs to a room set aside there for stacks of newspapers reaching to the ceiling, boxes of leaflets and letters and programs, racks of photo albums, scrapbooks, bundles of rolled-up posters and maps, flags and pennants and slanting piles of dusty magazines devoted mostly to motoring and the Christian ethic. I saw a bird cage, a tray of butterflies, a bugle, a stiff straw boater, and all kinds of tassels tied to a coat tree. He still possessed and had on display the steering lever from his first car, a linen duster, driving gloves and goggles, photographs along the wall of himself, his friends, and his various machines, a shell from the first war, a record of "Ramona" nailed through its hole to a post, walking sticks and fanciful umbrellas, shoes of all sorts (his baby shoes, their counters broken, were held in sorrow beneath my nose—they had not been bronzed, but he might have them done someday before he died, he said), countless boxes of medals, pins, beads, trinkets, toys, and keys (I scarcely saw—they flowed like jewels from his palms), pictures of downtown when it was only a path by the railroad station, a brightly colored globe of the world with a dent in Poland, antique guns, belt buckles, buttons, souvenir plates and cups and saucers (I can't remember all of it—I won't), but I recall how shamefully, how rudely, how abruptly, I fled, a good story in my mouth but death in my nostrils; and how afterward I busily, righteously, burned my

leaves as if I were purging the world of its years. I still wonder if this town—its life, and mine now—isn't really a record like the one of "Ramona" that I used to crank around on my grandmother's mahogany Victrola through lonely rainy days as a kid.

The First Person

Billy's like the coal he's found: spilled, mislaid, discarded. The sky's no comfort. His house and his body are dying together. His windows are boarded. And now he's reduced to his hands. I suspect he has glaucoma. At any rate he can scarcely see, and weeds his yard of rubble on his hands and knees. Perhaps he's a surgeon cleansing a wound or an ardent and tactile lover. I watch, I must say, apprehensively. Like mine-war detectors, his hands graze in circles ahead of him. Your nipples were the coloɪ of your eyes. Pebble. Snarl of paper. Length of twine. He leans down closely, picks up something silvery, holds it near his nose. Foil? cap? coin? He has within him—what, I wonder? Does he know more now because he fingers everything and has to sniff to see? It would be romantic cruelty to think so. He bends the down on your arms like a breeze. You wrote me: something is strange when we don't understand. I write in return: I think when I loved you I fell to my death.

Billy, I could read to you from Beddoes; he's your man perhaps; he held with dying, freed his blood of its arteries; and he said that there were many wretched love-ill fools like me lying alongside the last bone of their former selves, as full of spirit and speech, nonetheless, as Mrs. Desmond, Uncle Halley and the Ferris wheel, Aunt Pet, Miss Jakes, Ramona or the megaphone; yet I reverse him finally, Billy, on no evidence but braggadocio, and I declare that though my inner organs were devoured long ago, the worm which swallowed down my parts still throbs and glows like a crystal palace.

Yes, you were younger. I was Uncle Halley, the museum man and infrequent meteor. Here is my first piece of ass. They weren't so flat in those days, had more round, more juice. And over here's the sperm I've spilled, nicely jarred and clearly labeled. Look at this tape like lengths of intestine where I've stored my spew, the

endless worm of words I've written, a hundred million emissions or more: oh I was quite a man right from the start; even when unconscious in my cradle, from crotch to cranium, I was erectile tissue; though mostly, after the manner approved by Plato, I had intercourse by eye. Never mind, old Holsclaw, you are blind. We pull down darkness when we go to bed; put out like Oedipus the actually offending organ, and train our touch to lies. All cats are gray, says Mr. Tick; so under cover of glaucoma you are sack gray too, and cannot be distinguished from a stallion.

I must pull myself together, get a grip, just as they say, but I feel spilled, bewildered, quite mislaid. I did not restore my house to its youth, but to its age. Hunting, you hitch through the hollyhocks. I'm inclined to say you aren't half the cripple I am, for there is nothing left of me but mouth. However, I resist the impulse. It is another lie of poetry. My organs are all there, though it's there where I fail—at the roots of my experience. Poet of the spiritual, Rilke, weren't you? yet that's what you said. Poetry, like love, is—in and out—a physical caress. I can't tolerate any more of my sophistries about spirit, mind, and breath. Body equals being, and if your weight goes down, you are the less.

Household Apples

I knew nothing about apples. Why should I? My country came in my childhood, and I dreamed of sitting among the blooms like the bees. I failed to spray the pear tree too. I doubled up under them at first, admiring the sturdy low branches I should have pruned, and later I acclaimed the blossoms. Shortly after the fruit formed there were falls—not many—apples the size of goodish stones which made me wobble on my ankles when I walked about the yard. Sometimes a piece crushed by a heel would cling on the shoe to track the house. I gathered a few and heaved them over the wires. A slingshot would have been splendid. Hard, an unattractive green, the worms had them. Before long I realized the worms had them all. Even as the apples reddened, lit their tree, they were being swallowed. The birds preferred the pears, which were small—sugar pears I think they're called—with thick skins of graying green that ripen on

toward violet. So the fruit fell, and once I made some applesauce by quartering and paring hundreds; but mostly I did nothing, left them, until suddenly, overnight it seemed, in that ugly late September heat we often have in Indiana, my problem was upon me.

My childhood came in the country. I remember, now, the flies on our snowy luncheon table. As we cleared away they would settle, fastidiously scrub themselves and stroll to the crumbs to feed where I would kill them in crowds with a swatter. It was quite a game to catch them taking off. I struck heavily since I didn't mind a few stains; they'd wash. The swatter was a square of screen bound down in red cloth. It drove no air ahead of it to give them warning. They might have thought they'd flown head-long into a summered window. The faint pink dot where they had died did not rub out as I'd supposed, and after years of use our luncheon linen would faintly, pinkly, speckle.

The country became my childhood. Flies braided themselves on the flypaper in my grandmother's house. I can smell the bakery and the grocery and the stables and the dairy in that small Dakota town I knew as a kid; knew as I dreamed I'd know your body, as I've known nothing, before or since; knew as the flies knew, in the honest, unchaste sense: the burned house, hose-wet, which drew a mist of insects like the blue smoke of its smolder, and gangs of boys, moist-lipped, destructive as its burning. Flies have always impressed me; they are so persistently alive. Now they were coating the ground beneath my trees. Some were ordinary flies; there were the large blue-green ones; there were swarms of fruit flies too, and the red-spotted scavenger beetle; there were a few wasps, several sorts of bees and butterflies—checkers, sulphurs, monarchs, commas, question marks—and delicate dragonflies . . . but principally houseflies and horseflies and bottleflies, flies and more flies in clusters around the rotting fruit. They loved the pears. Inside, they fed. If you picked up a pear, they flew, and the pear became skin and stem. They were everywhere the fruit was: in the tree still—apples like a hive for them—or where the fruit littered the ground, squashing itself as you stepped . . . there was no help for it. The flies droned, feasting on the sweet juice. No one could go near the trees; I could not climb; so I determined at last to labor like Hercules. There were

fruit baskets in the barn. Collecting them and kneeling under the branches, I began to gather remains. Deep in the strong rich smell of the fruit, I began to hum myself. The fruit caved in at the touch. Glistening red apples, my lifting disclosed, had families of beetles, flies, and bugs, devouring their rotten undersides. There were streams of flies; there were lakes and cataracts and rivers of flies, seas and oceans. The hum was heavier, higher, than the hum of the bees when they came to the blooms in the spring, though the bees were there, among the flies, ignoring me—ignoring everyone. As my work went on and juice covered my hands and arms, they would form a sleeve, black and moving, like knotty wool. No caress could have been more indifferently complete. Still I rose fearfully, ramming my head in the branches, apples bumping against me before falling, bursting with bugs. I'd snap my hand sharply but the flies would cling to the sweet. I could toss a whole cluster into a basket from several feet. As the pear or apple lit, they would explosively rise, like monads for a moment, windowless, certainly, with respect to one another, sugar their harmony. I had to admit, though, despite my distaste, that my arm had never been more alive, oftener or more gently kissed. Those hundreds of feet were light. In washing them off, I pretended the hose was a pump. What have I missed? Childhood is a lie of poetry.

The Church

Friday night. Girls in dark skirts and white blouses sit in ranks and scream in concert. They carry funnels loosely stuffed with orange and black paper which they shake wildly, and small megaphones through which, as drilled, they direct and magnify their shouting. Their leaders, barely pubescent girls, prance and shake and whirl their skirts above their bloomers. The young men, leaping, extend their arms and race through puddles of amber light, their bodies glistening. In a lull, though it rarely occurs, you can hear the squeak of tennis shoes against the floor. Then the yelling begins again, and then continues; fathers, mothers, neighbors joining in to form a single pulsing ululation— a cry of the whole community—for in this gymnasium each body

becomes the bodies beside it, pressed as they are together, thigh
to thigh, and the same shudder runs through all of them, and runs
toward the same release. Only the ball moves serenely through
this dazzling din. Obedient to law it scarcely speaks but caroms
quietly and lives at peace.

Business

It is the week of Christmas and the stores, to accommodate
the rush they hope for, are remaining open in the evening. You
can see snow falling in the cones of the street lamps. The roads
are filling—undisturbed. Strings of red and green lights droop
over the principal highway, and the water tower wears a star.
The windows of the stores have been bedizened. Shamelessly they
beckon. But I am alone, leaning against a pole—no . . . there is
no one in sight. They're all at home, perhaps by their instruments,
tuning in on their evenings, and like Ramona, tirelessly playing
and replaying themselves. There's a speaker perched in the tower,
and through the boughs of falling snow and over the vacant
streets, it drapes the twisted and metallic strains of a tune that
can barely be distinguished—yes, I believe it's one of the jolly
ones, it's "Joy to the World." There's no one to hear the music but
myself, and though I'm listening, I'm no longer certain. Perhaps
the record's playing something else.

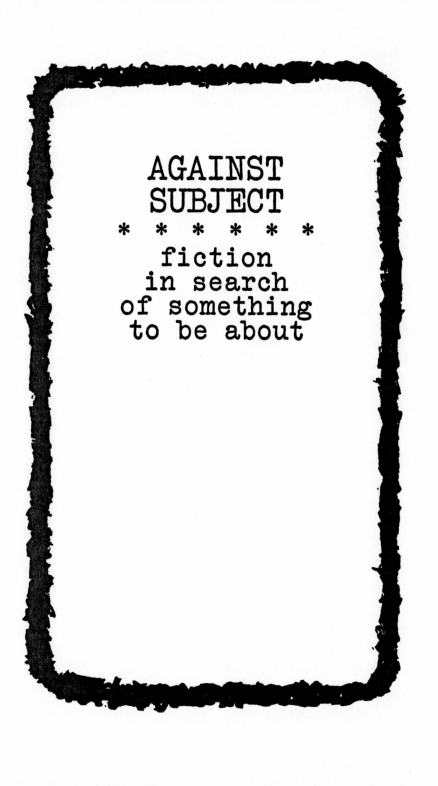

AGAINST
SUBJECT
*** * * * * ***

fiction
in search
of something
to be about

blow-up

Julio Cortázar

IT'LL NEVER be known how this has to be told, in the first person or in the second, using the third person plural or continually inventing modes that will serve for nothing. If one might say: I will see the moon rose, or: we hurt me at the back of my eyes, and especially: you the blond woman was the clouds that race before my your his our yours their faces. What the hell.

Seated ready to tell it, if one might go to drink a bock over there, and the typewriter continue by itself (because I use the machine), that would be perfection. And that's not just a manner of speaking. Perfection, yes, because here is the aperture which must be counted also as a machine (of another sort, a Contax 1.1.2) and it is possible that one machine may know more about another machine than I, you, she—the blond—and the clouds. But I have the dumb luck to know that if I go this Remington will sit turned to stone on top of the table with the air of being twice as quiet that mobile things have when they are not moving. So, I have to write. One of us all has to write, if this is going to get told. Better that it be me who am dead, for I'm less compromised than the rest; I who see only the clouds and can think without being distracted, write without being distracted (there goes another, with a grey edge) and remember without being distracted, I who am dead (and I'm alive, I'm not trying to fool anybody, you'll see when we get to the moment, because I have to begin some way and I've begun with this period, the last one back, the one at the beginning, which in the end is the best of the periods when you want to tell something).

All of a sudden I wonder why I have to tell this, but if one begins to wonder why he does all he does do, if one wonders why he accepts an invitation to lunch (now a pigeon's flying by and

it seems to me a sparrow), or why when someone has told us a good joke immediately there starts up something like a tickling in the stomach and we are not at peace until we've gone into the office across the hall and told the joke over again; then it feels good immediately, one is fine, happy, and can get back to work. For I imagine that no one has explained this, that really the best thing is to put aside all decorum and tell it, because, after all's done, nobody is ashamed of breathing or of putting on his shoes; they're things that you do, and when something weird happens, when you find a spider in your shoe or if you take a breath and feel like a broken window, then you have to tell what's happening, tell it to the guys at the office or to the doctor. Oh, doctor, every time I take a breath . . . Always tell it, always get rid of that tickle in the stomach that bothers you.

And now that we're finally going to tell it, let's put things a little bit in order, we'd be walking down the staircase in this house as far as Sunday, November 7, just a month back. One goes down five floors and stands then in the Sunday in the sun one would not have suspected of Paris in November, with a large appetite to walk around, to see things, to take photos (because we were photographers, I'm a photographer). I know that the most difficult thing is going to be finding a way to tell it, and I'm not afraid of repeating myself. It's going to be difficult because nobody really knows who it is telling it, if I am I or what actually occurred or what I'm seeing (clouds, and once in a while a pigeon) or if, simply, I'm telling a truth which is only my truth, and then is the truth only for my stomach, for this impulse to go running out and to finish up in some manner with this, whatever it is.

We're going to tell it slowly, what happens in the middle of what I'm writing is coming already. If they replace me, if, so soon, I don't know what to say, if the clouds stop coming and something else starts (because it's impossible that this keep coming, clouds passing continually and occasionally a pigeon), if something out of all this . . . And after the "if" what am I going to put if I'm going to close the sentence structure correctly? But if I begin to ask questions, I'll never tell anything, maybe to tell would be like an answer, at least for someone who's reading it.

Roberto Michel, French-Chilean, translator and in his spare time an amateur photographer, left number 11, rue Monsieur-le-Prince Sunday November 7 of the current year (now there're two small ones passing, with silver linings). He had spent three weeks working on the French version of a treatise on challenges and appeals by José Norberto Allende, professor at the University of Santiago. It's rare that there's wind in Paris, and even less seldom a wind like this that swirled around corners and rose up to whip at old wooden venetian blinds behind which astonished ladies commented variously on how unreliable the weather had been these last few years. But the sun was out also, riding the wind and friend of the cats, so there was nothing that would keep me from taking a walk along the docks of the Seine and taking photos of the Conservatoire and Sainte-Chapelle. It was hardly ten o'clock, and I figured that by eleven the light would be good, the best you can get in the fall; to kill some time I detoured around by the Isle Saint-Louis and started to walk along the quai d'Anjou. I stared for a bit at the hôtel de Lauzun, I recited bits from Apollinaire which always get into my head whenever I pass in front of the hôtel de Lauzun (and at that I ought to be remembering the other poet, but Michel is an obstinate beggar), and when the wind stopped all at once and the sun came out at least twice as hard (I mean warmer, but really it's the same thing), I sat down on the parapet and felt terribly happy in the Sunday morning.

One of the many ways of contesting level-zero, and one of the best, is to take photographs, an activity in which one should start becoming an adept very early in life, teach it to children since it requires discipline, aesthetic education, a good eye and steady fingers. I'm not talking about waylaying the lie like any old reporter, snapping the stupid silhouette of the VIP leaving number 10 Downing Street, but in all ways when one is walking about with a camera, one has almost a duty to be attentive, to not lose that abrupt and happy rebound of sun's rays off an old stone, or the pigtails-flying run of a small girl going home with a loaf of bread or a bottle of milk. Michel knew that the photographer always worked as a permutation of his personal way of seeing the world as other than the camera insidiously imposed upon it (now

a large cloud is by, almost black), but he lacked no confidence in himself, knowing that he had only to go out without the Contax to recover the keynote of distraction, the sight without a frame around it, light without the diaphragm aperture or 1/250 sec. Right now (what a word, *now*, what a dumb lie) I was able to sit quietly on the railing overlooking the river watching the red and black motorboats passing below without it occurring to me to think photographically of the scenes, nothing more than letting myself go in the letting go of objects, running immobile in the stream of time. And then the wind was not blowing.

After, I wandered down the quai de Bourbon until getting to the end of the isle where the intimate square was (intimate because it was small, not that it was hidden, it offered its whole breast to the river and the sky), I enjoyed it, a lot. Nothing there but a couple and, of course, pigeons; maybe even some of those which are flying past now so that I'm seeing them. A leap up and I settled on the wall, and let myself turn about and be caught and fixed by the sun, giving it my face and ears and hands (I kept my gloves in my pocket). I had no desire to shoot pictures, and lit a cigarette to be doing something; I think it was that moment when the match was about to touch the tobacco that I saw the young boy for the first time.

What I'd thought was a couple seemed much more now a boy with his mother, although at the same time I realized that it was not a kid and his mother, and that it was a couple in the sense that we always allegate to couples when we see them leaning up against the parapets or embracing on the benches in the squares. As I had nothing else to do, I had more than enough time to wonder why the boy was so nervous, like a young colt or a hare, sticking his hands into his pockets, taking them out immediately, one after the other, running his fingers through his hair, changing his stance, and especially why was he afraid, well, you could guess that from every gesture, a fear suffocated by his shyness, an impulse to step backwards which he telegraphed, his body standing as if it were on the edge of flight, holding itself back in a final, pitiful decorum.

All this was so clear, ten feet away—and we were alone against the parapet at the tip of the island—that at the beginning

the boy's fright didn't let me see the blond very well. Now, thinking back on it, I see her much better at that first second when I read her face (she'd turned around suddenly, swinging like a metal weathercock, and the eyes, the eyes were there), when I vaguely understood what might have been occurring to the boy and figured it would be worth the trouble to stay and watch (the wind was blowing their words away and they were speaking in a low murmur). I think that I know how to look, if it's something I know, and also that every looking oozes with mendacity, because it's that which expels us furthest outside ourselves, without the least guarantee, whereas to smell, or (but Michel rambles on to himself easily enough, there's no need to let him harangue on this way). In any case, if the likely inaccuracy can be seen beforehand, it becomes possible again to look; perhaps it suffices to choose between looking and the reality looked at, to strip things of all their unnecessary clothing. And surely all this is difficult besides.

As for the boy I remember the image before his actual body (that will clear itself up later), while now I am sure that I remember the woman's body much better than the image. She was thin and willowy, two unfair words to describe what she was, and was wearing an almost-black fur coat, almost long, almost handsome. All the morning's wind (now it was hardly a breeze and it wasn't cold) had blown through her blond hair which pared away her white, bleak face—two unfair words—and put the world at her feet and horribly alone in front of her dark eyes, her eyes fell on things like two eagles, two leaps into nothingness, two puffs of green slime. I'm not describing anything, it's more a matter of trying to understand it. And I said two puffs of green slime.

Let's be fair, the boy was well enough dressed and was sporting yellow gloves which I would have sworn belonged to his older brother, a student of law or sociology; it was pleasant to see the fingers of the gloves sticking out of his jacket pocket. For a long time I didn't see his face, barely a profile, not stupid—a terrified bird, a Fra Filippo angel, rice pudding with milk—and the back of an adolescent who wants to take up judo and has had a scuffle or two in defense of an idea or his sister. Turning

fourteen, perhaps fifteen, one would guess that he was dressed and fed by his parents but without a nickel in his pocket, having to debate with his buddies before making up his mind to buy a coffee, a cognac, a pack of cigarettes. He'd walk through the streets thinking of the girls in his class, about how good it would be to go to the movies and see the latest film, or to buy novels or neckties or bottles of liquor with green and white labels on them. At home (it would be a respectable home, lunch at noon and romantic landscapes on the walls, with a dark entryway and a mahogany umbrella stand inside the door) there'd be the slow rain of time, for studying, for being mama's hope, for looking like dad, for writing to his aunt in Avignon. So that there was a lot of walking the streets, the whole of the river for him (but without a nickel) and the mysterious city of fifteen-year-olds with its signs in doorways, its terrifying cats, a paper of fried potatoes for thirty francs, the pornographic magazine folded four ways, a solitude like the emptiness of his pockets, the eagerness for so much that was incomprehensible but illumined by a total love, by the availability analogous to the wind and the streets.

This biography was of the boy and of any boy whatsoever, but this particular one now, you could see he was insular, surrounded solely by the blond's presence as she continued talking with him. (I'm tired of insisting, but two long ragged ones just went by. That morning I don't think I looked at the sky once, because what was happening with the boy and the woman appeared so soon I could do nothing but look at them and wait, look at them and . . .) To cut it short, the boy was agitated and one could guess without too much trouble what had just occurred a few minutes before, at most half-an-hour. The boy had come onto the tip of the island, seen the woman and thought her marvelous. The woman was waiting for that because she was there waiting for that, or maybe the boy arrived before her and she saw him from one of the balconies or from a car and got out to meet him, starting the conversation with whatever, from the beginning she was sure that he was going to be afraid and want to run off, and that, naturally, he'd stay, stiff and sullen, pretending experience and the pleasure of the adventure. The rest was easy because it was happening ten feet away from me, and anyone could have gauged

the stages of the game, the derisive, competitive fencing; its major attraction was not that it was happening but in foreseeing its denouement. The boy would try to end it by pretending a date, an obligation, whatever, and would go stumbling off disconcerted, wishing he were walking with some assurance, but naked under the mocking glance which would follow him until he was out of sight. Or rather, he would stay there, fascinated or simply incapable of taking the initiative, and the woman would begin to touch his face gently, muss his hair, still talking to him voicelessly, and soon would take him by the arm to lead him off, unless he, with an uneasiness beginning to tinge the edge of desire, even his stake in the adventure, would rouse himself to put his arm around her waist and to kiss her. Any of this could have happened, though it did not, and perversely Michel waited, sitting on the railing, making the settings almost without looking at the camera, ready to take a picturesque shot of a corner of the island with an uncommon couple talking and looking at one another.

Strange how the scene (almost nothing: two figures there mismatched in their youth) was taking on a disquieting aura. I thought it was I imposing it, and that my photo, if I shot it, would reconstitute things in their true stupidity. I would have liked to know what he was thinking, a man in a grey hat sitting at the wheel of a car parked on the dock which led up to the footbridge, and whether he was reading the paper or asleep. I had just discovered him because people inside a parked car have a tendency to disappear, they get lost in that wretched, private cage stripped of the beauty that motion and danger give it. And nevertheless, the car had been there the whole time, forming part (or deforming that part) of the isle. A car: like saying a lighted streetlamp, a park bench. Never like saying wind, sunlight, those elements always new to the skin and the eyes, and also the boy and the woman, unique, put there to change the island, to show it to me in another way. Finally, it may have been that the man with the newspaper also became aware of what was happening and would, like me, feel that malicious sensation of waiting for everything to happen. Now the woman had swung around smoothly, putting the young boy between herself and the wall, I saw them almost in profile, and he was taller, though not much taller, and

yet she dominated him, it seemed like she was hovering over him (her laugh, all at once, a whip of feathers), crushing him just by being there, smiling, one hand taking a stroll through the air. Why wait any longer? Aperture at sixteen, a sighting which would not include the horrible black car, but yes, that tree, necessary to break up too much grey space ...

I raised the camera, pretended to study a focus which did not include them, and waited and watched closely, sure that I would finally catch the revealing expression, one that would sum it all up, life that is rhythmed by movement but which a stiff image destroys, taking time in cross section, if we do not choose the essential imperceptible fraction of it. I did not have to wait long. The woman was getting on with the job of handcuffing the boy smoothly, stripping from him what was left of his freedom a hair at a time, in an incredibly slow and delicious torture. I imagined the possible endings (now a small fluffy cloud appears, almost alone in the sky), I saw their arrival at the house (a basement apartment probably, which she would have filled with large cushions and cats) and conjectured the boy's terror and his desperate decision to play it cool and to be led off pretending there was nothing new in it for him. Closing my eyes, if I did in fact close my eyes, I set the scene: the teasing kisses, the woman mildly repelling the hands which were trying to undress her, like in novels, on a bed that would have a lilac-colored comforter, on the other hand she taking off his clothes, plainly mother and son under a milky yellow light, and everything would end up as usual, perhaps, but maybe everything would go otherwise, and the initiation of the adolescent would not happen, she would not let it happen, after a long prologue wherein the awkwardnesses, the exasperating caresses, the running of hands over bodies would be resolved in who knows what, in a separate and solitary pleasure, in a petulant denial mixed with the art of tiring and disconcerting so much poor innocence. It might go like that, it might very well go like that; that woman was not looking for the boy as a lover, and at the same time she was dominating him toward some end impossible to understand if you do not imagine it as a cruel game, the desire to desire without satisfaction, to

excite herself for someone else, someone who in no way could
be that kid.

Michel is guilty of making literature, of indulging in fabri-
cated unrealities. Nothing pleases him more than to imagine
exceptions to the rule, individuals outside the species, not-always-
repugnant monsters. But that woman invited speculation, per-
haps giving clues enough for the fantasy to hit the bullseye.
Before she left, and now that she would fill my imaginings for
several days, for I'm given to ruminating, I decided not to lose a
moment more. I got it all into the view-finder (with the tree, the
railing, the eleven-o'clock sun) and took the shot. In time to
realize that they both had noticed and stood there looking at me,
the boy surprised and as though questioning, but she was irri-
tated, her face and body flat-footedly hostile, feeling robbed,
ignominiously recorded on a small chemical image.

I might be able to tell it in much greater detail but it's not
worth the trouble. The woman said that no one had the right to
take a picture without permission, and demanded that I hand her
over the film. All this in a dry, clear voice with a good Parisian
accent, which rose in color and tone with every phrase. For my
part, it hardly mattered whether she got the roll of film or not,
but anyone who knows me will tell you, if you want anything
from me, ask nicely. With the result that I restricted myself to
formulating the opinion that not only was photography in public
places not prohibited, but it was looked upon with decided favor,
both private and official. And while that was getting said, I
noticed on the sly how the boy was falling back, sort of actively
backing up though without moving, and all at once (it seemed
almost incredible) he turned and broke into a run, the poor kid,
thinking that he was walking off and in fact in full flight, run-
ning past the side of the car, disappearing like a gossamer fila-
ment of angel-spit in the morning air.

But filaments of angel-spittle are also called devil-spit, and
Michel had to endure rather particular curses, to hear himself
called meddler and imbecile, taking great pains meanwhile to smile
and to abate with simple movements of his head such a hard sell. As
I was beginning to get tired, I heard the car door slam. The man

in the grey hat was there, looking at us. It was only at that point that I realized he was playing a part in the comedy.

He began to walk toward us, carrying in his hand the paper he had been pretending to read. What I remember best is the grimace that twisted his mouth askew, it covered his face with wrinkles, changed somewhat both in location and shape because his lips trembled and the grimace went from one side of his mouth to the other as though it were on wheels, independent and involuntary. But the rest stayed fixed, a flour-powdered clown or bloodless man, dull dry skin, eyes deepset, the nostrils black and prominently visible, blacker than the eyebrows or hair or the black necktie. Walking cautiously as though the pavement hurt his feet; I saw patent-leather shoes with such thin soles that he must have felt every roughness in the pavement. I don't know why I got down off the railing, nor very well why I decided to not give them the photo, to refuse that demand in which I guessed at their fear and cowardice. The clown and the woman consulted one another in silence: we made a perfect and un-bearable triangle, something I felt compelled to break with a crack of a whip. I laughed in their faces and began to walk off, a little more slowly, I imagine, than the boy. At the level of the first houses, beside the iron footbridge, I turned around to look at them. They were not moving, but the man had dropped his newspaper; it seemed to me that the woman, her back to the parapet, ran her hands over the stone with the classical and absurd gesture of someone pursued looking for a way out.

What happened after that happened here, almost just now, in a room on the fifth floor. Several days went by before Michel developed the photos he'd taken on Sunday; his shots of the Conservatoire and of Sainte-Chapelle were all they should be. Then he found two or three proof-shots he'd forgotten, a poor attempt to catch a cat perched astonishingly on the roof of a rambling public urinal, and also the shot of the blond and the kid. The negative was so good that he made an enlargement; the enlargement was so good that he made one very much larger, almost the size of a poster. It did not occur to him (now one wonders and wonders) that only the shots of the Conservatoire were worth so much work. Of the whole series, the snapshot of the tip of the island was

the only one which interested him; he tacked up the enlargement on one wall of the room, and the first day he spent some time looking at it and remembering, that gloomy operation of comparing the memory with the gone reality; a frozen memory, like any photo, where nothing is missing, not even, and especially, nothingness, the true solidifier of the scene. There was the woman, there was the boy, the tree rigid above their heads, the sky as sharp as the stone of the parapet, clouds and stones melded into a single substance and inseparable (now one with sharp edges is going by, like a thunderhead). The first two days I accepted what I had done, from the photo itself to the enlargement on the wall, and didn't even question that every once in a while I would interrupt my translation of José Norberto Allende's treatise to encounter once more the woman's face, the dark splotches on the railing. I'm such a jerk; it had never occurred to me that when we look at a photo from the front, the eyes reproduce exactly the position and the vision of the lens; it's these things that are taken for granted and it never occurs to anyone to think about them. From my chair, with the typewriter directly in front of me, I looked at the photo ten feet away, and then it occurred to me that I had hung it exactly at the point of view of the lens. It looked very good that way; no doubt, it was the best way to appreciate a photo, though the angle from the diagonal doubtless has its pleasures and might even divulge different aspects. Every few minutes, for example when I was unable to find the way to say in good French what José Norberto Allende was saying in very good Spanish, I raised my eyes and looked at the photo; sometimes the woman would catch my eye, sometimes the boy, sometimes the pavement where a dry leaf had fallen admirably situated to heighten a lateral section. Then I rested a bit from my labors, and I enclosed myself again happily in that morning in which the photo was drenched, I recalled ironically the angry picture of the woman demanding I give her the photograph, the boy's pathetic and ridiculous flight, the entrance on the scene of the man with the white face. Basically, I was satisfied with myself; my part had not been too brilliant, and since the French have been given the gift of the sharp response, I did not see very well why I'd chosen to leave without a com-

plete demonstration of the rights, privileges and prerogatives of citizens. The important thing, the really important thing was having helped the kid to escape in time (this in case my theorizing was correct, which was not sufficiently proven, but the running away itself seemed to show it so). Out of plain meddling, I had given him the opportunity finally to take advantage of his fright to do something useful; now he would be regretting it, feeling his honor impaired, his manhood diminished. That was better than the attentions of a woman capable of looking as she had looked at him on that island. Michel is something of a puritan at times, he believes that one should not seduce someone from a position of strength. In the last analysis, taking that photo had been a good act.

Well, it wasn't because of the good act that I looked at it between paragraphs while I was working. At that moment I didn't know the reason, the reason I had tacked the enlargement onto the wall; maybe all fatal acts happen that way, and that is the condition of their fulfillment. I don't think the almost-furtive trembling of the leaves on the tree alarmed me, I was working on a sentence and rounded it out successfully. Habits are like immense herbariums, in the end an enlargement of 32 x 28 looks like a movie screen, where, on the tip of the island, a woman is speaking with a boy and a tree is shaking its dry leaves over their heads.

But her hands were just too much. I had just translated: "In that case, the second key resides in the intrinsic nature of difficulties which societies . . ." —when I saw the woman's hand beginning to stir slowly, finger by finger. There was nothing left of me, a phrase in French which I would never have to finish, a typewriter on the floor, a chair that squeaked and shook, fog. The kid had ducked his head like boxers do when they've done all they can and are waiting for the final blow to fall; he had turned up the collar of his overcoat and seemed more a prisoner than ever, the perfect victim helping promote the catastrophe. Now the woman was talking into his ear, and her hand opened again to lay itself against his cheekbone, to caress and caress it, burning it, taking her time. The kid was less startled than he was suspicious, once or twice he poked his head over the woman's shoulder

and she continued talking, saying something that made him look back every few minutes toward that area where Michel knew the car was parked and the man in the grey hat, carefully eliminated from the photo but present in the boy's eyes (how doubt that now) in the words of the woman, in the woman's hands, in the vicarious presence of the woman. When I saw the man come up, stop near them and look at them, his hands in his pockets and a stance somewhere between disgusted and demanding, the master who is about to whistle in his dog after a frolic in the square, I understood, if that was to understand, what had to happen now, what had to have happened then, what would have to happen at that moment, among these people, just where I had poked my nose in to upset an established order, interfering innocently in that which had not happened, but which was now going to happen, now was going to be fulfilled. And what I had imagined earlier was much less horrible than the reality, that woman, who was not there by herself, she was not caressing or propositioning or encouraging for her own pleasure, to lead the angel away with his tousled hair and play the tease with his terror and his eager grace. The real boss was waiting there, smiling petulantly, already certain of the business; he was not the first to send a woman in the vanguard, to bring him the prisoners manacled with flowers. The rest of it would be so simple, the car, some house or another, drinks, stimulating engravings, tardy tears, the awakening in hell. And there was nothing I could do, this time I could do absolutely nothing. My strength had been a photograph, that, there, where they were taking their revenge on me, demonstrating clearly what was going to happen. The photo had been taken, the time had run out, gone; we were so far from one another, the abusive act had certainly already taken place, the tears already shed, and the rest conjecture and sorrow. All at once the order was inverted, they were alive, moving, they were deciding and had decided, they were going to their future; and I on this side, prisoner of another time, in a room on the fifth floor, to not know who they were, that woman, that man, and that boy, to be only the lens of my camera, something fixed, rigid, incapable of intervention. It was horrible, their mocking me, deciding it before my impotent

eye, mocking me, for the boy again was looking at the flour-faced clown and I had to accept the fact that he was going to say yes, that the proposition carried money with it or a gimmick, and I couldn't yell for him to run, or even open the road to him again with a new photo, a small and almost meek intervention which would ruin the framework of drool and perfume. Everything was going to resolve itself right there, at that moment; there was like an immense silence which had nothing to do with physical silence. It was stretching it out, setting itself up. I think I screamed, I screamed terribly, and that at that exact second I realized that I was beginning to move toward them, four inches, a step, another step, the tree swung its branches rhythmically in the foreground, a place where the railing was tarnished emerged from the frame, the woman's face turned toward me as though surprised, was enlarging, and then I turned a bit, I mean that the camera turned a little, and without losing sight of the woman, I began to close in on the man who was looking at me with the black holes he had in place of eyes, surprised and angered both, he looked, wanting to nail me onto the air, and at that instant I happened to see something like a large bird outside the focus that was flying in a single swoop in front of the picture, and I leaned up against the wall of my room and was happy because the boy had just managed to escape, I saw him running off, in focus again, sprinting with his hair flying in the wind, learning finally to fly across the island, to arrive at the footbridge, return to the city. For the second time he'd escaped them, for the second time I was helping him to escape, returning him to his precarious paradise. Out of breath, I stood in front of them; no need to step closer, the game was played out. Of the woman you could see just maybe a shoulder and a bit of the hair, brutally cut off by the frame of the picture; but the man was directly center, his mouth half open, you could see a shaking black tongue, and he lifted his hands slowly, bringing them into the foreground, an instant still in perfect focus, and then all of him a lump that blotted out the island, the tree, and I shut my eyes, I didn't want to see any more, and I covered my face and broke into tears like an idiot.

Now there's a big white cloud, as on all these days, all this

untellable time. What remains to be said is always a cloud, two clouds, or long hours of a sky perfectly clear, a very clean, clear rectangle tacked up with pins on the wall of my room. That was what I saw when I opened my eyes and dried them with my fingers: the clear sky, and then a cloud that drifted in from the left, passed gracefully and slowly across and disappeared on the right. And then another, and for a change sometimes, everything gets grey, all one enormous cloud, and suddenly the splotches of rain cracking down, for a long spell you can see it raining over the picture, like a spell of weeping reversed, and little by little, the frame becomes clear, perhaps the sun comes out, and again the clouds begin to come, two at a time, three at a time. And the pigeons once in a while, and a sparrow or two.

a view from the sky
Curtis Zahn

1.

ON MONDAYS, spoiled swans paddled aimlessly on the public ponds, thinning down for the holidays and pecking mechanically at kleenex, butts, waterlogged sandwiches. Mondays were days whose mornings preceded night, and the nights were far, held off by spears of light from prowlcars inching alleys where rats fumbled one another at the rear of Mayberry Electric. On Mondays, taxpayers placed their children squarely in the paths of frightened motorists, then hurried down and hung up their hats. Women unscrewed their bottletops, they pressed buttons, turned knobs, blew their noses and telephoned people who weren't home, while their water boiled on smokeless ranges. Every clock

had a different version. But time came slowly to some places, just as lateness arrived early at others. Monday got ready for Tuesday but it was already four minutes behind by midnight—an uneasy period set aside for positive thinking about survival in a nuclear age.

The town, by a man on a bulldozer, was being pried loose from its foundations, the dignified past; the past held no future for voters who dwelt in the present tense. The town was a plan —papery and outguessed by progress. It was imagined there by speculators who saw no trees, heard no birds. It was a chart financed by the Chamber of Commerce, nodded by Rotary, pledged by Lions and roamed by Moose. From the sky, it was a crisscross of lines running north and south only to die endlessly among mountains. To the east, streets turned abruptly towards the end of the river, hung there rocking on heels. An airborne public relations man named Eddie, staring straight down through plexiglass, saw water; fresh and salt. He saw tomorrow as glistening, ant-like automobiles and talked directly to city hall and the word was "no." Under him, everywhere, were newsboys with soaked papers, liquor salesmen with secret address books, cats from broken homes trailed by dogs dragging leashes. Unseen, a girl on the fourth floor of the Martin Building poured bourbon into a paper cup, while policemen winked and blinked, laughed and swore and lost no weight over the unbelievable things teen-agers did at night.

The town was golden iridescence sprayed by late summer's failing sun, it could be starkly dark, with hotness in its hollows and love among the movie theaters. There were songs, hummed tunelessly by deaf-mutes who sold genuine Air Force sun-glasses. There were nude dances in the basement of the Elks Club. People constantly changed clothes, changed their minds, but clung to proven tradition. Citizens were signatures, doubtfully signed in the presence of witnesses impatient to get back to their television sets. Children walked barefoot across grass already visited by unlicensed animals. A wastrel could drive his unpaid-for car over refugee kings and hope for a hung jury. Millionaires ran the risk of eating in the same restaurants as labor union men. Waitresses could look forward to having too many children and

a divorced husband living secretly in another state. The town was for a different kind of people all living at the same time. Musclemen worked as custodians; effeminate, wavy-haired youths concealed their sex in stylish trousers and told a great story about the unlimited possibilities of color linoleum for playrooms. The weak legislated the weak into power and shackled the strong. The strong softened, grew heavy and weak. Financial conquerors wrote rapidly with lifetime pens; fat, tough men who sassed facts and figures. Women listened. Women looked. They looked at themselves in mirrors, in store windows, and men looked after them. Women looked to their husbands but their husbands watched the game. Postal clerks murmured and spat and stamped through the days, marking them off on calendars containing impossible photographs of nude girls, dreaming of a time to retire and raise chinchillas. The town was made for clocks made for women ordained to catch the 12:30 matinee. You were either early or late. There were words of explanation, some true, some false. Everything was explainable. Men without a coin in their pockets were confronted by pay toilets. Bats plunged from four story buildings where they had no civil rights. Lumbermen complained of greenspurting boards riddled with knots; customers complained of cars that pumped oil, children who pumped bikes. And children complained. Their radios failed, within a week after their mothers had taken them down to Mayberry Electric. Electricity failed, even during the Ed Sullivan program. Restaurants failed. Restaurants prospered. Non-Caucasians ate three meals a day. The public accepted it.

The public voted for water, against schools, and for continued prosperity. A woman on the fourth floor of the Shangri-la Arms threw her key to the milkman. A diaper laundry truck ran over a pedigreed dog but the people were conditioned. You live in a town, you accept those things which are of the town. Otherwise, beat it.

"Beat it," a cop told several boys who were plotting against society. But where? Questions lay in the reaching hands of hospital patients, and scientists fed them to machines which would some day rebel. The girl on the bus had never thought of it that way. To her, nothing was so beautiful as an oil painting

of a farm thawed by the first rays of sun on a December morning. Nothing so attractive as men in dark suits, turning corners into the wind on long, thin, unathletic legs, their canvas flapping. Men on their way. To elevators. She said, "I like men who go up and down with their hats off. They tell offcolor business jokes, they order thick, expensive, rare steaks and they can walk out of a restaurant leaving their third martini untouched."

The girl riding beside her was going to have her sofa recovered. She said, "What this town needs is an up-to-date monorail transit system."

The town? By a man on a bulldozer was being pried loose from the taxpayers. Trees toppled, birds unsprung themselves against the sky; hills were gashed, boulders smashed. And under it, all of it, under it, an umbrella of dust made carburetors cough; romance hesitated upon the threshold of gritty thighs, round pistons pounded into polished cylinders, tended by men who drank. Civilization had been squired there from the speculative pen of some man with a plan whose trouser-bottoms were prematurely old and wrinkled. Men had speared topography, crisscrossed it with lines that ran north and south, and then turned right and ended abruptly against the river. Streets started out paved with promise, only to roam endlessly and die among the mountains. And there, a dynamite man had launched a thousand birds with a plunge of his detonator. Half the mountain came down in small pieces and Standard Oil built another service station with clean, modern restrooms where an Indian had died.

Man with a detonator, man with a bulldozer, man with a contract. Man with another man; both married. Fathers. Members of.

Both heavy. With legs. Like tapered pistons? Low-slung, powerful, rotund, quick with a pencil and paper. Driving dusty new cars, driving their polished shoes into the raw earth. Feet apart, conferring under twin brown hats. Blueprints. Ball-points, Armpits. They were men who could go. Into old apartment houses. Leaking gas sifted through their bank books. Termites roared—they heard that too. They sensed falling plaster, they forecast rain, coming through the roof and finding its way into overflowing basements. They ran sturdy fingernails across corrupt foundations. They counted the rings on ceilings and then calcu-

lated age. Their noses pointed mildew, froze on Death's gilt edge, knowing the difference between financial suicide and a coroner's certificate. They removed their twin black books from their twin buttocks and opened them. Each of them wrote the word "No," and called on the building inspector. The building inspector was a Rotarian but he still had to go through the formalities. Landlords wept, tenants shrieked, dogs barked. Landlords joined the Lion's Club but it was too late then. The bulldozer had already been told to report on Tuesday.

Goats and cows were being torn down all over that summer to make room for automobiles. Glassy apartment houses with deep, filtered ponds lay over the cemeteries. Artificially induced laughter ricocheted against windows where lights had been left on. People wet themselves inside and out and made love in numerous unacceptable ways. The town was growing, there would be a need for more people to fill it with. The more town, the more consumers, and the more consumers, the more jobs. The girl, on her way to have her watch repaired, saw the bulldozer. It had a man on it. She wondered how he would look in an elevator, hat removed? She passed 328 F Street, a stucco with a mustache of tile under its upstairs window. She passed between that and a 1956 Ford registered to Mayberry, George P. Beyond her lay the United States of America, most of it packaged; most of it tuned in. Somewhere, men swung handfuls of bats and waited for it to start. The operator of the bulldozer was tuned in, maintaining direct contact at all times through a transistor radio with ear-plugs. Mayberry fixed them—radios. And he went quite often.

To the bowling alley? Alone?

"Not by choice!" His mother had revealed this to his sister, most recently disengaged from a philandering sand & gravel man. "Why?" the sister blew her nose and examined her handkerchief for signs.

Mayberry? Put him beside a razorlipped trumpet player and you've heard music for the first time. She was heavier, the girl— the other girl, and had worked at Walgreen's until one night, late, when a gentleman came in to buy liquor.

"Oh, the face?" She smiled into her pocket mirror for reas-

surance. "Two goat's eyes strung apart like distant lanterns.
Against an eternal span of innocence. And the mouth—wondrous,
circling the oh's and ah's with the unspoiled zero of astonishment.
Put him beside—"

"Put who beside?"

"George Mayberry." Imagination had carried on where reality
died, waiting until the trumpet's sweet call could spell it out.

The air overhead was cloudblessed and perforated with elec-
tronic impulses that would some day turn commercial. Germs
splatted against the carefully scrubbed faces of fashion models.
Kelp flies dove suicidally into stinging bulbs. Everywhere, ani-
mals and vegetables were busy at becoming the ultimate mineral.
Glue factories flourished where rubber companies had fallen be-
fore the muscular hammers of cattle dispensaries. There was
a busy sky; bombers, jets, kites, balloons, birds, zeppelins and
airliners jammed with drinking fatalists. Wisps of cellophane
climbed high, shot there by unrecorded tornadoes. Sound waves
traveled back and forth from earth to stratosphere, bringing
censored reports on the progress of civilization. The air was
flagellated by smokes, colored by acids and grits, licensed by both
the Federal Communications Commission and the Civil Aero-
nautics Bureau. Private planes spun dizzily from low altitudes;
parachutists raced each other to the ground and the winners
never lived to tell. And finally, the whole extravaganza—the
turbulent air and all its alien accessories—was homogenized by
helicopters that were sprung into the sky by drunken command-
ers whose girlfriends dated younger lieutenants.

"Look," said George Mayberry's mother, "would you want
your sister to marry a steamfitter?"

"Why not? They're no different from anyone else when you
get to know them."

He was blowing ants out of his picnic. Now he looked, and,
seeing no sky, got no God; only the condensed purple sweat of
people. And their transparent ghosts. Of history? Drifting among
the languid currents where bored airpassengers glanced straight
through, and down, and saw absolutely nothing. His mother was
going to say, "Some of my best friends are steamfitters," unless
he could thrust a tongue sandwich into her mouth. She was thin-

ner, and recommended Elizabeth who was heavier. Her lips shaped themselves innocently around a cucumber-sized pickle; he thought of Sigmund Freud and then remembered he had forgotten to turn off the light down at the shop.

"Some of my best friends are steamfitters," his mother said suddenly; "your father associated with them." Absently, she flung a shred of lettuce to a snail that steamed slowly toward them, leaving a glistening wake on the blanket. "*Quite publicly,* darling."

Little had happened after that. A town was old and hollow on Sundays, slowed to a dead stop by Jesus and the money-changers.

"Can you change fifty cents?" the girl was asking, because the bulldozer operator sat hotly upon an ant hill in the shade, his lips pressed against a milk carton upon which were printed the sad, soulful eyes of Bessie-Lou, winner of twenty gold medals.

"I only got five bucks. Sorry."

"What are they going to build here?"

"*Building* I guess."

"I'm fifteen. My old man's a tycoon." She tried out her new legs, tan and well formed in shorts. "Does that radio really work?"

"Battery's dead." He was watching hard, held back by reason. Five years for five minutes fun. In another state, in another time, in another country, yes. In a better world under newer skies. Yes.

"You ought to see George Mayberry. He fixes everything if they're radios."

The town balanced upon the edge of the river, its feet wet, some of it falling in and drowning, and petroleum companies bored into the ground, took out money and erected towers that shot into the sky, to terrify amateur pilots. Buildings kept losing their balance, kept inching over to tramp out houses and trees while engineers with slide rules twitching from their khaki pants pockets took sightings and sweated, propped up by Coca-Colas, quietly talking back to financiers. They were the law. They were neutrals, operating amorally within the delicate strata of sociology. They removed their hats when they went up and down in elevators, but they weren't tall enough, nor dressed in black, and they smelled at five o'clock. The girl whose name was Char-

lotte instinctively knew this, at the same time wishing she were Alice Trent or Mrs. John Kennedy. To George Mayberry she turned, on Monday, and said, "Would you want your daughter —if you had a daughter—to marry a city councilman?"

"Why not? They're no different than anyone else."

"I thought you'd say that. I can always tell what you're going to say. This town's really had it." She turned her back and leaned an elbow on the counter so that it touched a dead tube from her grandmother's table model Philco. She noticed the calendars on the wall—an ice-skating girl in ear-muffs for January, a girl wearing a firecracker for July. June was absolutely naked except for two bands of fur, and grasping a fly-rod. Three goldfish bubbled apathetically inside a square tank that was squeezed on its shelf by the exoskeletons of dozens of radios. A bee bonged its head incessantly against the window where there was a sign that said, "Out to lunch. Had your tubes checked recently?" She was restless, helpless, ill at ease. You came into shops and there was nothing to understand, no interesting thing. You waited. And made conversation. And lit a cigarette and said, "Think there'll be a war?"

Mayberry shrugged. He had seen city councilmen do it and a thing like that didn't take so much out of you.

"You want to know what the gas station boys think about it?"

"Well—what do the gas station boys think when they think? If they do—think."

"They think there won't be any."

"How do they know?"

"They meet a lot of people." She said it with mother's omnipotent chide. "They get around—"

They darted around in their starched white uniforms pumping Boron into mothers and daughters, exclaiming over filthy oil, warning the populace of the great robberies being performed day and night by old sparkplugs. But then, *did* they? *Know?* He, usually, went to the wrestling matches. Alone. Not by choice. Because. He didn't give a damn about anybody. Because. Not anybody gave a damn about him. People. People who met Mayberry didn't seem to remember, they just didn't seem. To remember. . . .

He thought of his glands as small jellyfish, paddling ineffectually against the tide, losing years in a great backward drift while zealots in outboard motorboats crisscrossed the local sea, furrowing the kelp, decapitating fish. His sorrow was an elephant moving obediently into the jungle, ponderously swinging its things, prodded by naked girls wearing spike heels while men planned a life. It was neither a time nor a place to be born anonymous. His name would be found in an old telephone book centuries later. That would be his sole effect on destiny. The world owed him a great crime, he had it coming. He got, instead, arrogant women in stationwagons filled with explosive children who came in and turned everything on and off and on and off. While their mothers protested unconvincingly. Mothers with sick radios, supreme in the knowledge they would be overcharged, whittling an inch off the bill with ninety cents worth of exposed breast. A wriggle, a smile, a lowered lid.

Where was the flown bird upon which his destiny so delicately perched? He once asked a waitress who gave confidential tips to men who left a quarter on the counter. It was a line he had picked up unconsciously while soldering a condenser onto an old Zenith. "You seen one and you seen them all," she had told herself truthfully, and squirted chocolate syrup into somebody's strawberry malt. She had felt the man in the bulldozer, that wistful fall afternoon when shorebirds stood upon one foot and the other, awaiting the long shadows of unfulfilled resolution. And his chest, the man's, was a sagging expanse of eroded mudpies, held together by greying hairs you could count. The mood was almost redundant with power and sound, all of it under a jaunty umbrella while his little chimney popped black smoke. Autumns were her spring; they wore sex's great sad throb, told by the glistening, windless bay. It was a time when telephones exploded in your hand. Wrong numbers, yes—but people had to call, people wanted to ask, to tell. They murmured quietly in the heat and chill of shadow or sunlight, expecting bombs to drop; expecting earthquakes, love, significance. Men! Instead of swinging at balls they switched to kicking. TV came on with renewed life, determined to try again. You stopped chewing gum in the fall.

"Black smoke don't belong with diesels," Eddie had told her before he started hanging around coffeehouses; "why, half the diesels you see are hogging fuel. It's a crime. Nobody knows a goddamned thing about anything any more." They had been sitting in his 57 Olds not more than inches apart and his hand was climbing.

She sat quite still. She said, "George Mayberry says the gas station boys don't think it will ever really happen. War."

"What's so fascinating about this guy in the bulldozer?"

"He made all-American tackle at University high. Just works summers."

Precisely as she said this, the two men in brown suits and brown hats were drilling their tapered legs into the deep carpet in the silent office of Robertson, Warne, McAuliffe, Thomas, Frye & Appleyard. One of them leaned forward and said, "Look, Al, it's twelve twenty-two."

The other leaned back and brought his wrist up to within a foot of his serious eyes. "I've got just twelve twenty-one, Charley J—"

The other hesitated. There was a time to be shrewd, a time to be outgoing and friendly. He could hear the bulldozers now, plowing up mountains of gold leaf that would be converted into elaborate chains of hamburger stands. He could smell dollar bills, fives and tens, crumpled with the flavors of chewing gum, powder and perfume. Women. Young girls. Spoiled, gangling, sullen boys with wolf eyes and unformed faces, behind the wheels of their fathers' cars, sipping thick drinks. Putting thick drinks into one end of the girl and hoping against hope for the other.

"Well, Charley J—?"

There was no doubt about it. He quickly stood up, peeled back his sleeve and shook hands.

The other shook. Hands—

"We ought to talk to this fellow Mayberry."

"We certainly ought to."

"We could talk to him and tell him."

"Right! Talk to him and tell him."

"Right! Tell him and talk him."

"Right."

"Right."

Slowly, each had been backing away. But now one of them realized that the other was at a disadvantage; he had gone just about as far as he could go without stepping out the window, and it was a seven-story drop. Curiosity quickly overpowered him. He stood still for a second, then began again. "Right! We'll talk to this fellow Mayberry and tell him." He waited.

The other stood there, bewildered and undecided. And then like a mean animal he turned and came menacingly toward the other and said, "Al, I don't *know!* There's something *about* it! I don't like! I don't *know!*"

Directly below them, but on the second floor, the girl poured a stiff shot into a Dixie cup and hated herself for being afraid to come without stockings. You could come and go, but nobody really ever cared if you came. They only said! They did! She remembered the unhung backyard of her father's vegetable garden; green worms that squished to the touch, framed in the triangular shadow of the Richfield tower. He had been a submarine tender, had been accused of stealing cannons. Thereafter her mother took to chaining her airedale to the bar stool at Louie's Canteen at eleven o'clock every morning where she gave and received beers with the worst of them.

"George Mayberry's probably the kind that would diddle little children."

Unable to recall where or when. She had picked up the magical phrase. But it remained top-drawer in her mind, fresh as the day it was made. More exciting than television, more sinister than the bomb. She struck a match for her boss's cigarette. The open window brought life and death and a bumblebee, far above its altitude. It brought the bulldozer, grinding the filthy vacant lot, and men with neckties and blueprints who remained tuned by transistor radios to the ball game while they worked. They stood with their pantscreases knifing into the wind while a crewcut college boy stopped and squinted into a telescope and flapped his arms. Progress was a balloon to be shot down by Reds; it was China waking up while England fell asleep, it was strawberries and chrome for breakfast. Buildings were being torn down to make room for cars, people were growing up two sizes larger

and then, suddenly, buying compact cars. It was seeing how big you could make everything up to some undefined point, and then re-tooling and re-advertising to see how small. Except wristwatches. Wristwatches had never tried to be bigger than each other but. Maybe they would, now. And transistor radios. They would get smaller and smaller until one day they would start to get bigger and bigger.

"Americans can't make up their minds," Walter Groves said.

George P. Mayberry overheard him. He was standing just a foot away at the time.

"It's love of change," Groves continued, and one eye fell dangerously upon the ice-skating girl for January. "Change! And what is change? Escape! And what is escape? Refusal to face your environment!"

"I swatted sixteen flies this morning," Mayberry said. "I hate to do it. Perhaps if I just held the right thought—"

His voice had tricked him again. It was a child's daydream, uttered aloud in total solitude, the final wisp of smoke from the last bonfire of the season.

"What is progress?" Groves said. "Hauling a load of gravel to a wrong address and dumping it! Calling up people you don't know on the telephone! Hanging by your knees on the Ed Sullivan show. Cutting down the trees and remodelling your store front. People eat it up, they eat it up."

If you held the right thought, Mayberry theorized, the flies would stay outside. Some super-intelligence would hit them like radar. They'd get as far as the doorway and turn around and go back. Or, look at it! From an evolutionary standpoint! All the flies that didn't have enough sense to stay where they belonged would be killed. Eventually, the only survivors would be flies that were the descendants of flies that stayed outside. But it hadn't worked. Yet. . . .

"There's no flies on Linus Pauling," Groves said. "That man's the intellectual's pin-up boy." Again he was aware that his eye had been going over everything in the room, trying to play the objective observer. But it kept getting stuck on the body of the pin-up girl for January. Why was January better than June?

Flies always lighted on Mayberry's forehead when attractive

women came in to have him check their tubes. He had an uncle who fixed flats on the highway between Las Vegas and Los Angeles. There you got scorpions and tarantulas instead. Same thing; if you killed all the scorpions that came indoors, then only the ones that liked to stay outdoors would carry on the race.

"I got a couple of fins planted on the fifth race at Bay Meadows," Groves said.

George Mayberry said, "Golly, think of that, I'll be damned."

"Horse called 'Tarantula's Dance'!" Groves was making ready to cast off his lines, inch away from the dock. He had full steam up. His propellers were treading water. He gave three short blasts and they shuddered with life. "By now!" He began to glide majestically toward the door, out into the hotly sunned sidewalks where other passengers would have to alter their courses. The crowds waved. Bands played. "I take it back what I said," he called by ship-to-shore telephone. "It was all talk. There aren't any pin-up boys any more. All talk! I never know what to do with my hands when I have to stand and wait around."

Mayberry picked his teeth with a piece of copper wire and watched and waited. He thought, "Survival of the fittest. If you killed off all of them that came inside like that, then maybe the only people to survive would be the ones that stayed out." But it wouldn't be good for business.

2.

The town re-called all of its streets. They were too narrow, too long. It gave the sidewalks back to the people and planted four new trees for every hundred it cut down. A mountain got in the way and had to be eaten alive. The bay was too shallow, because ships got too big. Children wrote poems on the walls of abandoned sewage tunnels and publishers waited for them to grow up. Inflation came to penny parking meters and a Negro family moved into the Alta Terrace subdivision the same day George Mayberry installed fluorescent lighting. "Where is the hushed bird upon which my destiny pegged a wrong number?" Mayberry asked himself, and scratched them. In high school a girl had signed his yearbook, then moved in with a sailor without return-

ing his class ring. Train whistles agonized his sleep as he lay on an iron cot under an apartment with a phonograph that constantly played "Hound Dog Man." He had once gone into the shrubbery with a stenographer from Ace Plumbing, but he was unable: there were too many crickets, police sirens, false alarms. Women who were hot and damp dried up for him, discovering platonic virtue in his eyes. He was a driver's license good for one year. Paint fell upon him from ladders upon which men perched and apologized profusely. Traffic lights changed as he stepped from the curb. Whatever he ordered in restaurants, they were fresh out of, hadn't had time even to cross it off the menu. His doorbell never rang; when it did, it was the Fuller Brush man wanting the little lady of the house. The comics were torn and shredded when the Sunday paper arrived. Dogs went crazy when he walked past their yards, children threw stones at each other and hit his car. Little girls hung by their knees in front of him while their mothers watched suspiciously. In the bank, he always got in the wrong line, behind someone with ten thousand pennies to deposit. At some point, he stepped recklessly to another line, where an exacting, doddering woman had discovered an error in her deposit book. Mockingbirds pulled his hair. The drinking fountain suddenly went off as he bent thirstily over it. He was always getting airmail letters addressed to Bill Miller, 23,909 Woodland Terrace. In some other city. . . .

On the Fourth of July, the Senatorial candidate from the left side of town declared, "I think of myself as the voice of the little man—the chronic failure, the unequivocal jerk. Society is built upon its weakest link. So long as there's one single jerk running around, the Cadillac dwellers aren't safe."

"He's pretty wild isn't he?" Charlotte said to the man who, before removing his hat, and the mud, had been operating the bulldozer.

"Something's got to be done for the people who haven't got it or they'll become a bit of a nuisance."

"We got a pretty good big little old police force in this town. My sister's married to a rookie right this minute." He could see her, plated with mink stepping from an airliner into the arms of

some man who fixed radios. She had just been to Las Vegas with a couple of old boys in brown suits and hats. Heavy men who wanted a little fun. She wouldn't have wanted her sister to marry a steamfitter. They drank. And steam was giving way to electricity.

She said, "That's the trouble with the world—too many delinquents in proportion to the number of people."

The world was the honked sadness of unpaid-for Pontiacs, passing in the dark while cops in space helmets watched out for sex that came after football games. The world was a Chamber of Commerce dream of water for everyone, a dream of towns, themselves. Cemeteries bought billboard space to announce; "Die Now—Pay Later." Midgets were charged the same price as giants because all people were believed to be the same size when dead. Men flashed credit cards at skeptics, and skeptics urinated on civic lawns in plain sight on dark nights. Streetcar tracks were the poor man's chrome, polished a hundred times a day while lunatics cursed themselves in downtown alleys. Mrs. Mayberry caught the 11:30 matinee of *Hercules Unchained,* then blew herself to the 89-cent special plate at Walgreen's where the counter girls chewed gum in unison and bleached their hair different shades. Young, soft, selfcentered men pumped more Boron into the tanks of mothers who had to drive their children cross-town for shots, then to the beach, then to the donkey ride in the valley, and then to frosty freezes and then to the barbershop and then to music lessons and then to a party and then to the movies. It all helped. Putting money. Into circulation. And; the more money, the more rubbed off on you and anybody else. Young men greased Chevrolets and looked forward to the night when they might. Find a girl who. Would.

One August morning when barbecues were moving fast, the girl who had worked at Walgreen's until a gentleman came in to buy liquor turned to her father and said, "Why don't you get a job working with missiles?"

"Sure, daughter," he told her. He wore an oilstained shapeless hat low over his eyes and sat on park benches where he read discarded newspapers. But he had been a warehouse watchman

in his time, lugging a .45 and turning on his flashlight frequently.

"Missiles are the big thing now. You ought to turn up your hearing aid and learn what's going on."

"Maybe I could get it fixed over at Mayberry's."

"Mayberry never fixed a thing yet, Dad." She took three pins out of her mouth. "His equipment is absolutely obsolete. He ought to be driving a bulldozer or something, I'm sorry."

Her father was already completely disconnected from life. He was remembering chilled November mornings when they hunted ducks where the Bank of America now stands. The sun came up in colors, the ground was new, youthful, just starting. And in the exploring gray fingers of light, every shrub, every tree, took upon itself the magical promise of mystery. And crows called the day from wild lanes among the oaktrees; deer raised delicate hooves from a rippled mirroring of sky and quail exploded everywhere under the mudcaked oversized rubbers of men with double-barreled shotguns. The land had a smell, it knew how to remain quiet. There were no sheriffs in fat, black cars, no game wardens, no subdivisions flying flags, no streets, no buildings, no people, no crisscrossed skies with mysterious boomings.

"There's money in missiles," she said.

"They tore up the streetcar tracks and converted to buses," he answered. "I never could figure why."

"Lots of people can't get cleared to work in missiles. You could, Dad."

He looked at her, somebody else's daughter living in a house he didn't own in another part of the world. "I bet Mayberry could fix Grandma's old B-battery set, daughter. We used to get Amos and Andy every damn night."

"Why don't you go out to the missile base and see if there's anything for you to do?"

"I will." Uncertainly he got up from the bench. "And I'll ask him if he can do anything about my hearing aid, too."

George Mayberry came to work late, left early, and drove the two blocks to Edith's Drive-Inn several times a day for coffee-break. He knew that people committed suicide leaping from curbings. He wondered if it were actually true that male contortionists were completely self-sufficient. He agreed that there weren't

enough birds to go round; that taxpayers had no place to hide; that heavy women teetered on slick sidewalks in their high heels when fog was a wrap-around cloak bringing ache to the bones. He thought of cemeteries where owls perched disconsolately, longing for fewer moons, more rodents. His ears lied to him about caged musicians peeling off the forbidden hours on corroded old saxophones while crew-cut high school students nodded their heads helplessly and polished their glasses. His own moustache was a sieve, straining kisses from myopic fat women who shot their husbands. "Radios is okay," he told mother, "I pull down my three seventy-five an hour and that's not to be sneezed at."

She coughed. "Sure, son. Better than being a steamfitter and you can say that again."

"Steamfitter," he said.

They blew their noses now, sharing the same handkerchief just as they cooperated about bathrooms, lovers, and the *Reader's Digest*. He pulled out his soldering iron and laid it lovingly on his plate. She pulled a batch of green stamps from somewhere among her bosoms and dunked them into her coffee which she took weak. Then she excused herself to go out and vote for Jack. Everyone was. Doing it this year.

"What?" he asked suddenly, and there was purple cunning on his lips.

"Why running. For President, dear."

"I'd better run," he said, "I'll miss the bus." But it was a lie, almost three years old, for he had a Ford, almost. Paid for. Almost—

"Charlotte's a sweet, big, lovable little old youngster," his mother called without dialing a number.

"She kills goldfish!"

"Only when they become a nuisance, son."

"I'd rather marry Jane or Sue Ellen or Aggie Wells."

"You did." She was ironing green stamps onto the pages. "And where are they now?"

"Shall I call and find out?"

A tear fell from his mother's right eye. Girls worked themselves to the bone saving themselves for sons old enough to be

their fathers, and yet too young to watch late television programs. A mother was hamstrung without a laundromat and a pint of bourbon. Prefabricated houses told a big lie about heat insulation. Civil engineers thought they could measure domestic problems on their slide rules. Fathers secretly spent their overtime pay on outboard motorboats and then never caught a goddamned thing.

"Mother—I think I'll get me one of these here little outboard motorboats. Girls are crazy about water skiing." He noticed that she had gone and gotten butter all over the ice-skating girl on the sports page. He could read the type on the reverse side, backwards, but instead he remembered the roller-rink where girls in black leather jackets danced dirty to a Hammond electric organ with tall, pimpled boys with sideburns who would take a long, long time getting them home. Ice-skaters were purer but they had mothers. Women who bowled got hungry afterwards. Dark, handsome men went up and down with their hats removed but some going bald already. They usually carried three pens and a notebook and knew who was winning the game. Girls who went water skiing also got hungry afterwards. . . .

"There's no way out," his mother told herself and opened the back door.

The town? Was built. Of walls within walls.

Envious of its rotting shores where ships sat fat and calm, certain of escape. The people reached for the stinging bleat of sea gulls; they had no sand between their toes. Athlete's foot grew where adventure started. Shoe clerks never got above the knee; they longed for country air.

At 328 F Street was a power lawnmower purchased from Sears for a ridiculously low downpayment. But Sunday. Was for polishing. Cars. Bulldozers snored at their jobs while women in hats tiptoed through deep dust on mysterious errands. There were more trees on Sunday, fewer typewriters. Letter carriers took long, fast walks. Bus drivers drove. Businessmen talked business and landscape painters worked as ushers in movie houses. Squirrels came suddenly to earth and removed sandwiches from screaming children. Mumbling old men completely disappeared under clouds of pigeons. Caucasians leaned against pilings

already touched by non-Caucasians down at the docks, fishlines tied round their fingers while they dreamed of retirement. The forest called but nobody saw the trees. Families plummeted down the highways in search of absolutely nothing, found it, then turned around and became vaporlocked in traffic jams. A dress-shop proprietor walked past George Mayberry's Radio Repair Shop on the way to a drug store that would sell all of the god-damned sleeping pills anybody could want. An irritated wind whisked the gutters to shove beer cans, kleenex, and various kinds of rubber, shredded or frayed.

"Bye now." The phrase was good for workdays at quarter to eight. George Mayberry backed his Ford out of the garage and almost ran over a civil engineer. He quickly put the car into forward gear, re-entered the garage and closed the door.

"Hello again," his mother said, "back so soon?" She was knitting a pair of diapers, in case she, or George, or anybody.

"I left early," he told her, "business was dead."

"That's because it's Sunday—because your shop's closed."

"Yeah.

"I wish somebody would invent an electric shaver that didn't need electricity."

"Yeah." He had his anchor up. The crowds were throwing confetti. You'd have thought he'd won the war singlehandedly. Yet. His mother. Was completely unaware of the time, the moment. She had a dead short in her somewheres. "Bye now!" he called.

"Going out again already?"

"Yeah. Johannesburg, South Africa."

"Better take some candy bars. You'll get hungry." She got up and started to bake a cake. "Driving, son?"

"What's it to you?"

"Don't forget to get air for the tires, it's pretty hot there."

He backed the Ford out of the garage once more. His mother backed out of the kitchen, shaking her fist. It angered her on Tuesdays to have produced a son good only on Thursday; retarded for his size, and under age for his years. In a smaller community, he would have made Village Idiot; here, they let him play around with his tubes and wires as if he were only a gorilla

under glass. She could think clearly back to the time when rich, wild cousins from Eureka had taken her to the Hollywood Bowl to hear Kate Smith and Leo Stokowski. All of them opened their zippers when they went to the bathroom. It didn't run in the family. She should have married a jockey, there were few cases of insanity among jockeys. She broke an egg into a cup and wondered why. Always, there were filthy cousins, a Christian Scientist aunt, a large Catholic family whose washing hung in plain view of neatly dressed young insurance men. And daughters to be married off. Sons. Who missed Mass. She was secretly related to President Eisenhower by a curious sequence of love affairs going back to her great-great-grandfather who was famous with a putter. She was thinner than most fat people; turnstiles in supermarkets barely moved when she passed through them, laughing. Fat people were wider but not very deep, and looked short no matter how tall.

"Ford's a great big little old car," George shouted as he backed over a frog, honking at a hummingbird which was flying recon over the shrubs.

"Don't go over fifteen, darlin'."

"Why, mother!"

He remembered his soldering iron, on his breakfast plate between two half eaten eggs buried in chocolate syrup. And the slice of twice-eaten canteloupe. He always ate the canteloupe first, then his mother got a spoon and started over again, digging deeply. There would never be anyone else like her. Each time he married, she left the bedroom light on for him, covers turned back. Because. She knew. Sooner or later. . . .

"I hate Mother," he had told his first wife on their third night.

"Give your poor old mother a French kiss and she'll be happy," a voice said. It was mother all right, planted firmly between himself and the marmalade jar. "They're building a new building down at the lot next to Walgreen's," he told her, kindly but firmly. "Bye now."

He was backing out of the garage but part of him still hung around in the kitchen because his soldering iron lay there on his plate. Without looking he could see it; he was certain that if he turned the Ford around and drove 85 feet and parked, and then

went back and opened the kitchen screendoor he would see the two half-eaten eggs. And his wallet containing the photograph of Jayne Mansfield and her new baby. Was it a boy or girl?

"Anyone ought to be able to tell that," someone seemed to scoff.

"What?" he asked, and then assured himself quickly, "It's me, mom, only me. I forgot my rubbers."

"But it's not raining."

"Yeah, I know."

"That boy has a head on his shoulders," his mother told no one within hearing.

"What boy?"

"Dicky Nixon."

Some men had heads on their shoulders, other had shoulders under their heads. Hardly half a million were licensed radio technicians to whom beautiful girls came running helplessly in need of tubes. Once a city-councilman came in with a totally dead Magnavox and took off his hat. "Radios laugh at a king," George told him sympathetically.

He realized that he had been running in reverse for several blocks. It was unlawful, and yet it was a good way to see where you'd been before you got there. And also. It was like humming-birds which were absolutely incredible in reverse. But going. Forward. They were nothing but regular little tiny airforce jets flying without instruments. Never needed soldering.

"Charlotte!"

"Tom!"

He braked suddenly. A girl he knew only as Mary Jane was walking backwards down the sidewalk. She stopped. She started to walk forward in order to move backwards toward him. At the same time, he put the car in forward gear in order to get back to where he hadn't been.

"I'm George," he told her.

"My name's Alma, as any fool knows."

"Hi. Going my way?"

She waited, uncertain which way either of them was going. Then she said, "You ran over a frog."

"I'm sorry, Honest—"

"It's okay. It was already run over last week."

"This town's full of frogs."

"I know. There was one the other night." Her eyes looked at him beautifully. He had never, really, existed.

"Where?" he asked. "Get in."

"Down where they're bulldozing that lot. I'm going the other way—" She started to walk backwards in a forward direction.

He said, "There was a fire last night but I didn't go. Too busy."

In the other half of the town, the part that was to the left of right, the heavy man named Charley fanned himself with a brown hat and said, "It's quarter past two, Al. Read about that radio repairman this morning?"

"Wasn't that something?" The other watched a tall insurance salesman in a black suit, turning a corner into the wind. There were two kinds of people; those who would, and those that only wanted to. "It'll be a pretty messy business when all the details are made known."

"His mother claims he was always a well behaved boy." He put his hat back on and started to go down. The girl would be on the second floor, pouring herself another straight one into a Dixie cup. She had it coming, she was a thin sloop, tacking into the wind without a compass, her canvas flapping, a double reef in her underthings. She would walk home listing dangerously, her bilges foul. She was a mouse feeling some animal's triumphant roar, feeling it through her skin, trembling. Knowing. But too late. "Only the fit are fit to survive," he whispered to the old lady standing next to him, "let me off at men's furnishings, wherever the hell that is."

the
squirrel
cage

Thomas M. Disch

THE terrifying thing—if that's what I mean—I'm not sure that 'terrifying' is the right word—is that I'm free to write down anything I like but that no matter what I *do* write down it will make no difference—to me, to you, to whomever differences are made. But then what is meant by 'a difference'? Is there ever really such a thing as change?

I ask more questions these days than formerly; I am less programmatic altogether. I wonder—is that a good thing?

This is what it is like where I am: a chair with no back to it (so I suppose you would call it a stool); a floor, walls, and a ceiling, which form, as nearly as I can judge, a cube; white, white light, no shadows—not even on the underside of the lid of the stool; me, of course; the typewriter. I have described the typewriter at length elsewhere. Perhaps I shall describe it again. Yes, almost certainly I shall. But not now. Later. Though why not now? Why not the typewriter as well as anything else?

Of the many kinds of question at my disposal, 'why' seems to be the most recurrent. Why is that?

What I do is this: I stand up and walk around the room from wall to wall. It is not a large room, but it's large enough for present purposes. Sometimes I even jump, but there is little incentive to do that, since there is nothing to jump *for*. The ceiling is quite too high to touch, and the stool is so low that it provides no challenge at all. If I thought anyone were *entertained* by my jumping . . . but I have no reason to suppose that. Sometimes I exercise: push-ups, somersaults, head-stands, isometrics, etc. But never as much as I should. I am getting fat.

Disgustingly fat and full of pimples besides. I like to squeeze the pimples on my face. Every so often I will keep one sore and open with overmuch pinching, in the hope that I will develop an abscess and blood-poisoning. But apparently the place is germ-proof. The thing never infects.

It's well nigh impossible to kill oneself here. The walls and floor are padded, and one only gets a headache beating one's head against them. The stool and typewriter both had hard edges, but whenever I have tried to use *them*, they're withdrawn into the floor. That is how I know there is someone watching.

Once I was convinced it was God. I assumed that this was either heaven or hell, and I imagined that it would go on for all eternity just the same way. But if I were living in eternity already, I couldn't get fatter all the time. Nothing changes in eternity. So I console myself that I will someday die. Man is mortal. I eat all I can to make that day come faster. *The Times* says that that will give me heart disease.

Eating is fun, and that's the real reason I do a lot of eating. What else is there to do, after all? There is this little . . . nozzle, I suppose you'd call it, that sticks out of one wall, and all I have to do is put my mouth to it. Not the most elegant way to feed, but it tastes damn good. Sometimes I just stand there hours at a time and let it trickle in. Until *I have* to trickle. That's what the stool is for. It has a lid on it, the stool does, which moves on a hinge. It's quite clever, in a mechanical way.

If I sleep, I don't seem to be aware of it. Sometimes I do catch myself dreaming, but I can never remember what they were about. I'm not able to make myself dream at will. I would like that exceedingly. That covers all the vital functions but one —and there is an accommodation for sex too. Everything has been thought of.

I have no memory of any time before this, and I cannot say how long *this* has been going on. According to today's *New York Times* it is the Second of May, 1961. I don't know what conclusion one is to draw from that.

From what I've been able to gather, reading *The Times*, my position here in this room is not typical. Prisons, for instance, seem to be run along more liberal lines, usually. But perhaps

The Times is lying, covering up. Perhaps even the date has been falsified. Perhaps the entire paper, every day, is an elaborate forgery and this is actually 1950, not 1961. Or maybe they are antiques and I am living whole centuries after they were printed, a fossil. Anything seems possible. I have no way to judge.

Sometimes I make up little stories while I sit here on my stool in front of the typewriter. Sometimes they are stories about the people in *The New York Times,* and those are the best stories. Sometimes they are just about people I make up, but those aren't so good because. . . .

They're not so good because I think everybody is dead. I think I may be the only one left, sole survivor of the breed. And they just keep me here, the last one, alive, in this room, this cage, to look at, to observe, to make their observations of, to— I don't *know* why they keep me alive. And if everyone is dead, as I've supposed, then who are they, these supposed observers? Aliens? *Are* there aliens? I don't know. Why are they studying me? What do they hope to learn? Is it an experiment? What am I supposed to do? Are they waiting for me to say something, to write something on this typewriter? Do my responses or lack of responses confirm or destroy a theory of behaviour? Are the testers happy with their results? They give no indications. They efface themselves, veiling themselves behind these walls, this ceiling, this floor. Perhaps no human could stand the sight of them. But maybe they are only scientists, and not aliens at all. Psychologists at M.I.T. perhaps, such as frequently are shown in *The Times:* blurred, dotty faces, bald heads, occasionally a moustache, certificate of originality. Or, instead, young, crew-cut Army doctors studying various brainwashing techniques. Reluctantly, of course. History and a concern for freedom has forced them to violate their own (privately-held) moral codes. Maybe I *volunteered* for this experiment! Is that the case? O God, I hope not! Are you reading this, Professor? Are you reading this, Major? Will you let me out now? I want to leave this experiment *right now.*

Yeah.

Well, we've been through that little song and dance before, me and my typewriter. We've tried just about every password

there is. Haven't we, typewriter. And as you can see (can you see?)—here we are still.

They are aliens, obviously.

* * *

Sometimes I write poems. Do you like poetry? Here's one of the poems I wrote. It's called *Grand Central Terminal*. ('Grand Central Terminal' is the right name for what most people, wrongly, call 'Grand Central Station.' This—and other priceless information—comes from *The New York Times*.)

Grand Central Terminal

How can you be unhappy
when you see how high
the ceiling is?

 My!

the ceiling is high!
High as the sky!
So who are *we*
to be gloomy here?

 Why,

there isn't even room
to die, my dear.

This is the tomb
of some giant so great
that if he ate
us there would be
simply no taste.

 Gee,

what a waste
that would be
of you and me.

And sometimes, as you can also see, I just sit here copying old poems over again, or maybe copying the poem that *The Times* prints each day. *The Times* is my only source of poetry. Alas the day! I wrote *Grand Central Terminal* rather a long time ago. Years. I can't say exactly how many years though.

I have no measures of time here. No day, no night, no waking and sleeping, no chronometer but *The Times*, ticking off its dates. I can remember dates as far back as 1957. I wish I had a little diary that I could keep here in the room with me. Some record of my progress. If I could just save up my old copies of *The Times*. Imagine how, over the years, they would pile up. Towers and stairways and cosy burrows of newsprint. It would be a more humane architecture, would it not? This cube that I occupy does have drawbacks from the strictly human point of view. But I am not allowed to keep yesterday's edition. It is always taken away, whisked off, before today's edition is delivered. I should be thankful, I suppose, for what I have.

What if *The Times* went bankrupt? What if, as is often threatened, there were a newspaper strike! Boredom is not, as you might suppose, the great problem. Eventually—very soon, in fact—boredom becomes a great challenge. A stimulus.

My body. Would you be interested in my body? I used to be. I used to regret that there were no mirrors in here. Now, on the contrary, I am grateful. How gracefully, in those early days, the flesh would wrap itself about the skeleton; now, how it droops and languishes! I used to dance by myself hours on end, humming my own accompaniment—leaping, rolling about, hurling myself spread-eagled against the padded walls. I became a connoisseur of kinesthesia. There is great joy in movement—free, unconstrained speed.

Life is so much tamer now. Age dulls the edge of pleasure, hanging its wreathes of fat on the supple Christmas tree of youth.

I have various theories about the meaning of life. Of life *here*. If I were somewhere else—in the world I know of from *The New York Times*, for instance, where so many exciting things happen every *day* that it takes half a million words to tell about them—there would be no problem at all. One would be so busy running around—from 53rd St. to 42nd St., from 42nd St. to

the Fulton Street Fish Market, not to mention all the journeys one might make *crosstown*—that one wouldn't have to worry whether life had a meaning.

In the daytime one could shop for a multitude of goods, then in the evening, after a dinner at a fine restaurant, to the theatre or a cinema. Oh, life would be so full if I were living in New York! If I were free! I spend a lot of time, like this, imagining what New York must be like, imagining what other people are like, what I would be like with other people, and in a sense my life here is full from imagining such things.

One of my theories is that they (*you* know, ungentle reader, who they are, I'm sure) are waiting for me to make a confession. This poses problems. Since I remember nothing of my previous existence, I don't know what I should confess. I've tried confessing to everything: political crimes, sex crimes (I especially like to confess to sex crimes), traffic offences, spiritual pride. My God, what *haven't* I confessed to? Nothing seems to work. Perhaps I just haven't confessed to the crimes I really did commit, whatever they were. Or perhaps (which seems more and more likely) the theory is at fault.

I have another theory th

* * *

A brief hiatus.

The Times came, so I read the day's news, then nourished myself at the fount of life, and now I am back at my stool.

I have been wondering whether, if I were living in that world, the world of *The Times*, I would be a pacifist or not. It is certainly the central issue of modern morality, and one would have to take a stand. I have been thinking about the problem for some years, and I am inclined to believe that I am in favour of disarmament. On the other hand, in a practical sense I wouldn't object to the bomb if I could be sure it would be dropped on me. There is definitely a schism in my being between the private sphere and the public sphere.

On one of the inner pages, behind the political and international news, was a wonderful story headlined: BIOLOGISTS HAIL MAJOR DISCOVERY. Let me copy it out for your benefit:

Washington D.C.—Deep-sea creatures with brains but no mouths are being hailed as a major biological discovery of the twentieth century.

The weird animals, known as pogonophores, resemble slender worms. Unlike ordinary worms, however, they have no digestive system, no excretory organs, and no means of breathing, the National Geographic Society says. Baffled scientist who first examined pogonophores believed that only parts of the specimens had reached them.

Biologists are now confident that they have seen the whole animal, but still do not understand how it manages to live. Yet they know it does exist, propagate, and even think, after a fashion, on the floors of deep waters around the globe. The female pogonophore lays up to thirty eggs at a time. A tiny brain permits rudimentary mental processes.

All told, the pogonophore is so unusual that biologists have set up a special phylum for it alone. This is significant because a phylum is such a broad biological classification that creatures as diverse as fish, reptiles, birds, and men are all included in the phylum, Chordata.

Settling on the sea bottom, a pogonophore secretes a tube around itself and builds it up, year by year, to a height of perhaps five feet. The tube resembles a leaf of white grass, which may account for the fact that the animal went so long undiscovered.

The pogonophore apparently never leaves its self-built prison, but crawls up and down inside at will. The wormlike animal may reach a length of fourteen inches, with a diameter of less than a twenty-fifth of an inch. Long tentacles wave from its top end.

Zoologists once theorised that the pogonophore, in an early stage, might store enough food in its body to allow it to fast later on. But young pogonophores also lack a digestive system.

It's amazing the amount of things a person can learn just by reading *The Times* every day. I always feel so much more *alert* after a good read at the paper. And creative. Herewith, a story about pogonophores:

Striving
The Memoirs of a Pogonophore

INTRODUCTION

In May of 1961 I had been considering the purchase of a pet. One of my friends had recently acquired a pair of tarsiers, another had adopted a boa constrictor, and my nocturnal roommate kept an owl caged above his desk.

A nest (or school?) of pogs was certainly one-up on their eccentricities. Moreover, since pogonophores do not eat, excrete, sleep, or make noise, they would be ideal pets. In June I had three dozen shipped to me from Japan at considerable expense.

A brief interruption in the story: do you feel that it's credible? Does it possess the *texture* of reality? I thought that by beginning the story by mentioning those other pets, I would clothe my invention in greater verisimilitude. Were you taken in?

Being but an indifferent biologist, I had not considered the problem of maintaining adequate pressure in my aquarium. The pogonophore is used to the weight of an entire ocean. I was not equipped to meet such demands. For a few exciting days I watched the surviving pogs rise and descend in their translucent white shells. Soon, even these died. Now, resigned to the commonplace, I stock my aquarium with Maine lobster for the amusement and dinners of occasional out-of-town visitors.

I have never regretted the money I spent on them: man is rarely given to know the sublime spectacle of the rising pogonophore—and then but briefly. Although I had at that time only the narrowest conception of the thoughts that passed through the rudimentary brain of the sea-worm ("Up up up Down down down"), I could not help admiring its persistence. The pogonophore does not sleep. He climbs to the top of the inside passage of his shell, and, when he has reached the top, he retraces his steps to the bottom of his shell. The pogonophore never tires of his self-imposed regimen. He performs his duty scrupulously and with honest joy. He is *not* a fatalist.

The memoirs that follow this introduction are not allegory.

I have not tried to 'interpret' the inner thoughts of the pogono-
phore. There is no need for that, since the pogonophore himself
has given us the most eloquent record of his spiritual life. It is
transcribed on the core of translucent white shell in which he
spends his entire life.

Since the invention of the alphabet it has been a common
conceit that the markings on shells or the sand-etched calligraphy
of the journeying snail are possessed of true linguistic meaning.
Cranks and eccentrics down the ages have tried to decipher these
codes, just as other men have sought to understand the language
of the birds. Unavailingly, I do not claim that the scrawls and
shells of *common* shellfish can be translated; the core of the
pogonophore's shell, however, can be—for I have broken the
code!

With the aid of a United States Army manual on cryptog-
raphy (obtained by what devious means I am not at liberty to
reveal) I have learned the grammar and syntax of the pogono-
phore's secret language. Zoologists and others who would like to
verify my solution of the crypt may reach me through the editor
of this publication.

In all thirty-six cases I have been able to examine, the in-
dented traceries on the inside of these shells have been the same.
It is my theory that the sole purpose of the pogonophore's ten-
tacles is to follow the course of this "message" up and down the
core of his shell and thus, as it were, to think. The shell is a sort
of externalized stream-of-consciousness.

It would be possible (and in fact it is an almost irresistible
temptation) to comment on the meaning that these memoirs
possess for mankind. Surely, there is a philosophy compressed
into these precious shells by Nature herself. But before I begin
my commentary, let us examine the text itself.

The Text
I
Up. Uppity, up, up. The Top.
II
Down. Downy, down, down. Thump. The Bottom.
III

A description of my typewriter. The keyboard is about one foot wide. Each key is flush to the next and marked with a single letter of the alphabet, or with two punctuation signs, or with one number and one punctuation sign. The letters are not ordered as they are in the alphabet, alphabetically, but seemingly at random. It is possible that they are in code. Then there is a space bar. There is not, however, either a margin control or a carriage return. The platen is not visible, and I can never see the words I'm writing. What does it all look like? Perhaps it is made immediately into a book by automatic linotypists. Wouldn't that be nice? Or perhaps my words just go on and on in one endless line of writing. Or perhaps this typewriter is just a fraud and leaves no record at all.

Some thoughts on the subject of futility:

I might just as well be lifting weights as pounding at these keys. Or rolling stones up to the top of a hill from which they immediately roll back down. Yes, and I might as well tell lies as the truth. It makes no difference what I say.

That is what is so terrfying. Is 'terrifying' the right word?

I seem to be feeling rather poorly today, but I've felt poorly before! In a few more days I'll be feeling all right again. I need only be patient, and then. . . .

What do they want of me here? If only I could be sure that I were serving some good *purpose*. I cannot help worrying about such things. Time is running out. I'm hungry again. I suspect I am going crazy. That is the end of my story about the pogonophores.

A hiatus.

Don't *you* worry that I'm going crazy? What if I got catatonia? Then *you'd* have nothing to read. Unless they gave *you* my copies of *The New York Times*. It would serve *you* right.

You: the mirror that is denied to me, the shadow that I do not cast, my faithful observer, who reads each freshly-minted *pensée*; Reader.

You: Horrorshow monster, Bug-Eyes, Mad Scientist, Army Major, who prepares the wedding bed of my death and tempts me to it.

You: Other!

Speak to me!

YOU: What shall I say, Earthling?

I: Anything so long as it is another voice than my own, flesh that is not my own flesh, lies that I do not need to invent for myself. I'm not particular, I'm not proud. But I doubt sometimes —you won't think this is too melodramatic of me?—that I'm real.

YOU: I know the feeling. (Extending a tentacle) May I?

I: (Backing off) Later. Just now I thought we'd talk. (You begin to fade.)

There is so much about you that I don't understand. Your identity is not distinct. You change from one being to another as easily as I might switch channels on a television set, if I had one. You are too secretive as well. You should get about in the world more. Go places, show yourself, enjoy life. If you're shy, I'll go out with you. You let yourself be undermined by fear, however.

YOU: Interesting. Yes, definitely most interesting. The subject evidences acute paranoid tendencies, fantasises with almost delusional intensity. Observe his tongue, his pulse, his urine. His stools are irregular. His teeth are bad. He is losing hair.

I: I'm losing my mind.

YOU: He's losing his mind.

I: I'm dying.

YOU: He's dead.

(Fades until there is nothing but the golden glow of the eagle on his cap, a glint from the oak leaves on his shoulders.) But he has not died in vain. His country will always remember him, for by his death he has made this nation free.

(Curtain. Anthem.)

Hi. It's me again. Surely you haven't forgotten *me?* Your old friend, me? Listen carefully now—this is my plan. I'm going to escape from this damned prison, by God, and *you're* going to help me. 20 people may read what I write on this typewriter, and of those 20, 19 could see me rot here forever without batting an eyelash. But not number 20. Oh no! He—*you*—still has a conscience. He/you will send me a Sign. And when I've seen the

Sign, I'll know that someone out there is trying to help. Oh, I won't expect miracles overnight. It may take months, years even, to work out a foolproof escape, but just the knowledge that there is someone out there trying to help will give me the strength to go on from day to day, from issue to issue of *The Times*.

You know what I sometimes wonder? I sometimes wonder why *The Times* doesn't have an editorial about me. They state their opinion on everything else—Castro's Cuba, the shame of our Southern States, the Sales Tax, the first days of Spring.

What about me!

I mean, isn't it an injustice the way *I'm* being treated? Doesn't anybody care, and if not, why not? Don't tell me they don't know I'm here. I've been years now writing, writing. Surely they have some idea. Surely *someone* does!

These are serious questions. They demand serious appraisal. I insist that they be *answered*.

I don't really expect an answer, you know. I have no false hopes left, none. I know there's no Sign that will be shown me, that even if there is, it will be a lie, a lure to go on hoping. I know that I am alone in my fight against this injustice. I know all that—and *I don't care!* My will is still unbroken, and my spirit free. From my isolation, out of the stillness, from the depths of this white, white light, I say this to you—I DEFY YOU! Do you hear that? I said: I DEFY YOU!

Dinner again. Where does the time all go to?

While I was eating dinner I had an idea for something I was going to say here, but I seem to have forgotten what it was. If I remember, I'll jot it down. Meanwhile, I'll tell you about my other theory.

My *other* theory is that this is a squirrel-cage. You know? Like the kind you find in a small town park. You might even have one of your own, since they don't have to be very big. A squirrel-cage is like most any other kind of cage except it has an exercise wheel. The squirrel gets *into* the wheel and starts running. His running makes the wheel turn, and the turning of the wheel makes it necessary for him to keep running inside it. The exercise is supposed to keep the squirrel healthy. What I don't understand is why they put the squirrel in the cage in the first

place. Don't they know what it's going to be like for the poor little squirrel? Or don't they care?

They don't care.

I remember now what it was I'd forgotten. I thought of a new story. I call it "An Afternoon at the Zoo." I made it up myself. It's very short, and it has a moral. This is my story:

An Afternoon at the Zoo

This is the story about Alexandra. Alexandra was the wife of a famous journalist, who specialised in science reporting. His work took him to all parts of the country, and since they had not been blessed with children, Alexandra often accompanied him. However this often became very boring, so she had to find something to do to pass the time. If she had seen all the movies playing in the town they were in, she might go to a museum, or perhaps to a ball game, if she were interested in seeing a ball game that day. One day she went to a zoo.

Of course it was a small zoo, because this was a small town. Tasteful but not spectacular. There was a brook that meandered all about the grounds. Ducks and a lone black swan glided among the willow branches and waddled out onto the lake to snap up bread crumbs from the visitors. Alexandra thought the swan was beautiful.

Then she went to a wooden building called the 'Rodentiary'. The cages advertised rabbits, otters, raccoons, etc. Inside the cages was a litter of nibbled vegetables and droppings of various shapes and colours. The animals must have been behind the wooden partitions, sleeping. Alexandra found this disappointing, but she told herself that rodents were hardly the most important thing to see at any zoo.

Nearby the Rodentiary, a black bear was sunning himself on a rock ledge. Alexandra walked all about the demi-lune of bars without seeing other members of the bear's family. He was an enormous bear.

She watched the seals splash about in their concrete pool, and then she moved on to find the Monkey House. She asked a

friendly peanut vendor where it was, and he told her it was closed for repairs.

"How sad!" Alexandra exclaimed.

"Why don't you try *Snakes and Lizards?*" the peanut vendor asked.

Alexandra wrinkled her nose in disgust. She'd hated reptiles ever since she was a little girl. Even though the Monkey House was closed she bought a bag of peanuts and ate them herself. The peanuts made her thirsty, so she bought a soft drink and sipped it through a straw, worrying about her weight all the while.

She watched peacocks and a nervous antelope, then turned off on to a path that took her into a glade of trees. Poplar trees, perhaps. She was alone there, so she took off her shoes and wiggled her toes, or performed some equivalent action. She liked to be alone like this, sometimes.

A file of heavy iron bars beyond the glade of trees drew Alexandra's attention. Inside the bars there was a man, dressed in a loose-fitting cotton suit—pyjamas, most likely—held up about the waist with a sort of rope. He sat on the floor of his cage without looking at anything in particular. The sign at the base of the fence read:

Chordate.

"How lovely!" Alexandra exclaimed.

Actually, that's a very old story. I tell it a different way every time. Sometimes it goes on from the point where I left off. Sometimes Alexandra talks to the man behind the bars. Sometimes they fall in love, and she tries to help him escape. Sometimes they're both killed in the attempt, and this is *very* touching. Sometimes they get caught and are put behind the bars *together*. But because they love each other so much, imprisonment is easy to endure. That is also touching, in its way. Sometimes they make it to freedom. After that though, after they're free, I never know what to do with the story. However, I'm sure that if I were free myself, free of this cage, it would not be a problem.

One part of the story doesn't make much sense. Who would put a person in a zoo? Me, for instance. Who would do such

a thing? Aliens? Are we back to aliens again? Who can say about aliens? I mean, *I* don't know anything about them.

My theory, my best theory, is that I'm being kept here by people. Just ordinary people. It's an ordinary zoo, and ordinary people come by to look at me through the walls. They read the things I type on this typewriter as it appears on a great illuminated billboard, like the one that spells out the news headlines around the sides of The Times Tower on 42nd Street. When I write something funny, they may laugh, and when I write something serious, such as an appeal for help, they probably get bored and stop reading. Or *vice versa* perhaps. In any case, they don't take what I say very seriously. None of them care that I'm inside here. To them I'm just another animal in a cage. You might object that a human being is not the same thing as an animal, but isn't he, after all? They, the spectators, seem to think so. In any case, none of them is going to help me get out. None of them thinks it's at all strange or unusual that I'm in here. None of them thinks it's wrong. That's the terrifying thing.

'Terrifying'?

It's not terrifying. How can it be? It's only a story, after all. Maybe *you* don't think it's a story, because you're out there reading it on the billboard, but I know it's a story because I have to sit here on this stool making it up. Oh, it might have been terrifying once upon a time, when I first got the idea, but I've been here now for years. Years. The story has gone on far too long. Nothing can be terrifying for years on end. I only *say* it's terrifying because, you know, I have to say something. Something or other. The only thing that could terrify me now is if someone were to come in. If they came in and said, "All right, Disch, you can go now." That, truly, would be terrifying.

AGAINST THE MIDDLE RANGE OF EXPERIENCE

* * * * * *

new forms
of
extremity

the pukey
Nigel Dennis

MR. TROY's refusal to have a pukey in the house had caused enormous trouble in the family. "Pukeys are nasty, degenerate things," he said: "they make filthy messes all over the floor, they corrupt the young, they interrupt homework and sap the nation, and we have nowhere to put one." His wife would answer: "Well, well, we are getting distinguished, aren't we? It seems we're the Duke of Devonshire. Let me tell you that Blanche and Mabel both have pukeys in their drawing-rooms, and far from being corrupted, they are happier." Young Miss Troy appealed to her father's sense of status, saying: "Everywhere I go, Father, it's always: 'What did your pukey do last night?' I have to admit we haven't got one." "Oh, all right," said Mr. Troy, after a couple of years, "I'll let the pukey-man come and give a demonstration.

A few days later, the man arrived with the pukey and put its box against the wall opposite the fireplace. When Mrs. Troy asked: "Won't it catch the draught there?" the pukey-man only laughed and said: "The point about a pukey, madam, is that it's bred to be insensible." "But it is *alive*, isn't it?" asked Mrs. Troy quickly, "because we'd never pay for something dead. And if it's alive, won't the dog resent it?" "Both dog and budgie will be unconscious of it, madam," said the pukey-man, "a pukey speaks only to a human brain." "Well, cut the brainy cackle and open the box," said Mr. Troy roughly.

Let us admit at once that the first impression the pukey made on Mr. Troy was a good one. Even lying stupefied on the carpet, its eyes had a wondering gaze that fell hardly short of sweetness. "It's not just going to flopdown like that all the time, is it?" asked Mr. Troy, to hide the fact that he liked it so far. "Give it a minute, my dear sir!" begged the pukey-man, "it's hardly got its bearings." "Pay him no attention!" exclaimed Mrs.

Reprinted by permission of the author.

Troy, "he's been picking on pukeys for years." "Oh, what shall we *call* it?" said Miss Troy.

She had hardly spoken when the pukey shuddered from snout to stern and let its muzzle fall right open, showing six rows of vivid pink gums and bubbles of sparkling saliva: "No teeth; that's curious!" muttered Mr. Troy. Then, with no warning, it vomited all over the carpet—a perfectly-filthy, greenish-yellow mess—causing Mrs. Troy to cry spontaneously: "Oh, the filthy little beast!" and Miss Troy to say: "Oh, Mum, don't *fuss!*" and Mr. Troy to say: "I told you it would foul everything up. Take the little brute away!" "An ounce of patience, if you please," asked the pukey-man, "or how can it grow on you?" "I'm sure that's true—and I don't mean I don't like it," said Mrs. Troy, rallying. "Isn't it actually *good* for the carpet?" Miss Troy asked the pukey-man, "I know the Vicar said, reasonably used, it was." "That is perfectly correct, Miss Troy," said the pukey-man, "it's not the vomit but the abuse of it." "Now, there's a remark I always like to hear," said Mr. Troy.

At that moment the pukey, which had been staring at its own emission in a rather vague, contented way, changed its expression entirely. A sort of pathetic anguish came over its whole face: it held its snout sideways and looked at Miss Troy in a pleading, tender way. "Oh, *look!*" cried Mrs. Troy, "it's trying to say it didn't mean bad." They were all wrenched by the pukey's fawning expression, and when it slobbered and grovelled and brownish tears dripped from the corners of its eyes, Mrs. Troy could have hugged it. "Damned sentimental, hypocritical brute!" said Mr. Troy, "I still reserve my judgement." But he was the first to jump in his seat when the pukey, suddenly throwing-up on to the carpet a clot of gritty mucus, followed this up with a string of shrieks and groans. Everyone was deafened except Miss Troy, who sensed at once that the pukey was illustrating the dilemma of girls of her own age in search of happiness. "Why, bless my soul!" said Mrs. Troy soon, "it's trying to have *sex*, that's what it is"—and sure enough, the pukey was now twisting its hind-parts in the most indecent way and rubbing its flanks in its own vomit. "I'll not have that in *my* house," said Mrs. Troy,

pursing her lips, "it's just plain filth, and showing-off." "My dear madam, it never actually *gets* there," said the pukey-man: "nothing ever really *happens.*" "Oh, Mother, you and Father make everything seem obscene!" said Miss Troy, "even love." "Well, as long as it only suggests but can't actually do it, I don't mind," said Mrs. Troy, watching the pukey with a new curiosity. "My mind is still unmade up," said Mr. Troy.

Worn out, it seemed, by sexual frustration, the pukey lay still for a moment. Then, suddenly fixing its eye on Mrs. Troy, it gave her such a glare of horrible malignancy that she reached for her husband's arm. Next minute, there was a dreadful spectacle: throwing itself into a spasm of rage, the pukey began tearing and biting at its own body, like a thing bent on suicide. "Stop it! Stop it! Put the lid on!" screamed Mrs. Troy, "it's cruel, and drawing blood." "Frankly, you'll have to adjust to that madam," said the pukey-man, "because it fights more than anything else." "Oh, then, that's decisive for me," said Mr. Troy, "because I love to see a good scrap." "It *is* the men who like that best," agreed the pukey-man, as the pukey went through the motions of winding its entrails round the throat of an enemy and jumping on his face. "I don't *mind* its fighting," Mrs. Troy said grudgingly, "but I'll put its lid on if it overdoes it. I like *beautiful* things best." The words, alas, were hardly out of her mouth when the pukey, sighting backwards over its spine like a mounted cowboy firing at his pursuers, shot her full in the face with an outrageous report. "Now, no grumbling, Mother!" screamed poor Miss Troy, knowing her mother's readiness to take affront. "But it's *not* nice!" protested Mrs. Troy, fanning herself with an evening paper. "Oh, Mother, can't you see it *means* nothing?" cried Miss Troy, "it's not like *us*, with our standards." "Standards or no," said Mrs. Troy, "I never saw Mabel's pukey do that to *her*." "Ah, but this is an improved model, madam," said the pukey-man.

"Am I correct in supposing," asked Mr. Troy, "that nothing substantial ever comes out of its rear end anyway?" "That is correct, sir," answered the pukey-man, "all secretion and excretion are purely visual and oral. The vent is hot air at most: hence, no

sand-box." "Yet it has a belly on it," said Mr. Troy, "I know because I can see one." "You can see a belly, sir," answered the pukey-man, "but you can't see any guts, can you?" They all laughed at this, because it was so true.

After throwing-up another couple of times ("Mercy, what a messy little perisher it is!" said kind Mrs. Troy), the pukey became inordinately grave and a whole rash of wettish pimples spread over its face. "Well, you are in luck!" said the pukey-man, jumping up as if genuinely interested, "it never does this more than once a week at most. Can you guess what it is?" They all racked their brains, guessing everything from sewage farming to guitar-playing, and still couldn't imagine; until Miss Troy, who was the quickest of the family, screamed: "I know! It's *thinking!*" "*Mes compliments,* young lady," said the pukey-man, bowing.

They all watched the pukey thinking because it was so unexpected; but none of them really liked it. "When it vomits, it only makes me laugh," said Mr. Troy, "but when it thinks, *I* feel like vomiting." "I just feel nervous and embarrassed, like it was something you'd seen and shouldn't," said Mrs. Troy, and even Miss Troy for once agreed with her mother, saying, "You feel it's only doing it as a change from being sick, but it's the same really." "Don't judge it too hardly," said the pukey-man, "surely the wonder is that with no brains it can think at all." "Has it really no brains?" asked Mr. Troy, curious. "No, sir," said the pukey-man: "that's *why* its thinking makes you sick." "Funny sort of animal, I must say," said Mr. Troy, "thinks without brains, bites without teeth, throws-up with no guts, and screws without sex." "Oh, *please* stop it thinking!" begged Mrs. Troy. "I had an experience once that smelt like that." At which words, the pukey's pimples disappeared completely and, lying prone with its paws out, it gave Mrs. Troy a smug, complacent look, showing all its gums in a pleading whimpering. "Oh, the little angel! It wants to be congratulated for having thought!" cried Mrs. Troy: "then we *will*—yes! we *will,* you smelly little darling—you little, stinking, clever, mother's thing!" "I find that touching, too," said Mr. Troy, "no wonder there's so much nicker in pukeys." "It's for love and culture, too, Dad," Miss Troy reminded. "Thank you, Miss Troy," said the pukey-man, "we breeders tell ourselves that too."

During the next hour the pukey did all manner of things—such as marching like the Coldstream Guards, dancing and balancing on one paw like Pavlova, folding its arms like a Member of Parliament, singing the national anthem, plucking away at its parts mysteriously, fighting like mad, and making such vulgar explosive noises at both ends that the Troys were all left speechless with wonder. What charmed them as much as anything was feeling that the pukey made no distinction about what it did: whether it was fawning or screeching, or thinking or puking, it made it all like the same, because it loved each thing equally and looked at you always so proudly for it. "I can only say you breeders must be jolly highly-skilled," summed-up Mr. Troy, "to root out all the natural organs and still poison the air." "It's more a sixth sense than a skill," said the pukey-man modestly, "and one which your wife, I may say, seems to have instinctively." This was the first compliment Mrs. Troy had had since she gave birth to Miss Troy, and to cover her natural embarrassment she said sharply, "Well, put its lid on again now and take it away. We'll come and fill out the Never-never forms tomorrow."

With the pukey gone, it wasn't like the same home. The walls seemed to have been sprayed with a dribble the colour of maple-syrup, and dead flies kept dropping from the ceiling. The state of the carpet was beyond description, although the last thing the pukey had done before the lid closed was puff a sort of scented detergent powder over the stinking mess it had made. But the Troys were much too impressed to worry about the room: they could only think of buying the pukey and doing this every night. "It baffles me," said Mr. Troy, as they went to bed: "it's not human, it's not mechanical, it's not like any animal I've ever known." "What it leaves on the carpet is human through-and-through," said Mrs. Troy, and they all laughed at this because it was so true.

the locust cry

Norman Mailer

On p. 293 of *The Early Masters*[1] is a short story.

The Test

IT IS TOLD:

When Prince Adam Czartoryski, the friend and counselor of Czar Alexander, had been married for many years and still had no children, he went to the maggid of Koznitz and asked him to pray for him and because of his prayer the princess bore a son. At the baptism, the father told of the maggid's intercession with God His brother who, with his young son, was among the guests, made fun of what he called the prince's superstition. "Let us go to your wonder-worker together," he said, "and I shall show you that he can't tell the difference between left and right."

Together they journeyed to Koznitz, which was close to where they lived. "I beg of you," Adam's brother said to the maggid, "to pray for my sick son."

The maggid bowed his head in silence. "Will you do this for me?" the other urged.

The maggid raised his head. "Go," he said, and Adam saw that he only managed to speak with a great effort. "Go quickly, and perhaps you will still see him alive."

"Well, what did I tell you?" Adam's brother said laughingly as they got into their carriage. Adam was silent during the ride.

Copyright © 1963, by Norman Mailer. First appeared in Commentary *as* Responses and Reactions II. *Reprinted by permission of the author and his agents, Scott Meredith Literary Agency, Inc. 580 Fifth Avenue, New York, N.Y. 10036.*

1. From Martin Buber's *Tales of the Hasidim.* Published by Schocken Books. Volume I: *The Early Masters,* Volume II: *The Later Masters.*

When they drove into the court of his house, they found the boy dead.

What is suggested by the story is an underworld of real events whose connection is never absurd. Consider, in parallel, this Haiku:[2]

> *Yagate shinu*
> *keshiki wa mei-zo*
> *semi-no koe*

> So soon to die
> and no sign of it showing—
> locust cry.

The sense of stillness and approaching death is occupied by the cry of the locust. Its metallic note becomes the exact equal of an oncoming death. Much of Haiku can best be understood as a set of equations in mood. Man inserting himself into a mood extracts an answer from nature which is not only the reaction of the man upon the mood, but is a supernatural equivalent to the quality of the experience, almost as if a key is given up from the underworld to unlock the surface of reality.

Here for example is an intimation of the architecture concealed beneath·

Upsetting the Bowl[3]

It is told:

Once Rabbi Elimelekh was eating the Sabbath meal with his disciples. The servant set the soup bowl down before him. Rabbi Elimelekh raised it and upset it, so that the soup poured all over the table. All at once young Mendel, later the rabbi of Rymanov, cried out: "Rabbi, what are you doing? They will put us all in jail!" The other disciples smiled at these foolish words. They would have laughed out loud, had not the presence of their teacher restrained them. He, however, did not smile. He nodded to young Mendel and said: "Do not be afraid, my son!"

2. *An Introduction to Haiku* by Harold G. Henderson, p. 43. The poem is by Matsuo Basho, translated by Henderson.
3. *The Early Masters*, p. 259.

Some time after this, it became known that on that day an edict directed against the Jews of the whole country had been presented to the emperor for his signature. Time after time he took up his pen, but something always happened to interrupt him. Finally he signed the paper. Then he reached for the sand-container but took the inkwell instead and upset it on the document. Hereupon he tore it up and forbade them to put the edict before him again.

A magical action in one part of the world creates its historical action in another—we are dealing with no less than totem and taboo. Psychoanalysis intrudes itself. One of the last, may it be one of the best approaches to modern neurosis is by way of the phenomenological apparatus of anxiety. As we sink into the apathetic bog of our possible extinction, so a breath of the Satanic seems to rise from the swamp. The magic of materials lifts into consciousness, proceeds to dominate us, is even enthroned into a usurpation of consciousness. The protagonists of *Last Year at Marienbad* are not so much people as halls and chandeliers, gaming tables, cigarettes in their pyramid of 1, 3, 5, and 7. The human characters are ghosts, disembodied servants, attendants who cast their shadows on the material. It is no longer significant that a man carries a silver cigarette case; rather it is the cigarette case which is significant. The man becomes an instrument to transport the case from the breast pocket of a suit into the air; like a building crane, a hand conducts the cigarette case to an angle with the light, fingers open the catch and thus elicit a muted sound of boredom, a silver groan from the throat of the case, which now offers up a cigarette, snaps its satisfaction at being shut, and seems to guide the hand back to the breast pocket. The man, on leave until he is called again, goes through a pantomime of small empty activities—without the illumination of his case he is like all dull servants who cannot use their liberty.

That, one may suppose, is a proper portrait of Hell. It is certainly the air of the phenomenological novel. It is as well the neurotic in slavery to the material objects which make up the locks and keys of his compulsion.

But allow me a quick portrait of a neurotic. He is a sociologist, let us say, working for a progressive foundation, a disenchanted

atheist ("Who knows—God may exist as some kind of thwarted benevolence"), a liberal, a social planner, a member of SANE, a logical positivist, a collector of jokes about fags and beatniks, a lover of that large suburban land between art and the documentary. He smokes two packs of cigarettes a day: he drinks —*when* he drinks—eight or ten tots of blended whiskey in a night. He does not get drunk, merely cerebral, amusing, and happy. Once when he came home thus drunk, he bowed to his door and then touched his doorknob three times. After this, he went to bed and slept like a thief.

Two years later he is in slavery to the doorknob. He must wipe it with his fingertips three times each morning before he goes out. If he forgets to do this and only remembers later at work, his day is shattered. Anxiety bursts his concentration. His psyche has the air of a bombed city. In an extreme case, he may even have to return to his home. His first question to himself is whether someone has touched the knob since he left. He makes inquiries. To his horror he discovers the servant has gone out shopping already. She has therefore touched the knob and it has lost its magical property. Stratagems are now necessary. He must devote the rest of the day to encouraging the servant to go out in such a manner that he can open the door for her, and thus remove the prior touch of her hand.

Is he mad? the man asks himself. Later he will ask his analyst the same question. But he is too aware of the absurdity of his activities. He suffers at the thought of the work he is not accomplishing, he hates himself for being attached to the doorknob, he tries to extirpate its dominance. One morning he makes an effort to move out briskly. He does not touch the brass a second and third time. But his feet come to a halt, his body turns around as if a gyroscope were revolving him, his arm turns to the knob and pats it twice. He no longer feels his psyche is to be torn in two. Consummate relief.

Of course his analysis discloses wonders. He has been an only son. His mother, his father, and himself make three. He and his wife (a naturally not very happy marriage) have one child. The value of the trinities is considered dubious by the analyst but is insisted upon by the patient. He has found that he need touch

the doorknob only once if he repeats himself, "I was born, I live, and I die." After a time he finds that he does not have to touch the knob at all, or upon occasion, can use his left hand for the purpose. There is a penalty, however. He is obliged to be concerned with the number nine for the rest of the day. Nine sips of water from a glass. A porterhouse steak consumed in nine bites. His wife to be kissed nine times between supper and bed. "I've kicked over an ant hill," he confesses to his analyst. "I'm going bugs."

They work in his cause. Two testes and one penis makes three. Two eyes and one nose; two nostrils and one mouth; the throat, the tongue, and the teeth. His job, his family, and himself. The door, the doorknob, and the act of opening it.

Then he has a revelation. He wakes up one morning and does not reach for a cigarette. There is a tension in him to wait. He suffers agonies—the brightest and most impatient of his cells seem to be expiring without nicotine—still he has intimations of later morning bliss, he hangs on. Like an infantryman coming up alive from a forty-eight-hour shelling, he gets to his hat, his attaché case, and the doorknob. As he touches it, a current flows into his hand. "Stick with me, pal," says the message. "One and two keep you from three."

Traveling to the office in the last half hour of the subway rush, he is happy for the first time in years. As he holds to the baked enamel loop of the subway strap, his fingers curl up a little higher and touch the green painted metal above the loop. A current returns to him again. Through his fingertips he feels a psychic topography which has dimensions, avenues, signals, buildings. From the metal of the subway strap through the metal of the subway car, down along the rails, into the tunnels of the city, back to the sewer pipes and electric cables which surround the subway station from which he left, back to his house, and up the plumbing, up the steam pipe, up the hall, a leap through the air, and he has come back to the doorknob again. He pats the subway strap three times. The ship of his body will sink no further. "Today," thinks the sociologist, "I signed my armistice. The flag of Faust has been planted here."

But in his office he has palpitations. He believes he will have

a heart attack. He needs air. He opens the window, leans out from the waist. By God, he almost jumped!

The force which drew him to touch the knob now seems to want to pull his chest through the window. Or is it a force opposed to the force which made him touch the doorknob? He does not know. He thinks God may be telling him to jump. That thwarted benevolent God. "You are swearing allegiance to materials," says a voice. "Come back son. It is better to be dead."

Poor man. He is not bold enough to be Faust. He calls his analyst.

"Now, for God's sake, don't do anything," says the analyst. "This is not uncommon. Blocked material is rising to the surface. It's premature, but since we've gotten into it, repetition compulsions have to do with omnipotence fantasies which of course always involve Almighty figures and totemic Satanistic contracts. The urge to suicide is not bona fide in your case—it's merely a symbolic contraction of the anxiety."

"But I tell you I almost went through the window. I felt my feet start to leave the floor."

"Well, come by my office then. I can't see you right now— trust me on this—I've got a girl who will feel I've denied her her real chance to bear children if I cut into her hour, she's had too many abortions. You know, she's touchy"—rare is the analyst who won't gossip a *little* about his patients, it seems to calm the other patients—"but I'll leave an envelope of tranquilizers for you on the desk. They're a new formula. They're good. Take two right away. Then two more this afternoon. Forget the nausea if it comes. Just side-effect. We'll get together this evening."

"Mind if I touch your doorknob three times?"

"Great. You've got your sense of humor back. Yes, by all means, touch it."

> So soon to die
> and no sign of it is showing—
> locust cry.

in a hole

George P. Elliott

I AM in a hole. At first I did not want to get out of the hole.
It was a sort of relief to be in it. In my city we are prepared for
cataclysms. You cannot be sure which kind of destruction is go-
ing to catch you, but one or another is pretty sure to. In fact,
I am lucky. I am nearly forty and this is the first one to catch me.
Properly speaking, I am not caught yet, for I am still alive and
not even injured. When I first came to in this hole and realized
what had happened and where I was, I had no impulse to get
out. I was afraid of finding the city in rubble, even though I knew
we were a tough people and would rebuild it as we had done
more than once before. My first thought was: caught at last.
Perhaps the shock had stunned me. In any case, I certainly felt
relieved of anxiety, my worry about how and when trouble was
going to find me was over.

Our city is great and strong. Yet when it was founded over
three hundred years ago, our forefathers were warned against
the location. We are at the tip of a promontory at the extreme
west of the continent, situated on a geological fault—typhoons
rake us—the land is sterile, everything worth having must be
brought to us from outside—our people are immigrants, dis-
satisfied and ambitious, we have not brought many of our an-
cestors' myths with us, we are eager to rid ourselves of customs,
we are unruly and rely on police to keep us in order—no matter
how rich we are, no matter how hard we work, we are always
overcrowded—despite the researches of our dieticians, we have
many nutritional ailments, new ones springing up among us as
fast as the old ones are cured. Perhaps the hardships of our loca-
tion have tested us and made us tough, and our founding fathers
knew this would be the case. They were stubborn in choosing
this raw location. We question their wisdom, we grumble, we

analyze the possibilities. But we do not seriously complain, we have no real intention of rebelling, even if we did it is dangerous to say anything but what is expected. We are too rich from trade, we are richer than we can explain, we are envied by outsiders who do not appreciate the extent and nature of our troubles. They have no idea how troubling it is not to know when and how you will be caught. One can never forget it here for long. Perhaps because of our difficulty with food, threats are always alive in our minds, ready to leap at us. No matter how much we eat, no matter what our dieticians do, no matter what chefs we import to make our food savory, we suffer from malnutrition. We are fat and undernourished. The stupid are luckiest for they do not know they lack. The wise suffer most. There are a few who make a virtue of fasting and austerity; they say they are at peace; but I have never seen one look me in the eye when he said it. They look up at the sky or out to sea, and talk of love and peace and truth. Their strict diet makes their skin rough and scaly, their nails thicken and turn blue, their eyes become vague. They do not bother people much, nobody cares enough to restrain them. We keep on trying to improve our diet, we hold conferences and symposiums on the subject, it has become the subject of our most intensive experiments.

An earthquake caught me. It was quite a severe one, but I don't think it was as bad as the one that killed a third of our people when I was a young man. I was nimble and quick, and came through with nothing worse than a few bruises. In that one, great chasms opened, whereas the hole I am in now is not more than twenty feet deep. This one caught me just as I was coming out of the telephone building.

I had gone there to argue about a mistake on my bill. They had charged me for two long distance calls to Rome the month before. Absurd! Neither my wife nor I would dream of talking with anyone at such a distance. Overseas connections are notoriously unreliable, even with our communications system, our greatest civic pride—we would be able to talk with the moon if there were anyone there to talk to. Neither my wife nor I have any friends in Rome. It is true that I have corresponded for years with a numismatist in Rome—I collect old coins—but our com-

mon interest conceals the profoundest disagreement. I would do much to avoid meeting him in person, should he ever propose such a thing, as he has never shown the slightest sign of doing. To him ancient coins are objects of trade, their value varies from time to time but at any given moment it can be agreed upon, they are commodities. I would never expose to him the slightest edge of what they mean to me, of the speculations they excite in me. (A drachma which was worth many loaves of bread two thousand years ago is now worth nothing—except to a few anti-quarians like me, to whom it means a hundred times more than it did then. I looked at it unable to comprehend. If I did com-prehend, it would cease to be worth even a slice of bread to me. Do all those to whom it is worthless understand something that eludes me?) The numismatist and I share no language but the code of catalogues. We would not be able to talk to one another face to face, much less over the telephone. And the length of time these supposed long distance calls went on! One lasted an hour, the other nearly as long. I went to the telephone building to complain, politely of course, but firmly. They had to prove that my wife or I had made such preposterous calls. They said they would find out who it was the call had gone to—both calls to Rome were to the same number. I saw they did not believe me. I knew that legally they could not force me to pay if I denied responsibility. All the same, I was not feeling cleanly victorious as I left the building.

I was thrown to the street. I remember seeing the façade of the telephone building topple out toward me in one slab, then crack and buckle. When I came to my senses, I was in this hole. There was still dust in the air. I stood up, coughed, and wiped my eyes. The rubble at the bottom of the hole was all small stuff, no boulders or big chunks of material. There was a good deal of light coming down the chimney above me; it could not be late in the day; I had not been out long. I got up, stiff, creak-ing a bit, but uninjured, and I inspected the hole I was in. It was shaped like a funnel, big end down. The bottom of the chimney was at least five feet above my head, and the chimney itself ap-peared to extend up another eight or nine feet. The walls of the

cone I was in were of chunks of rock propped on one another. To remove one would risk making the whole haphazard structure fall in. I yelled. There was no answer, no answering noise, no noise of any sort. I whistled and shouted. The echo hurt my ears. I collapsed. At that moment I realized I did not want to get out. Not till light returned next morning did my forces rally.

Hunger drove me. At first, choked with dust, I suffered badly from thirst. But during the night it rained, and enough rain water dripped down for me to refresh my mouth and rinse my face. Then hunger pulled me up from my lethargy. I determined not to die alone. I would get out if I could.

But how? I yelled for help, there was no response. Once I got up into the chimney above me, I would be able to brace myself, back and knees like a mountain climber, and inch my way up. But getting myself into the chimney, that was the problem. The walls sloped back, only an experienced mountain climber with equipment would even try to climb them. There was nothing else to be done—I would have to build a pile of rocks to climb up on so that I could insert my body into the chimney. I tried to pull one of the boulders free but it was lodged too tight to budge. Another was as tight; another, another. Then one moved a little as I pulled and pushed. But when it moved, there were ominous shiftings in the wall above me, and a stone as big as my fist sprang out from just over my head, narrowly missing me. All the other boulders I could reach were wedged tight. I pulled at the loose one again. Suddenly half of it broke free and I fell on my back. It was of rotten stone, it crumbled, I had gained nothing.

I complained. If there had been anyone to hear me I would never have been so self-indulgent as to complain. But I was alone and not quite hopeless. I stood with legs spread, raised my fists, and spoke in a loud clear voice as though I were addressing myself to someone who would have understood me if he had heard me. "I have not been unwilling to be destroyed, I know how to resign myself to destruction. But why must I exhaust myself laboring to return to a world which may be in ruins and where, if it is still standing, I will be even more fearful than I was

before?" As I finished speaking, a fair-sized piece of stone fell from the wall high above me onto the floor of the hole. I waited to see what else might happen. Nothing happened. I complained again, watchfully. Another rock fell. The sound of my voice was dislodging some of the upper rocks without causing the whole pile to shatter down onto me. I sang, hummed, yelled, whooped, wailed: nothing happened. I went back to complaining, in a loud clear voice and complete, rather formal sentences. Another rock fell. One of the fallen boulders was too big for me to lift, but I could roll it into place. They were of irregular shapes and would not pile easily and securely. I was going to need a great many pieces of stone of this size. I am healthy and my gardening has kept me in good condition; nevertheless, I felt myself weaker after each complaining and rock-piling episode and had to rest for longer and longer periods. My predicament did not allow me to complain mildly. I am reserved by temperament, I tried to hold back both out of inclination and out of a desire to save my strength, but I found that I could give each complaint nothing less than everything I could muster.

I did not dare complain during the night, for fear a dislodged stone would fall on me. In the daytime I watched when I talked, I could jump to one side in time. I kept trying to figure out which of my words had the power to dislodge the rocks; it must have something to do with vibrations, wave lengths.

In our city we are quite experimental. Even a private citizen like myself is infected with the spirit of experiment. I live off the income from my inheritance. My wife and I love gardening above everything. Our few friends are scattered throughout the city, we make a point of being strangers to our neighbors. Our rock garden, at the edge of a cliff overlooking a northern cove, is quite remarkable. I am sure it would win prizes and be much visited if we were interested in that sort of thing. But our friends respect our wish to keep our garden private, and our neighbors, whose gardens are severely arranged and have swept paths, do not notice the perfection of our succulents (which they think of as being no more than cliff plants anyway) nor do they see any order in the way our paths and steppingstones adapt themselves

to the terrain. My wife and I have little use for most of what our city gets excited about, we are inclined to scorn prizes and fashion, I had thought I was equally indifferent to the fervor for experimentation. Now, in this hole, I have learned better.

The second night, unable to sleep well because of the discomfort of the floor, I planned experiments to try the next day. I have never heard of anyone who was in a hole like mine. Perhaps these conditions are unique. There are plenty of holes into which our citizens have been known to have fallen; sometimes they were rescued, sometimes they died before they could be got out, often no doubt they just disappeared from sight as I have done. Perhaps no one else discovered how to dislodge boulders as I did. There might be something exceptional about my voice, though no one has ever commented on it. There certainly is nothing odd about my words. They are just ordinary words used with care. Still, though I am not slovenly in my use of words, neither am I a poet. I must not let this opportunity to experiment slip from me, even though, since I need all the physical strength I have to pile the rocks up, I must work fast before I give out. During the night I planned a series of speeches to try out.

I prayed. When our city was founded, many churches were built, strong, handsome, stone structures. Our city had originally been built with walls, to withstand the assaults of pirates. To be sure, the pirates were suppressed two centuries ago, and the city grew far beyond the walls, which are now visited by tourists as museum pieces. But our churches, the best ones, which look like and once served as fortresses, have been kept in good repair, services are held in them, the choir schools still function at public expense. I knew many prayers, having been a boy soprano for a few years till my voice cracked. Neither the prayers I recollected nor the ones I made up worked to dislodge the stones.

I delivered the patriotic speeches memorized by every schoolchild—the salute to the flag, a constitution day address, the funeral oration which had been delivered by our first prime minister after the revolution had established parliamentary government, our oath of allegiance. None of them worked.

I gave an exact and full history of how I came to be where I

was. I described my condition with scientific accuracy and offered every reasonable hypothesis about why I was doing what I was doing. Nothing happened.

I recited a poem, nursery rhymes, a folk tale, the prologue of our constitution. I counted to twenty in Latin, I recited as many of Euclid's axioms as I could recall. No result.

I recited a speech from a play I had acted in when I was in college. Actually I saved this till the last because the speech had become more than the character's words for me, it had come to say what I meant or at least I had come to mean what it said. The part was a small one. I was one of the lesser court gentlemen. At a crucial moment the king gives me a vital message, his throne depends on its delivery. Halfway to the nobleman to whom I am supposed to deliver it, I decide not to, and then the playwright gives me my only important speech, a soliloquy, the great speech of the play. I have no good political reason not to deliver the message, nothing but good will befall me if I do deliver it, I have never before done such a thing as I am now doing. The longer I try to account to myself and the audience for what I am doing, the stranger my action appears; I labor to find the right words, for my court language is insufficient. Twice in the history of our city this play, one of our classics, has been proscribed because of this speech, which cannot be cut out of the play, being its keystone. I recite it now in my hole. A boulder is dislodged all right, but it almost hits me. It is too large for me to lift to the top of the pile I have made. Worst, it comes from the mouth of the chimney above, enlarging it, so that now I must build up my pile even higher than before, in order to be able to brace myself in the chimney and work my way out.

I have to use our language in my own way, I have to speak for myself.

"I am in a hole, I want to get out. I don't know what I shall find when I make my way back into the city. I long to see my wife; if she is still alive and well, she will care for me while I recuperate; if she is injured, I will do what I can for her. These stones are heavy; after I put one up onto the pile, my muscles do not leave off trembling until I raise my voice to talk another rock down from the jumble about me and then hoist it into place;

each time after such effort, the trembling penetrates into me
deeper. I fear I will not have strength to work my way up the
chimney once I have got myself into it. I want to cry, but I
must save my strength for words. I do not know why I am here,
I did nothing to deserve being thrown down here alone and
abandoned."

So, the rocks fall.

What would happen if I did not pretend someone is listening
to what I say? I know of course that no one hears my voice, but
I speak as though I were being listened to. It must be that which
gives my voice the right wave lengths to dislodge the stones. It
obviously is neither the words themselves nor their arrangement;
my experiments have removed those possibilities. In the interests
of exact knowledge I should complain without audience. I know
well enough that I have no audience, not a sound from outside
has reached me. But I cannot imagine doing anything so un-
reasonable as to complain without any audience at all, even
though that is what I am in fact doing. Besides, suppose when
I did that, all the rocks should fall in on me at once? If I had
more strength I would take the risk, I would try to imagine my-
self as I am. Meanwhile, I had better get on with my complaining
while I still have strength and time.

a
pedestrian
accident

Robert Coover

PAUL stepped off the curb and got hit by a truck. He didn't
know what it was that hit him at first, but now, here on his back,
under the truck, there could be no doubt. Is it me? he wondered.
Have I walked the earth and come here?

Just as he was struck, and while still tumbling in front of the
truck and then under the wheels, in a kind of funhouse gambado
of pain and terror, he had thought: this has happened before.
His neck had sprung, there was a sudden flash of light and a
blaze roaring up in the back of his head. The hot—almost fragrant
—pain: that was new. It was the *place* he felt he'd returned to.

He lay perpendicular to the length of the truck, under the
trailer, just to the rear of the truck's second of three sets of wheels.
All of him was under the truck but his head and shoulders.
Maybe I'm being born again, he reasoned. He stared straight up,
past the side of the truck, toward the sky, pale blue and cloudless.
The tops of skyscrapers closed toward the center of his vision;
now that he thought about it, he realized it was the first time in
years he had looked up at them, and they seemed inclined to fall.
The old illusion; one of them anyway. The truck was red with
white letters, but his severe angle of vision up the side kept him
from being able to read the letters. A capital "K," he could see
that—and a number, yes, it seemed to be a "14." He smiled in-
wardly at the irony, for he had a private fascination with num-
bers: fourteen! He thought he remembered having had a green
light, but it didn't really matter. No way to prove it. It would

have changed by now, in any case. The thought, obscurely, troubled him.

"Crazy goddamn fool he just walk right out in fronta me no respect just burstin for a bustin!"

The voice, familiar somehow, guttural, yet falsetto, came from above and to his right. People were gathering to stare down at him, shaking their heads. He felt like one chosen. He tried to turn his head toward the voice, but his neck flashed hot again. Things were bad. Better just to lie still, take no chances. Anyway, he saw now, just in the corner of his eye, the cab of the truck, red like the trailer, and poking out its window, the large head of the truckdriver, wagging in the sunshine. The driver wore a small tweed cap—too small, in fact: it sat just on top of his head.

"Boy I seen punchies in my sweet time but this cookie takes the cake God bless the laboring classes I say and preserve us from the humble freak!"

The truckdriver spoke with broad gestures, bulbous eyes rolling, runty body thrusting itself in and out of the cab window, little hands flying wildly about. Paul worried still about the light. It was important, yet how could he ever know? The world was an ephemeral place, it could get away from you in a minute. The driver had a bent red nose and coarse reddish hair that stuck out like straw. A hard shiny chin, too, like a mirror image of the hooked nose. Paul's eyes wearied of the strain, and he had to stop looking.

"Listen lays and gentmens I'm a good Christian by Judy a decent hardworkin fambly man earnin a honest wage and got a dear little woman and seven yearnin younguns all my own seed *a responsible man* and goddamn that boy what he do but walk right into me and my poor ole truck!"

On some faces Paul saw compassion, or at least a neutral curiosity, an idle amusement, but on most he saw reproach. There were those who winced on witnessing his state and seemed to understand, but there were others—a majority—who jeered.

"He asked for it if you ask me!"

"It's the idler plays the fool and the workingman's to hang for it!"

"Shouldn't allow his kind out to walk the streets!"

"What is the use of running when you are on the wrong road?"

It worsened. Their shouts grew louder and ran together. There were orations and the waving of flags. Paul was wondering: had he been carrying anything? No, no. He had only—*wait!* a book? Very likely, but . . . ah well. Perhaps he was carrying it still. There was no feeling in his fingers.

The people were around him like flies, grievances were being aired, sides taken, and there might have been a brawl, but a policeman arrived and broke it up. "All right, everybody! Stand back, please!" he shouted. "Give this man some air! Can't you see he's been injured?"

At last, Paul thought. He relaxed. For a moment, he'd felt himself in a strange and hostile country, but now he felt at home again. He even began to believe he might survive. Though really: had he ever doubted it?

"Everybody back, *back!*" The policeman was effective. The crowd grew quiet, and by the sound of their sullen shuffling, Paul guessed they were backing off. Not that he got more or less air by it, but he felt relieved just the same. "Now," said the policeman, gently but firmly, "what has happened here?"

And with that it all started up again, same as before, the clamor, the outrage, the arguments, the learned quotations, but louder and more discordant than ever. I'm hurt, Paul said. No one heard. The policeman cried out for order, and slowly, with his shouts, with his nightstick, with his threats, he reduced them again to silence.

One lone voice hung at the end: "—for the last time, Mister, *stop goosing me!*" Everybody laughed, released.

"Stop goosing her, sir!" the policeman commanded with his chin thrust firmly forward, and everybody laughed again.

Paul almost laughed, but he couldn't quite. Besides, he'd just, with that, got the picture, and given his condition, it was not a funny one. He opened his eyes and there was the policeman bent down over him. He had a notebook in his hand.

"Now, tell me, son, what happened here?" The policeman's face was thin and pale, like a student's, and he wore a trim little

tuft of black moustache under the pinched peak of his nose.

I've just been hit, Paul explained, by this truck, and then he realized that he probably didn't say it at all, that speech was an art no longer his. He cast his eyes indicatively toward the cab of the truck.

"Listen, I asked you what happened here! Cat got your tongue, young man?"

"Crazy goddamn fool he just walk right out in fronta me no respect just burstin for a bustin!"

The policeman remained crouched over Paul, but turned his head up to look at the truckdriver. The policeman wore a brilliant blue uniform with large brass buttons. And gold epaulettes.

"Boy I seen punchies in my sweet time but this cookie takes the cake God bless the laboring classes I say and preserve us from the humble freak!"

The policeman looked down at Paul, then back at the truckdriver. "I know about truckdrivers," Paul heard him say.

"Listen lays and gentmens I'm a good Christian by Judy a decent hardworkin fambly man earnin a honest wage and got a dear little woman and seven yearnin younguns all my own seed *a responsible man* and goddamn that boy what he do but walk right into me and my poor ole trike. Truck, I mean."

There was a loose tittering from the crowd, but the policeman's frown and raised stick contained it. "What's your name, lad?" he asked, turning back to Paul. At first, the policeman smiled, he knew who truckdrivers were and he knew who Pauls were, and there was a salvation of sorts in that smile, but gradually it faded. "Come, come, boy! Don't be afraid!" He winked, nudged him gently. "We're here to help you."

Paul, Paul replied. But, no, no doubt about it, it was jammed up in there and he wasn't getting it out.

"Well, if you won't help me, I can't help you," the policeman said pettishly and tilted his nose up. "Anybody here know this man?" he called out to the crowd.

Again a roar, a threatening tumult of words and sounds, shouts back and forth. It was hard to know if none knew him or if they all did. But then one voice, belted out above the others, came

through: "O God in heaven! It's Amory! *Amory Westerman!*" The voice, a woman's hysterical by the sound of it, drew near. "Amory! What . . . *what* have they *done* to you?"

Paul understood. It was not a mistake. He was astonished by his own acumen.

"Do you know this young man?" the policeman asked, lifting his notebook.

"What? Know him? Did Sarah know Abraham? Did Eve know Cain?"

The policeman cleared his throat uneasily. "Adam," he corrected softly.

"You know who you know, I know who I know," the woman said, and let fly with a low throaty snigger. The crowd responded with a belly laugh.

"But this young man—!" the policeman insisted, flustered.

"Who, you and Amory?" the woman cried. "I can't believe it!" The crowd laughed and the policeman bit his lip. "Amory! What new persecutions are these?" She billowed out above him: old, maybe even seventy, fat and bosomy, pasty-faced with thick red rouges, head haloed by ringlets of sparse orangish hair. "My poor Amory!" And down she came on him. Paul tried to duck, got only a hot flash in his neck for it. Her breath reeked of cheap gin. Help, said Paul.

"Hold, madame! Stop!" the policeman cried, tugging at the woman's sleeve. She stood, threw up her arms before her face, staggered backwards. What more she did, Paul couldn't see, for his view of her face was largely blocked by the bulge of her breasts and belly. There were laughs, though. "Everything in order here," grumped the policeman, tapping his notebook. "Now, what's your name, please . . . uh . . . miss, madame?"

"My name?" She twirled gracelessly on one dropsied ankle and cried to the crowd: "*Shall I tell?*"

"Tell! Tell! Tell!" shouted the spectators, clapping rhythmically. Paul let himself be absorbed by it; there was, after all, nothing else to do.

The policeman, rapping a pencil against the blue notebook to the rhythm of the chant, leaned down over Paul and whispered: ("I think we've got them on our side now!")

Paul, his gaze floating giddily up past the thin white face of the police officer and the red side of the truck into the horizonless blue haze above, wondered if alliance were really the key to it all. What *am* I without them? Could I even die? Suddenly, the whole world seemed to tip: his feet dropped and his head rose. Beneath him the red machine shot grease and muck, the host rioted above his head, the earth pushed him from behind, and out front the skyscrapers pointed, like so many insensate fingers, the path he must walk to oblivion. He squeezed shut his eyes to set right the world again—he was afraid he would slide down beneath the truck to disappear from sight forever.

"*My name*—*!*" bellowed the woman, and the crowd hushed, tittering softly. Paul opened his eyes. He was on his back again. The policeman stood over him, mouth agape, pencil poised. The woman's puffy face was sequined with sweat. Paul wondered what she'd been doing while he wasn't watching. "My name, officer, is Grundy."

"I beg your pardon?" The policeman, when nervous, had a way of nibbling his moustache with his lowers.

"Mrs. Grundy, dear boy, who did you think I was?" She patted the policeman's thin cheek, tweaked his nose. "But you can call me Charity, handsome!" The policeman blushed. She twiddled her index finger in his little moustache. "Kootchy-kootchy-koo!" There was a roar of laughter from the crowd.

The policeman sneezed. "Please!" he protested.

Mrs. Grundy curtsied and stooped to unzip the officer's fly. "Hello! Anybody home!"

"*Stop that!*" squeaked the policeman through the thunderous laughter and applause. Strange, thought Paul, how much I'm enjoying this.

"Come out, come out, wherever you are!"

"*The story!*" the policeman insisted through the tumult.

"Story? What—?"

"This young fellow," said the policeman, pointing with his pencil. He zipped up, blew his nose. "Mr., uh, Mr. Westerman . . . you said—"

"Mr. *Who?*" The woman shook her jowls, perplexed. She frowned down at Paul, then brightened. "Oh yes! Amory!" She

paled, seemed to sicken. Paul, if he could've, would've smiled. "Good God!" she rasped, as though appalled at what she saw. Then, once more, she took an operatic grip on her breasts and staggered back a step. "O mortality! O fatal mischief! Done in! A noble man lies stark and stiff! Delenda est Carthago! *Sic transit glans mundi!*"

Gloria, corrected Paul. No, leave it.

"Squashed like a lousy bug!" she cried. "And at the height of his potency!"

"Now, wait a minute!" the policeman protested.

"The final curtain! The last farewell! The journey's end! Over the hill! The last muster!" Each phrase was answered by a happy shout from the mob. "Across the river! The way of all flesh! The last roundup!" She sobbed, then ballooned down on him again, tweaked his ear and whispered: ("How's Charity's weetsie snotkins, enh? Him fall down and bump his little putsy? Mumsy kiss and make well!") And she let him have it on the—well, sort of on the left side of the nose, left cheek, and part of his left eye: one wet enveloping sour blubbering kiss, and this time, sorrily, the policeman did not intervene. He was busy taking notes. Officer, said Paul.

"Hmmm," the policeman muttered, and wrote. "G - R - U - N - ah, ahem, Grundig, Grundig - D, yes, D - I - G. Now what did you—?"

The woman labored clumsily to her feet, plodded over behind the policeman, and squinted over his shoulder at the notes he was taking. "That's a 'Y' there, buster, a 'Y.'" She jabbed a stubby ruby-tipped finger at the notebook.

"Grundigy?" asked the policeman in disbelief. "What kind of a name is that?"

"No, no!" the old woman whined, her grand manner flung to the winds. "Grundy! Grundy! Without the '-ig,' don't you see? You take off your—"

"Oh, *Grundy!* Now I have it!" The policeman scrubbed the back end of his pencil in the notebook. "Darned eraser. About shot." The paper tore. He looked up irritably. "Can't we just make it Grundig?"

"Grundy," said the woman coldly.

The policeman ripped the page out of his notebook, rumpled it up angrily, and hurled it to the street. "All right, gosh damn it all!" he cried in a rage, scribbling: "Grundy. I have it. Now get on with it, lady!"

"Officer!" sniffed Mrs. Grundy, clasping a handkerchief to her throat. "Remember your place, or I shall have to speak to your superior!" The policeman shrank, blanched, nibbled his lip.

Paul knew what would come. He could read these two like a book. *I'm* the strange one, he thought. He wanted to watch their faces, but his streetlevel view gave him at best a perspective on their underchins. It was their crotches that were prominent. Butts and bellies: the squashed bug's-eye view. And that was strange, too: that he wanted to watch their faces.

The policeman was begging for mercy, wringing his pale hands. There were faint hissing sounds, wriggling out of the crowd like serpents. "Cut the shit, mac," Charity Grundy said finally, "you're overdoing it." The officer chewed his moustache, stared down at his notebook, abashed. "You wanna know who this poor clown is, right?" The policeman nodded. "Okay, are you ready?" She clasped her bosom again and the crowd grew silent. The police officer held his notebook up, the pencil poised. Mrs. Grundy snuffled, looked down at Paul, winced, turned away and wept. "Officer!" she gasped. *"He was my lover!"*

Halloos and cheers from the crowd, passing to laughter. The policeman started to smile, blinking down at Mrs. Grundy's body, but with a twitch of his moustache, he suppressed it.

"We met . . . just one year ago today. O fateful hour!" She smiled bravely, brushing back a tear, her lower lip quivering. Once, her hands clenched woefully before her face, she winked down at Paul. The wink nearly convinced him. Maybe I'm him after all. Why not? "He was selling seachests, door to door. I can see him now as he was then—" She paused to look down at him as he was now, and wrinkles of revulsion swept over her face. Somehow this brought laughter. She looked away, puckered her mouth and bugged her eyes, shook one hand limply from the wrist. The crowd was really with her.

"Mrs. Grundy," the officer whispered, "please . . ."

"Yes, there he was, chapfallen and misused, orphaned by the rapacious world, yet pure and undefiled, there: there at my door!" With her baggy arm, flung out, quavering, she indicated the door. "Bent nearly double under his impossible seachest, perspiration illuminating his manly brow, wounding his eyes, wrinkling his undershirt—"

"Careful!" cautioned the policeman nervously, glancing up from his notes. He must have filled twenty or thirty pages by now.

"In short, my heart went out to him!" Gesture of heart going out. "And though—alas!—my need for seachests was limited—"

The spectators somehow discovered something amusing in this and tittered knowingly. Mainly in the way she said it, he supposed. Her story in truth did not bother Paul so much as his own fascination with it. He knew where it would lead, but it didn't matter. In fact, maybe that *was* what fascinated him.

"—I invited him in. Put down that horrid seachest, dear boy, and come in here, I cried, come in to your warm and obedient Charity, love, come in for a cup of tea, come in and rest, rest your pretty little shoulders, your pretty little back, your pretty little . . ." Mrs. Grundy paused, smiled with a faint arch of one eyebrow, and the crowd responded with another burst of laughter. "And it *was* pretty little, okay," she grumbled, and again they whooped, while she sniggered throatily.

How was it now? he wondered. In fact, he'd been wondering all along.

"And, well, officer, that's what he did, he *did* put down his seachest—alas! sad to tell, right on my unfortunate cat Rasputin, dozing there in the day's brief sun, God rest his soul, his (again, alas!) somewhat homaloidal soul!"

She had a great audience. They never failed her, nor did they now.

The policeman, who had finally squatted down to write on his knee, now stood and shouted for order. "Quiet! *Quiet!*" His moustache twitched. "Can't you see this is a serious matter?" He's the funny one, thought Paul. The crowd thought so, too, for the laughter mounted, then finally died away. "And . . . and then

what happened?" the policeman whispered. But they heard him anyway and screamed with delight, throwing up a new clamor in which could be distinguished several coarse paraphrases of the policeman's question. The officer's pale face flushed. He looked down at Paul with a brief commiserating smile, shrugged his shoulders, fluttering the epaulettes. Paul made a try at a never-mind gesture, but, he supposed, without bringing it off.

"What happened next, you ask, you naughty boy?" Mrs. Grundy shook and wriggled. Cheers and whistles. She cupped her plump hands under her breasts and hitched her abundant hips heavily to one side. "You don't understand," she told the crowd "I only wished to be a mother to the lad." Hoohahs and catcalls. "But I had failed to realize, in that fleeting tragic moment when he unburdened himself upon poor Rasputin, how I was wrenching his young and unsullied heart asunder! Oh yes, I know, I know—"

"This is the dumbest story I ever heard," interrupted the policeman finally, but Mrs. Grundy paid him no heed.

"I know I'm old and fat, that I've crossed the Grand Climacteric!" She winked at the crowd's yowls of laughter. "I know the fragrant flush of first flower is gone forever!" she cried, not letting a good thing go, pressing her wrinkled palms down over the soft swoop of her blimp-sized hips, peeking coyly over one plump shoulder at the shrieking crowd. The policeman stamped his foot, but no one noticed except Paul. "I know, I know—*yet:* somehow, face to face with little Charity, a primitive unnameable urgency welled up in his untaught loins, his pretty little—"

"*Stop it!*" cried the policeman, right on cue. "This has gone far enough!"

"And *you* ask what happened next? I shall tell you, officer! For why conceal the truth . . . from *you* of all people?" Though uneasy, the policeman seemed frankly pleased that she had put it this way. "Yes, without further discourse, he buried his pretty little head in my bosom—" (Paul felt a distressing sense of suffocation, though perhaps it had been with him all the while) "—and he tumbled me there, yes he did, there on the front porch alongside his seachest and my dying Rasputin, there in the sun-

light, before God, before the neighbors, before Mr. Dunlevy the mailman who is hard of hearing, before the children from down the block passing on their shiny little—"

"Crazy goddamn fool he just walk right out in fronta me no respect just burstin for a bustin!" said a familiar voice.

Mrs. Grundy's broad face, now streaked with tears and mottled with a tense pink flush, glowered. There was a long and difficult silence. Then she narrowed her eyes, smiled faintly, squared her shoulders, touched a handkerchief to her eye, plunged the handkerchief back down her bosom, and resumed: "—Before, in short, the whole itchy eyes-agog world, a coupling unequaled in the history of Western concupiscence!" Some vigorous applause, which she acknowledged. "Assaulted, but—yes, I confess it—assaulted, but *aglow*, I reminded him of—"

"Boy I seen punchies in my sweet time but this cookie takes the cake God bless the laboring classes I say and preserve us from the humble freak!"

Swiveling his wearying gaze hard right, Paul could see the truckdriver waggling his huge head at the crowd. Mrs. Grundy padded heavily over to him, the back of her thick neck reddening, swung her purse in a great swift arc, but the truckdriver recoiled into his cab, laughing with a taunting cackle. Then, almost in the same instant, he poked his red-beaked head out again, and rolling his eyes, said: "Listen lays and gentmens I'm a good Christian by Judy a decent hardworkin fambly man earnin a honest wage and got a dear little woman and seven yearnin younguns all my own seed *a responsible—*"

"*I'll responsible your ass!*" hollered Charity Grundy and let fly with her purse again, but once more the driver ducked nimbly inside, cackling obscenely. The crowd, taking sides, was more hysterical than ever. Cheers were raised and bets taken.

Again the driver's waggling head popped out: "*—man* and god—" he began, but this time Mrs. Grundy was waiting for him. Her great lumpish purse caught him square on his bent red nose —*ka*-RAACKK!—and the truckdriver slumped lifelessly over the door of his cab, his stubby little arms dangling limp, reaching just below the top of his head. As best Paul could tell, the tweed cap did not drop off, but since his eyes were cramped with

fatigue, he had to stop looking before the truckdriver's head ceased bobbing against the door.

Man and god! he thought. Of course! terrific! What did it mean? Nothing.

The policeman made futile little gestures of interference, but apparently had too much respect for Mrs. Grundy's purse to carry them out. That purse was big enough to hold a bowling ball, and maybe it did.

Mrs. Grundy, tongue dangling and panting furiously, clapped one hand over her heart and, with the handkerchief, fanned herself with the other. Paul saw sweat dripping down her legs. "And so—*fool*—I . . . I—*puf!*—I reminded him of . . . of the —*whee!* —the cup of tea!" she gasped. She paused, swallowed, mopped her brow, sucked in a deep lungful of air, and exhaled it slowly. She cleared her throat. "*And so I reminded him of the cup of tea!*" she roared with a grand sweep of one powerful arm, the old style recovered. There was a general smattering of complimentary applause, which Mrs. Grundy acknowledged with a short nod of her head. "We went inside. The air was heavy with expectation and the unmistakable aroma of catshit. One might almost be pleased that Rasputin had yielded up the spirit—"

"Now just stop it!" cried the policeman. "This is—"

"I poured some tea, we sang the now famous duet, '¡Ciérrate la bragueta! ¡La bragueta está cerrada!,' I danced for him, he—"

"Enough, I said!" screamed the policeman, his little moustache quivering with indignation. "This is absurd!"

You're warm, said Paul. But that's not quite it.

"Absurd?" cried Charity Grundy, aghast. "*Absurd?* You call my dancing *absurd?*"

"I . . . I didn't say—"

"Grotesque, perhaps, and yes, a bit awesome—but *absurd!*" She grabbed him by the lapels, lifting him off the ground. "What do you have against dancing, you worm? *What do you have against grace?*"

"P-please! Put me down!"

"Or is it, you don't believe I *can* dance?" She dropped him.

"N-No!" he squeaked, brushing himself off, straightening his epaulettes. "No! I—"

"Show him! Show him!" chanted the crowd.

The policeman spun on them. "Stop! In the name of the law!" They obeyed. "This man is injured. He may die. He needs help. It's no joking matter. I ask for your cooperation." He paused for effect. "That's better." The policeman stroked his moustache, preening a bit. "Now, ahem, is there a doctor present? A doctor, please?"

"Oh, officer, you're cute! You're *very* cute!" said Mrs. Grundy on a new tack. The crowd snickered. "*Is there a doctor present?*" she mimicked, "*a doctor, please?*"

"Now just cut it out!" the policeman ordered, glaring angrily across Paul's chest at Mrs. Grundy. "Gosh damn it now, you stop it this instant, or . . . or you'll see what'll happen!"

"Aww, you're *jealous!*" cried Mrs. Grundy. "And of poor little supine Rasputin! Amory, I mean." The spectators were in great spirits again, total rebellion threatening, and the police officer was at the end of his rope. "Well, *don't* be jealous, dear boy!" cooed Mrs. Grundy. "Charity tell you a weetsie bitty secret."

"*Stop!*" sobbed the policeman. Be careful where you step, said Paul below.

Mrs. Grundy leaned perilously out over Paul and got a grip on the policeman's ear. He winced, but no longer attempted escape. "That boy," she said, "*he humps terrible!*"

It carried out to the crowd and broke it up. It was her big line and she wambled about gloriously, her rouged mouth stretched in a flabby toothless grin, retrieving the pennies that people were pitching (Paul knew about them from being hit by them; one landed on his upper lip, stayed there, emitting that familiar dead smell common to pennies the world over), thrusting her chest forward to catch them in the cleft of her bosom. She shook and, shaking, jangled. She grabbed the policeman's hand and pulled him forward to share a bow with her. The policeman smiled awkwardly, twitching his moustache.

"You asked for a doctor," said an old but gentle voice.

The crowd noises subsided. Paul opened his eyes and discovered above him a stooped old man in a rumpled gray suit. His hair was shaggy and white, his face dry, lined with age. He wore rimless glasses, carried a black leather bag. He smiled down at

Paul, that easy smile of a man who comprehends and assuages pain, then looked back at the policeman. Inexplicably, a wave of terror shook Paul.

"You wanted a doctor," the old man repeated.

"Yes! *Yes!*" cried the policeman, almost in tears. "Oh, thank God!"

"I'd rather you thanked the profession," the doctor said. "Now what seems to be the problem?"

"Oh, doctor, it's awful!" The policeman twisted the notebook in his hands, fairly destroying it. "This man has been struck by this truck, or so it would appear, no one seems to know, it's all a terrible mystery, and there is a woman, but now I don't see—? and I'm not even sure of his name—"

"No matter," interrupted the doctor with a kindly nod of his old head, "who he is. He is a man and that, I assure you, is enough for me."

"Doctor, that's so good of you to say so!" wept the policeman.

I'm in trouble, thought Paul. Oh boy, I'm really in trouble.

"Well, now, let us just see," said the doctor, crouching down over Paul. He lifted Paul's eyelids with his thumb and peered intently at Paul's eyes; Paul, anxious to assist, rolled them from side to side. "Just relax, son," the doctor said. He opened his black bag, rummaged about in it, withdrew a flashlight. Paul was not sure exactly what the doctor did after that, but he seemed to be looking in his ears. I can't move my head, Paul told him, but the doctor only asked: "Why does he have a penny under his nose?" His manner was not such as to insist upon an answer, and he got none. Gently, expertly, he pried Paul's teeth apart, pinned his tongue down with a wooden depressor, and scrutinized his throat. Paul's head was on fire with pain. "Ahh, yes," he mumbled. "Hum, hum."

"How . . . how is he, Doctor?" stammered the policeman, his voice muted with dread and respect. "Will . . . will he . . . ?"

The doctor glared scornfully at the officer, then withdrew a stethoscope from his bag. He hooked it in his ears, slipped the disc inside Paul's shirt and listened intently, his old head inclined to one side like a bird listening for worms. Absolute silence now.

Paul could hear the doctor breathing, the policeman whimpering softly. He had the vague impression that the doctor tapped his chest a time or two, but if so, he didn't feel it. His head felt better with his mouth closed. "Hmmm," said the doctor gravely, "yes . . ."

"Oh, please! What *is* it, Doctor?" the policeman cried.

"What is it? *What is it?*" shouted the doctor in a sudden burst of rage. "I'll tell you *what is it!*" He sprang to his feet, nimble for an old man. "I cannot examine this patient while you're hovering over my shoulder and mewling like a goddamn schoolboy, *that's* what *is* it!"

"B-but I only—" stammered the officer, staggering backwards.

"And how do you expect me to examine a man half buried under a damned truck?" The doctor was in a terrible temper.

"But I—"

"Damn it! I'll but-I you, you idiot, if you don't remove this truck from the scene so that I can determine the true gravity of this man's injuries! *Have I made myself clear?*"

"Y-yes! But . . . but wh-what am I to *do?*" wept the police officer, hands clenched before his mouth. "I'm only a simple policeman, Doctor, doing my duty before God and count—"

"Simple, you said it!" barked the doctor. "I *told* you what to do, you God-and-cunt simpleton—*now get moving!*"

God and cunt! Did it again, thought Paul. Now what?

The policeman, chewing wretchedly on the corners of his notebook, stared first at Paul, then at the truck, at the crowd, back at the truck. Paul felt fairly certain now that the letter following the "K" on the truck's side was an "I." "Shall I . . . shall I pull him out from under—?" the officer began tentatively, thin chin aquiver.

"*Good God, no!*" stormed the doctor, stamping his foot. "This man may have a broken neck! Moving him would *kill* him, don't you see that, you sniveling birdbrain? Now, goddamn it, wipe your wretched nose and go wake up your—your accomplice up there, *and I mean right now!* Tell him to back his truck *off* this poor devil!"

"B-back it off—! But . . . but he'd have to run *over* him again! He—"

"Don't by God run-over-him-again *me*, you blackshirt hireling, *or I'll have your badge!*" screamed the doctor, brandishing his stethoscope.

The policeman hesitated but a moment to glance down at Paul's body, then turned and ran to the front of the truck. "Hey! Come on, you!" He whacked the driver on the head with his nightstick. Hollow *thunk!* "Up and at 'em!"

"—DAM THAT BOY WHAT," cried the truckdriver, rearing up wildly and fluttering his head as though lost, "HE DO BUT WALK RIGHT INTO ME AND MY POOR OLE TRICK! TRUCK, I MEAN!" The crowd laughed again, first time in a long time, but the doctor stamped his foot and they quieted right down.

"Now, start up that engine, you, right now! I mean it!" ordered the policeman, stroking his moustache. He was getting a little of his old spit and polish back. He slapped the nightstick in his palm two or three times.

Paul felt the pavement under his back quake as the truckdriver started the motor. The white letters above him joggled in their red fields like butterflies. Beyond, the sky's blue had deepened, but white clouds now flowered in it. The skyscrapers had grayed, as though withdrawing information.

The truck's noise smothered the voices, but Paul did overhear the doctor and the policeman occasionally, the doctor ranting, the policeman imploring, something about mass and weight and vectors and direction. It was finally decided to go forward, since there were two sets of wheels up front and only one to the rear (a decent kind of humanism maintaining, after all, thought Paul), but the truckdriver apparently misunderstood, because he backed up anyway, and the middle set of wheels rolled up on top of Paul.

"Stop! STOP!" shrieked the police officer, and the truck motor coughed and died. "I ordered you to go *forward*, you pighead, not backward!"

The driver popped his head out the window, bulged his ping-pong-ball eyes at the policeman, then waggled his tiny hands in his ears and brayed. The officer took a fast practiced swing at the driver's big head (epaulettes, or no, he had a skill or two),

but the driver deftly dodged it. He clapped his runty hands and bobbed back inside the cab.

"What oh *what* shall we ever do *now?*" wailed the officer. The doctor scowled at him with undisguised disgust. Paul felt like he was strangling, but he could locate no specific pain past his neck. "Dear lord above! There's wheels on each side of him and wheels in the middle!"

"Capital!" the doctor snorted. "Figure that out by yourself, or somebody help you?"

"You're making fun," whimpered the officer.

"AND YOU'RE MURDERING THIS MAN!" bellowed the doctor.

The police officer uttered a short anxious cry, then raced to the front of the truck again. Hostility welling in the crowd, Paul could hear it. "Okay, okay!" cried the officer. "Back up or go forward, *please*, I don't care, but hurry! HURRY!"

The motor started up again, there was a jarring grind of gears abrading, then slowly slowly slowly the middle set of wheels backed down off Paul's body. There was a brief tense interim before the next set climbed up on him, hesitated as a ferris wheel hesitates at the top of its ambit, then sank down off him.

Some time passed.

He opened his eyes.

The truck had backed away, out of sight, out of Paul's limited range of sight anyway. His eyelids weighed closed. He remembered the doctor being huddled over him, shreds of his clothing being peeled away.

Much later, or perhaps not, he opened his eyes once more. The doctor and the policeman were standing over him, some other people too, people he didn't recognize, though he felt somehow he ought to know them. Mrs. Grundy, she was there; in fact, it looked for all the world as though she had set up a ticket booth and was charging admission. Some of the people were holding little children up to see, warm faces, tender, compassionate; more or less. Newsmen were taking his picture. "You'll be famous," one of them said.

"His goddamn body is like a mulligan stew," the doctor was telling a reporter.

The policeman shook his head. He was a bit green. "Do you think—?"

"Do I think what?" the doctor asked. Then he laughed, a thin raking old man's laugh. "You mean, do I think he's going to *die?*" He laughed again. "Good God, man, you can see for yourself! There's nothing left of him, he's a goddamn gallimaufry, and hardly an appetizing one at that!" He dipped his fingers into Paul, licked them, grimaced. "Fool"

"I think we should get a blanket for him," the policeman said weakly.

"Of course, you should!" snapped the doctor, wiping his stained hands on a small white towel he had brought out of his black bag. He peered down through his rimless spectacles at Paul, smiled. "Still there, eh?" He squatted beside him. "I'm sorry, son. There's not a damn thing I can do. Well, yes, I suppose I can take this penny off your lip. You've little use for it, eh?" He laughed softly. "Now, let's see, there's no function for it, is there? No, no, there it is." The doctor started to pitch it away, then pocketed it instead. The eyes, don't they use them for the eyes? "Well, that's better, I'm sure. But let's be honest: it doesn't get to the real problem, does it?" Paul's lip tickled where the penny had been. "No, I'm of all too little use to you there, boy. I can't even prescribe a soporific platitude. Leave that to the goddamn priests, eh? Hee hee hee! Oops, sorry, son! Would you like a priest?"

No thanks, said Paul.

"Can't get it out, eh?" The doctor probed Paul's neck. "Hmmm. No, obviously not." He shrugged. "Just as well. What could you possibly have to say, eh?" He chuckled drily, then looked up at the policeman who still had not left to search out a blanket. "Don't just stand there, man! Get this lad a priest!" The police officer, clutching his mouth, hurried away, out of Paul's eye-reach. "I know it's not easy to accept death," the doctor was saying. He finished wiping his hands, tossed the towel into his black bag, snapped the bag shut. "We all struggle against it, boy, it's part and parcel of being alive, this brawl, this meaningless gutterfight with death. In fact, let me tell you, son, it's *all* there is to life." He wagged his finger in punctuation, and

ended by pressing the tip of it to Paul's nose. "That the secret, *that's* my happy paregoric! Hee hee hee!"

KI, thought Paul. KI and 14. What could it have been? Never know now. One of those things.

"But death begets life, there's *that*, my boy, and don't you ever forget it! Survival and murder are synonyms, son, first flaw of the universe! Hee hee h—oh! Sorry, son! No time for puns! Forget I said it!"

It's okay, said Paul. Listening to the doctor had at least made him forget the tickle on his lip and it was gone.

"New life burgeons out of rot, new mouths consume old organisms, father dies at orgasm mother dies at birth, only old Dame Mass with her twin dugs of Stuff and Tickle persists, suffering her long slow split into pure light and pure carbon! Hee hee hee! A tender thought! Don't you agree, lad?" The doctor gazed off into space, happily contemplating the process.

I tell you what, said Paul. Let's forget it.

Just then, the policeman returned with a big quilted comforter, and he and the doctor spread it gently over Paul's body, leaving only his face exposed. The people pressed closer to watch.

"Back! *Back!*" shouted the policeman. "Have you no respect for the dying? *Back, I say!*"

"Oh, come now," chided the doctor. "Let them watch if they want to. It hardly matters to this poor fellow, and even if it does, it can't matter for much longer. And it will help keep the flies off him."

"Well, doctor, if you think . . ." His voice faded away. Paul closed his eyes.

As he lay there among the curious, several odd questions plagued Paul's mind. He knew there was no point to them, but he couldn't rid himself of them. The book, for example: did he have a book? And if he did, what book, and what had happened to it? And what about the stoplight, that lost increment of what men call history, why had no one brought up the matter of the stoplight? And pure carbon he could understand, but as for light: what could its purity consist of? KI. 14. That impression that it had happened before. Yes, these were mysteries, all right. His head ached from them.

People approached Paul from time to time to look under the blanket. Some only peeked, then turned away, while others stayed to poke around, dip their hands in the mutilations. There seemed to be more interest in them now that they were covered. There were some arguments and some occasional horseplay, but the doctor and policeman kept things from getting out of hand. If someone arrogantly ventured a Latin phrase, the doctor always put him down with some toilet-wall barbarism; on the other hand, he reserved his purest, most mellifluous toponymy for small children and young girls. He made several medical appointments with the latter. The police officer, though queasy, stayed nearby. Once, when Paul happened to open his eyes after having had them closed some while, the policeman smiled warmly down on him and said: "Don't worry, good fellow. I'm still here. Take it as easy as you can. I'll be here to the very end. You can count on me." Bullshit, thought Paul, though not ungratefully, and he thought he remembered hearing the doctor echo him as he fell off to sleep.

When he awoke, the streets were empty. They had all wearied of it, as he had known they would. It had clouded over, the sky had darkened, it was probably night, and it had begun to rain lightly. He could now see the truck clearly, off to his left. Must have been people in the way before.

MAGIC KISS LIPSTICK

IN

14

DIFFERENT SHADES

Never would have guessed. Only in true life could such things happen.

When he glanced to his right, he was surprised to find an old man sitting near him. Priest, no doubt. He had come after all . . . black hat, long grayish beard, sitting in the puddles now forming in the street, legs crossed. Go on, said Paul, don't suffer on my account, don't wait for me, but the old man remained,

silent, drawn, rain glistening on his hat, face, beard, clothes: prosopopoeia of patience. The priest. Yet, something about the clothes: well, they were in rags. Pieced together and hanging in tatters. The hat, too, now that he noticed. At short intervals, the old man's head would nod, his eyes would cross, his body would tip, he would catch himself with a start, grunt, glance suspiciously about him, then back down at Paul, would finally relax again and recommence the cycle.

Paul's eyes wearied, especially with the rain splashing into them, so he let them fall closed once more. But he began suffering discomforting visions of the old priest, so he opened them again, squinted off to the left, toward the truck. A small dog, wiry and yellow, padded along in the puddles, hair drooping and bunching up with the rain. It sniffed at the tires of the truck, lifted its legs by one of them, sniffed again, padded on. It circled around Paul, apparently not noticing him, but poking its nose at every object, narrowing the distance between them with every circle. It passed close by the old man, snarled, completed another half-circle, and approached Paul from the left. It stopped near Paul's head—the wet-dog odor was suffocating—and whimpered, licking Paul's face. The old man did nothing, just sat, legs crossed, and passively watched. Of course . . . not a priest at all: an old beggar. Waiting for the clothes when he died. If he still had any. Go ahead and take them now, Paul told him, I don't care. But the beggar only sat and stared. Paul felt a tugging sensation from below, heard the dog growl. His whole body seemed to jerk upwards, sending another hot flash through his neck. The dog's hind feet were planted alongside Paul's head, and now and again the right paw would lose its footing, kick nervously at Paul's face, a buffeting counterpoint to the waves of hot pain behind his throat and eyes. Finally, something gave way. The dog shook water out of its yellow coat, and padded away, a fresh piece of flesh between its jaws. The beggar's eyes crossed, his head dipped to his chest, and he started to topple forward, but again he caught himself, took a deep breath, uncrossed his legs, crossed them again, but the opposite way, reached in his pocket and pulled out an old cigarette butt, molded it between his yellow fingers, put it in his mouth, but did not light it. For an

instant, the earth upended again, and Paul found himself hung on the street, a target for the millions of raindarts somebody out in the night was throwing at him. There's nobody out there, he reminded himself, and that set the earth right again. The beggar spat. Paul shielded his eyes from the rain with his lids. He thought he heard other dogs. How much longer must this go on? he wondered. How much longer?

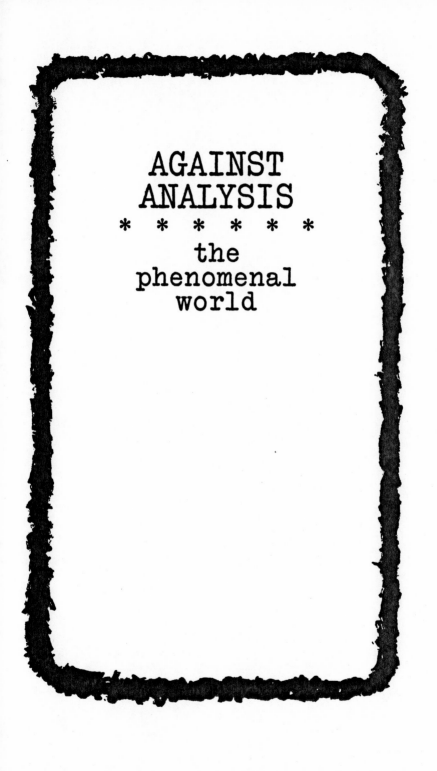

AGAINST
ANALYSIS
* * * * * *
the
phenomenal
world

tropism xv
Nathalie Sarraute

SHE so loved old gentlemen like him, with whom you could talk, they understood so many things, they knew all about life, they had associated with interesting people (she knew that he had been a friend of Félix Faure and that he had once kissed Empress Eugénie's hand.

When he came to dine with her parents, very much the child, deference itself (he was so learned), slightly awed, but all of a twitter (it would be so instructive to hear his views), she preceded the others to the salon, to keep him company.

He rose laboriously: "Well, well! So there you are! And how are you? And how is everything going? And what are you doing? What are you doing that's nice this year? Ah! So you're going back to England? Indeed?"

She was going back. Really, she loved the country so much. The English, when you knew them . . .

But he interrupted her: "England . . . Ah, yes, England . . . Shakespeare, eh? Eh? Shakespeare. Dickens. I remember, by the way, when I was young, I amused myself translating Dickens. Thackeray. Have you read Thackeray? Th . . . Th . . . Is that how they pronounce it? Eh? Thackeray? Is that it? Is that the way they say it? . . ."

He had grabbed her and was holding her entirely in his fist. He watched her as she flung herself about a bit, as she struggled awkwardly, childishly kicking her little feet in the air, while maintaining a pleasant smile: "Why yes, I think it's like that. Yes. You pronounce well. Indeed, the t-h . . . Tha . . . Thackeray . . . Yes, that's it. Why of course I've read *Vanity Fair*. Oh, yes, it's by him all right."

He turned her round a bit, the better to see her: "*Vanity*

Fair? Vanity Fair? Ah! yes, you're sure of that? *Vanity Fair?* It's by him?"

She continued to wriggle gently, still wearing her polite little smile, her expression of eager expectation. He squeezed harder and harder: "And by which route will you go? Via Dover? Via Calais? Dover? Eh? Via Dover? Is that it? Dover?"

There was no way to escape. No way to stop him. She who had read so widely . . . who had thought about so many things . . . He could be so charming . . . But it was one of his bad days, he was in one of his strange moods. He would keep on, without pity, without respite; "Dover, Dover, Dover? Eh? Eh? Dover? Thackeray? England? Dickens? Shakespeare? Eh? Eh? Dover?" while she would try to free herself gently, without daring to make any sudden movement that might displease him, and answer respectfully in a faint voice that was just a bit husky: "Yes, Dover, that's it. You must have traveled that way often . . . I believe it's more convenient via Dover. Yes, that's it . . . Dover."

Not until he saw her parents arrive, would he come to himself, would he relax his grip, and a bit red, a bit disheveled, her pretty dress a bit mussed, she would finally dare, without fearing to displease him, escape.

in the
corridors
of the
underground:
the
escalator

Alain Robbe-Grillet

A MOTIONLESS group, at the bottom of the long, iron-grey staircase, whose steps become level, one after the other, as they get to the top, and disappear, one by one, with a sound of well-oiled machinery, and with a heavy, and yet at the same time abrupt, regularity, which gives the impression of being quite rapid at the place where the steps disappear, one after the other, beneath the horizontal surface, but which seems, on the contrary, to be of extreme slowness, and also to have lost all its jerkiness, to the eye which travels down the series of successive steps, and rediscovers, right at the bottom of the long, rectilinear staircase, as if in the same place, the same group, whose position hasn't varied in the slightest degree—a motionless group, standing on the bottom steps, which has only just got on to the escalator, has immediately become petrified for the duration of the mechanical journey, has suddenly come to a standstill in the midst of its bustle and rush—as if the fact of setting foot on the moving steps had suddenly paralysed the bodies forming the group, one after another, into positions both relaxed and tense, in suspense, representing a temporary halt in the midst of an interrupted journey, while the whole rectilinear staircase continues its climb, ascends regularly with a movement that is uniform, slow, almost imperceptible, and, in relation to the vertical bodies, oblique.

These bodies are five in number, grouped on three or four

steps, on the left-hand side of these steps, at a greater or lesser distance from the handrail, which is also moving at the same speed, though here the movement is made even more imperceptible, more uncertain, by the very shape of the handrail, an ordinary thick strip of black rubber which has a smooth surface, two rectilinear edges, and no fixed point against which it is possible to determine its speed, unless it is the two hands which are placed on it, about a yard apart, at the very bottom of the narrow, oblique strip whose immobility everywhere else seems obvious, and which yet advances continuously, smoothly, at the same time as the whole of the rest of the system.

The higher of these two hands belongs to a man in a grey suit, a grey that is rather pale, uncertain, yellowish under the yellow light, who has a step to himself at the head of the group, and who holds his body very erect, with his legs together, his left arm bent round close against his chest, the hand holding a newspaper folded in four, over which his face is inclined in what seems a somewhat excessive fashion so exaggerated is the downward flexion of his neck, the chief effect of which is to bring well into view not his forehead and nose, but the top of his cranium and his large bald patch, a big circle of pink and shining scalp which is transversally intersected by a breakaway wisp of thin red hair sticking to the skin.

But the face is suddenly raised, in the direction of the top of the staircase, showing the forehead, the nose, the mouth—all the features, which, however, are expressionless, and it stays there for a few instants, certainly for longer than would be necessary to make sure that the ascent is still by no means at an end and so allows the continuance of the reading of the article that has been begun, which the person finally decides to do, abruptly lowering his head again, though his countenance, now hidden once more, has not given the slightest sign of the kind of attention that has been paid for a moment to the surroundings, which perhaps were not even noticed by those wide-open, staring eyes with the blank look. In their place, in the same position as it was at the beginning, the round cranium, with its bald zone in the middle, now reappears.

As if the man, in the middle of the reading to which he has returned, has then suddenly thought about the enormous, empty, rectilinear staircase, which he has just contemplated without seeing, and wants, by a sort of delayed-action reflex, to look behind him, to find out whether there is a similar desert in that direction, he turns round, as abruptly as he just now raised his head, and ·without moving the rest of his body any more than he did then. He can thus observe that there are four people behind him, that they are motionless, and gently ascending at the same speed as he, and he immediately returns to his original position and to his perusal of the newspaper. The other passengers haven't budged.

In the second row, after an empty step, come a woman and a child. The woman is exactly behind the man with the paper, but she hasn't put her right hand on the rail; her arm hangs down at her side and is holding a kind of handbag, or string shopping bag, or spheroid parcel, the precise nature of whose brownish mass cannot be determined, as it is almost completely hidden behind the man's grey trouser leg. The woman is neither young nor old; her face looks tired. She is dressed in a red mackintosh and on her head is a multi-coloured scarf which is knotted beneath her chin. On her left, the child, a boy of about twelve, wearing a high-necked sweater and tight blue jeans, holds his head either tilted to one side, against his shoulder, with his face raised towards his right, towards the profile of the woman, or else slightly further round towards the bare wall, which is completely covered with small white ceramic rectangles and which is passing by at an even speed, above the handrail, between the woman and the man with the paper.

Next, and still at the same speed, against this shiny white background cut up into countless little rectangles, all identical and drawn up in methodical lines, the horizontal joins being continuous and the vertical joins alternate, come the silhouettes of two men in dark lounge suits, the first standing behind the woman in red, two steps lower down, with his right hand on the rail, then, after three empty steps, the second, standing behind the child, his head coming very little higher than the child's

thonged sandals, in other words, a bit lower than his knees, which are indicated at the back of his blue jeans by numerous horizontal puckers creasing the material.

And the rigid group continues to ascend, and each individual's pose remains as invariable as his position in the group. But, as the man in front has turned round to look behind him, the man at the bottom, who is probably wondering what the object of this abnormal interest is, also turns round. All he can see is the long series of successive steps and, at the very bottom of the rectilinear, iron-grey staircase, standing on the bottom steps, a motionless group that has only just got on to the escalator, is ascending at the same slow and sure speed, and stays the same distance away.

welcome to
Utah
Michel Butor

the sun is setting in
WELLINGTON, Mountain Time.
After having walked for months and months through the desert, the Latter-Day Saints came in sight of Great Salt Lake.

Kings Peak, highest point in the state
WELLINGTON, NEV., the Far West,—the Summit
Lake Indian Reservation.

HUNTSVILLE, Weber County.

In July 1847, Brigham Young decided that it was in this place that the city was to be built.

Deadman and Thousand Lake Mountains.

CLEVELAND, Emery County, UTAH,—The Shivwits Indian Reservation.

In 1889, some Oceanians from Hawaii, converted to the Mormon religion, founded the city of Iosepa.

A gray Pontiac driven by an old Negro passes an old black Hudson driven by a young white man going much faster than the daytime speed limit, "go straight ahead."

MILFORD, Mormon state,—the Koosharem Indian Reservation.

In 1893, leprosy broke out among the Hawaiian Mormons of Iosepa.

Through Sears, Roebuck & Co., you can obtain the new "Map of the United States" school bag, "now it is so easy for children to learn something about their country! Bright colored map on the back. Seals of eighteen governmental departments, photographs of the Capitol and the White House on the front . . ."

> MILFORD, WYOMING, the least heavily populated state after Alaska and Nevada,—the Wind River Indian Reservation.
>
> *Still a little red sunlight on the mountain tops.*
>
> Shoshone National Forest.

On a dead branch, a sharp-shinned hawk, tearing apart a small bird with a purple breast.

> NEWCASTLE.

NEWCASTLE, Iron County, UTAH, a desert state.—the Ute Indian Reservation.

In 1916, when a Mormon temple was built in Hawaii, the last survivors of the Iosepa colony returned to their country, abandoning the town to its ghosts.

Sand Pass, Thomas Pass.

 NEW CASTLE, COLO.,—Southern Ute Indian Reservation.

ALPINE, UTAH.

In Mountain Meadows, in September 1857, a group of 140 emigrants from Arkansas were stopped by the Federal troops about to invade the Mormon state because the Easterners were scandalized by the practice of polygamy. After a siege lasting several days, the emigrants were massacred. The only survivors, 17 children, were taken back to Arkansas.

Indian Peak.—When it is seven P.M. in

RANDOLPH,
 already nine P.M. in
RANDOLPH, Eastern Time.

Are you asleep?

 RANDOLPH.

The trial of Susanna Martin, Salem, June 29, 1692:
"11) Jervis Ring testified that about seven or eight years ago he had ben severall times afflicted in the night time by some body or some thing coming up upon him when he was in bed and did sorely afflict by Laying upon him and he could neither move nor speak while it was upon him but sometimes made a kind of noyse; but one time in the night it came upon me as at other times and I did then see the person of Susanna Martin of Amesbury, and she came to this deponent

*and took him by the hand and bitt him by the finger
by force and the print of the bite is yet to be seen on
the little finger of his right hand . . ."*

CHESTER, Windsor County.

Asleep . . .

CHESTER, MASS., New England.

*"12) But beyond all these evidences there was a very
marvelous testimony of one Joseph Ring produced
upon this occasion. This man had been strangely trans-
ported by demons into unknown places where he saw
meetings and feastings and many strange sights and
from August Last he was Dum and could not speake
till this last Aprill. He also relates that there was a cer-
tain Thos. Hardy which said Hardy demanded of this
deponent two shillings and with that dreadfull noyse
and hideous shapes of creatures and fireball. About
Oct following coming from Hampton in Salsbury pine
plane a company of horses with men and women upon
them overtook this deponent and the aforsead Hardy
being one of them came to this deponent as before and
demanded his two shillings of him and threatened to
tear him to pieces to whom this deponent made no
answer and so he and the rest went away and left this
deponent. After this this deponent had divers strange
appearances which did force him away with them into
unknown places where he saw meetings and he also
relates that there did use to come to him a man that
did present him a book to which he would have him
sett his hand with promise of anything that he would
have and there were presented all Delectable things
and persons. And places imaginall, but he refusing it
would usually and with most dreadful shapes noyses
and screeking that almost scared him out of his witts
and this was the usuall manner of proceeding with*

*him and one time the book was brought and a pen
offered him and to his apprehension there was blod in
the Ink horne but he never toucht the pen. He further
say that they never told him what he should writt nor
he could not speak to ask them what he should writ.
He farther say in several their merry meetings he have
seen Susanas Martin appear among them. And in that
house did also appear the aforesayd Hardy and an-
other female person which the deponent did not know,
there they had a good fire and drink it seemed to be
sider their continued most part of the night said Mar-
tin being then in her natural shape and talking as shee
used to do, but toward the morning the said Martine
went from the fire made a noyse and turned into the
shape of a black hog and went away and so did the
other to persons go away and this deponent was
strangely caryed away also and the first place he knew
was by Salmuel woods house in Amsbury . . ."*

CHESTER, CONN., New England.

RICHMOND.

RICHMOND, Chittenden County, VERMONT, New England,—
the border of the Canadian province of Quebec, one
of the least heavily populated states.

The woods at night.

An old overloaded jeep parked beside the highway; another jeep
passes, "turn left."

RICHMOND.
53,000 Norwegians,
410,000 Poles,
the Greeks who read the "National Herald,"
*the Hungarians who read the "Amerikai
Magyar Nepszava,"*

the Italians who read "Il Progresso."

SATURDAY EVENING POST SATURDAY EVENING POST SATUR

Colombo's, steaks,
 Quo Vadis, French cuisine,
 East of Suez, Indonesian,
White Turkey, American specialties,
 Schine's, Irish,
 Grotta Azzurra, Italian.

The planes leaving for Munich,
 for Léopoldville,
 coming from Beirut,
 from Athens.

WBNX, Ukranian broadcasts,
 WEVD, Norwegian broadcasts,
 WFUV-FM, Polish broadcasts.

The ships sailing for Boston,
 for Mobile,
 arriving from Philadelphia,
 from Providence.

Even cheaper clothes for women at Macy's, Saks-34th, Gimbels and Ohrbach's.

The Empire State Building: the most powerful searchlights in the world, a city of shops on the street floor.

Loew's Commodore,
 Art Theater,
 Academy of Music.

The subways coming from the far ends of the Bronx, Brooklyn and Queens:

Northern Boulevard,
Atlantic Avenue,
Intervale Avenue,
46 Street,
De Kalb Avenue,
Prospect Avenue,
Steinway Street,
Myrtle Avenue,
Jackson Avenue.
36 Street,
(crossing the East River)
Broadway.
Queens Plaza.
Museum of Natural History: superb wax reproduction
(life size) of a flowering magnolia.

Alone tonight, baby?
Thirsty?
Terribly!
Do you know them?
That's what he said on television.
I can't remember their names.
Great!
Not bad . . .

Bronx Zoo:
griffon vultures,
bearded vultures,
Pondicherry vultures.

Drink Coca-Cola!
Drink Pepsi-Cola!
Kleenex!

CHESTER, Orange County.

85,000 Rumanians,
the Hungarians who read "Az Ember,"

Sea Fare, fish,
the planes leaving for Chicago,
for Istanbul,
WEVD, Spanish broadcasts,
Danny's Hide-a-way, steaks,
the ships leaving for Naples,
for Tangiers,
Irving Place Theater.

> *950,000 Russians,*
> *the Italians who read the "Corriere degli Italiani,"*
> *Twenty-One, French cuisine,*
> *the planes coming from Kansas City,*
> > *from Teheran,*
> *WFUV-FM, Russian broadcasts,*
> *Shanghai, Chinese dishes,*
> *the ships coming from Genoa,*
> > *from Madeira,*
> *Gramercy Theater.*

> > *The Portuguese who read, "A Luta,"*
> > *San Marino, Italian cuisine,*
> > *WHOM, Polish broadcasts,*
> > *Giovanni, Italian specialties,*
> > *the Empire State Building: 35,-ooo visitors a day, coming from every country in the world,*
> > *Murray Hill Theater.*

HOLIDAY HOLIDAY HOLIDAY HOLIDAY HOLIDAY HOLIDA

Cheapest clothes for women, at Klein's.
The subways coming from the Bronx, lower Manhattan, Queens:
> > *Courthouse Square,*
> *Prince Street,*

Third Avenue,
 Ely Avenue,
 Eighth Street,
 149 Street,
 (crossing the East River)
 Lexington Avenue,
 Union Square,
 (crossing the Harlem River)
 135 Street.
 Fifth Avenue,
 23 Street.
 Seventh Avenue.

Museum of Natural History: Audubon Gallery: collection of objects relating to the life and work of John James Audubon; Audubon's original paintings and drawings, and those of his son; some bronze and copper plates used in printing "Birds of America"; portrait of the engraver Robert Havell; plates showing Audubon armed with his rifle.

Bronx Zoo:
white-headed vulture,
 white Egyptian vulture,
 black East African vulture.

Smoke Chesterfield,
 Smoke Lucky Strike,
 Smoke Salem!
 There must be a mistake.
 Not too tired?
 I've reserved a room.
 Did you hear?
They had to send a bill.
 Shut up!
 She still hasn't come in.
 What can she do?
 I've rarely been so bored.

New York Historical Society: sleds and prints of New York winter scenes.

RANDOLPH, Cattaraugus, N.Y.,—the Saint Regis Indian Reservation.

65,000 Scots,
the Japanese who read "Hokubei Shimpo,"
Stouffer's, American specialties,
the planes leaving for Detroit,
 for Karachi,
WEVD, Swedish broadcasts,
Hickory House, steaks,
the ships leaving for the Bahamas,
 for Bermuda,
Cameo Theater,
the subway coming from Harlem:
125 Street,
116 Street,
110 Street,
Bronx Zoo: mountain zebra,
Fly Air France!
THE NEW YORKER THE NEW YORKER THE NEW YORKER THE NEW YO
 25,000 Spaniards
 the Lithuanians who read "Tevyne,"
 Voisin, French cuisine,
 the planes coming from Montreal,
 from Honolulu,
 WFUV-FM, Spanish broadcasts,
 Miyako, Japanese dishes,
 the ships coming from the Azores,
 from the Windward Islands,
 Loew's Lexington,
 the subway coming from downtown New York:
 28 Street,
 33 Street,
 49 Street,

57 Street,
Bronx Zoo: Grant's zebra,
Fly Pan American!
Fruits and vegetables: Washington, Fulton and Vesey
Streets.

The Norwegians who read the
"Nordisk Tidende,"
Café Geiger, German cuisine,
Empire State Building: 16,000
tenants,
WHOM, Russian broadcasts,
Alamo, Mexican specialties,
New York Historical Society:
old fire pumps,
R.K.O. 58 Street Theater,
the subway from uptown New
York:
50 Street,
42 Street,
Pennsylvania Station,
23 Street,
14 Street,
Bronx Zoo: Grevy's zebra,
Fly TWA!

Museum of Natural History: hall of human biology:
growth and development of the individual, racial
classification of man; genetics and mixture of races;
population problems; development of a human em-
bryo; life-size figures showing the chief racial types.

New York City Museum: gallery devoted to the history
of the fire department of New York.

Have you been here long?
Just a minute.
When are you leaving?

I was late.
 A last glass.
He had to sell his car.
 Not another.
 We're coming.
 I'd never have believed it.
 What will you have?

Shell,—a huge Nash collides with an old one already going much faster than the 50-mile speed limit,—through Montgomery Ward, you can obtain the booklet "Sports Cars of the Future," by Strother MacMinn, "deals with the cars of your dreams planned by European and American builders," as well as the prototypes of the makes:
—Corvette,

WINDSOR, Green Mountain State.

 La Salle II,

The covered bridges at night.

 —Oldsmobile F 88,

Through Sears, Roebuck & Co., a "Lady Kenmore" sewing machine, "stitches with inconceivable daintiness. The 20 styles illustrated on the dial can be modified and combined to produce countless intricate decorative variations. You can embroider in two colors thanks to twin needles . . . vary the size of the stitch with the regulator . . ."

 —Chrysler Gran Turismo. Also discusses mechanical elements and body design likely to appear in future cars.

WINDSOR, Broome County.

Hep!

Miss!

This isn't for you?

Oh, thank you!

Don't you feel well?

They had to sell their apartment.

Go home.

Go home!

Sleep.

If you think . .

Did you think . . .

55,000 Swedes,

15,000 Swiss,

32,000 Turks,

the Poles who read the "Nowy Swiat,"

the Spanish who read "La Prensa,"

the Swedes who read "Norden,"

Keen's, steaks and chops,

Côte Basque, French cuisine,

Berkowitz, Rumanian,

the planes leaving for Lima,

for Helsinki,

coming from Bogotá,

from Oslo,

Chrysler Building, 77 floors,

60 Wall Street, 66 floors,

WEVD, Ukrainian broadcasts,

WHOM, Spanish broadcasts,

WWRL, Greek broadacsts,

Pen and Pencil, steaks,

Balalaika, Russian cooking,

Sevilla, Spanish specialties,

the ships leaving for Bristol,

for Barcelona,

coming from Cardiff,

from Piraeus,

the Seagram Building, like a

huge block of solidified whis-
key.

On top of the Mutual Life In-
surance Building, the green star
if the weather is going to be
fair, orange for cloudy, winking
orange for rain, white for snow.

THE MAGAZINE OF FANTASY AND SCIENCE FICTION THE M
EBONY EBONY EBONY EBONY EBONY EBONY EB
MAD MAD MAD MAD MAD MAD M

Flowers, 28 Street and Sixth Avenue,
 linen, Grand Street,
 silver, Lexington Avenue be-
 tween 56 and 58 Street, and on
 Nassau Street,
Plaza Theater,
 Baronet Theater,
 Trans-Lux 52 Street Theater,
the subways going to the Bronx, Queens and Brooklyn:
86 Street,
 Fifth Avenue,
 West Fourth Street,
96 Street,
 Lexington Avenue,
 Spring Street,
103 Street.
 (crossing the East River)
 Queensboro Plaza,
 Canal Street,
 Beebe Avenue.
 Chambers Street,
 Broadway, Nassau Street.
Bronx Zoo: cassowaries,
 yaks,
 ornithorynchus,
New York Historical Society: Audubon Gallery: all the
original drawings for "Birds of America,"

New York City Museum: 1920 doll's house,
made by Varrie Walter Stettheimer; note
the ballroom painting which is a real Mar-
cel Duchamp,

> *Museum of Natural History:*
> *Planetarium: a new show each*
> *month:*
> *Trip to Mercury,*
> *Trip to the Moon,*
> *The End of the World . . .*

Fly Sabena,
> *Fly BOAC,*
> > *Fly KLM.*

In April 1524, the Florentine navigator Verrazzano
piloted the French caravel Dauphine to the discovery
of the port of New York and named the place Angou-
lême in honor of François I, King of France.

The drive-in movie is over.

NEWPORT.

NEWPORT, county seat of Orleans County, VT., ski state.

The mountains at night.

NEWPORT.

O right!

NEWPORT.

The sea at night.

BRISTOL, Addison County.

The streams at night.

BRISTOL, Grafton County.

Mother night!

> BRISTOL, ME.,—the border of the Cana-
> dian provinces of Quebec and
> New Brunswick,—the Penobscot Indian
> Reservation.

> *The rocks at night.*

RICHMOND, Cheshire County, N.H.

The highway at night.

Texaco,—a Kaiser passes a shiny Hudson.

The movement of the windshield wipers.

> RICHMOND.

The water streaming over the glass.

> CHESTER, Rockingham County.

> *The street lamp at night.*

The water streaming over the highway.

> DANVILLE.—When it is ten P.M. in

DANVILLE,

> ten P.M. in

DANVILLE.

"Notes on the State of Virginia":
". . . The improvement of the blacks in body and mind, in the first

instance of their mixture with the whites, has been observed by every one, and proves that their inferiority is not the effect merely of their condition of life. We know that among the Romans, about the Augustan age especially, the condition of their slaves was much more deplorable than that of the blacks on the continent of America. The two sexes were confined in separate apartments, because to raise a child cost the master more than to buy one. Cato, for a very restricted indulgence to his slaves in this particular, took from them a certain price. But in this country the slaves multiply as fast as the free inhabitants. Their situation and manners place the commerce between the two sexes almost without restraint . . ."

Thomas Jefferson.

At Monticello, Thomas Jefferson set a light stucco frieze around the ceiling of his hall: griffons, vases, foliage and torches.

DANVILLE.

Sleep.

DANVILLE.

Sleep.

DANVILLE, KANS.

GLASGOW, Rockbridge County.

At Monticello, Thomas Jefferson installed the first parquet flooring in the United States in his salon.

". . . The same Cato, on a principle of economy, always sold his sick and superannuated slaves. He gives it as a standing precept to a master visiting his farm, to sell his old oxen, old wagons, old tools, old and diseased servants, and everything else become useless . . . The American slaves cannot enumerate this among the injuries and insults they receive . . ."

Thomas Jefferson.

GLASGOW, KY.

The falls at night.

GLASGOW, MO.

The insomnia.

FRANKLIN.

Green light.

FRANKLIN.

FRANKLIN, Southampton County, VIRGINIA.

*". . . It was the common practice to expose in the island Aescu-
lapius, in the Tyber, diseased slaves whose cure was like to
become tedious. The emperor Claudius by an edict, gave freedom
to such of them as should recover, and first declared that if any
person chose to kill rather than to expose them, it should not be
deemed homicide. The exposing them is a crime of which no in-
stance has existed with us; and were it to be followed by death, it
would be punished capitally We are told of a certain Vedius
Pollio, who, in the presence of Augustus, would have given a
slave as food to his fish, for having broken a glass. With the
Romans, the regular method of taking the evidence of their slaves
was under torture. Here it has been thought better never to resort
to their evidence. When a master was murdered, all his slaves, in
the same house, or within hearing, were condemned to death.
Here punishment falls on the guilty only, and as precise proof is
required against him as against a freeman. Yet notwithstanding
these and other discouraging circumstances among the Romans
their slaves were often their rarest artists. They excelled too i .
science, insomuch as to be usually employed as tutors to their
masters' children. Epictetus, Terence, and Phaedrus were slaves.
But they were of the race of whites . . ."*

 Thomas Jefferson.

Thomas Jefferson,
 at Monticello, above the door from the salon to the dining room, under an elegant pediment, set a light stucco frieze of bucrania, vases, shields, helmets, whose elements were repeated over the mantelpiece.

FRANKLIN.

The smells of the night.

FRANKLIN, ALA.

BRISTOL, where you can order apple ice cream in the Howard Johnson Restaurant.

At Monticello, Thomas Jefferson had a white stucco eagle set in the entrance hall ceiling, surrounded by eighteen gold stars and holding in its talons the suspension pulleys of a lamp to be raised and lowered which he had purchased in Paris.

Thomas Jefferson.

". . . It is not their condition then, but nature, which has produced the distinction. Whether further observation will or will not verify the conjecture, that nature has been less bountiful to them in the endowments of the head, I believe that in those of the heart she will be found to have done them justice. That disposition to theft with which they have been branded, must be ascribed to their situation, and not to any depravity of the moral sense. The man in whose favor no laws of property exist, probably feels himself less bound to respect those made in favor of others. When arguing for ourselves, we lay it down as a fundamental, that laws, to be just, must give a reciprocation of right; that, without this, they are mere arbitrary rules of conduct, founded in force, and not in conscience; and it is a problem which I give to the master to solve, whether the religious precepts against the violation of property were not framed for him as well as his slave? And whether the slave may not as justifiably take a little from one who has taken all from him, as he may slay one who would slay him?

That a change in the relations in which a man is placed should change his ideas of moral right or wrong, is neither new, nor peculiar to the color of the blacks. Homer tells us it was so two thousand six hundred years ago:

> *'Jove fix'd it certain, that whatever day*
> *Makes man a slave, takes half his worth away.'*

But the slaves of which Homer speaks were whites . . ."

<div align="right">

Thomas Jefferson.

</div>

Through Sears, Roebuck & Co., you can obtain painting equipment that will give hours of pleasure to your whole family: "merely follow the numbers to have fun and relax. Our finest selection: 2 large prepared panels, 30 numbered colors, 3 washable brushes, instructions; choose from:

—bouquet of flowers,
 roses,
—Madonna and Child,

 BRISTOL, TENN.

 the Good Shepherd
—winter shadows,
 fisherman's luck

 If you're not asleep . . .

—the Last Supper,
 Christ with children,
—decorative owls,

 NEWPORT.

 decorative raccoons,
—the fisherman up in his tree,
 the fisherman on the bank."

NEWPORT, Giles County, VA.

"... *Notwithstanding these considerations which must weaken their respect for the laws of property, we find among them numerous instances of the most rigid integrity, and as many as among their better instructed masters, of benevolence, gratitude, and unshaken fidelity. The opinion that they are inferior in the faculties of reason and imagination, must be hazarded with great diffidence. To justify a general conclusion, requires many observations, even where the subject may be submitted to the anatomical knife, to optical glasses, to analysis by fire or by solvents. How much more then where it is a faculty, not a substance, we are examining; where it eludes the research of all the senses; where the conditions of its existence are variously combined; where the effects of those which are present or absent bid defiance to calculation; let me add too, as a circumstance of great tenderness, where our conclusion would degrade a whole race of men from the rank in the scale of beings which their Creator may perhaps have given them ..."*

Thomas Jefferson.

Thomas Jefferson,
 at Monticello, over the mantelpiece of the dining room set exquisite panels of blue-and-white Wedgwood representing Apollo and the Muses.

Or a group of three panels, eighteen jars of paint; choose from "Distant lands:
 —Chinese pagoda,
 —the old mill,
 —lofty mountains,

 NEWPORT.

—Biblical subjects:
 —Christ,
 —the Good Shepherd,
 —Jesus in meditation,
 Thieves ...

—Seascapes:

 —Clipper ship,

 —rocks and beaches,

 —harbor scene,

NEWPORT, S.C.

—Horses:

 —pride of the stable,

 —out to grass,

 —Derby winner,

Prowlers ...

—Far West:

 —majestic canyons,

 —heavenly waterfalls,

 —enchanted valleys,

WINDSOR. State Flower: dogwood.

—Holland:

 —Delft,

 —windmills,

 —canals," page 1037.

At Monticello, in the dining room, on each side of the mantel-piece, Thomas Jefferson ingeniously concealed small bottle elevators connecting with the wine cellar.

". . . To our reproach it must be said, that though for a century and a half we have had under our eyes the races of black and of red men, they have never yet been viewed by us as subjects of natural history. I advance it, therefore, as a suspicion only, that the blacks, whether originally a distinct race, or made distinct by times and curcumstances, are inferior to the whites in the endowments both of body and mind. It is not against experience to sup-

pose that different species of the same genus, o. varieties of the same species, may possess different qualifications. "

Thomas Jefferson.

Or a group of four small panels framed in black plastic; choose from: "Birds,

WINDSOR, N.C.

—Dogs,

Murderers . . .

—Parisian scenes,

WINDSOR.

—Horses."

FRANKLIN.

RICHMOND, where you can order pear ice cream in the Howard Johnson Restaurant, county seat of Henrico County, capital of the state, VA.

". . . Will not a lover of natural history then, one who views the gradations in all the races of animals with the eye of philosophy, excuse an effort to keep those in the department of man as distinct as nature has formed them? This unfortunate difference of color, and perhaps of faculty, is a powerful obstacle to the emancipation of these people . . ."

Thomas Jefferson.

Thomas Jefferson,
at Monticello, situated the slaves' quarters under the southern terrace, so that their comings and goings would not spoil the view.

VIENNA, Fairfax County.

"*. . . Many of their advocates, while they wish to vindicate the liberty of human nature, are anxious also to preserve its dignity and beauty. Some of these, embarrassed by the question, 'What further is to be done with them?' join themselves in opposition with those who are actuated by sordid avarice only. Among the Romans emancipation required but one effort. The slave, when made free, might mix with, without staining the blood of his master. But with us a second is necessary, unknown to history. When freed, he is to be removed beyond the reach of mixture . . .*"

Thomas Jefferson.

Thomas Jefferson,
 on January 10, 1806, being then President of the United States, wrote to the chiefs of the Cherokee Nation:
"*. . . Tell all your chiefs, your men, women and children, that I take them by the hand and hold it fast. That I am their father, wish their happiness and well-being, and am always ready to promote their good. My children, I thank you for your visit and pray to the Great Spirit who made us all and planted us all in this land to live together like brothers that He will conduct you safely to your homes, and grant you to find your families and your friends in good health.*"

VIENNA, MD.—When it is eleven .M. in

CHESTER, where you can order pistachio ice cream in the Howard Johnson Restaurant,

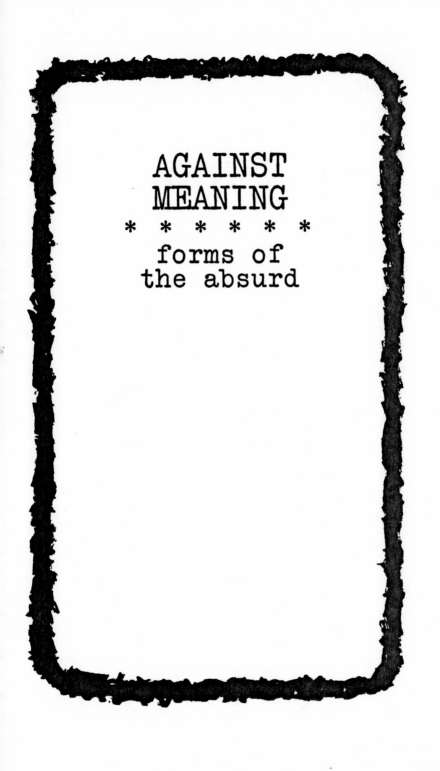

AGAINST
MEANING
* * * * * *
forms of
the absurd

the man in
pyjamas

Eugenio Montale

I WAS WALKING up and down the corridor in slippers and py-
jamas, stepping from time to time over a heap of dirty linen. It
was an A class hotel. It had two lifts and one goods lift which
were almost always out of order, but there was no store-room for
sheets, pillow-slips and towels in temporary disuse, and the
chambermaids had to pile them up where they could, that is, in
all sorts of odd corners. Late at night I used to visit these corners
and because of this the chambermaids never liked me. However,
by tipping them I had, as it were, obtained their tacit approval
to stroll wherever I wanted. It was past midnight and I heard the
telephone ring softly. Could it be in my room? I glided stealthily
towards it but noticed that it was ringing in a room adjacent to
mine—room 22. As I was returning I overheard a woman's voice
on the phone, saying: "Don't come yet, Attilio; there's a man in
pyjamas walking through the corridor. He might see you."

From the other end of the line I heard an indistinct chatter.
"Oh," she answered, "I don't know who he is—a poor wretch
always hanging around. Please, don't come. In any case I'll let
you know." She put the .eceiver down with a bang. I heard
her footsteps in the room. I slipped hurriedly back towards the
far end of the corridor where there was a sofa, another pile of
linen and a wall. But I could hear the door of room 22 open
and I gathered that the woman was watching me through the
slit. I could not stay where I was for long, so I slowly returned.
In something like ten seconds I was to pass her room and
I considered the various alternatives: (1) to return to my room
and lock myself up; (2) the same, but with a difference, that is to
say, to inform the lady that I had overheard everything and that I
intended to do her a favor by retiring; (3) to ask her if she was

really all that keen on having Attilio, or if I was merely used as pretext to avoid a rather disagreeable nocturnal bullfight; (4) to ignore the telephonic conversation and carry on my stroll; (5) to ask if she might eventually care to substitute me for Attilio for the object referred to in alternative number 3; (6) to demand explanation for the nomenclature "poor wretch" with which she had chosen to designate me; (7) . . . there was some difficulty in formulating the seventh alternative. But by this time I was already in front of the slit. Two dark eyes, a crimson bed-jacket worn over a silk skirt, and short curly hair. Just a brief second and the opening shut again with a snap. My heart was beating fast as I entered my room and heard the telephone ring again next door. The woman was saying something in a soft voice which I did not catch. Like a wolf I shot back to the corridor and tried to make out what she was saying. "It's impossible, Attilio, I say it's impossible. . . ." And then the clack of the telephone followed by the sound of her footsteps nearing the door. I made a dash towards the second pile of dirty linen, turning over in my mind alternatives 2, 3 and 5. The door opened again narrowly and it was now impossible for me to stand still. . . . I said to my self: I *am* a poor wretch, but how could *she* know that? And what if by my walking up and down the corridor I may not have perhaps saved her from Attilio? Or saved Attilio from her? I am not born to be an arbiter of anything, much less an arbiter of the life of others. I returned to my room, kicking along a pillow-slip with a slipper. This time the door opened rather wider and the curly head projected a little further. I was just about a yard away from it so, having kicked off the slipper and come to attention, I bellowed out in a voice that could be heard right down the corridor: "I have finished walking up and down, Madam. But how do you know that I am a poor wretch?"

"We all are," she snapped and slammed the door. The telephone was ringing again.

the self-
contained
compartment
Michael Goldstein

AT THE stroke of nine he entered the room and without turning on the light began to undress. Then as if remembering something, he began to dress again. He had noticed, in this time of forgetting and remembering, that something had stirred in the lower bunk, and he could see this stirring through the dimness. It could not be Joseph for Joseph's was the top bunk; it was his own bunk then. But Joseph's bunk was made. He moved stealthily towards Joseph's bunk, which most concerned him. He knew already that his own was occupied, hence his interest in Joseph's. Having reached Joseph's bunk he avoided looking beneath for he knew there was nothing more to discover except Joseph. He felt Joseph's bed-linen and found it cold and what is more, empty. He thereupon closed the door on the room. He did not lock the door; he had only infrequently to unlock it and he accepted that it was always Joseph who locked it but never questioned Joseph on this matter.

At the stroke of nine the next morning he returned and unlocked the door, which to him meant that Joseph had returned and retreated, for if Joseph had not returned it would be free as he had left it. So Joseph must be out after returning, unless Joseph had locked himself in, which he never did.

Meanwhile he had undressed and entered his own bunk which was empty but warm. This meant nothing, for Joseph often sat on his bed to put on his shoes and this Joseph might have done after returning and before leaving. He slept, or rather kept to his bed, both morning and night for several days. On one morning he thought he saw Joseph putting his shaving things away. On one evening he thought he noticed Joseph above him. But he never

thought or imagined that he noticed or saw anyone but Joseph. At last, after convincing himself that this could not be otherwise, he dressed and went, leaving the door unlocked as Joseph had done. For Joseph, as yet, had never locked him in.

Later that evening he returned and without turning on the light began to undress as was his habit. Then as if remembering something that he had failed to do before undressing, dressed again and left the room, locking the door. He wanted to think. If he was to share his bed he wanted to think. For one night it was only slight inconvenience, but what if it were the beginning of many nights?—but he could not sleep with this nagging thought, so, indeed, for that night he decided not to seek sleep.

That evening much later he returned not to sleep but to discover. He did not unlock the door and prepared to undress. He knew that Joseph had returned and not retreated for the door was unlocked, and if it was Joseph, then Joseph had told him nothing. And if Joseph had told him nothing then Joseph preferred to tell him nothing for Joseph never concealed anything from him by pure whim. In all cases he could act as if, by mutual consent, he knew nothing—unless Joseph knew nothing either, but this did not occur to him.

So saying he climbed into his bunk. The fact that his bunk was occupied did not prevent him from falling to sleep at once, for he was very tired and a natural man. However on the morrow while shaving he noticed that Joseph's bunk was occupied, doubtless by the same person who had previously filled his bed, if it was not Joseph, himself. On the assumption that he knew nothing and did not want to know anything, this being his latest discovery, he decided that any further discovery could in no manner be enlightening. So before leaving the room and the occupant, he inspected closer, and found that she was not Joseph. He left the room leaving the door unlocked.

At the stroke of nine that evening he returned and without turning on the light undressed and, remembering everything, climbed into Joseph's bed.

—This can not go on, said Joseph.

game

Donald Barthelme

SHOTWELL KEEPS THE JACKS and the rubber ball in his attaché case and will not allow me to play with them. He plays with them, alone, sitting on the floor near the console hour after hour, chanting "onesies, twosies, threesies, foursies" in a precise, well-modulated voice, not so loud as to be annoying, not so soft as to allow me to forget. I point out to Shotwell that two can derive more enjoyment from playing jacks than one, but he is not interested. I have asked repeatedly to be allowed to play by myself, but he simply shakes his head. "Why?" I ask. "They're mine," he says. And when he has finished, when he has sated himself, back they go into the attaché case.

It is unfair but there is nothing I can do about it. I am aching to get my hands on them.

Shotwell and I watch the console. Shotwell and I live under the ground and watch the console. If certain events take place upon the console, we are to insert our keys in the appropriate locks and turn our keys. Shotwell has a key and I have a key. If we turn our keys simultaneously the bird flies, certain switches are activated and the bird flies. But the bird never flies. In one hundred thirty-three days the bird has not flown. Meanwhile Shotwell and I watch each other. We each wear a .45 and if Shotwell behaves strangely I am supposed to shoot him. If I behave strangely Shotwell is supposed to shoot me. We watch the console and think about shooting each other and think about the bird. Shotwell's behavior with the jacks is strange. Is it strange? I do not know. Perhaps he is merely a selfish bastard, perhaps his character is flawed, perhaps his childhood was twisted. I do not know.

Each of us wears a .45 and each of us is supposed to shoot

the other if the other is behaving strangely. How strangely is strangely? I do not know. In addition to the .45 I have a .38 which Shotwell does not know about concealed in my attaché case, and Shotwell has a .25 calibre Beretta which I do not know about strapped to his right calf. Sometimes instead of watching the console I pointedly watch Shotwell's .45, but this is simply a ruse, simply a maneuver, in reality I am watching his hand when it dangles in the vicinity of his right calf. If he decides I am behaving strangely he will shoot me not with the .45 but with the Beretta. Similarly Shotwell pretends to watch my .45 but he is really watching my hand resting idly atop my attaché case, my hand resting idly atop my attaché case, my hand. My hand resting idly atop my attaché case.

In the beginning I took care to behave normally. So did Shotwell. Our behavior was painfully normal. Norms of politeness, consideration, speech, and personal habits were scrupulously observed. But then it became apparent that an error had been made, that our relief was not going to arrive. Owing to an oversight. Owing to an oversight we have been here for one hundred thirty-three days. When it became clear that an error had been made, that we were not to be relieved, the norms were relaxed. Definitions of normality were redrawn in the agreement of January 1, called by us, The Agreement. Uniform regulations were relaxed, and mealtimes are no longer rigorously scheduled. We eat when we are hungry and sleep when we are tired. Considerations of rank and precedence were temporarily put aside, a handsome concession on the part of Shotwell, who is a captain, whereas I am only a first lieutenant. One of us watches the console at all times rather than two of us watching the console at all times, except when we are both on our feet. One or us watches the console at all times and if the bird flies then that one wakes the other and we turn our keys in the locks simultaneously and the bird flies. Our system involves a delay of perhaps twelve seconds but I do not care because I am not well, and Shotwell does not care because he is not himself. After the agreement was signed Shotwell produced the jacks and the rubber ball from his attaché case, and I began to write a series of descriptions of

forms occurring in nature, such as a shell, a leaf, a stone, an animal. On the walls.

Shotwell plays jacks and I write descriptions of natural forms on the walls.

Shotwell is enrolled in a USAFI course which leads to a master's degree in business administration from the University of Wisconsin (although we are not in Wisconsin, we are in Utah, Montana or Idaho). When we went down it was in either Utah, Montana or Idaho, I don't remember. We have been here for one hundred thirty-three days owing to an oversight. The pale green reinforced concrete walls sweat and the air conditioning zips on and off erratically and Shotwell reads *Introduction to Marketing* by Lassiter and Munk, making notes with a blue ballpoint pen. Shotwell is not himself but I do not know it, he presents a calm aspect and reads *Introduction to Marketing* and makes his exemplary notes with a blue ballpoint pen, meanwhile controlling the .38 in my attaché case with one-third of his attention. I am not well.

We have been here one hundred thirty-three days owing to an oversight. Although now we are not sure what is oversight, what is plan. Perhaps the plan is for us to stay here permanently, or if not permanently at least for a year, for three hundred sixty-five days. Or if not for a year for some number of days known to them and not known to us, such as two hundred days. Or perhaps they are observing our behavior in some way, sensors of some kind, perhaps our behavior determines the number of days. It may be that they are pleased with us, with our behavior, not in every detail but in sum. Perhaps the whole thing is very successful, perhaps the whole thing is an experiment and the experiment is very successful. I do not know. But I suspect that the only way they can persuade sun-loving creatures into their pale green sweating reinforced concrete rooms under the ground is to say that the system is twelve hours on, twelve hours off. And then lock us below for some number of days known to them and not known to us. We eat well although the frozen enchiladas are damp when defrosted and the frozen devil's food cake is sour and untasty. We sleep uneasily and acrimoniously. I hear Shot-

well shouting in his sleep, objecting, denouncing, cursing some-
times, weeping sometimes, in his sleep. When Shotwell sleeps I
try to pick the lock on his attaché case, so as to get at the jacks.
Thus far I have been unsuccessful. Nor has Shotwell been suc-
cessful in picking the locks on my attaché case so as to get at the
.38. I have seen the marks on the shiny surface. I laughed, in the
latrine, pale green walls sweating and the air conditioning whis-
pering, in the latrine.

I write descriptions of natural forms on the walls, scratching
them on the tile surface with a diamond. The diamond is a two
and one-half carat solitaire I had in my attaché case when we
went down. It was for Lucy. The south wall of the room con-
taining the console is already covered. I have described a shell,
a leaf, a stone, animals, a baseball bat. I am aware that the
baseball bat is not a natural form. Yet I described it. "The base-
ball bat," I said, "is typically made of wood. It is typically one
meter in length or a little longer, fat at one end, tapering to afford
a comfortable grip at the other. The end with the handhold
typically offers a slight rim, or lip, at the nether extremity, to pre-
vent slippage." My description of the baseball bat ran to 4500
words, all scratched with a diamond on the south wall. Does
Shotwell read what I have written? I do not know. I am aware
that Shotwell regards my writing-behavior as a little strange. Yet
it is no stranger than his jacks-behavior, or the day he appeared
in black bathing trunks with the .25 calibre Beretta strapped to
his right calf and stood over the console, trying to span with his
two arms outstretched the distance between the locks. He could
not do it, I had already tried, standing over the console with my
two arms outstretched, the distance is too great. I was moved to
comment but did not comment, comment would have provoked
counter-comment, comment would have led God knows where.
They had in their infinite patience, in their infinite foresight, in
their infinite wisdom already imagined a man standing over the
console with his two arms outstretched, trying to span with his
two arms outstretched the distance between the locks.

Shotwell is not himself. He has made certain overtures. The
burden of his message is not clear. It has something to do with
the keys, with the locks. Shotwell is a strange person. He appears

to be less affected by our situation than I. He goes about his business stolidly, watching the console, studying *Introduction to Marketing*, bouncing his rubber ball on the floor in a steady, rhythmical, conscientious manner. He appears to be less affected by our situation than I am. He is stolid. He says nothing. But he has made certain overtures, certain overtures have been made. I am not sure that I understand them. They have something to do with the keys, with the locks. Shotwell has something in mind. Stolidly he shucks the shiny silver paper from the frozen enchiladas, stolidly he stuffs them into the electric oven. But he has something in mind. But there must be a quid pro quo. I insist on a quid pro quo. I have something in mind.

I am not well. I do not know our target. They do not tell us for which city the bird is targeted. I do not know. That is planning. That is not my responsibility. My responsibility is to watch the console and when certain events take place upon the console, turn my key in the lock. Shotwell bounces the rubber ball on the floor in a steady, stolid, rhythmical manner. I am aching to get my hands on the ball, on the jacks. We have been here one hundred thirty-three days owing to an oversight. I write on the walls. Shotwell chants "onesies, twosies, threesies, foursies" in a precise, well-modulated voice. Now he cups the jacks and the rubber ball in his hands and rattles them suggestively. I do not know for which city the bird is targeted. Shotwell is not himself.

Sometimes I cannot sleep. Sometimes Shotwell cannot sleep. Sometimes when Shotwell cradles me in his arms and rocks me to sleep, singing Brahms' "Guten abend, gute Nacht," or I cradle Shotwell in my arms and rock him to sleep, singing, I understand what it is Shotwell wishes me to do. At such moments we are very close. But only if he will give me the jacks. That is fair. There is something he wants me to do with my key, while he does something with his key. But only if he will give me my turn. That is fair. I am not well.

a mean teacher
Mitchell Sisskind

THERE WAS no chalk in Miss Carter's room. It was gone. She wanted to write on the blackboard. I'll send a child to Miss Baylie's room, thought Miss Carter, to get some chalk.

Still, she remembered: Miss Baylie is like an elephant. Who shall I send there, she wondered.

There were no troublemakers.

The children sat in blue desks, thinking: There is such a thing as ghosts. They read of other lands.

"All right, Paula," said Miss Carter. "Four times eight."

"Four times eight," Paula said. "Thirty-two. You scared me." There was a general flying laugh. At that Miss Carter changed colors.

"Less noise, if I were you," she said. "Maurice, give me five times eight plus three times eight, in your head. You had better know the eights, my friend."

"Three times eight," said the boy. "Twenty-four. Sixty-four, I guess it is," he said, thinking: I have nothing to be ashamed of.

Outside mothers pushed their babies past the school. The pupils heard them crying in their carriages. And safes fell on those baby carriages in Miss Carter's mind.

"Maurice," she said. "Can a man on foot escape an elephant?"

They look slow thought Maurice, but they are not.

"No," he said. "They look slow, but they're too big. Why, with one step of their giant legs. . . ." He was humiliated quickly.

"The answer is sometimes!" shouted the children. "It says in the book sometimes you can: Bumba was chased by one!" In their minds men were escaping.

Miss Carter roamed the front of the room. There was her hair, the color of a radiator. Then there were her metal lips.

Mitchell Sisskind a mean teacher

"Maurice," she said, "go down to Miss Baylie's room and ask nicely if you may borrow some chalk."

Maurice was fat yet loved to hum when he ran. This makes it like a movie, he would think. But he walked quietly down the hall to Miss Baylie's room and knocked on the door.

"Come in," said Miss Baylie. Maurice opened the door, thinking: She is more like the dinosaurs. There were the big kids, so awful.

"I'm sorry to bother you, Miss Baylie," Maurice said. "But Miss Carter would like to borrow some chalk."

A mean teacher, Miss Baylie took the boy into her cloak room, a bully. She beat him up there, asking: "How would you like to go down to the office, and see Mr. Wadsworth?" Outside some laughed to hear the thuds. "My glasses, my glasses!" shouted Maurice, in her clutches. "Really, it's hilarious, Charlie," said a big kid girl, and whispered: "From inside there she can't see us, darling." "Let me take you to the land of dreams," responded a young man. That night Maurice told his mother what had happened.

What kind of a woman is Miss Baylie, anyway, she wondered. Where does she come from?

Miss Baylie lived with her father Jake. She had become a big fat one through the years.

When Miss Baylie was small her parents would walk with her around the block. In those days her mother would hold the right hand, and her father would hold the left hand. Those were the days, too, of her mother's strange infection. Those were the days that Jake was out of a job. Once an old man approached him.

"I'm not going to tell you a long story," said the old man. "I want a quarter for a drink of whiskey."

"I just don't have a quarter to give you," Miss Baylie's father told him. He put one hand on the old man's shoulder. "I just haven't got it. I'm out of a job."

"Then we part friends," said the bum, moving along. They heard his spitting. Just then Miss Baylie's mother made some noise: she claimed her whole body itched. One day her life collapsed like a chair.

"We have to be brave," said Jake, thinking: I've got to find a job. Then he found one.

With time things became easier for Miss Baylie and her father. They moved to a neighborhood where the dogs were not quite lovely collies, but neither were they chows. And on Sundays when Miss Baylie and Jake walked around the block he no longer held her hand, but it was displayed for all the passers-by. And they thought: So light brown! One day an old man approached Miss Baylie's father.

"Give me this moist daughter of yours," he shouted, his arms on her shoulders, her face in his mouth. Miss Baylie covered the man with punches.

"All right, mister," said Jake. "Okay for you." This is no fun, the bum thought. He forgot about the whole idea.

It was a hot day for April. The trees made short shadows on the sidewalk. Because it is almost noon, thought Miss Baylie. But then: I hate that old man, whose lips dripped. They went ahead.

"Well, what do you want to do with your life," Jake asked. "Say, I hope you're not hurt."

"Be a teacher," said Miss Baylie.

"That's a good idea," her father said. Yet one day he would rip her heart out and eat it. One day Miss Baylie would turn around, and she would be shaped differently. Then Jake would ask: "How was work today? Well, I know there's nothing wrong with working for a while when you're eighteen or nineteen years old. All the girls get jobs in banks, or they become secretaries, or they become teachers. But they don't just let themselves go! You just let yourself go! By the time a girl is twenty-five she's married, and has a girl of her own. And believe me by the time she's thirty-five she's mighty glad to have the children around; they bring some cheerfulness into her life. Do you think movie actresses don't have kids? Well, sometimes the studio doesn't want the public to know how many kids an actress has because it might make her look like an old woman to some people. Listen, every one of those actresses has plenty of kids! Do they know how long their careers are going to last? How do they know when some young actress is going to come along and steal the audience? And · lot of them get killed in accidents. But one thing is for sure: no

matter what happens, they've left some kids to carry on, and provide them with grandchildren if they're still here. And most of the time, if the mother was a beautiful actress, the daughter will turn out to be beautiful and probably will go into acting herself, or if it's a son he'll be a handsome actor. And neither of them will have very much trouble getting married and providing a few kids, that's all I know. Well, I could stand to hear the laughter of children again. Is it too late? What's your plan?" "I don't feel well," Miss Baylie would say. "Shut up."

Maurice's mother grabbed her son and went to see Mr. Wadsworth, saying: "You're the principal, aren't you?"

"Why yes," said Mr. Wadsworth. He listened to her organ recital. Then he sent for Miss Baylie; she appeared at his door.

"Come in, Miss Baylie," said Mr. Wadsworth. "This is Mrs. Minor. I gather you know Maurice."

"Yes," said Miss Baylie.

"And in fact Maurice has a lot to do with my asking you to come down here this morning," Mr. Wadsworth said. "That is, it concerns your relationship with Maurice. Now correct me if I'm wrong, but this seems to be the situation: last night the boy here told his mother that he'd come into your room on an errand from Miss Carter and that you took him into the cloak room and punched him. Is that right, Maurice?"

"Yes, Mr. Wadsworth," he said.

"Now then. Miss Baylie, what's your side of the story?"

"Sir," Miss Baylie said, "I was trying to conduct a class, and I was interrupted. I don't mind, of course, as long as the child is a gentleman. But I'm afraid . . ."

"Is that the kind of school I'm sending my son to?" asked Mrs. Minor. "Is that the kind of thing that goes on?" Once she had witnessed the beating of a horse.

"Now Maurice, did you provoke Miss Baylie in any way?" Mr. Wadsworth asked. "Did you knock on the door?"

"No . . . yes," said Maurice. Suddenly he burst into tears. "Yes, I did. She knows I knocked, too. She might not say so." His mother flew to him.

"You see, Miss Baylie," Mr. Wadsworth said, "this kind of

thing creates a lot of problems. And really, is there any excuse for it?" He studied his folded hands. "Now I want to make myself crystal clear. We cannot . . ."

"Excuse me, Mr. Wadsworth! Excuse me!" said Miss Baylie, standing up.

"Now don't get upset," Mr. Wadsworth said. "I'd imagine there are enough people upset already, wouldn't you say? Well then."

"It's not that," said Miss Baylie. "It's just that my body has begun to itch. It's happened before. But . ."

"Itch?" sobbed Maurice.

"Now, Miss Baylie . . ." said Mr. Wadsworth.

"It's all right," Miss Baylie said, sitting down. "Pardon me."

"Well, as I was about to say . . ." Mr. Wadsworth continued.

"Just one thing!" Miss Baylie burst out. "I know the children dislike me. I know they tell their parents about me, and make jokes about me. I don't need to be told that. But I want one thing to be clear: whatever I did, it was to help them. I knew they would often misunderstand, and be hurt, but I hoped that some-day in the future it would become clear to them, that someday they would think kindly of me, or—if not that—at least remember me. I felt I owed them something which no one else seems pre-pared to give—the feeling that what they do is important, that it makes a difference whether even a child acts rightly or wrongly, that there is such a thing as right and wrong. What does a child see when he looks about him in today's world? He sees adults abdicating their responsibilities to him, perhaps with the best of intentions but often with the worst possible results. He sees parents who so misunderstand love as to think it can only find ex-pression in the gift of a new whistle of some sort, or in the de-cision *not* to administer a well-deserved beating. Today's are parents who fail to realize that the sowing in a child of integrity and self-denial will reap rich harvest long after the sting of a good crack in the mouth has been forgotten. But we have denied our children the pleasures—for they are pleasures, finally—of receiving these gifts, and hence we have denied ourselves the perhaps equally great pleasures of bestowing them. For the parents of today, seeking to retain for themselves the careless

freedoms of childhood as children to their children, have thereby
forfeited the satisfactions of seeing their sons and daughters grow
into real men and women, real mothers and fathers of whom they
can be proud. It is the irony of today's parent, who believes that
to make one's child happy one need only remain ever a child
oneself, to have brought down upon the young people exactly
that uncertainty, even panic perhaps, which was presumably to
be avoided. Can we imagine a generation more filled with doubt
than that growing up today? It looks to its elders for guidance
and finds only a few more 'pals.' And if the parents don't care,
or care only in the wrong way, where can the children turn?
The church, all the churches—with variations according to the
degree that fashion has replaced principle in one or another of
them—have simply followed the prevailing winds. So from the
pulpits come only talk and more talk about the latest miracles—
of the cinema, that is—or of the trash which has most recently
fought its way to the top of the best-seller lists. And *what of* the
writers? *What of* the artists? Have they moved to fill the blank
sheet of paper, the empty canvas which is conscience in our
time? The answer is no. No, they have decided to go on paint-
ing and writing and filming only whatever is least worthwhile
and filthiest. But what a moment for poets and painters, and
especially for the motion picture colony, to disdain even one
more tasteless fling in the hay in favor of reminding us of those
values which we have so utterly forgotten, yet seem ever the
more trying to forget: the sunset over Hawaii, a bear trapping
salmon in our Pacific Northwest. Indeed, things are at such a
pass that the moment has traveled through ripeness into ur-
gency, the opportunity having grown into a responsibility. It is
this kind of responsibility that I have felt as a teacher, and it
is this sense of urgency that has compelled me to act as I have.
I can only wish it felt by every child's hero who is tempted to
throw the big ball game, by every hunter who decides on just
one pheasant over the limit, by every bride and groom who
might then feel each other's kisses not simply in a spirit of
whoop-jamboreehoo, but thinking: 'Will tonight bring a child
into the world?' "

And the next moment she knelt before God's throne.

Mr. Wadsworth hurried to her side, and knelt to take her pulse. "Miss Baylie!" he shouted.

"Will she be all right?" asked Mrs. Minor, thinking: She grew too fat.

"It's no use," Mr. Wadsworth said. When the ambulance arrived he told them, "There is nothing more to be done."

"Of course not," said a young doctor. "Not as far as the woman herself is concerned. But a good autopsy may teach us things that will help in the future, and not just in cases like hers. We learn a lot."

"I don't understand it," Mr. Wadsworth said. "She'd never missed even a day of work, and then this. And then this "

"Well, from what you've told me," said the doctor, "it certainly sounds like the big itch. And if, as I suspect it will, a talk with the family shows there to be a history, well . . ."

"I'm closing the school," said Mr. Wadsworth. "I have no stomach for any more school today."

The children filed into the assembly hall. They knew something was up.

They thought: This is a special assembly.

"No talking" said Miss Carter. "For the first one who talks there is the furnace. Who will that be?"

Mr. Wadsworth rose slowly, carrying his body like a piano. "There will be no more school today," he said. "You see, Miss Baylie has suddenly passed away. Now, I don't know if you can understand . . . but I want you to understand. Oh, she's dead, she's fallen down that elevator shaft! And the cables gave way one after the other, and we may wonder, many of us, 'Mightn't she have grabbed something on the way down? Aren't the springs down there?' But it only remains for us to stare down the hole." There was some noise. "Listen, she gave something to you. In ten years you'll know what it was. As for now . . . well, what does a fish know about the water?" He unbuttoned his coat. "You'll know what she gave you when you move into high school, and go on to college. She always gave one hundred and ten percent." Mr. Wadsworth rebuttoned his coat. That felt good. "She was always ready to lend a hand—be it in the lunch room, or

ɔn Work Day, or on Stupid Day, or for graduation: Miss Baylie."
There was a quiet moment. "And now you may silently go. I
expect the older ones to keep an eye on the younger ones."

The school opened like a can. It was near the end of May.
Outside the children went to the park, hid in dark alleys, carried
one another's books in kindness. Soon each would be in a differ-
ent grade. One thought: Hooray. Boo-hoo, thought another. In
the park many were attracted to the interesting flies eating a
doodie. "That's human," they said. "There's no dog big enough
to make that." "Of course there is," one said. Blocks away a big
kid decided: I'll throw Kathleen's homework high in the air.
"Awk!" said the girl. "Now I'm going to start kissing you," he
said, thinking: This is Sergeant Rock, and we're moving into
enemy territory. She thought dreamland.

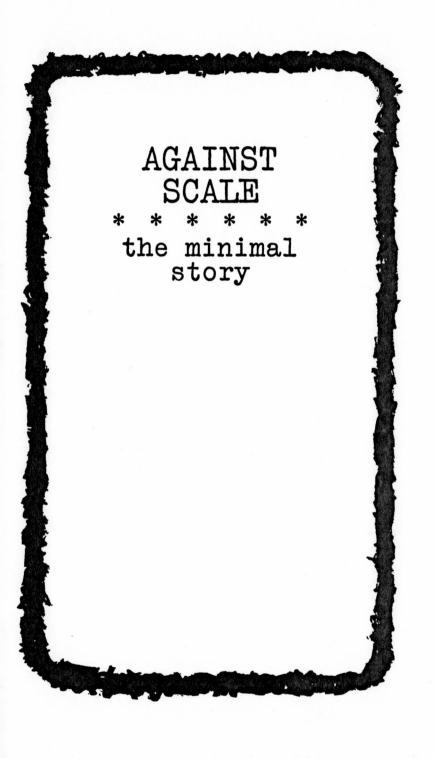

AGAINST
SCALE
* * * * * *
the minimal
story

games

Reinhard Lettau

TWO GENTLEMEN make an appointment, but in addition to that each sends a friend to a given place. These friends of the friends also walk up to each other at the proper time at the given place, peel off their gloves, rejoice in meeting. Immediately afterwards they make a new appointment at a different place, immediately walk off in opposite directions, visit friends and send them also to a given place, where these friends greet each other, in turn make an appointment, walk away, find friends whom they send to a place they have thought up. On their separate ways these two will see gentlemen standing here and there throughout the town, shaking hands, making appointments, walking away from each other, soon many gentlemen know each other, the town is humming, a stranger who is driving through it says: "This is a friendly town."

father
father,
what have
you done?
Russell Edsor

A MAN straddling the apex of his roof cries, giddyup. The house rears up on its back porch and all its bricks fall apart and the house crashes to the ground.

His wife cries from the rubble, father father, what have you done?

taboo
Enrique Anderson
Imbert

HIS guardian angel whispered to Fabián, behind his shoulder:
"Careful, Fabián! It is decreed that you will die the minute you pronounce the word *doyen*."
"Doyen?" asks Fabián, intrigued.
And he dies.

about the
authors

John Barth's works include *The Sot-Weed Factor, The Floating Opera, End of the Road,* and *Giles Goat-Boy,* all novels, and *Lost in the Funhouse,* a collection of short fiction. He was born in eastern Maryland, taught for a number of years at Pennsylvania State University, and is now at the State University of New York at Buffalo.

Heinrich Böll was born in Cologne in 1917. His fiction in translation includes *Billiards at Half-Past Nine, Absent Without Leave, The Clown,* and *Eighteen Stories.* Along with Günter Grass, he is the best known of a powerful group of post-war German novelists.

Joyce Carol Oates was born in Lockport, N.Y., and presently teaches at the University of Windsor, Ontario. She is a prolific writer of short fiction: her work appears in dozens of journals and in nearly any collection of "best" stories of the past few years. Her novels include *The Garden of Earthly Delights, Expensive People,* and *them.*

Keith Fort is at Georgetown University in Washington where he has been concerned with teaching writing to inner-city students of various ages and "working on a novel that is somewhat more traditional than 'The Coal Shoveller' and some short stories that are somewhat more experimental."

Jorge Luis Borges, writer, translator, and, for many years, director of the National Library of Argentina, has had the fortune, good or bad, to be "discovered" by readers in the United States in the '60s. Two recent collections of his translated works are *Ficciones* and *Labyrinths.*

Tomasso Landolfi was born in 1908 in the provincial Italian town of Pico. He has published novels, translations from several languages, and short fiction, a collection of which has been translated as *Gogol's Wife and Other Stories*. Despite an international reputation, ne has successfully avoided becoming a public figure, living apart from literary circles at his home in Pico.

Eugene Ionesco is a Romanian-born French playwright. Some of his best-known plays are *The Bald Soprano, The Chairs, The Lesson,* and *Rhinoceros.* His criticism is collected under the title *Notes and Counter Notes* and his short fiction as *The Colonel's Photograph and Other Stories.*

Wolfgang Hildesheimer was born in Hamburg in 1916, has been free-lance artist, interpreter at the Nuremberg war crimes trials, dramatist, and writer of fiction. His work is largely untranslated into English.

Theodore Roethke was one of America's most distinguished poets and a dominant figure in the '50s. His best known volume of poetry is *Words for the Wind.* He was born in Michigan and taught at the University of Washington for a number of years before his death in 1963.

Oscar Lewis has taught anthropology at the University of Illinois since 1948. He has explored the culture of poverty in a remarkable series of books including *Five Families, Children of Sanchez,* and *La Vida,* which won a National Book Award.

Ann Quin lives in London. She has published three books, *Berg, Three,* and *Passages,* has held a D. H. Lawrence Fellowship, and is presently at work on a fourth book of fiction called *Tripticks.*

William Gass is author of the widely praised novel *Omensetter's Luck* and a collection of short fiction *I* *the Heart of the Heart of the Country.* He is a percep

tive reviewer of new fiction and his reviews are frequently found in *The New York Review of Books*. He teaches philosophy at Purdue University.

Julio Cortázar is an Argentine who now lives in Paris. His fiction includes the remarkable novel *Hopscotch*, a collection of his short fictions under the title *End of the Game*, and a recent book which defies description, *C nopios and Famas*.

Curtis Zahn has lived most of his life on the California coast where he has been a professional painter, a beachcomber, and a contributor of unorthodox fiction, poetry and drama to little magazines.

Thomas M. Disch, born in Minnesota, has lived abroad, mostly in England, since 1964. His more recent short fiction is in the tradition established by the British journal *New Worlds*, in which certain classic possibilities of science fiction are wedded to experiments in form.

Nigel Dennis, an English writer now living in Malta, has been an editor of *Encounter*. He has written a study of Jonathan Swift, a highly regarded comic novel, *Cards of Identity*, and more recently an elusive and symbolic novel, *House in Order*.

Norman Mailer, of Brooklyn, Harvard, and the South Pacific in the Second World War, wrote *The Naked and the Dead* in 1948, generally considered the finest work of fiction to come out of that war. Since then he has published fiction, plays, polemical works, and has chronicled his own career in *Advertisements for Myself*. Recently his accounts of current political events, as in *Armies of the Night*, have become contemporary classics.

George P. Elliott is a distinguished critic of fiction and a short story writer whose best known story is "Among the Dangs," from ne collection of that title. Among his fiction of novel length are *Parktilden Village* and *David Knudsen*. He teaches at Syracuse University.

Robert Coover's first novel, *The Origin of the Brunists*, won the William Faulkner Award in 1966 for the best first novel of that year. Since then he has written another novel, *The Universal Baseball Association, J. Henry Waugh, Prop.*, and a collection of shorter fictions, *Pricksongs and Descants*.

Nathalie Sarraute's *Tropisms, The Age of Suspicion* (a critical work on the novel), *Between Life and Death, The Golden Fruits*, and *Portrait of a Man Unknown* have been translated into English. She has been a practitioner and advocate of the "new novel" in France.

Alain Robbe-Grillet was born in Brest in 1922. For a number of years he worked as an agronomist, specializing in the study of tropical fruits. His first novel was published in 1953 and translated as *The Erasers*. Since then he has written the novels *The Voyeur, Jealousy*, and *In the Labyrinth*, several important critical essays, and the script for the film *Last Year at Marienbad*.

Michel Butor was born in France in 1927, has traveled and lectured widely, and has taught in the United States. His fiction published in this country includes *Passing Time, A Change of Heart, Degrees*, and his strange map of the United States *Mobile*.

Eugenio Montale is probably the most influential Italian poet of the twentieth century, who defined and exemplified modern poetry for his language rather as T. S. Eliot did for the English-speaking world. He has translated into Italian such writers as Shakespeare, Corneille, Hawthorne, and Melville.

Michael Goldstein lives in Manchester, England, where he is a computer technologist, plays amateur violin, cricket, and table tennis with such old friends as Harold Pinter.

Donald Barthelme, who lives in New York, has published two collections of short fiction, *Come Back, D*

Caligari, and *Unspeakable Practices, Unnatural Acts,*
and a short novel, *Snow White.*

Mitchell Sisskind is a football coach in Chicago. His
stories have appeared in *Tri-Quarterly, Art and Litera-
ture, Paris Review* and *Columbia Review.*

Reinhard Lettau, a native of Germany, teaches German
literature at Smith College. A collection of his shorter
fictions has been translated with the title *Obstacles.*

Russell Edson lives in Stamford, Connecticut. A chapter
of an unpublished novel appears in *New Directions in
Prose and Poetry #20* and a group of his fables has
been published under the title *The Very Thing That
Happens.*

Enrique Anderson Imbert, a native of Argentina, has
taught Hispanic American literature in the United
States since 1947, most recently at Harvard. A group of
his short fiction has been translated as *The Other Side
of the Mirror.*

Printed in the United States
6358